IRISH PEOPLE, IRISH LINEN

Stylized flax flower. This tile is one of a long row of decorative ceramic tiles that lined the halls of Conway Mills, Belfast, 2008. *Private collection of the author.*

Irish People, Irish Linen

Kathleen Curtis Wilson

OHIO UNIVERSITY PRESS

ATHENS

ALSO BY KATHLEEN CURTIS WILSON:

Textile Art from Southern Appalachia: The Quiet Work of Women (Overmountain Press, 2001)

Uplifting the South, Mary Mildred Sullivan's Legacy for Appalachia (Overmountain Press, 2006)

Encyclopedia of Appalachia, Craft Section editor (University of Tennessee Press, 2006)

Ohio University Press, Athens, Ohio 45701

ohioswallow.com

© 2011 by Ohio University Press

All rights reserved

Printed in China

Ohio University Press books are printed on acid-free paper ⊗™

20 19 18 17 16 15 14 13 12 11 5 4 3 2 1

Photograph captions: page v, ruins of the Newgrove Flax Mill, 2008, private collection of the author; page vi, small cut samples for salesman's case, c. 1921, private collection of the author; page viii, courtesy of the Irish Linen Centre & Lisburn Museum, photo by David Pauley; page xxii, poem by Michael Longley, printed on linen by John England, Ltd., artist: Trish Belford, 2007, courtesy of the University of Ulster.

Library of Congress Cataloging-in-Publication Data

Wilson, Kathleen Curtis.

 Irish people, Irish linen / Kathleen Curtis Wilson.

 p. cm.

 Includes bibliographical references and index.

 ISBN 978-0-8214-1971-7 (hardcover : acid-free paper)

1. Linen—Ireland—History. 2. Linen—Northern Ireland—History. 3. Ireland—Social conditions. 4. Ireland—Economic conditions. 5. Northern Ireland—Social conditions. 6. Northern Ireland—Economic conditions. 7. Irish—Migrations—History. 8. Irish Americans—Appalachian Region, Southern—History. 9. Linen—Appalachian Region, Southern—History. 10. Flax—Appalachian Region, Southern—History. I. Title.

 TS1715.I6W55 2011

 677'.1109417—dc22

 2011012521

To Thomas J. Tracy, Sr.—a proud Irish American who loved the land of his ancestors, its people, and their culture with a passionate perseverance that nurtured him throughout his life.

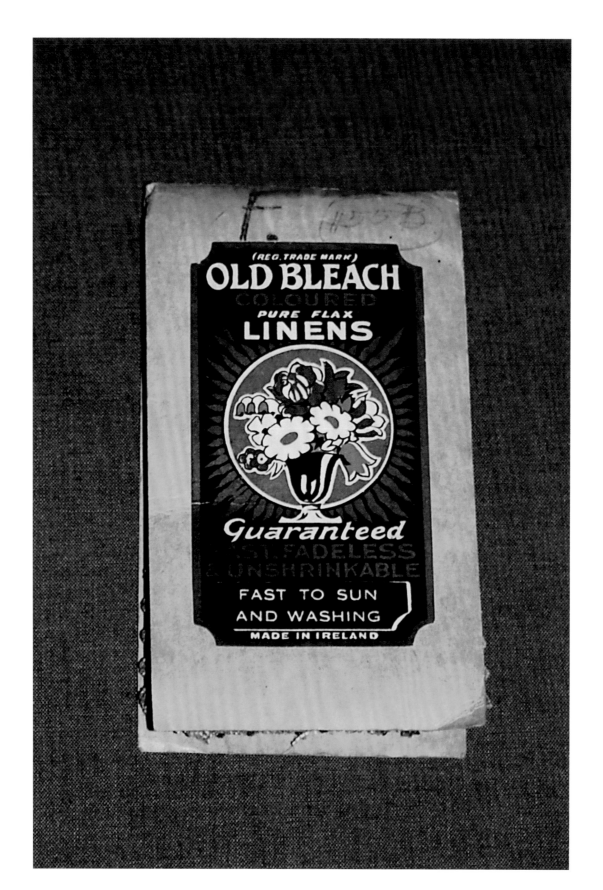

Sponsors

Major Donors

The Lynch Family Foundation

The Thomas and Erma Jean Tracy Family Foundation

North Carolina Museum of History, Raleigh, North Carolina

Virginia Foundation for the Humanities, Charlottesville, Virginia

University of Ulster, Northern Ireland

Rodney Miller & Associates, Belfast, Northern Ireland

Haskett Law Firm, P. C., Pleasanton, California

Friends of the Book

Carole Frisselle Cassio

Janet Chang-Pryor

The Irish Literary and Historical Society

Richard and Cherie King

Brian and Helen Williamson

Contents

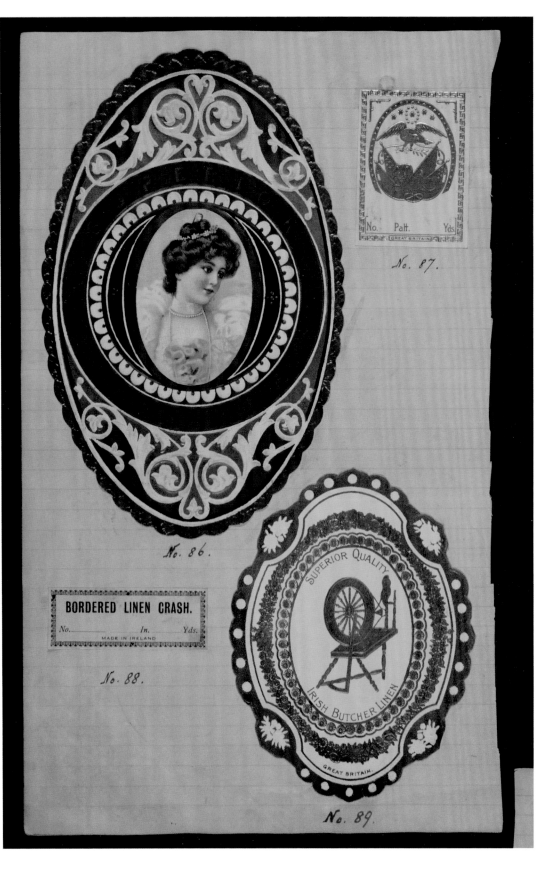

No. 86.

No. 87.

BORDERED LINEN CRASH.

No._____ In._____ Yds._____

MADE IN IRELAND

No. 88.

SUPERIOR QUALITY

IRISH BUTCHER LINEN

GREAT BRITAIN.

No. 89.

Preface

THE TOUCH AND SMELL of woven cloth has enthralled me since I was a little girl, when I opened a trunk in my grandparents' attic to discover a cache of brightly colored sewing fabrics Grandma brought back from their three years in Japan prior to World War II. At twelve years old, I began learning to weave under the expert tutelage of Lillian Holm, a Swedish tapestry weaver, and during my senior year in high school, I tied an 8' × 10' rhea rug with a three-inch-deep wool pile. Ms. Holm taught her students the practical applications for weaving, so I designed pattern drafts and chose color combinations and yarn textures to weave upholstery, curtain material, and clothing fabrics, never tiring of watching strands of yarn turn into cloth with each crossing of the shuttle.

In school, I found history a boring subject, but I loved the stories my grandmother told about living in Japan, Germany, and England while her hands were constantly busy knitting, sewing, crocheting, or doing needlepoint on canvas. It would be years before I understood that her stories about life experiences were also history—women's history, social history, and cultural history, that is, the humanities.

I got my first handloom when I graduated from high school and briefly had my own studio, but not until I was in my thirties and living in the Appalachian mountains of Virginia did I form a partnership to establish Old Abingdon Weavers, Inc. For nearly ten years, we used early twentieth-century mechanized looms to weave high-end Colonial bedding, table linens, and accessories sold at country folk art shows, by mail order, and in our showroom attached to the mill. We were the only company in the country using old looms for this style of overshot weaving, so we maintained a strong customer base and developed a thriving business.

During those years, men and women brought a wide variety of beautiful old textiles to the mill to show me, asking for advice on how to clean and store their prized heirlooms that had remained in the family of origin for generations. I soon realized that each blanket, quilt, and coverlet came with a family story that was as much a part of the textile as if it had been woven into the cloth.

By the time we sold Old Abingdon Weavers in 1991, I had developed a serious fascination with the early weavers of southern Appalachia; it was time to change my career path from entrepreneur to researcher and writer, focusing my study on the textile traditions of the Scots-Irish who immigrated to the mountain region. It is a subject overlooked by many textile historians, who often consider Appalachia unworthy of their efforts, but I thought there was a rich textile history to uncover. Intrigued by the power of storytelling in advertising, I also began to look for marketing strategies used by regional mill owners a hundred years

Facing page: Packaging labels. © National Museums Northern Ireland 2011. Collection Ulster Folk & Transport Museum.

ago. I realized that Grandma's handwork and storytelling ability had been my underlying inspiration to write about textiles, made and used by everyday people. It was worthy work for me to undertake; it is how I have spent the past twenty years.

In Appalachia, linen, cotton, and wool yarn was handwoven into wearing apparel, bed covers, and household accessories into the early twentieth century. Large numbers of sheep were raised in the mountains for their wool, which was sold to local weaving mills. Cotton did not grow in the mountain climate; in the early years, it was brought into the region in bales, and later it was purchased already spun. Many handweavers grew a small plot of flax to spin into linen for their personal use, spinning it for strong warp yarn and occasionally weaving it in combination with cotton or wool for the weft.

As my research deepened, I became increasingly curious about the use of linen in Appalachia. Why would anyone go to so much trouble to process flax into yarn in the nineteenth century, when cotton was available and easier to work with? Was linen chosen for its strength and durability as woven cloth? Did weavers grow flax for warp yarn because there was a shortage of cotton during the Civil War? Was it a cultural tradition that was part of immigrant weaving traditions? There were too many reliable stories about a "small patch of flax grown near the house" for me to doubt its existence, so I decided to find out whether flax was part of the cultural tradition of handweaving in Appalachia. I wanted to discover whether the Scots-Irish, who came from a land with a long history of linen making, clung to the styles of their ancestors; or did the use of linen in Appalachia come from an amalgamation of many cultures? On a fellowship at East Tennessee State University, I had an opportunity to travel and study textiles in Edinburgh through the university's School of Scottish Studies program. One opportunity led to another, and my first book, *Textile Art from Southern Appalachia: The Quiet Work of Women*, was published in 2001. By that time, I had become intrigued with the story of how Appalachian textiles related to the story of the Scots-Irish linen makers weaving on both side of the Atlantic, but I had yet to find a way to proceed.

The idea for *Irish People, Irish Linen* was born in the course of a conversation with Professor Robert Welch during my first visit to the University of Ulster, Derry, in January 2001. I was there at the invitation of Professor John Wilson for the university's launch of the Institute for Ulster Scots Studies. Professor Welch encouraged me to submit a proposal, and my determination to write this book began in earnest. First as a visiting scholar and then as an honorary fellow at the University of Ulster, I traveled between my home in the United States and Northern Ireland on a regular basis for nearly five years.

From 2001 to 2009, my time in Northern Ireland and the Republic of Ireland was spent researching the history of the linen industry and identifying appropriate textiles to illustrate the story. During these years, I met an incredible number of scholars and laypeople on both sides of the Atlantic who advised me, helped me understand the politics and culture on the island, suggested sources for additional research, fed me, housed me, and made me feel welcome when I was away from home and family.

Probably because I love all kinds of fabric, I have long been intrigued by how many words in the English language come from the making and using of textiles. Many years ago, I began to make a list of the

words, and I often shared my findings with friends, who seemed quite unaware of the actual origin of words they used frequently in their daily conversations.

It is nearly impossible to tell any story, let alone the history of Irish linen, without using textile terms in the descriptive narrative. As an example, the following phrases are used in everyday speech but with little regard to the original connotation of their textile relevance: let's follow the *thread* of her argument and *weave* together a story about your adventures; the *fabric* of the community is made up of a few close-*knit* families who share good times and bad; it is a tightly *woven* group of friends.

Since most people have no idea of the original meaning of many textile-related words in their vocabulary, I decided to pepper my speeches and presentations with these interesting and entertaining sidebars. At first, it was the *wool* words that I found most fun to share. The phrase *he pulled the wool over her eyes* means that, in some way, the person was briefly blinded to the truth of a situation, an expression that actually comes from the manner in which sheep are sheared. Starting at the hind end of the animal, an expert shearer moves forward as he clips, keeping the wool pelt intact until it is pulled over the face of the sheep, covering its eyes while the front portion is cut free. When someone is called the *black sheep of the family,* he or she is considered to be outside the thinking of a family unit. Black wool does not dye as purely as white wool, and if the wool from black sheep is mixed with white fleeces, the resulting color is compromised. Black sheep were routinely cut out of the herd, and their wool was used separately without being dyed. Whether a person chooses to be a black sheep or becomes one because of his or her actions, the result is the same—black sheep are apart from other family members.

Dyed-in-the-wool is another expression frequently used in contemporary language without appreciating its original intent. If a person is a dyed-in-the-wool Democrat, he or she is firmly committed to the party platform and cannot easily be persuaded to change his or her mind. Wool fleece can be dyed either before it is spun into yarn or after it is spun. When wool is dyed prior to spinning, it is referred to as dyed-in-the-wool because the color can penetrate individual fibers more completely and evenly than after spinning, when the dye must infiltrate twisted fibers.

In time, I began to look for words and expressions used in daily conversation that come from the processes of turning all natural fibers into wearable cloth but are farther removed from their textile context. Many of these words, separated as sidebar comments, are sprinkled throughout the chapters of this book; I hope the reader will find the common and uncommon expressions and explanations interesting and informative. I am reminded that everything old is new again—even words.

I have approached a few specific topics within the broad subject of linen hoping to share what fascinates me the most, as an American and an outsider. I expect that some readers will be interested in the history of Irish lace while others will be curious about the working life of men and women who toiled long hours inside the mills and factories. There are many books available on every subject discussed in this manuscript, and readers can consult the bibliography to find sources with more in-depth information if they wish

to pursue a particular interest. I decided to concentrate on the overall subject of linen, its uses, production, and worldwide distribution, illustrating its beauty and lasting desirability with as many informative and sumptuous photographs as possible.

Including the names and background of more than a few of the many manufacturers that spun and wove linen in Ireland over the centuries would be impossible. Most companies had long and interesting histories of mergers, growth, and decline; additionally, many linen families intermarried, making each story longer and often too similar to others to engage the average reader. I apologize to the great number of manufacturers who once wove fabulous Irish linen but do not appear in these pages, for they deserve to have their story told in detail. I leave that task to others.

Derry/Londonderry is the fourth-largest city in Northern Ireland, but its name is still a source of debate for many people. Depending on the resident, historian, tour guide, book, or politician speaking, the city is called Londonderry, Derry, Derry City, and Derry/Londonderry. I chose to use the name Derry in the book without a personal affiliation or prejudice and to differentiate the city name from county Londonderry, within which it lies.

During the many years between conceptualizing this book and producing the final manuscript, I have been privileged to meet many very talented fiber artists across the island of Ireland. Out of the many possibilities, it was extremely difficult to choose a specific few to illustrate the ongoing legacy of Irish linen and how it continues to permeate the conscious and unconscious mind of artists working in all mediums and styles.

Because of its long and close affiliation with the linen industry, the Normal School of Design (School of Art and Design, University of Ulster), founded in 1849, trained students in practical design applications throughout the nineteenth and twentieth centuries, when linen manufacturing was the major industry in Ulster province. In the nineteenth century, the Metropolitan School of Art, Dublin, while bigger than its Belfast counterpart, reflected the culture of Dublin as the capital of the whole island and was, therefore, more of a fine art academy than a school of design. As a result of the differences in economic and industrial growth in the two major cities, there is a particularly strong community of fiber artists living and working in Northern Ireland in the twenty-first century, especially near Belfast. I was based in Belfast during my fellowship at the University of Ulster, so I naturally saw more textile exhibitions and met more artists living and working in Northern Ireland than in the Republic of Ireland.

Living and working in such close proximity to the people and culture that once produced some of the world's finest linen, many of today's Northern Ireland artists working in and around Belfast are naturally influenced by their surroundings. Although they do not work exclusively with linen fabric, I take this opportunity to pay tribute to a few artists whose work I particularly admire. Karen Fleming, University of Ulster's director of the Art and Design Research Institute, is a versatile artist who likes to manipulate linen fabric with paint, polishing, and quilting for her innovative creations. Hazel Bruce is a fiber artist who loves linen and the history of the industry; her wall hangings are bold and confident. Caroline Quail used brightly colored silk cloth to fashion collars reminiscent of the Derry shirt industry in one of her pieces, and Rachel

Glynne embedded colored scraps of linen, silk, and cotton in fifty ice cube–size blocks of resin and glass. Janet Ledsham makes her own cloth out of natural fibers and plant materials to fashion art that can be gossamer thin or earthy and dense. In the book *Cloth*, Rita Duffy's paintings illustrate Paul Muldoon's poem "Glad Rags." His words challenge and confront political and social prejudices while her art provides the visual resonance for a collaboration that is powerful and evocative. It has been my great pleasure and an honor to get to know a few of the many talented artists who are inspired by their sense of place in their imaginative creations.

In conclusion, I continue to be fascinated with all the ways in which Irish linen products have been marketed to a vast array of consumers, wholesale and retail, and by market demands that caused an industry to reinvent itself time and time again. Beyond its uses to cover the human body, Irish linen has advanced humankind's exploration of the world in the form of sailcloth, provided food to many in the form of fish netting, and helped fight a war as an outer skin covering on the Sopwith Camel airplane. How could I not be endlessly impressed and inspired by Irish linen and the people who made it famous around the world?

Acknowledgments

I WILL ALWAYS BE exceedingly grateful to Robert Welch, dean of Art, Design and Humanities, University of Ulster at Coleraine (retired), for finding the financial support for the years I was affiliated with the university as a visiting scholar and honorary fellow, and for his confidence that I would complete the manuscript despite the many political upheavals that occurred over the course of the past decade.

My greatest appreciation and thanks goes to Jean Haskell, who read the manuscript many times as it progressed through the years, editing my words but not my voice. She never wavered from her belief in my ability to write the story of Irish linen, and I am forever in her debt.

Many scholars provided me with vital information that came out of their personal and professional research; this book would not be as rich or informative or have as many personal stories without contributions from Linda Ballard, Paul Louden-Brown, Caroline Carr, Patrick Cassidy, Brenda Collins, Mairead Dunlevy, Robert Gavin, Jonathan Hamill, Maurice Leyden, Linde Lunney, Brian J. Mackey, Elizabeth McCrum, and Lee Wright. I am thankful for Brian Lambkin's insightful introduction and for his friendship on a couple of occasions when I really needed it.

A special thanks goes to Belfast photographer David Pauley and his partner, Cheryl Johnston, for their ability to take ordinary objects and photograph them in a quality and style worthy of publication. David's artistic photographs, which set off each chapter, add artistic beauty and interest to the overall publication. He understood my conception of the design for the front and back covers of the book and translated that vision into unusual and creative images.

The extensive photography that illustrates the story of Irish linen is due to the tireless contribution of many curators and museum personnel who provided the physical space and time needed to photograph textiles from their collections. In particular, Elaine Flanigan of the Irish Linen Centre and Lisburn Museum, Valerie Wilson of the Folk and Transport Museum, Elizabeth McCrum of the Ulster Museum, Frances Bailey of the National Trust, and Andy Hogg and Noel Breakey of the Monaghan County Museum spent the time and financial resources that were necessary to identify historically and regionally important textiles from each collection, many pieces of which had never before been photographed for publication. I also wish to acknowledge the efforts of directors and staff of the aforementioned institutions for their support.

Other curators and museum persons I wish to thank for their important contributions are Diane Fagan Affleck and Karen Herbaugh, American Textile History Museum; Paddy Boylan, Ulster Canal Stores; Debbie McCamphill and Sheena Taylor, Mount Stewart; Samantha Curry, Mossley Mill; Sr. Maura Dempsey, St. Louis Convent and Heritage Centre; John Gilmour, National Museums of Northern Ireland; Pat O'Donnell, Ulster-American Folk Park; Helen Perry, Causeway Museum Services; Mo James and Jennifer Richardson,

Facing page: Portfolio of linen fabric samples. © *National Museums Northern Ireland 2011. Collection Ulster Folk & Transport Museum.*

xvii

Castle Ward; Elise Taylor, Ulster Museum; and Kimberly Webber and Lindie Ward, Powerhouse Museum, Australia. I am especially grateful to the American Textile History Museum for providing most of the photographs used to illustrate the processes of turning flax into yarn and linen cloth.

I am indebted to Rodney Miller (1949–2010), founder of Rodney Miller and Associates, Belfast, for his contribution both financially and verbally to this publication. I went to Rodney for help in designing the first proposal presented to the University of Ulster and to government officials interested in promoting my research, and Rodney assigned his superb graphic designer Anne Mitchell to work with me. Over the years when I periodically became discouraged about completing the project, Rodney would take me out to lunch and give me all the reasons why I should fight to make the publication as luscious and informative as he and I believed it should be. I am so grateful for his encouragement during our eight-year friendship. As Rodney predicted, Anne Mitchell was a tremendous help to me during the entire time I worked overseas. With her keen sense of artistry and color, in her I had found someone who understood my vision for the book. Anne listened to my concerns, supported my determination, and fed me great dinners during the many weeks I stayed with her and her husband, Michael Langston. Our working relationship became a lasting friendship.

As I finished writing the manuscript, Nell Carpenter came to Charlottesville, Virginia, to view the vast number of photography choices I had accumulated. Her great visual sense helped me narrow the selection down to a manageable number. I am very appreciative for all the work that Traci Boya did in California to format photographs for proposals, slide shows, and the final publication during the past few years as I prepared it for the publisher. She is great to work with, extremely competent, and very artistic.

I spent many cold rainy days and saw some spectacular double rainbows while driving across the island of Ireland looking at textile collections and talking to people along the way. Nearly everyone I met introduced me to someone else who had a connection to the linen industry and a story to tell. Over time, wonderful friendships were formed, and I received kindness and hospitality that will never be forgotten. I am thankful that I can mention Jeremy and Dame Joan Harbison as dear friends and dedicated supporters of the project from its inception. Their wise counsel was invaluable as I navigated the political and social nuances unfamiliar to me as an American.

In the early years of research, I spent a great deal of time working with Denise Gray, senior lecturer at the University of Ulster's School of Art and Design. The genuine hospitality and warm, engaging personality of Denise and her husband, George, always made me feel welcome, especially on dreary weekends when I otherwise would have been alone.

Many thanks to Celia Ferguson, great-great-granddaughter of James Herdman, and the family historian; Bernard Gilliland, who helped me locate and photograph the McIntyre Hogg and Marsh Company building in Derry City; Anne Montgomery and Anne McCartney, who listened to me talk endlessly about Irish linen; Karen Fleming, who identified talented fiber artists; Chris Bailey, director of the Northern Ireland Museums Council, for his sage advice; Nicola Gault, for her wisdom and support; Iain Davidson, Arts Council of Northern Ireland, for his efforts to organize an international exhibition of Irish linen; and

Geoff Fulton, a talented artist who helped visualize my children's book about linen making, *The Adventurous Max Flax.*

I would also like to thank the Hannigan family, particularly Nóin Hannigan (who has the keen interest and intellect of a future historian), Joan Smyth, Anne Millner, and all the individuals who allowed me to document and photograph cherished family textiles. I remember Lyn and Bobby Franks, Jim and Liz Devenney, and William Montgomery for their warm friendship and hospitality. I extend a most heartfelt thank you to Anne Heaslett, principal of Stranmillis University College, Belfast, whose family once grew a flax crop. She was an avid supporter of the book from the beginning and became a good friend who provided important guidance over the years.

Thank you again to Paul Larmor, marketing services manager for Ulster Weavers Home Fashions Ltd., who sent me his grandfather's copy of *Irish Folk Ways* by E. Estyn.

I owe a debt of gratitude to Mike Catto, University of Ulster lecturer, writer, and broadcaster in Northern Ireland, for his practical advice on artistic and cultural subjects and his reading of the final manuscript. In the last days before this manuscript was submitted to the press, he helped me locate a few additional illustrations I needed and answered my e-mail queries with lightning speed, each message filled with great and helpful information. Chris Kittredge, a lifelong friend and professional photographer, took the time to repair and reformat a few important photographs when her talent was needed elsewhere.

All who knew Tony McAuley know that he will forever be missed. I am grateful to him for repeatedly reminding me that the story of Irish linen was worth telling.

Many thanks to Lord John Laird for his enthusiastic support of my work (and for introducing me to Baroness May Blood in 2001), to Lord John Rogan, and especially to Sir Reg Empey for understanding my original vision for a multifaceted project. May Blood was a wealth of information about life as a textile worker, and I enjoyed every one of our conversations.

It is not possible to thank everyone who helped guide and nurture me during my travels abroad, so I hope those who do not find their names here will forgive me and know that I truly do appreciate all of you—from the waitress in Port Stewart who kept filling my pot of tea when I had terrible bronchitis to the staff at the Europa and McCausland Hotels who always found a quiet room for me to work; the total list would fill many pages.

The Thomas and Erma Jean Tracy Family Foundation funded the major cost of the extensive color photography that creates visual beauty and substance throughout the text. I owe my sincerest appreciation and personal thanks to Erma Jean and Tom (1938–2006) for making this possible. I also wish to thank Betsy Buford, former director of the North Carolina Museum of History, for her interest in the transatlantic connections to Irish linen and for the museum's management of funds for the project.

A very special thanks to Norman Houston, counsellor for the Northern Ireland Bureau, Washington, D.C., for his friendship, which has now spanned ten years, and his help in promoting the book in the United States, the United Kingdom, and Ireland.

The Virginia Foundation for the Humanities (VFH) holds a special place in my heart. Grants and Public Programs Director David Bearinger encouraged me to write my first grant application in 1993, believing I could make the career shift from owner of a small textile mill to researcher and author. The staff at VFH encouraged me and supported my work financially and professionally from that day forward, frequently opening doors to new opportunities for me to embrace. I am especially thankful for my second fellowship during the summer of 2009 when I had the time, space, solitude, and extensive library resources needed to complete the manuscript. Thank you, Robert Vaughan, Hilary Holladay, Roberta Culbertson, Ann Spencer, and Bill Freehling for making it possible.

Gillian Berchowitz, editorial director at Ohio University Press, approached me some years ago after hearing me speak at a Civil War conference and asked about my next book. I am so grateful that she encouraged me to keep at the task, as I struggled to pull all the strands together on both sides of the Atlantic over the ensuing years. Managing editor Nancy Basmajian and production manager Beth Pratt did a marvelous job at every stage as we moved from manuscript to finished publication. I am thrilled with Chiquita Babb's design; it is as sumptuous and elegant as I envisioned at the beginning of the long process that spanned ten years from concept to the printed page.

I especially want to thank Amber, Sarah, Robbie, Mark, Christine, Mills, Nicola, and my husband, David, for their patience, encouragement, and loving support during the time I was working overseas and during the endless weekends I spent closeted in my office. I also want to thank Henrietta Umberger, Kim Wilson, and Sally Binard for helping me to stay focused. At the end of the day, I am eternally thankful for my grandmother, Ethel Mae Alcorn Motherwell (1900–1986), who taught me to appreciate fine linens and listen to stories of their makers and wearers.

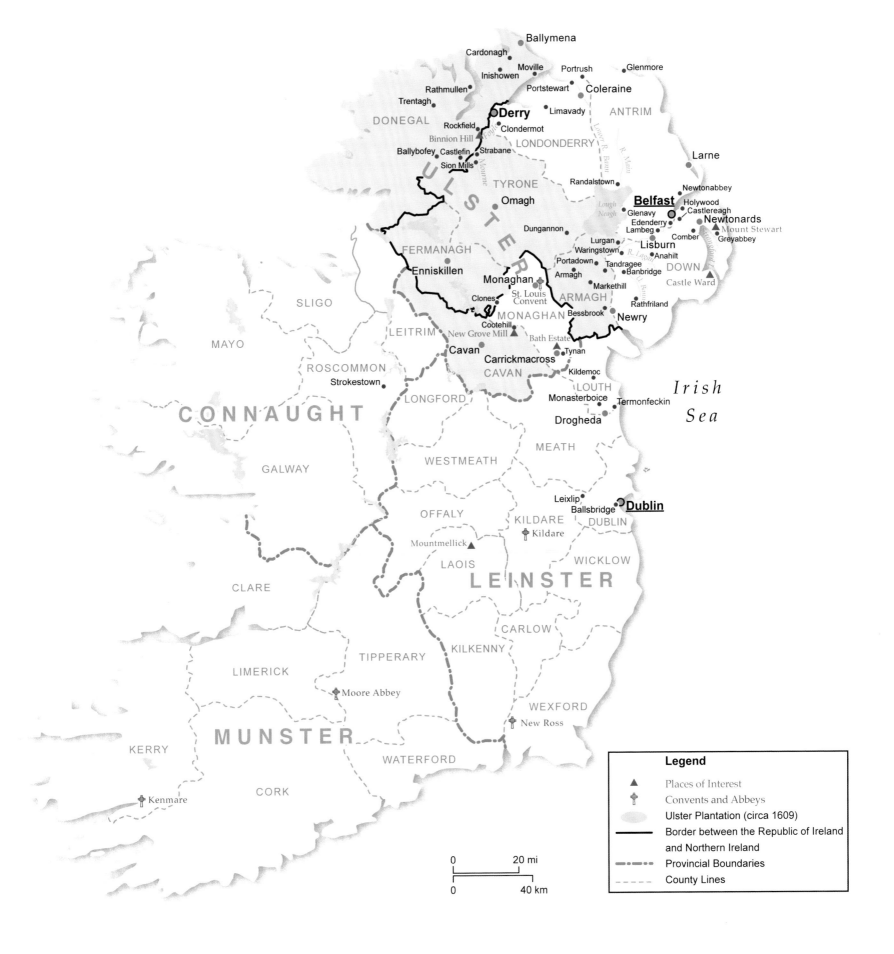

Ballymena

Cardonagh

Moville

Portrush

Glenmore

Inishowen

Portstewart

Coleraine

ANTRIM

Rathmullen

ODerry

Limavady

Trentagh

Rockfield

Clondermot

LONDONDERRY

Larne

DONEGAL

Binnion Hill

Strabane

Ballybofey Castlefin

Sion Mills

Randalstown

Newtonabbey

TYRONE

Belfast

Holywood

Omagh

Lough
Neagh

Glenavy

Castlereagh

Edenderry

Newtonards

Dungannon

Lambeg

Comber

Greyabbey

Mount Stewart

FERMANAGH

Lurgan

Lisburn

Waringstown

Enniskillen

Portadown

Tandragee

Banbridge

DOWN

Monaghan

Armagh

St. Louis
Convent

Markethill

Castle Ward

Clones

ARMAGH

Bessbrook

Rathfriland

MONAGHAN

Cootehill

Newry

New Grove Mill

Bath Estate

LEITRIM

Tynan

SLIGO

Cavan

Carrickmacross

MAYO

CAVAN

Kildemoc

LOUTH

ROSCOMMON

Strokestown

LONGFORD

Monasterboice

Termonfeckin

Irish
Sea

Drogheda

CONNAUGHT

MEATH

WESTMEATH

GALWAY

Leixlip

Ballsbridge

Dublin

OFFALY

KILDARE

DUBLIN

Mountmellick

Kildare

WICKLOW

LAOIS

LEINSTER

CLARE

CARLOW

KILKENNY

TIPPERARY

LIMERICK

Moore Abbey

WEXFORD

MUNSTER

New Ross

KERRY

WATERFORD

Kenmare

CORK

	Legend
▲	Places of Interest
✝	Convents and Abbeys
	Ulster Plantation (circa 1609)
——	Border between the Republic of Ireland and Northern Ireland
—··—	Provincial Boundaries
----	County Lines

0 20 mi

0 40 km

Peaty

Flax

Fields

Blue

Linen

Passion

Fibres

The Linen Industry

Pulling up flax after the blue flowers have
And laying our handfuls in the peaty

Those grasses to the bone, or build
That recall the skirts of an invisible da

We become part of the linen industry
Its processes to the grubby
Whole fields are compacted into windo
And there is little room among the big

In our attic under the skyligh
Love on a beach green, the w
Draped with material turning white in
As though snow reluctant to melt wer

What's passion but a battering of stub
Then a gentle combing out of fibres li
And a weaving of these into christenir
To garments for a marriage or funer

Once the la
Workers in a dy
Flax be our matchmaker, our und
The provider of sheets for whatever t

And be shy of your breasts in the pre
Say that you look more beautiful in li
Wearing white petticoats, the bow on
A butterfly attending the embroidere

IRISH PEOPLE, IRISH LINEN

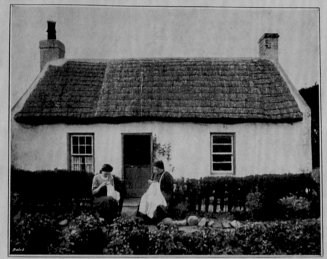

Irish Linen and the Irish Diaspora

fabrics spanning water

Brian Lambkin, *Director, Centre for Migration Studies,*

Ulster-American Folk Park, Omagh, Northern Ireland

THE STORY OF Irish linen is intimately connected with the story of Irish emigration. About 10 million emigrants, over the preceding four centuries, left Ireland to make new homes throughout the world, especially in the United States and Canada, Britain, South Africa, Australia, and New Zealand. Within the context of this vast scattering, the worldwide spread of Irish linen took place. Today about 70 million people outside Ireland claim a connection, as emigrants or descendants of emigrants, with the island and its 5.5 million people. It should go without saying that this huge global grouping includes those who are Australian, Canadian, British, or American in terms of loyalty to a state and Catholic, Presbyterian, Anglican, Methodist, Baptist, agnostic, or other in terms of religious identity. What connects them is a sense of being—even in a secondary way—*of Ireland.*[1] Together they form, like linen, the ocean-spanning fabric of the Irish diaspora. The making of the modern Irish diaspora can be traced over the past four hundred years, century by century, through the number of emigrants from Ireland, bearing in mind that in most cases the figures offered can only be rough estimates because of the fragmentary nature of the surviving historical evidence.[2]

Facing page: Old Bleach Co. sales and promotion booklet, c. 1921. *Private collection of the author.*

1600–1700

During the seventeenth century, there was immigration to Ireland of about 260,000 settlers from the island of Britain and emigration of about 130,000. These numbers may seem relatively small, the total of emigration

for the whole century being less than that of single years of the Great Famine (1845–51). However, given that the population of Ireland in the seventeenth century was about 2 million (as compared with over 8 million at the time of the famine), the emigration of 130,000 represented about 6 percent of the population. Most of these Irish emigrants (about 90,000) moved to continental Europe. Mostly they were military migrants, leaving in particularly large numbers after the military reverses of 1601, the early 1650s, and 1691. In the second half of the century, the British Caribbean became a significant destination for about 30,000 emigrants. Over the whole century, about 10,000 people (some of them returning settlers) continued the long-established tradition of movement from Ireland to Britain.

1700–1800

In the eighteenth century, there was much less immigration and much more emigration. The island's population had grown slowly to about 2.4 million by 1750, but there was emigration of about 265,000, so the emigration rate had increased to about 11 percent. North America had become the main emigration destination; about 110,000 emigrants crossed the Atlantic from Ireland in the decades before the American Revolution (1775–81), with a further 40,000 crossing between 1782 and 1800, making a total of about 150,000 emigrants for the whole century. About 60 percent of these emigrants were from the northern province of Ulster, and at least two-thirds of these were Presbyterians with Scottish ancestors (who had been part of the immigrant stream to Ireland in the previous century). Migration to Europe remained strong, particularly in the first half of the century and particularly by Irish Catholics from the southeastern counties. About 60,000 in total left for the continental mainland, attracted by opportunities for military service, education, and trade. About 50,000 moved to Britain. And with the start of convict transportation in the 1790s, about 5,000 Irish people were moved to Australia.

1800–1900

The nineteenth century saw the greatest numbers by far of people emigrating from Ireland. Over the whole century, the total number of emigrants was almost 7 million. Given the midcentury population of 8,175,124, the emigration rate was about 85 percent (compared with about 6 percent and 11 percent in the seventeenth and eighteenth centuries). North America remained the dominant destination with a staggering 5 million emigrants crossing the Atlantic between 1800 and 1900. The great majority settled in the United States. In the first half of the century, about 400,000 of these settled in British North America (which later became Canada). The second most important destination was Britain, which probably received about 1.5 million emigrants. As continental Europe declined as a destination for emigrants from Ireland, Britain's colonies

became increasingly important. During the century, about 350,000 moved to Australia, about 80,000 moved to New Zealand, and about 15,000 moved to South Africa. The only non-English-speaking country to receive large numbers of emigrants from Ireland was Argentina, which had close trading links with Britain; about 30,000 moved there.

Over the whole century, the total number of people emigrating from the island of Ireland, north and south, was about 2.5 million. Given the much smaller total population in 1951 of 4,331,514, the emigration rate was about 56 percent (compared with 6 percent, 11 percent, and 85 percent in the preceding three centuries). Britain replaced North America as the dominant destination in the late 1920s; about 1.2 million immigrated to Britain. About 1.1 million immigrated to North America, with more than two-thirds of these departing before 1930. About 150,000 went to other overseas destinations. Following the accession of the Republic of Ireland to the European Economic Community in 1973, there has been a reemergence of emigration to continental Europe. By the end of the twentieth century, Ireland had become again, for the first time since the seventeenth century, a country of net immigration.

The Spread of Irish Linen with Emigration

Thus we arrive at a total figure of about 10 million emigrating from Ireland over four centuries. This was extremely significant in the broader European context: between 1821 and 1914, about 44 million people emigrated from Europe worldwide, of whom about 6 million were emigrants from Ireland.[3] No other European country has been so profoundly affected by emigration, and two features of Irish emigration tend to set it apart. In the emigrant stream from most European countries, there were more males than females, and about 3 in 10 eventually returned; in the emigrant stream from Ireland, by contrast, the numbers of males and females were more or less evenly balanced, and only about 1 in 10 ever returned. That so few returned and so many married within their ethnic group largely accounts for the 70 million people scattered around the world today who claim a connection with Ireland.

In writing about the "exodus" to North America, Kerby Miller has pointed to the importance of distinguishing between "emigrants and exiles"—between those who left to take advantage of new opportunities and those who left because they had no choice but to leave.[4] As linen was moved around the world by the linen trade, so too were people (and exiles) moved by the emigrant trade.[5] Various other writers have suggested that it may be helpful to think metaphorically about the Irish worldwide as a scattering, an empire, or a jewel. The image of Irish emigrants as a *scattering*, which is taken from the root meaning of the

ancient Greek word *diaspora* (scattering or dispersal of seeds or spores), is discussed by Piaras Mac Éinrí in the published proceedings of the groundbreaking international conference hosted by the Irish Centre for Migration Studies at University College Cork in 1997.[6] *The Irish Empire*, a large-scale television series commissioned by BBC Northern Ireland, RTÉ, and SBS Independent Television in Australia, with an accompanying book, has promoted the idea that emigrants from Ireland succeeded effectively in establishing an empire: "This is the story of one of the greatest triumphs of the human spirit. It tells the tale of how the people of a small, poor nation, moored at the edge of Europe, spread themselves throughout the world winning power, wealth and fame. Over centuries, emigrants fleeing political and religious oppression, poverty and lack of opportunity turned the experience of exile into some sort of victory. Fate had prevented them from fulfilling their destiny at home. So they took their dreams and their identity elsewhere and built an *empire* overseas."[7]

Most colorfully of all, perhaps, Donald Akenson has suggested that we should think of the multigenerational phenomenon of the Irish worldwide in terms of a precious, intricate jewel such as a Fabergé egg. He argues that "one cannot understand very much about the Irish in the United States [for example] if one knows only the Irish who migrated to the States. The migrants to America (both historically and in the present day) are part of a larger pattern. Like *constellations of enamelled pearls on a gilded egg*, they cannot be interpreted on their own. The story of the Irish in America makes sense only within the context of a world-encircling history."[8]

Another powerful way of thinking metaphorically about the Irish diaspora is as a fabric. In the nineteenth century, entities as disparate as a steamship, the British Empire, and the Fenians[9] were thought of in terms of fabric. For example, a member of Parliament expressed concern for "the consolidation of the *fabric* of the Empire" in a debate on emigration in the British House of Commons.[10] A newspaper report on the return of the SS *Great Britain* to Liverpool after sea-trials referred to "the wonderful facility with which the immense *fabric* yields to the direction of the helm."[11] Another newspaper writer clearly had fabric in the sense of textile in mind when, in an article titled "The Fenian Brotherhood," he attributed to the Fenians "the many thousand *cords* which are gradually being *woven* around that now corpulent and fast-failing monster, the British lion in Ireland."[12]

The idea of the *fabric of society* is a familiar one. One leading historian of Irish emigration uses it to help explain how the preconditions for mass emigration were established in the period 1750–1844: "The commercialization of Ireland's rural economy and the Anglicization of much of Catholic culture *rewove the fabric of Irish society*."[13] Another has applied it in this way to thinking about emigration: "So deeply had the possibility of migrating been *woven* into the *fabric* of Irish social life that for most young people staying in Ireland has been just as much a matter of conscious choice as, for others, has been the decision to leave."[14] The point is that not only did people on the island of Ireland constitute the *fabric* of Irish society, so too did Ireland's emigrants constitute a worldwide extension of that fabric—the Irish diaspora.

As well as being thought of as a scattering of seed, the physical movement of emigrants overseas is also thought of, appropriately enough, in terms of water. It is a "vast flow" out of the "fountain" that is

Ireland.[15] The flow is also thought of in terms of blood, as a hemorrhage.[16] However, once the emigrants have stopped flowing and have new homes established in the New World, it feels more appropriate to describe their relationship (and that of their descendants) with the old home in the Old World in terms of something more pliable, like a textile. While linen is ultimately about turning flaxseed into fabric,[17] diaspora is metaphorically about making the scattering of seeds into a fabric.

Thinking about the Irish diaspora as a world-encircling fabric is well suggested by the following extract from a newspaper article titled "The Great West's Debt to the Irish": "For more than two hundred years the sons of Ireland have been among the pathfinders who prepared the way for the American nation in its mighty sweep from the Atlantic to the Pacific. No region has ever been too remote or perilous to daunt the Irish pioneer. Whoever discovers the North Pole will no doubt find a Kelly or an O'Brien already on the spot. . . . The plain, straight truth about the Western Irish is more wonderful than any fanciful tale *woven* in the *loom* of the Arabian imagination."[18] The implication is that an actual fabric had been woven on the loom of the Irish experience and that its threads connect the emigrants (the daughters as well as the sons of Ireland) to each other and to the homeland. By the late nineteenth century, the idea was widespread that wherever one might go on earth, there would be found someone from Ireland. It was expressed, for example, in "The Kellys," a song that was a great favorite on the New York vaudeville stage:

> And there's Kelly from Dublin, Kelly from Sligo
> Little Mickey Kelly who came from the County Clare,
> Sure Kelly built the Pyramids with good old Galway granite
> And when Kelly discovered the North Pole sure he found Pat Kelly there.[19]

We can see now the whole story of Irish emigration and the development of the Irish diaspora as an aggregation of the myriad individual stories of emigrants and their descendants. Increasingly, as a result of the explosion of interest in family history in recent years, these individual stories are being reconstructed from the surviving evidence, including passenger lists and emigrant letters. We see the global Irish diaspora as being made up of connected networks of relationships operating at different scales. At the largest scale, there is the network of emigrant relationships centered on the homeland—the island of Ireland. In descending order, there are networks centered on particular provinces, counties, towns, parishes, townlands, and families. Local history and family history are increasingly taking into consideration the concepts of the townland diaspora and the family diaspora.[20]

Just as the Irish diaspora has been described metaphorically as a fabric, such as linen, so too has linen been described metaphorically as a person. It is "the best and the most elegant and most beautiful fabric,"[21] "the aristocrat of fabrics," and the "queen of fabrics."[22] It has also been described as an "environment," having "an appearance as varied and attractive as an Irish landscape."[23] Intriguingly, the metaphoric expressions of diaspora and linen intersect in the title of Heather Thompson's *Weaving Webs of Wealth*.[24] In the same way that we can think about the Irish diaspora as being made up of networks or *webs* of relationships

centered on the homeland, so too can we think about the physical webs of linen being made within lucrative webs of commercial relationships, centered on the place of manufacture.

One individual story that illustrates the family diaspora in operation, and in connection with linen, is that of Alex T. Stewart, the son of a farmer from Ballygawley, county Tyrone, who immigrated to New York as a sixteen-year-old in 1818. Having been left an inheritance by his grandfather, he returned to Ireland in 1821 to collect his legacy:

> He was advised not to come back with his money in his pocket but to buy *Irish linen & laces* in which he would double his money. He invested his legacy of £600 in *Linen & laces.* There were only two houses in New York city at that time [that] dealt in that class of goods and they both offered him exactly the same price for his stock which was just a little more than he paid in Belfast. He rented a small store in Broadway 8 × 18 feet to retail his stock. . . . Mr Stewart died April 10th 1876 worth about $100,000,000.[25]

Through the study of surviving emigrant letters, Kerby Miller, David Fitzpatrick, and others have studied in fascinating detail the ongoing relationship between Ireland and its diaspora across the generations.[26]

Again, it is appropriate that in explaining the importance of reconstructing individual emigrant stories, Fitzpatrick makes use of the fabric metaphor:

> Illustrations showing personal trajectories of migration may enrich a *threadbare* model, yet the typicality of those trajectories cannot be assessed. A model based on aggregate statistics may be used to illuminate individual motivation, yet its applicability to a particular migrant remains conjectural. However skillfully the historian may *weave* general and particular into a *seamless* narrative, the underlying tension between these disparate forms of representation will endure.[27]

As in the case of Alex T. Stewart, some emigrant letters shed particular light on the significance of linen in the emigration story. One correspondent closed his letter with the following words: "I write this *sitting on my Loom* in a Shop where there are 10 in real Good health & Spirits, and with my Prayors to God for your Welfare & Happiness, I am Dr Brother yours affectionately, John McBride."[28]

Another opened her letter in this way:

> My Dear Sister
>
> I Send you These Lines In Answer To yours. I am Glad To Hear From you to Know That you are yet Alive. . . . As for my Husband and Myself our Health is Much Worse than it used to be. But thanks to God for all his Mercies to us our Children are all well and able to work and Hard it is *to make a living by weaving for the webs is so long* and wages little though wages is a little better these last few Months than they have been for some years. . . . *the Children still wave [weave]* for Mr Henning of Waringstown since Before you Left Home. *Some of them weaves orangs[?] work 17100 60 yards long and 30 inches wide 59 Hanks wft [weft] wages 12s and Bordered weebs [webs] 7 dozen Long 28 inchs Broad 16100 wages 9s.* Now Dear Sister you can see from this how we are Doing.[29]

In these letters, we see evidence of the effort to maintain contact that marks the relationship between a diaspora and its homeland. An intriguing question is the extent to which Irish linen played a part in helping emigrants and their descendants to sustain a positive sense of their Irish identity abroad. How many Irish emigrants who became servants in the houses of the wealthy in London, New York, or Sydney must have taken some satisfaction from the knowledge that the linen they were washing or ironing or spreading on the dinner table had been made in Ireland and that its name was famed throughout the world?[30]

Although Irish linen became a truly global product and sold well beyond the Irish who lived abroad, they had been instrumental in its worldwide spread. The ports of Ireland, especially those of Ulster, were where the networks of the emigrant trade and the linen trade were most clearly connected.[31] Ships taking flaxseed to Europe from North America returned with emigrants.[32] The intimacy of this shipboard connection between linen and emigration is vividly illustrated in a letter of 1795 in which Silas Weir in Philadelphia tells James Robinson in Stewartstown, county Tyrone, "I could not buy Flaxseed or any other article here this season with the smallest hope of getting a profit" and he recommends that "you cant lose any thing by bringing over Indent[ur]ed Servants, Linins, or Irish flannels, and these are the only articles I would recommend."[33] Flaxseed was coming into Ireland from North America and then returning as linen fabric with emigrants who were the seeds for the making of that other fabric—the Irish diaspora. Just as the story of the Irish in America makes sense only within the context of its world-encircling history, so too does the story of Irish linen.

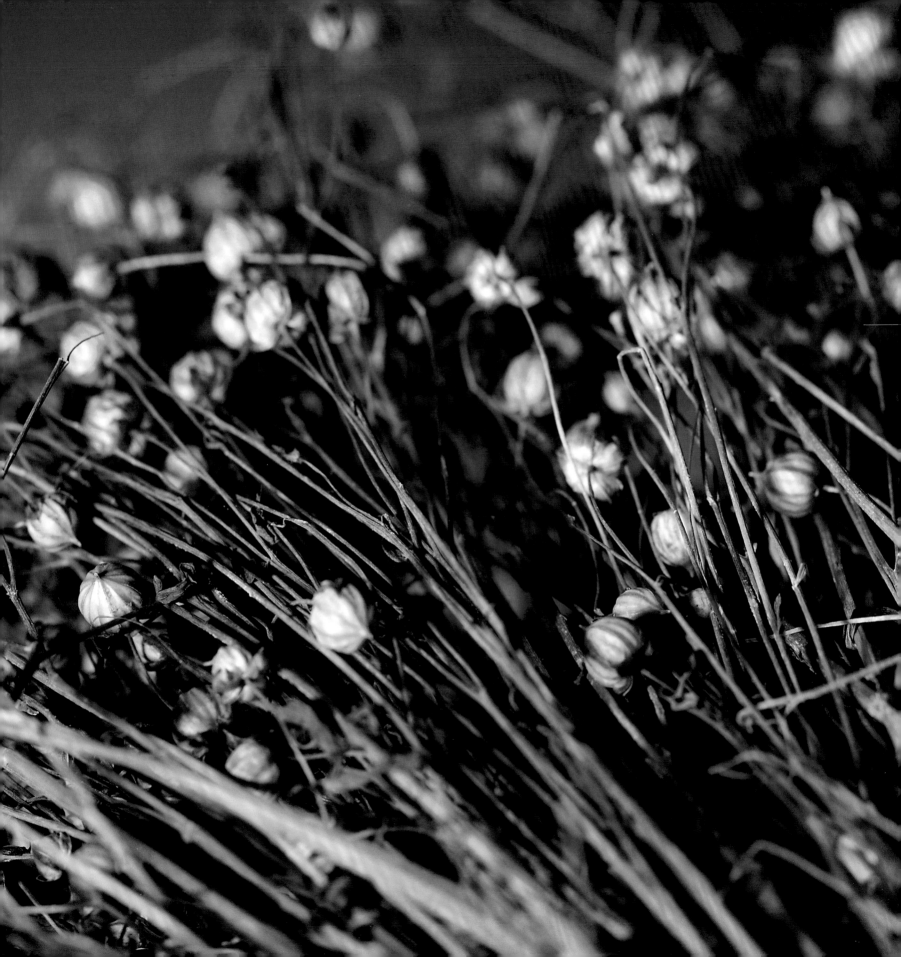

Chapter 1

The People and the Place

> I confess myself to be a great admirer of tradition. The longer you can look back, the farther you can look forward. . . . The wider the span, the longer the continuity, the greater is the sense of duty in individual men and women, each contributing their brief life's work to the preservation and progress of the land in which they live, the society of which they are members, and the world of which they are the servants.
>
> Winston S. Churchill[1]

FOOD, SHELTER, and clothing are indispensable to life itself. Humans have struggled throughout history to provide their families with enough food to prolong life and find refuge to protect them from the elements. Clothing the body is particularly important in colder climates, and cloth, like food and shelter, can also be a commodity used to obtain other necessities.

In the twenty-first century, we tend to consider textiles innately feminine and their history and beauty a subject more interesting to women than to men. Regardless of our level of sophistication or economic status, the making and wearing of cloth is taken for granted. We need it, we want it, and we buy it. Throughout history, processing fiber into cloth is a story of people using fabric as an essential of life, to clothe themselves, an article of trade to improve their lives, and a commodity to provide more food for their families and better shelter to surround them.

For beauty and desirability, the finest Irish linen once had little competition, but even coarser linen also had many utilitarian uses long forgotten in today's world of plastic and synthetics. Linen's distinction as an important fabric emerged from the efforts of a vast number of Irish people who grew the plant, harvested the fiber, spun the yarn, wove the cloth, and found buyers willing to purchase the final product. At

Facing page: Flax stalks with seed heads. *Courtesy of Irish Linen Centre and Lisburn Museum. Photography by David Pauley, Belfast.*

every opportunity, they improved quality with skill and technology until the phrase *Irish linen* resonated throughout the world as a product of quality and distinction. This is their story, the story of the people of Ireland—not a history of fashion through the ages, but a story of innovation and opportunity, migration and cultural identity that traveled around the world along strands of finely spun linen thread.

For more than a hundred years, a worldwide audience has associated the phrase *Irish linen* with the island of Ireland as closely as it has the Great Famine, leprechauns, Irish whiskey, limericks, green hills, and stone walls. How and why the small island of Ireland became so identified with this plain white cloth, criticized for its wrinkles and revered for its durability, is a story of emigration, politics, industry, and marketing initiatives. Ireland's first wave of migration to the American colonies and Ireland's prominence as a center for shipbuilding and machine production can be traced directly to the demands of the linen industry.

Linen is one of the oldest textiles in the world. Fine linen cloth has been associated with cleanliness, purity, and high social status since the days of the pharaohs. Greeks and Romans manufactured sails and ropes out of coarse linen fiber and traded sheer linen cloth for ivory, beeswax, resins, and vegetable oils.[2] Ceremonial use of linen expanded with Christianity when the liturgy specified the use of pure linen for altar cloths because of its elegant sparkling sheen that increased with repeated washings. Abbeys frequently took raw flax or linen cloth in trade from tenants for rent payment.

The first recorded use of linen cloth in Ireland occurred in eighth- and ninth-century legends referring to warriors and men of noble rank wearing linen tunics. By the eleventh century, flax was being cultivated in Ireland for home use, and in the following century, ecclesiastical linen made from Irish yarn was used in Winchester Cathedral in England. By the second half of the seventeenth century, Ireland had realized the potential market for linen cloth, and Ireland's greatest industry—the linen industry—was born.[3]

Historically, the island of Ireland was divided into four provinces: Ulster, Leinster, Munster, and Connaught. Each province was in turn divided into counties. Ulster is located in the northern portion of the island; the soil and climate were particularly well suited to growing flax, and its deep ports ideal for exporting and importing goods. The nine counties that make up Ulster province are now part of two separate countries.[4] The three counties in the Republic of Ireland are Cavan, Donegal, and Monaghan; the six remaining counties of Antrim, Armagh, Down, Fermanagh, Londonderry, and Tyrone are part of the United Kingdom. Flax growing and linen production were always more prevalent in certain counties on both sides of the border, depending on geography and water sources. County Fermanagh was too wet and off the beaten path to contribute significantly to the linen industry, but county Donegal was full of scutching mills,[5] which are essential to the quality of linen thread. Londonderry (Derry), the westernmost port in the United Kingdom, which is situated at the mouth of the River Foyle (county Londonderry), and the port of Belfast (county Antrim) at the mouth of the Lagan River, where it flows into the Irish Sea, enabled Ulster merchants to ship goods west across the Atlantic and east to Great Britain.[6]

In 1603, King James VI of Scotland inherited the English and Irish thrones, uniting the crowns and making him King James I of England, Scotland, and Ireland. King James, an ardent Protestant, was thereby in the position of ruling a very Catholic, Gaelic-speaking Ireland. James had the title but no real power in Ireland, and he intended to change the power structure of his newly acquired island by establishing an ag-

ricultural estate. He would establish a plantation on 3.8 million acres of land seized from two Ulster chieftains, the earls of Tyrone and Tyrconnell, who fled to France rather than live under English rule. King James populated the plantation in Ulster province with English-speaking Protestant families loyal to the Crown and made it compulsory for many Presbyterian Scots to move onto the Ulster Plantation as tenant farmers, not landowners. Other plantation efforts were attempted in Ireland, but Ulster Plantation was the largest and most effective.[7]

At the end of the sixteenth century, lowland Scotland was overpopulated, and inadequate housing caused rents to increase significantly. An elite few actually owned land, but they were often absentee landlords. Tenant farmers worked for the lord (or laird) and paid yearly tithes for the privilege.[8] A tenant farmer owned virtually nothing that could improve his lot—not the roof over his head, not the sticks or rocks on the ground, not the sheep's wool that caught on the hedgerows or kelp in the sea—and he subsisted only if he could grow enough food to feed his family and pay the laird his due. The newly formed Ulster Plantation in Ireland provided an opportunity for a better life that was appealing for many destitute farmers in Scotland, although they still did not own the land. Ireland was nearby geographically, and the land was suitable for small crops like potatoes (as opposed to mass acreage for wheat cultivation) and grazing large herds of sheep or cattle. Spinning wool and flax into yarn to weave into cloth was a common home industry in Scotland, and immigrants continued to use these skills in their new homes in Ireland.

People have always moved back and forth across the Irish Sea separating Ireland and Scotland. During the Middle Ages, mercenary soldiers from both sides crossed the sea to fight in each other's armies. In the eighteenth century, smuggling was prevalent between the north coast of Ireland and the southwest of Scotland. In the eighteenth century, a local poet penned the following:

> The pretty traders with their bags of meal,
> Their fruit, and flax and whisky too for sale
> Their flour, potatoes and their fine bohea
> Pass o'er in boats along the watery way.[9]

Until the late 1800s, some hardy Presbyterians living near the coast in Ulster rowed back and forth across the narrowest part of the Irish Sea to attend regular church services in Scotland. That so many Scots viewed economic opportunity and religious freedom as sufficient incentives to build a new life in Ireland is not surprising. Some historians refer to this forced resettlement as an ethnic cleansing (a term commonly used in the twenty-first century to describe a vast purging of one religious or ethnic group by a ruling party). King James wanted to change the fabric of Irish society, governed by Catholicism and local chieftains, and he had the power to move a large number of Scots to serve as his instrument of change. An enticement for Scots to settle in Ulster was the opportunity to rent the land for twenty-one to thirty-one years, a time period known as three lifetimes because those years would roughly constitute three generations. High-ranking Englishmen undertook to hold Crown lands in parcels of one thousand to two thousand acres with the proviso that the land be rented to Scottish or English tenants only, whereas military men and government administrators who received land grants could rent to Scottish, English, and Irish tenants. Small

grants of up to two hundred acres were allocated to native Irish, and they could lease to any group willing to work the land and pay the rent.

The move from lowland Scotland to the Ulster Plantation in Ireland in the seventeenth century did accrue benefits to the settlers. There was opportunity for economic improvement on land that was similar to that of their native Scotland. Sheep and cattle grazed on like terrain, and small farms planted in crops provided food for home use and a possible cash income. Whether Scots moved off the land by force or by choice, by 1619 over eight thousand families had relocated from lowland Scotland to Ireland's Ulster province, and within another hundred years over one-third of Ulster's six hundred thousand inhabitants were of Scottish descent.

Additional plantation settlements in Ireland were established under Oliver Cromwell during the 1650s, and migration to Ireland from Britain and Europe continued well into the eighteenth century. Plantation settlements created a British Protestant ruling class, which strengthened Parliament's control over Ireland, at the same time marginalizing the native Roman Catholic population. Plantations also substantially altered the physical and economic nature of Irish culture—changing the subsistence economy to one of intensive commercial agriculture and trade, which ultimately led to deforestation of the entire island.[10]

After a few years, many of the original landlords returned to England, leaving Scottish immigrants to maintain plantation life. Over the next hundred years, some plantation Scots married Protestants within the local population and established businesses and a social culture quite apart from the Catholic population. Historians have named this group of immigrants Ulster-Scots, Scotch-Irish, or Scots Irish, but there is little evidence that these labels were commonplace during the seventeenth or eighteenth centuries. The native Irish Catholic population and peoples with Presbyterian Scottish heritage maintained a degree of separateness from each other even though some Scots intermarried with native Irish and lived in Ireland for many generations.

Two English noblemen, the Earl of Strafford (1593–1641) and Duke of Ormonde (1610–1688), took a personal interest in expanding the local textile industry. In their time, flax grown in Ireland was of poor quality, but these two men had the vision to foresee production of a better grade of linen cloth through the use of improved seed stock, new styles of spinning wheels, and looms imported from Holland. They also encouraged French Protestant Huguenot immigrants who were skilled in the linen trade to settle in the province. By the second half of the seventeenth century, landlords in Ulster province were offering long leases and low rents to tenants who took up linen manufacturing as a trade. Market towns such as Lisburn and Lurgan were established to provide places for selling the cloth, and at the end of the century, at least five hundred handlooms in Ireland were manufacturing cloth fine enough to compete with high-quality French linen.

The thickness of spun yarn determines the coarseness or fineness of the finished woven cloth. For warmth or utilitarian purposes, thicker yarn is adequate, but for the finest quality of sheer linen cloth, the spinner must have the skill to spin a single strand of evenly twisted yarn strong enough to weave cloth of gossamer-like delicacy. The spinner's skill is based on a careful balance of tension and twist, the quality of the fibers used, and a great deal of practice. Only yarn spun expertly and evenly was used to weave the very

finest linen cloth. A woman in Aghagallon (county Antrim) spun yarn so fine that three skeins of it could pass through a wedding ring. Three skeins of fine linen yarn could be approximately one thousand yards wound into a loose knot. Her yarn was woven into a piece of fine linen cambric and presented to Queen Charlotte (1744–1818), wife of King George III.[11] This story may be more folklore than fact, but it accurately describes the expert skill of some spinners.

Ulster Plantation comprised three ethnically and religiously adversarial groups: the English, who worshipped at the Anglican Church; the Scots, who attended the Presbyterian Church; and the Irish, who followed the teachings of the Catholic Church. With England being the ruling power, the Anglican Church was the official Church of Ireland, and Parliament established penal laws to impose harsh civil and legal restrictions on members of the Roman Catholic and Nonconformist (that is, Scottish) churches. Native Irish became more devoutly Catholic in reaction to an increasing resentment of the unwanted English, whom they considered an occupying force. The Presbyterian Scots were also controlled by penal laws and closed ranks, becoming an isolated community of Calvinists, more radical and unyielding than their counterparts in Scotland.

English landlords sent by King James to establish the Ulster Plantation controlled the land for the Crown, but the cold, wet climate and a society they considered uncivilized did not appeal to lords and ladies, who preferred to associate with rich, powerful, and well-connected politicians and titled gentry in England. The Scots came to Ireland for a better life, but the structure of Ulster Plantation society, the presence of diverse and uncompromising religious factions, and English penal laws made lasting assimilation into Irish culture unworkable. As tenant farmers but not landowners, Presbyterian Ulster Scots were never economically or socially rooted permanently enough in Ireland to overcome the financial hardships they still faced a hundred years after leaving Scotland. Ireland turned out to be only the first port of call on a migration exodus that ebbed and flowed for hundreds of years.

The first wave of migration to the American colonies began in the 1680s and dramatically escalated in the period following 1717, when crop failures, religious tension, and a declining linen trade caused economic hardship across Ireland, particularly in the northern provinces. Leases that constituted three lifetimes ended, and landlords drastically increased rent payments for new leases. With each consecutive generation of tenant farmers, the number of mouths to feed grew, and the size of the land decreased as plots were continually divided to support additional families. Potatoes were the staple food source for all lower classes and provided nourishment to vast numbers of people relative to the amount of land needed to grow and harvest the crop; unlike grain crops, the potato took only a small amount of labor to produce a large yield.

It was a vicious cycle for farmers. Without sufficient land, the tenant farmer had no way to make a living, and if his crops failed because of bad weather, he could not pay the rent and lost his leased land. When property rents were dramatically raised, the farmer's livelihood was more precarious than usual, and many farmers were unable to pay the increased amounts that were demanded by landlords or leaseholders. The small amount of money that women made from spinning disappeared when six successive years of drought from 1714 through 1719 severely depressed the linen industry. The landless laborer relied on equally

poor tenant farmers for his daily survival. During hard times, he and his family were immediately on the brink of starvation. Ulster Scots felt they had no choice but to make another major move, and the American colonies, with no emigration restrictions, penal laws, or language barriers, seemed an obvious choice.

America had an abundance of land for the taking, rich natural resources, and an extreme shortage of labor. Compared to the economic conditions that were prevalent in the northern counties of Ireland, America offered economic opportunity and religious freedom. Between 1717 and 1800, the first wave of approximately a quarter million people left Ulster province for America. Some Catholics and Anglicans emigrated, but the vast majority of people leaving Ulster identified themselves as Presbyterian Scots when they registered on the tax rolls in North America. With skills for growing and processing flax into linen cloth, some immigrants stayed in the northeastern colonies to establish a new textile industry in America, while others moved into the middle colonies or down the Shenandoah Valley of Virginia to the Carolinas, where the vast territories of the Appalachian Mountains beckoned to more than a few of the hardy immigrants.

The importance of flaxseed cargos in this emigration process and for North Atlantic trade in the mid-eighteenth century cannot be underestimated. Colonies from Virginia northward counted heavily on the Irish market for trade, and flaxseed represented about half the value of their exports to Ireland. Between 1750 and 1775, approximately 80 percent of Ireland's imported flaxseed came from the American colonies. Farmers in Ireland harvested their flax while the seeds were green to produce a softer, finer fiber for spinning into yarn, but harvesting before the plant fully ripens prevents seeds from being mature enough to plant for next year's crop. A large quantity of flaxseed was vital to the increasing Irish linen trade, and manufacturers looked to Connecticut, New York, Delaware, and Pennsylvania to provide the seed stock necessary for sowing the annual crop in Ireland.[12] Colonies such as Rhode Island produced and exported flaxseed to the middle colonies, contributing to and supporting flaxseed exportation to Ireland.[13]

Ships carrying flaxseed from the American colonies to Irish ports traveled both east and west across the Atlantic. No ship's captain could afford to cross the water in either direction without a paying cargo. With an increasing demand for labor in the colonies, shipping companies realized that passengers were the return cargo they needed to be cost-effective. Fortunes could be made by finding enough emigrants to fill ships, and ships were anchored in Irish harbors for weeks to acquire a sufficient cargo of men, women, and children seeking a better life. The constant movement of ships across the Atlantic transporting cargos of migrants westward and flaxseed eastward became highly profitable to merchant houses and ship owners alike.

The Irish cloth imported to the American colonies consisted of low-cost, coarse linen yard goods. The same material was imported to the English Caribbean to clothe the black slave population.[14] Irish foreign trade flourished as linen manufacturers improved quality and production of linen and increased their exportation of provisioning goods, such as salted beef, pork, and herring, as well as butter and beer; shipping became a prosperous industry in county Cork, with its deep-water port in Queenstown (renamed Cobh). This intercolonial trade within the British Empire and its participating industries in Ireland and North America was a highly organized and sophisticated business. By the mid-eighteenth century, Ireland's domestic economic well-being had become inextricably linked to foreign trade. It made practical sense for American colonies to import yarn and cloth (which were labor-intensive industries) and concentrate colonial resources

on agriculture in a region of plentiful, fertile land. Ireland's ability to provide provisioning supplies for export created the impetus to develop and expand the island's principal seaports, market towns, and cities. Ireland was thus positioned to compete effectively in a global textile marketplace in the nineteenth century.[15]

North American flaxseed was almost exclusively traded to Ireland by a vast fleet of ships known as flaxseed vessels; as many as one hundred of these ships were on the Atlantic in 1767. Eastbound ships carried barrel staves, lumber, and iron as well as flaxseed. Wheat and flour were also imported into Ireland, especially during harvest failures, such as the pre-famine years of 1739–41. Voyages formed a triangle pattern linking ports in North America, the West Indies, Ireland, and Great Britain, but there was little connection to the classic slave-trade triangle of ships sailing from London, Bristol, and Liverpool for West Africa. Slave ships carried cargos of guns, gunpowder, iron bars, alcohol, and cotton fabric produced in English mills or bought from Britain's East India Company to serve as trade for human cargo. Mercantile regulations for the British Empire were made by Parliament in London, and until 1780, Ireland was forbidden to send ships to West Africa. Ireland did not possess a slave-trading port but did benefit economically from the vast numbers of slaves on plantations in the Caribbean who needed to be fed. The role of Ireland in the slave trade was to send provisions such as heavily salted beef, butter, pork, and fish directly across the Atlantic to the sugar islands under French and British rule. Ireland's primary function in the West Indies thus was to feed the white and black population, with only a minor role in clothing them in linen.[16]

Without the banking technology that was two hundred years into the future, merchants and ship owners had to rely on a well-structured system of credit for transatlantic business; consequently, capital could be tied up for months while ships were on the high seas. Acheson Thompson, a New York agent for Ulster linen that was woven and shipped out of the port town of Newry (county Down), extended buyers a six-month credit for half the amount, with the balance payable in twelve months. This practice caused Irish shippers to be without capital for at least a year or more, but the extended credit reduced the cost of flaxseed. Irish linen merchants continued to look for ways to lower costs and increase profits while staying competitive with textile manufacturers in London, where a more sophisticated and readily accessed system for long-term credit was already in place.[17] Ireland's linen industry was improving its product and business acumen as it sought new markets and uses for the product.

Flaxseed was transported in large wooden casks called hogsheads, each containing approximately seven bushels of seed, with an average shipment of four

Winnowing is the process of separating chaff from grain by letting the wind blow lighter outer coverings away while the more valuable seeds remain in the container. When flax ripened and the dried seeds were separated from the flower head, it was winnowed. This is a slow, imperfect process and used by relatively few flax growers; a *rippling comb* was the preferred choice for most farmers. Although the verb *winnow* is not common in twenty-first-century conversation, it was used by former U.S. president William Clinton in a televised interview (on *Larry King Live,* March 3, 2009) to describe the process of narrowing down the Democratic candidates in the 2008 presidential campaign to the two most promising ones: his wife, Hillary, and Barack Obama, "By the time the primary was winnowed down to 2 candidates. . . ."

As far back in history as 1440, *rippling* was the word used to describe removing seeds from the flax plant, and references to a ripple as a toothed comb-like tool used for the same purpose are recorded in 1660. Rippling the seeds from the stalk is emblematic of Irish emigration and its connection with linen during the past four centuries. Today, *ripple* has a very different connotation, referring to a shape made up of repeated arcs, such as on the rubber soles of shoes, or as a verb describing the surface of the water when a stone is tossed into a lake.

In the twenty-first century, we say *table linens* and *household linens* or just *linens*—not limiting the phrases to describing an article of linen cloth made from the flax plant, for *linens* has become a generic word that defines any articles of cloth, whether made from sheep's wool, cotton fibers, or synthetic blends.

hundred hogsheads per vessel. After 1733, London agreed to a bounty of five shillings per hogshead of flaxseed to guarantee the cost of freight. Ships transporting Irish flaxseed moved through English ports to collect the legislated bounty before reexportation to the Caribbean with cargos of provisional goods to trade for sugar and tobacco to sell in the North American colonies.

Some Irish linen merchants sought to manage their supply cost by purchasing flaxseed directly from farmers in the American colonies, establishing warehouses in port cities, and investing in shipping companies that owned flaxseed vessels. The Society of Friends (Quakers) was a well-established community in Pennsylvania in the early eighteenth century, and its members were connected by business interests, kinship, and faith to Quaker communities in Dublin and London. As a group, the Quakers had good credit, and even before 1731, Dublin Quakers maintained inventories of Irish linen in Philadelphia warehouses to sell in exchange for flaxseed. Before the American Revolution, Dublin linen merchant James Leckey and Company, a Quaker-owned firm, had at least three flaxseed vessels.[18]

In 1756, Thomas Greg (a provision merchant in Belfast) and Waddell Cunningham (a county Antrim man trading in New York) entered into a partnership to send Irish ships filled with emigrants directly to America to purchase flaxseed, a commodity that was sent back to Ireland without landing in England for customs.[19] In the mid-eighteenth century, the city of Derry alone imported between six thousand and eight thousand hogsheads to provide farmers with enough seed stock to support the local flax-spinning industry.[20]

By establishing more authority over their purveyors at either end of the supply line, linen merchants were able to negotiate favorable contracts to reduce expenses and increase profits, especially in the emigrant trade. In the twentieth century, business schools would teach the strategies and benefits of the concept known as vertical integration, but a strategy for controlling the cost of goods all along a product supply line and ideas for global marketing were already developing in the sixteenth- and seventeenth-century linen industry. From the early 1730s until the outbreak of the American Revolution, the Irish-American trade of linen for flaxseed remained stable and lucrative.

The flaxseed fleet traveling west transported large numbers of passengers, convicts, and indentured servants to ports in the middle colonies of New York, Pennsylvania, and Delaware in one of history's greatest migrations. Ships loaded with flaxseed left North America at the beginning of the year to arrive in Ireland in March—flax planting season. The cost to prepare, outfit, and man flaxseed ships was higher than for other ships because of the increased risks of crossing the Atlantic in the winter months. The return voyage of emigrants usually departed Ireland in midsummer, arriving in New York or at the Delaware River in autumn. The number of passengers onboard was determined by the size of a ship and corresponded to Ireland's demand for flaxseed. A ship could accommodate an average of one person per ton of ship's weight, so a 250-ton ship could transport about 250 emigrants. In 1718, 120 Scots-Irish families sailed for Boston. Sixteen of the families founded the town of Nutfield, New Hampshire (which they renamed Londonderry), and by 1719, the community had become the largest Scots-Irish settlement in New England and was developing its own linen industry.[21]

Derry (county Londonderry) is a port city located on the northwest coast of Ireland. Derry merchants aggressively engaged in Atlantic trade and served as a point of departure for emigrants during the

second and third decades of the eighteenth century. By 1750, Derry had surpassed Belfast as an emigrant port. Derry merchants owned shares in Philadelphia ships, and shipping companies had agents and family members working in Philadelphia and New York to purchase flaxseed for export to Ireland. Meanwhile, independent agents sought out people in the more remote counties of Donegal, Fermanagh, and Tyrone to fill ships to capacity on the return voyage to North America. Promotional flyers were posted in villages and town centers, and newspapers ran ads listing the ship's name, sailing schedule, port of departure, destination, and cost. Some emigrants paid their own way, while others arranged to become indentured servants before leaving, selling their labor for a period of seven years, after which they would be free to establish independent livelihoods. Emigrants who had no way to pay the ship's captain remained on board ship after landing until the captain was able to sell their labor to individuals willing to pay the fare for passage. In his book *A Tour in Ireland,* Arthur Young states that in 1776, "For eighteen to twenty years back, two thousand four hundred persons went annually," referring to those emigrants who left Derry by ship.[22]

The cargo from flaxseed-producing districts in the colonies sustained and financed a steady flow of migrants to the New World. Linen merchants further controlled their profit margin at the other end by supplying flaxseed vessels with sufficient human cargo to reduce the cost of westward transport. The story of Irish emigrants packed tightly into cargo holds of eighteenth-century transport ships is a story of both suffering and survival; the trillions of small seeds from the flax plant that were offloaded in Irish ports provided space and opportunity for the first migration of Ulster Scots to the American colonies.

Millions of acres of land in Ulster province that were granted to English Protestants to manage had originally been taken from a native Catholic population. King James I may have intended to pacify the Irish people when he established the Ulster Plantation, but ownership of the land has been a source of hostility, resentment, and bloodshed for hundreds of years. The contentious division between Catholic and Protestant became known in the twentieth century as The Troubles. The animosity between English settlers and the native Irish population started with King James's plantation initiatives, but clashes between the two groups have surfaced over and over again up to the present day. Alongside the conflict, and despite the ongoing friction, the people's ability to spin flax into yarn and weave it into linen cloth developed into a global industry that brought fame and prosperity to the island of Ireland.

Migration out of Ireland started as a ripple effect that never ceased to flow across the Atlantic to North and South America, into the Caribbean islands, to Australia, and to South Africa. Ripple after ripple of human cargo flowed from Ireland's shores. During the first migration in the early eighteenth century and the Great Famine migration of the nineteenth century, the ripples became tidal waves; between times, the ripples ebbed and flowed but continued to move steadily outward and onward. Regardless of individual reasons why each family emigrated from Ireland, the mass of people who left the small island spread a personal and cultural identity so rich and powerful that, four hundred years later, the average American is probably more aware of the Irish ethnicity than of any other group of immigrants who came to this country. The rippling or extraction of seed from flax stalks in the American colonies in the seventeenth century exported to Ireland thus resulted in an important and long-lasting rippling effect in human history.

Chapter 2

A Long Way from Field to Finish by Hand

THE STORY OF Irish linen is a story about people and circumstances interwoven through the centuries by local and government decisions that determined who grew flax, spun the fibers into yarn, wove the cloth, bleached it, embellished it, taxed it, and sold it; which middlemen gained customers and lost contracts; which landlords protected their linen makers and encouraged the trade; and who got rich by marketing linen far beyond the shores of Ireland. Ultimately, Irish linen became part of a cultural identity promoted and nurtured by the migration, a diaspora, of millions of people who left their homeland but remained powerfully connected to those who stayed behind. Endless strands of yarn helped bind the two groups together.

Before and during the Industrial Revolution, making spun yarn out of fibers from inside the flax plant was a long, arduous process performed at various stages by men, women, and children who needed skill and patience to complete the task. Until the twentieth century, anywhere from twelve to forty people could be involved in making a single piece of cloth, and the number could be even greater if all processes are included.[1] Spinning flax fibers into yarn and weaving the yarn into cloth were processes accomplished concurrently by hand and by machine over many decades. Much depended on the ultimate use of the yarn or cloth, the needs of the industry during a particular period, and the labor force available and willing to work.

Facing page: Weaving shuttle. *Courtesy of Irish Linen Centre and Lisburn Museum. Photography by David Pauley, Belfast.*

The Plant

Flax is the common name for the genus *Linum* (family Linaceae), a plant with small blue or white flowers on top of a thin stalk with a bark-like outer layer and an interior of silky fibers around a woody core; a gummy

A country lane leading to fields where flax once grew, county Cavan, 2008. *Private collection of the author.*

substance holds the layers together. Flax is an annual plant, so new seeds are sown every year. Ireland did not have sufficient land to produce the quantity of flax needed to keep a large portion aside for the next year's seed stock, so Irish flax growers imported vast amounts of seed annually. During the late seventeenth and eighteenth centuries, flaxseed was imported primarily from North America, but in the nineteenth century most of the flaxseed was imported from the Baltic region.

Today, it is nearly impossible to imagine the long weeks of hard labor that were once required to transform this plant material into crisp white cloth. Perhaps it is even more challenging to envision turning hundreds of thousands of yards of linen cloth into a viable global industry. Weaving can be described most simply as the vertical and horizontal crossing of yarns. But weaving is only one of many steps necessary to turn brittle plant fibers into cloth luxurious enough to be desired by royalty. Appreciating all the processes for making linen cloth enables us to understand the complexities of the industry, its importance to the region's economic development, and its effect on the Irish people: both those who stayed and those who had to leave.

Flax requires a temperate moist climate to thrive, so it is perfectly suited to the damp weather in Ireland, which is particularly prevalent in the northern province of Ulster. The crop takes substantial nourishment from the soil and cannot be grown on the same land year after year; it has to be rotated with other crops, such as oats and barley. In the spring, flaxseed was sown by hand, broadcast across fields that were plowed three times to ensure a very fine-grained soil. The seeds are small, lightweight, and shiny; approximately one and a half bushels of seed was needed to sow one acre of land. Depending on weather, soil, and seed quality, an acre of flax could produce twenty pieces of finished linen cloth, each a yard wide and twenty-five yards long.[2] Women and children had the tedious, backbreaking job of weeding the crop as it matured in late summer. Unlike grain crops, flax was not cut at harvest time but had to be pulled by hand to prevent damage to the fiber and preserve the maximum length of the stalk. Men pulled plants out of the ground by the bunch, being careful to keep stalks straight and evenly aligned. Plants were tied in bundles called *beets,* then stacked upright to dry.

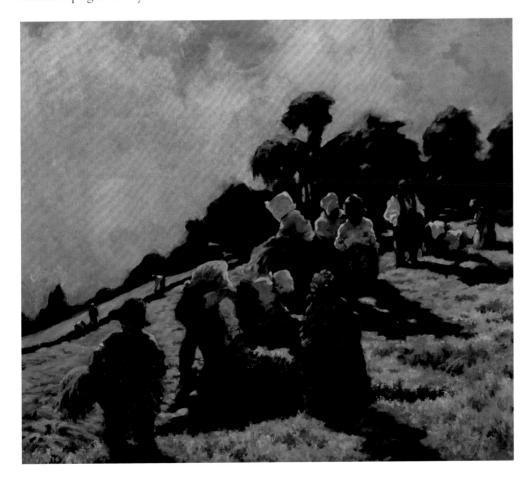

The Flax Pullers, 1921, oil painting by Lillian Lucy Davidson (Irish, 1893–1954). *Courtesy of Brian P. Burns Art Collection.*

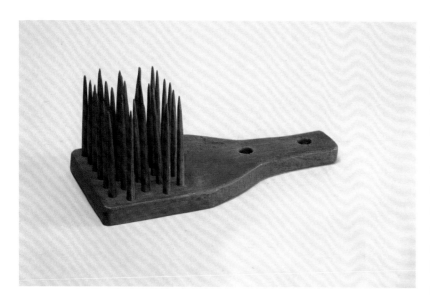

Rippling comb with wooden teeth, 1775–1850. *Courtesy of American Textile History Museum, Lowell, Massachusetts.*

After drying, the flax stalks were pulled through a rippling comb to remove the seeds, which were fed to livestock or, if ripe, saved to sow the following year. The hard outer bark of each stalk that resembled straw at this stage had to be softened, crushed, and discarded to reach the inner fibers used for spinning in a process called *retting.*

Dew retting utilized molds that decomposed the bark when the unbundled, deseeded straw was laid on the ground for two to four weeks. The stalks had to be turned, at least once, with a long stick slid under the top ends of the stems and flipped over to reverse the direction of the stalk exposing both sides to the weather. It was the cheapest form of retting if the farmer had space, but unpredictable weather conditions could cause sufficient rotting to take up to three months.

For *water retting,* bundled and dried beets were placed in a small pond or stream for four to five days, weighed down with stones. In Ireland, natural ponds or "lint holes" were dug in the boggy area of the farmer's land close to the flax fields. The pond behind a typical retting dam measured seventy feet by seven feet and was about three and a half feet deep. If it was any deeper, the water became too cold to allow thorough retting; sun warmed the water at the top, which became progressively colder toward the bottom.

Retting dams, generally built close to a fast-running stream, blocked out the water until all beets had been packed in, seed ends upright, in multiple layers. The beets designated to make the finest linen were placed at the bottom with the coarser beets on top because the coarser stalks retted more easily and could be taken out first. The dammed-up stream was then allowed to cover the crop. When the outer bark was sufficiently rotted, the polluted water was drained off and clean water flushed through the beets. Local children delighted in the opportunity to wade barefoot into the pool to stamp down the stalks, making sure the beets didn't float to the surface.

When beets were removed from the water, the rotting vegetation smelled dreadful, and so did anyone who handled it. Men who carried out the retting process tended to be ostracized from society because no one wanted to be around the abhorrent smell, which permeated the skin and stayed with the men for months on end. If he hoped to marry, a man chose not to stand in a retting pond.[3]

After retting, women and children separated the wet flax beets, spreading the stalks across fields to dry for about three weeks (depending on weather conditions). Once dried, rotted flax was brittle, and the bark and pulpy core had to be broken without damaging interior fibers. Men used a broad wooden mallet, or *flax brake,* to strike repeatedly along the length of the stalk. A flax brake resembles a wooden sawhorse with a horizontal heavy board that would be manually lifted and dropped on each handful of plants draped across the bottom half of the brake. Once the stems were broken, a *scutcher* hung a bunch of stems over a *scutching*

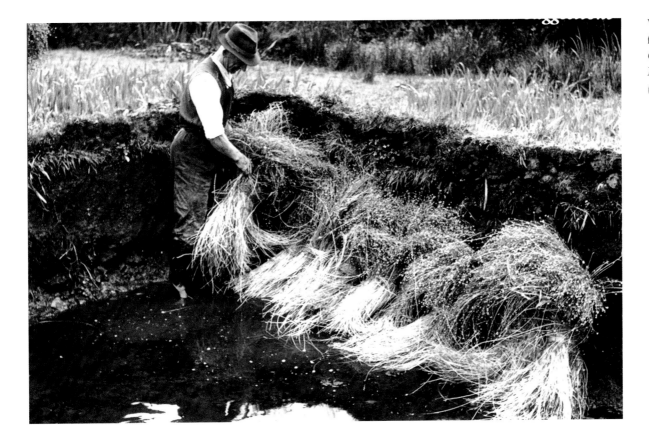

Worker stacking bundles of flax to rot in a retting pond. *Courtesy of Public Records Office, Northern Ireland, Crown copyright (INF/7A/11/5/1).*

Flax brake, oak with remnants of red paint on two legs, eighteenth or nineteenth century. *Courtesy of American Textile History Museum, Lowell, Massachusetts.*

Scutching knife, used to break away the outer layer of flax stalks to reveal the interior fibers, nineteenth century. *Courtesy of Monaghan County Museum, Republic of Ireland. Photography by David Pauley, Belfast.*

A *heckle*, or *hackle*, is used to prepare flax fibers for spinning into yarn. At one time, *heckle* and *hackle* had the same meaning; both were flat paddles or boards with sharp nails protruding out of the wood. Crudely made or carefully crafted, this piece of equipment was used to separate the mass of flax fibers and remove outer bits of stalk. In bunches, the stalks were slapped onto the nails and quickly pulled through, a process repeated many times before the fibers were soft, smooth, and in alignment. In today's society, the meaning has the same ferocity as tearing apart fibers, but *heckle* usually refers to a person loudly opposing the ideas of a politician or authority figure, while *hackle* (as a verb) describes mangling or roughly cutting something or someone.

A *flaxen-haired* child has smooth, fine, pale hair, hanging straight down and resembling flax fibers ready to spin. *Towhead* also refers to a child with pale hair, but it is usually shorter and coarser hair, more like the short fibers (tow) discarded when the flax is heckled or hackled.

In the mid-fourteenth century, flax prepared for spinning was known by the single word *lint;* this was also the name for flax waste used as a combustible. By mid-fifteenth century, the flax plant itself had come to be referred to as lint; and scraping linen cloth provided soft material known as lint for dressing wounds or to burn for tinder. Flaxseed is put under pressure to obtain linseed oil, and the remainder can be pressed into cakes for cattle feed. Patented in 1863, *linoleum* was the name given to a kind of floor cloth made by coating (linen) canvas with a preparation of oxidized linseed oil. Most people now consider lint to be any fluff of unwanted fiber on clothing or trapped in the clothes dryer and linoleum as any synthetic kitchen flooring.

The words *weave* and *wove* are used so often in everyday language that most people say the words in a sentence without even thinking about the textile context: *wove a story of deceit* or *weaving in and out of the crowd.* Weaving on a loom means that the warp and weft (vertical and horizontal) yarns are crossed over and under each other to form an interlocking piece of fabric.

board and beat the stems with a long wooden knife until the already-broken pieces of bark fell away, the gummy residue was gone, and many of the shortest fibers (called *tow*) fell to the floor. An experienced scutcher was left with a clean, tangled mass of long soft fiber.

Before the introduction of mechanized flax breaking, women in county Donegal were known to drape flax over the back of a chair for scutching; they would then tie it in neat bundles and take it to the nearest flax merchant to sell. The price they received was based on the quality and grade of each bundle.

Wheels made of granite or other hard stone were also used for crushing stems after retting and drying. A horse was attached to an iron ring at the outer end of a pole that rotated a stone wheel in a circle around the edge of a stone platform; this movement of vertical stone against horizontal stone was the same process used to grind grain into meal. Flax placed on the platform broke under the weight as the wheel passed over it. The broken stalks were spread on the road, and a horse and cart were driven over it to pulverize the outer bark. Some scutching mills passed flax between grooved rollers to finish the breaking process. County

Donegal and northwestern county Tyrone were both famous for growing the finest flax and having plenty of local scutching mills to process the plant for spinning.

In the mid-nineteenth century, water-powered scutching mills peppered the landscape across county Donegal. A surviving description of the work at a local mill in Trentagh, near the town of Letterkenny, provides a lasting impression of the physical labor that went into just one step in the process of turning flax into yarn.

> The force of the water turned a large mill wheel of 12 feet in diameter. A shaft from this wheel protruded into the mill where it turned a large pit-wheel, which had wooden teeth in it. As the power was passed on from the large wheel to the smaller until it reached the scutcher, the spindle holding the wipers was turning at a terrific rate. Each spindle had 10 wipers (a board measuring 2 feet by 10 inches by 1 inch). The scutcher held the flax in the path of these wipers until all the shell and chaff had been beaten off. There were usually three sections side by side in a mill and each section had its set of ten wipers whirring around. The first man held a small bunch of flax in the path of the wipers in his section—he was called the buffer. The next man took a few of the bundles together and scutched them once more. Then the third man gave it the finishing scutch. Each time the scutcher held onto one end of a bunch while the other was pushed under the wipers. The last man was left with a woolly looking fibre, which he twisted and threw in the corner.[4]

A scutcher was the most important worker in the mill. If the finished fiber was not cleanly scutched and bits of bark, called *shoos*, were left in the fibers, farmers got a poor price at market. (In many homes, shoos were used to build kitchen fires.[5]) To ensure good work, farmers regularly tipped scutchers half a crown (worth two shillings and sixpence). With high-quality flax and perfectly operating equipment, an expert scutcher could prepare up to a hundred pounds of flax a day. Most scutchers were missing a finger or two that got caught in fast-turning paddles on the waterwheel-driven equipment. The air inside scutching mills was thick with dry fiber and dust, a prevalent fire hazard. One mill near Ballybofey (county Donegal) caught fire so many times, local residents suspected each red sunset of being the mill on fire again.[6]

It was the job of a *hackler* (or *heckler*) to transform the tangled fibers into smooth, uniform strands for spinning. Combs used for this purpose bore no resemblance to contemporary combs used for getting snarls out of hair, but they did function in much the same way. The teeth were sharp nails or heavy pins attached to a block of wood with about three inches of nail showing above the base. The distance between the nails and the diameter of the nails varied on a series of blocks. The hackler started by slinging the long mass into the coarsest metal teeth and pulling it through the first block. Each pass through the teeth straightened long fibers and discarded short ones. Over and over again the hackler combed a bunch of fibers through the progressively finer teeth on a series of blocks until long fibers were smooth and straight and short fibers lay on the ground. Long fiber was spun into fine linen yarn; short fiber, or *tow*, was spun into coarser yarn or used for other purposes.

Bench hackle, illustrating the difference in the density of the spikes. The hackle covers are below the bench. Overall measurements: 44" L × 25" H × 23" D. *Courtesy of American Textile History Museum, Lowell, Massachusetts.*

In 1851, 9,737 acres of flax were grown in county Donegal; by 1901, the flax crop had declined to 607 acres. Donegal's homegrown flax and scutching mills had virtually disappeared by the 1920s, although a demand for military uniforms caused a brief resurgence during World War II. The last scutching mill in county Donegal closed in 1959, though the use of stone wheels had ended in the late nineteenth century.[7]

Family-owned mills were scattered across Ireland. The ruins of one such mill can be found in county Cavan, where the Mayne family built Newgrove Mill in the eighteenth century. Nestled in a sheltered valley along the Knappagh River, it was once a large family concern with a big house, bleach yards, bleaching greens, and buildings for scutching and hackling the flax. Locally, it is now referred to as Murphy's Mill, in memory of the last family to live in the mill house and operate the mill. Rich green foliage and vines have claimed parts of the buildings; roofs and windows are long gone, but decorative metal fireplace inserts and intricate brickwork recall a time when Irish linen was a successful and lucrative enterprise.

Spinners Spinning by Hand

Hand spinning was woman's work, and spinning in the home combined household chores and child-raising responsibilities with income-producing labor. In the simplest form of spinning, a spinner needed only a distaff to hold the prepared fibers and a spindle to provide the twist to make yarn. Distaffs came in a wide variety of shapes and sizes, but the long fibers of flax required support of some kind to keep the distaff farther from the spindle. Whether a distaff was cone shaped, pear shaped, bell shaped, or in the form of a lantern or truncheon, it was the personal possession of the spinner, often an engagement or wedding gift. A distaff made of light wood or thick cane could be mounted at the end of a long pole, attached to a bench, or held in the spinner's lap, usually under her left arm. Regardless of the size or shape of the distaff, for a smooth strand of yarn, a dressed distaff held fibers that were aligned to face the point of the twist and parallel to receive twist from a turning drop spindle.

On a spinning wheel, a movable arm held a distaff with a shortened shaft, usually placed to the left of the spinner and adjustable to suit the individual. With the distaff placed vertically, the spinner sat in front

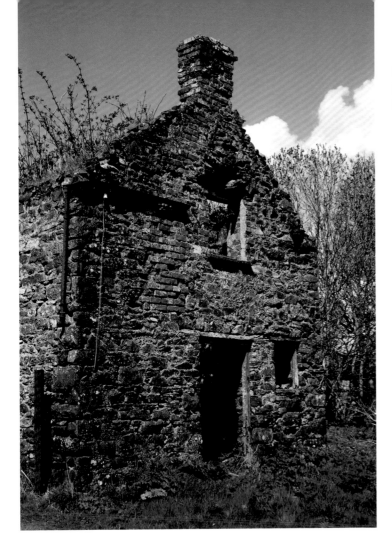

Ruins of the Newgrove flax mill originally built and operated by the Mayne family in the eighteenth century, county Cavan, and later known as Murphy's Mill, named for the last family to operate the mill, 2008. *Private collection of the author.*

Side view of the ruins of the Newgrove flax mill originally built and operated by the Mayne family in the eighteenth century, county Cavan, 2008. This building is believed to have been used for scutching flax. Gorse shrubs along the bank of the creek are in full bloom. *Private collection of the author.*

Drop spindle, consisting of a wooden shaft having a groove at the top and running through the center of a wooden whorl that rests ½ inch from the bottom of shaft, nineteenth century. Off-white yarn is wound on the spindle. Overall measurements: 10.5" L, 1.5" diameter on the whorl. *Courtesy of American Textile History Museum, Lowell, Massachusetts.*

of the wheel feeding the fibers onto the spindle attached horizontal to the wheel. A flyer arm attached to the spindle guided the yarn onto a bobbin, and the spinner controlled the speed of the turning wheel with a treadle. Many different styles of wheels were developed to meet the needs of hand spinners and the different kinds of fibers, with improvements still being made to flax spinning wheels in 1800. The Irish *castle* wheel, peculiar to Ulster flax spinners, was a sturdy design with the flyer mechanism placed under the wheel. Many of these wheels were taken to America by Irish immigrants.[8]

Using the treadle to keep the wheel revolving, a spinner fed twisted strands of fiber onto a rotating bobbin, being careful to keep a continuous strand of yarn the same thickness as it filled the bobbin. Flax fiber is brittle and needs dampness to keep it pliable and unbroken as it is spun. Some spinners kept a dish of water handy to dip their fingers into as they spun, and various wheels had a built-in recessed space to hold a wooden cup of water. Many flax spinners, however, constantly spat on their fingers to keep the fiber moist, a habit carried on from the days when they would have had only a distaff and drop spindle for spinning. The detachable distaff continued to have sentimental value to hand spinners, and it was often removed as a keepsake after the wheel was no longer in use.

After the yarn was spun, it was taken off the filled bobbins and wound onto a clock reel or hand reel (also called a niddy-noddy), a process called *reeling.* Then it was loosely twisted into skeins or hanks and set aside. Reeling was an important step, necessary for measuring the length of the yarn, and twisted skeins kept the many strands in manageable order. When needed, each skein of yarn was wound onto smaller bobbins (spools) to be inserted in a weaver's shuttle. It took many spinners to keep up with the work of one weaver, who required a constant supply of filled bobbins for his shuttle. At a very early age, children worked long hours to transfer yarn spun by women onto bobbins for weaving, which was undertaken by

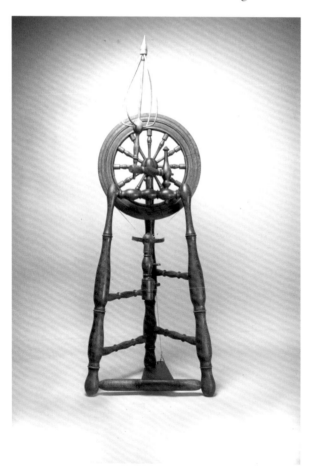

Irish castle spinning wheel with bobbin/flyer unit below the drive wheel on a tripod frame, made by Daniel Danner (1803–81), Mannheim, Pennsylvania, c. 1825–40. Danner's father was a weaver. Overall measurements: 21" W × 45.5" H × 18.5" D. *Courtesy of American Textile History Museum, Lowell, Massachusetts.*

fathers and older sons and only occasionally by women. As a domestic industry, weaving primarily occupied the household for the first half of the year before weavers returned to farming and harvesting winter provisions for the family.

Linen Goes to Market

There are three stages in the ripening of flax grown to make linen: green, yellow, and brown. For the finest of fibers, the green plant is harvested following its flowering period. Once flax was spun into yarn, the yarn was woven on a handloom into a variety of widths and lengths of dull, unattractive, light brown cloth. In the natural unbleached state, it is known as brown or green linen. Weavers sold brown linen at market fairs to merchants or drapers who managed the final process—bleaching the cloth snow white and pounding it repeatedly to strengthen the cloth and produce a finish that had a smooth sheen.

During the eighteenth century, the linen industry expanded rapidly in areas where successful linen markets developed. The whole of Ireland was still an agriculture-based society, and market towns, relatively new to the Ulster landscape, required proper planning and investment to succeed. Most Ulster towns and cities were established during this period of growth in the linen industry. Landowners in the later half of the seventeenth century were anxious to develop market towns on their estates as trading centers to attract new settlers and generate increased revenue.

For villages and towns to prosper, a good network of roads was essential, and the eighteenth century witnessed a steady growth of road networks across Ireland as landlords received government grants for this purpose. For a village or town to thrive, it had to appeal to artisans and farmers from the surrounding

Niddy-noddy, of mortise and tenon joint construction with curved brace, example of a courting gift, c. 1775–1850. Overall measurements: 13.25" L × 19.5" H. *Courtesy of American Textile History Museum, Lowell, Massachusetts.*

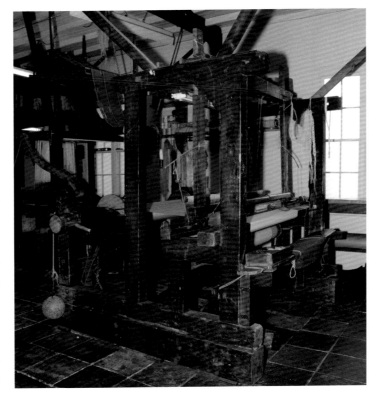

Nineteenth-century working cambric handloom in the weaving workshop at the Irish Linen Centre and Lisburn Museum. *Courtesy of the Irish Linen Centre and Lisburn Museum.*

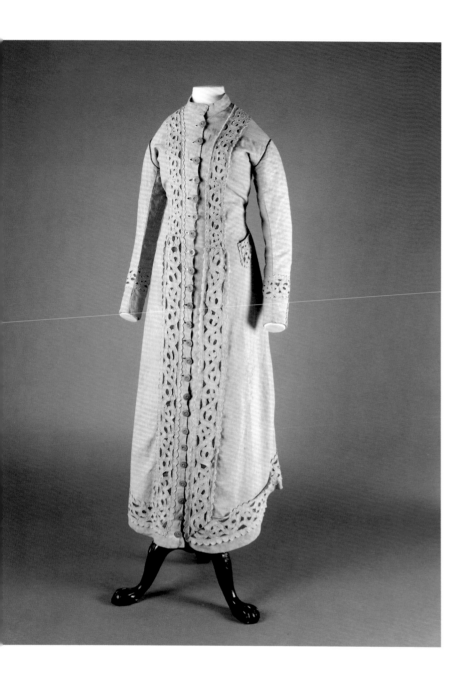

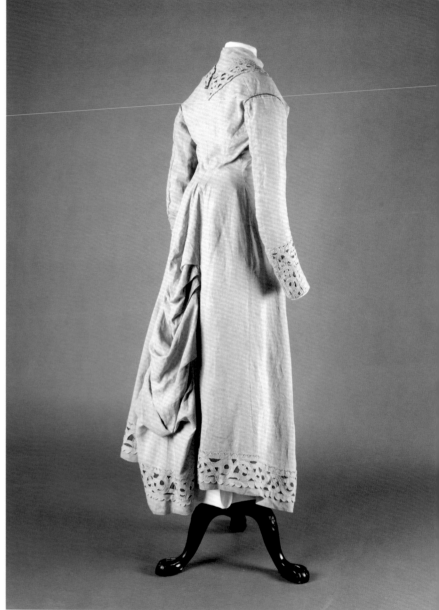

Front view of unbleached linen dress, featuring bands of cutwork backed with red cotton on the cuffs, collar, hem, pocket, and front of the dress. The Springhill Costume Collection: McDonald-Tyler family, c. 1875–80. © *National Trust. Photography by Michael McKinley.*

Back view of unbleached linen dress, featuring bands of cutwork backed with red cotton. The Springhill Costume Collection: McDonald-Tyler family, c. 1875–80. © *National Trust. Photography by Michael McKinley.*

countryside so that they would move to town centers. Commercially successful villages and towns attracted traders and merchandise from a radius of five to ten miles, which was the distance a farmer on foot could drive his livestock to market in a day. The majority of urban settlements in Ireland are still separated by similar distances.

Landlords were required to obtain patents from the central government in London to hold fairs or markets; collecting tolls and customs without a patent to do so was illegal. In county Cavan, the only town predating King James's Ulster Plantation was Cavan town itself. The native Irish led a pastoral existence, trading in fixed locations on a seasonal basis without government control or specific patents to establish market fairs. However, in post-plantation Ulster, urban settlements increased rapidly with the influx of English and Scots immigrants, an intrinsic part of the plantation policy.[9] In the aftermath of the Williamite War of the late seventeenth century, Ireland enjoyed a degree of relative peace and stability, leading the way for renewed economic expansion in county Cavan and other parts of southern Ulster.[10]

Many Ulster towns and villages originated as a direct result of the increased linen trade. Market towns emerged in the flax-growing regions of Ulster, and each town had a specific number of markets and fairs each year. Markets generally took place on a fixed day each week, and certain towns gained a reputation as brown linen market centers.

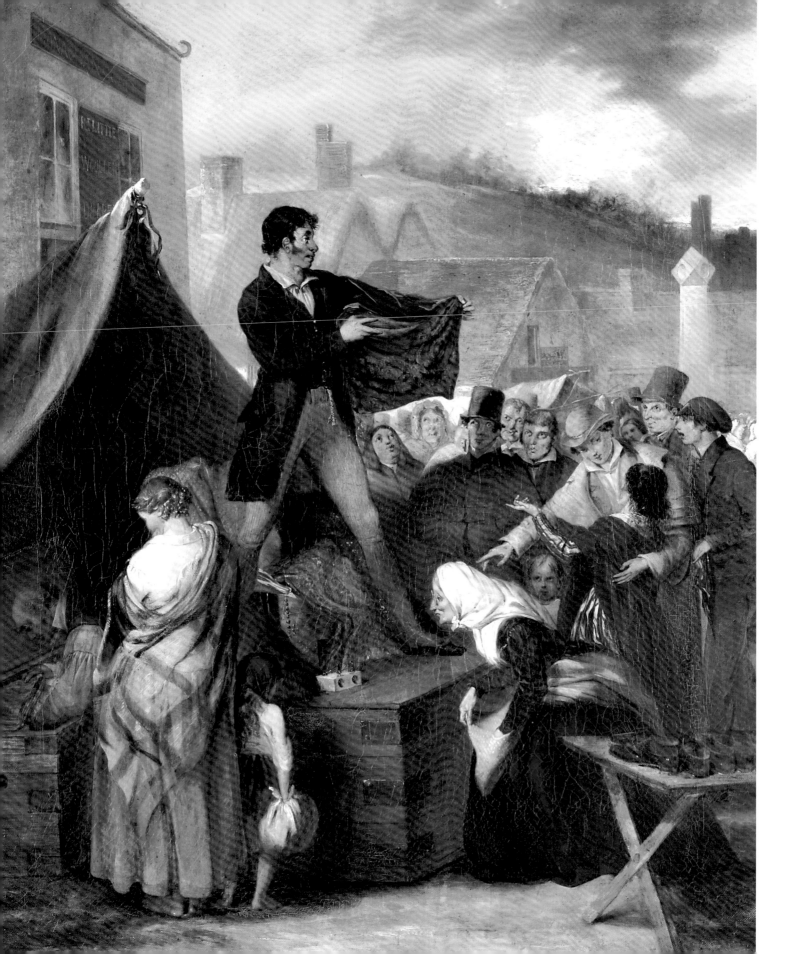

Cootehill is a good example of a market town that developed in the early part of the eighteenth century when the linen trade was beginning to expand.[11] Colonel Thomas Coote acquired 17,000 plantation acres in county Cavan under the terms of the Acts of Settlement in 1662, when the monarchy was restored under King Charles II.[12] Coote, a successful Dublin lawyer, married Frances Hill from Hillsborough in county Down, and their joint names were given to the new estate. His nephew and namesake, also named Thomas Coote, inherited Cootehill; the younger Coote is given credit for creating county Cavan's linen industry. Thomas was a founding member of the Irish Linen Board, established in 1711 by the government to improve and regulate the growing industry. In 1725, Thomas Coote obtained a patent for a Friday market in Cootehill and annual fairs held on two consecutive days in March, May, September, and November.[13] Coote attracted skilled linen workers from other parts of northeastern Ulster by offering them land with long leases at favorable rates. The steady growth of the linen industry and the expansion of spinning and weaving in the homes of tenants on the estate promoted the growth of the town's linen market.

The linen trade in Cootehill continued to prosper under the patronage of the Coote family throughout the eighteenth century, so much so that, in 1760, *Faulkner's Dublin Journal* published an article about a great parade that took place in Cootehill. The landlord, Charles Coote, led a band of "about five hundred of the linen weavers of that place, together with linen drapers" and other local townspeople. The parade made its way through the town, "with a machine carried, on which a boy was weaving and a girl spinning, dressed in linen and white gloves, ornamented with orange and blue ribbons." The article also describes the lavish dinner that Mr. Coote gave in his residence to the linen drapers, while the weavers and other townspeople had public houses opened to them. Later that evening, Mr. Coote gave a "grand ball and supper" for the ladies in the new Assembly Rooms in Cootehill.[14]

National exports of linen declined during the later part of the seventeenth century but increased steadily during the second half of the eighteenth century. By 1803, Cootehill's market had become one of the most important brown linen markets in Ulster.[15] Other principal markets in Ulster selling brown linen that year included Armagh, Dungannon, Belfast, Lisburn, Lurgan, Derry, and Tandragee.[16]

Linen markets were tightly regulated by the Linen Board to protect the quality of the product. Weavers took their lengths of cloth to weekly markets, where they were inspected for quality, measured, and stamped by seal masters appointed by the board. The final cloth was shown to linen drapers and dealers, who were looking for the best-quality cloth to purchase at the best price. Weavers could display their cloth for sale only at an appointed hour; any infraction of this regulation resulted in a fine imposed upon the weaver.

Arthur Young, who traveled throughout Ireland in the late 1770s, made the following observation on his visit to Lurgan market in county Armagh:

> The cambrics are sold early and through the whole morning, but when the clock strikes eleven, the drapers jump upon stone standings and the weavers instantly flock about them with their pieces. The bargains

Facing page: A Market in Monaghan in 1830. Oil painting by Henry MacManus (1810–78). Courtesy of Monaghan County Museum, Republic of Ireland. Photography by David Pauley, Belfast.

are not struck at a word, but there is a little altercation whether the price shall be one-half penny or a penny a yard. . . . The draper's clerk stands by him and writes his master's name on the pieces he buys, with the price, and giving it back to the seller, he goes to the draper's quarters and waits his coming. At twelve it ends; then there is an hour for measuring the pieces and paying the money[,] for nothing but ready money is taken and this is the way the business is carried on at all the markets.[17]

Bleaching It White

After the cloth was purchased at market, it still had to be bleached and *beetled.* These are the two final steps that are required to turn stiff brown linen into elegant white cloth with a luxurious shine—the cloth recognized worldwide for its beauty and desirability. At this point in the process, linen cloth was transformed from the product of individual spinners and weavers into the wholesale commodity of an industry.

In the seventeenth century, women bleached linen at home on a small scale. Crude ingredients including buttermilk and cow's urine were used in a process that lasted from March to October. In 1626, there was a bleach green in Lambeg (county Antrim) where linen was laid on the grass in the sun to bleach.[18] By the early decades of the eighteenth century, skilled bleachers had arrived from Holland along with Huguenot refugees from France; bleaching standards soon improved with the introduction of specialized bleach works. The rural landscape naturally provided all the elements required for bleaching: fresh (unpolluted) air, plenty of uncontaminated water, and acres of grassland. The Linen Board provided grant monies for the construction of new, more efficient, and cost-effective bleaching yards across Ireland. Between 1722 and 1728, £10,000 was spent in grants for bleach works.[19]

Linen merchants or drapers took the brown linen they purchased at market to bleach works, also known as bleach greens or bleach yards, where the dull fabric was gradually transformed into sparkling white cloth —the next crucial element in creating finished linen. Bleaching whitened the cloth and rid it of impurities but could also weaken the cloth if improperly applied. Bleaching was a long, complicated process that took months to complete; only wealthy merchants and entrepreneurs could afford to invest capital in the lengthy process. Drapers paid the bleacher for his services, and when the bleached cloth was returned to a draper, it was sent on to agents at White Linen Halls in Dublin, Belfast, and Newry to be sold and exported. Although the linen industry was still a cottage-based one in the eighteenth century, bleaching linen required land for bleach fields; multiple buildings for soaking, boiling, washing the cloth, and storage; and a huge supply of water for the processes and to serve as a power source. If a draper could afford it, he invested in a bleach works to lower his cost and increase his profit margin by controlling two stages of the business.

Bleaching linen took multiple steps to complete and was a much more complicated and tedious process than bleaching cotton fabric. When the brown linen was received at a bleach works, it was weighed and marked. Orders for a similar grade of cloth were then sewn together. In the boiling house, the cloth was steeped in large containers of lukewarm water to remove the greasy dressing that weavers used to stiffen it

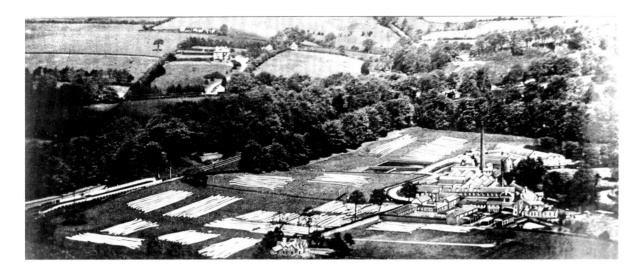

Long lengths of linen cloth spread out on the Seymour Hill bleach green of J. and W. Charley and Company, c. 1850. *Public Records Office, Northern Ireland (D/2242/7/18).*

prior to sale. It was then boiled over great fires in vats filled with water and alkali *ley* (lye), a bleaching liquid made from burnt wood ash, used to remove the brown coloring caused by oil in the fabric. After the cloth was boiled, it was rinsed in cold water. Next, in the wet works or *croft,* it was steeped in an acid solution such as buttermilk and salts to counteract the effect of the alkaline lye. This solution was washed out, and the cloth was spread on the bleach green (grass) for a number of days, depending on the weather, to allow it to bleach in the sunshine. The process of soaking in an acid solution, washing, and drying on the bleaching green was repeated until the cloth reached the requisite whiteness. In the final stage of bleaching, linen was washed with soap and boiled to expel the acids, salts, and other impurities. Work in the croft was physically demanding and dangerous for the men, who had to move across narrow, wet, slippery catwalks from one facility to another, carrying saturated cloth that was extremely heavy and difficult to maneuver, while working in an atmosphere that was oppressively humid and filled with chemical fumes.

The damp bleached linen was moved to the *beetling* mill, where it was wrapped on a revolving beam and placed under perpendicular bars of beech timber that pounded the cloth for up to ten hours as the beam rotated. The noise was deafening and incessant, but the result was a fine sheen on the linen that greatly enhanced its appearance. Damask was beetled on the backside of the cloth, typically for four periods of four hours each, with each roll of cloth reversed at the end of each session. The cloth was dried before it was beetled a final time to give it a glossy appearance. Then it was measured, sorted for quality and color, lapped (folded, not rolled), and transported to White Linen Halls, from which most linen was exported to England or the Americas. Toward the end of the nineteenth century, many bleach works installed hydraulic mangles in an attempt to speed up the finishing process. For most linen, this was a successful way to increase output, but for the finest damasks and cambrics that were the most valuable types of linen cloth, there was no substitute for the beautiful finish provided by traditional beetling.[20]

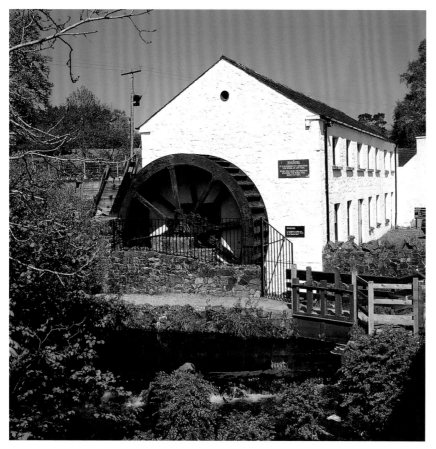

Wellbrook Beetling Mill, county Tyrone. This water-powered mill was used in the manufacturing of linen for commercial use from 1765 to 1961. © National Trust. Photography by Roger Kinkead.

During the early part of the eighteenth century, bleaching necessitated considerable expenditure; only wealthier drapers could afford to invest in this process, which took up to five months to complete. It was seasonal work, taking place between March and October, so large sums of money were tied up for the long periods that elapsed between the purchase of brown linen at market and the sale of the finished bleached linen. Linen merchants were obliged to extend credit to their agents who purchased the finished cloth in Dublin or London for resale to buyers abroad.

Long lengths of linen cloth, lying across acres of grassland for weeks at a time, were a valuable commodity and proved extremely vulnerable to theft, especially under cover of darkness. To protect their investment, bleachers built small shelters at each corner of a bleach green, and guards were on duty twenty-four hours a day to watch for thieves determined to pilfer the highly marketable linen. Stone gathered locally was used to construct charming small round huts known as watch huts, which often had peaked roofs and peepholes for observation. An arched opening allowed a guard to stand out of the weather but with a clear view of the green.

Anyone taken before the magistrate and charged with stealing was dealt with harshly, regardless of sex, as was the case for the unfortunate Maryanne Jane Hamilton. Hamilton was discovered stealing from the bleach green of Hugh Jackson by Jackson's foreman, Ross McMahon. In July 1824, Maryanne was sentenced to transportation for life at a court inquiry in Monaghan. Transportation to a distant land was a common punishment for both major and petty crimes in Great Britain and Ireland from the seventeenth century until well into the nineteenth century. A sentence could be for life or for a specific period. The penal system required all convicts to work; women were expected to work as domestic servants and farm laborers. Maryanne was probably shipped to Australia, a common destination for criminals at the time of her sentence. She pleaded her case by telling the court that she was a fifty-three-year-old widow with eight children, five of whom were deceased. Apparently, the court was unmoved by her excuse.[21] Maryanne may have been fortunate to survive, as the penalty for stealing from a bleach green was usually death.

Despite these deterrents, determined thieves still managed to outsmart the guards and steal the cloth from bleach greens or from linen hall markets. On May 6, 1820, James King, serving as chamberlain at the linen hall in the town of Coleraine, county Antrim, wrote to the trustees of the Linen Board asking for funds to add an iron railing and wire across the windows to provide additional security to the building after

recent robberies occurred: "Two thefts having been lately committed in the middle floor of the Hall; and from the vigilance of the Gate-Keepers and Watchmen employed therein, I think it is impossible for the articles so stolen to be taken out in the day-time. People may conceal themselves in the Galleries at night, and have accomplices outside, to carry off whatever may be thrown to them; which would be prevented by the adoption of these measures I have taken the liberty to recommend." The board ordered the renovations and instructed an architect to estimate the cost.[22]

Bleach yards in Cootehill were situated between the Rivers Annalee and Dromore, tributaries of Ireland's waterway system. In Reverend Dean Richardson's 1740 account of Cootehill, he wrote, "There is a great number of weavers and bleachers in this town and neighborhood and no less than ten Bleach-Yards, the least of which bleaches a thousand pieces of cloth every year."[23] This was a sizeable number of bleach yards at this early stage of the industry, considering the expense of establishing and running them profitably.

The conventional method of bleaching linen involved using potash, most of which was imported from America, to produce lye. Buttermilk or another source of acid such as bran sour or imported Spanish barilla (sea plant material) was used to neutralize the alkaline lye. The long, demanding process of bleaching linen was revolutionized when diluted sulfuric acid (called oil of vitriol) replaced buttermilk in the 1750s; at the close of the century, a new bleaching liquid derived from chlorine dramatically speeded up the bleaching process.

By the 1790s, the bleaching process had been reduced to a single day.[24] Within ten years, water-powered technology enabled bleach yards to turn out nearly ten thousand lengths of linen cloth annually, as opposed to the one thousand pieces per year that were the standard at the start of the century. The number of bleach yards peaked at 357 in 1787, but by the middle of the nineteenth century, this number had fallen dramatically to only 40 facilities.[25] Thus, industrialization of bleaching linen in the mid-nineteenth century resulted in a small number of bleach works (by this time, commonly referred to as bleach mills) able to cope with much greater quantities of cloth. The town of Lisburn in county Antrim was a major linen-producing center and developed a large vitriol works on the river Lagan. Bleaching linen was confined to bleach mills such as Richardson's at Glenmore (county Antrim). In 1900, the Glenmore bleach works covered more than two hundred acres, the largest in Ulster. Smaller bleach works across Ulster were unable to compete and ultimately disappeared from the landscape.[26]

Stone guardhouse. Small buildings were placed at the corners of Irish bleach yards and manned twenty-four hours a day to protect against theft. This watchtower was originally one of a pair that guarded the bleach green at Tullylish near Gilford (county Down) c. 1800s. It was re-erected at the Ulster Folk and Transport Museum site in 1967. © *National Museums Northern Ireland 2011. Collection Ulster Folk & Transport Museum.*

Linen fabric strip used to wrap the register of births recorded in county Monaghan, 1876–78. *Courtesy of Monaghan County Museum, Republic of Ireland. Photography by David Pauley, Belfast.*

The weaving factory and bleach works were complementary in terms of employment requirements, providing a balance in the labor force, especially in rural areas, if both operations were financed and administered by the same employer. The work in a weaving factory was labor intensive and employed mainly women; the bleach works needed relatively few employees, and they were primarily men.

Fine Irish linen was bleached snow white, while coarser linen was left an unbleached natural shade of beige or off-white. Linen does not dye as easily as cotton or wool and wrinkles copiously, but it has other properties that make it a desirable fabric with many uses for home and industry. As a fabric, linen cloth is valued for its durability and strength even when wet. The tensile strength of linen yarn is twice as high as that of cotton and three times that of wool. Linen has high heat conductivity and is extremely absorbent, capable of absorbing as much as 20 percent of its dry weight, which explains why the cloth always feels fresh and cool. Because it does not accumulate static electricity, linen clothing does not stick to the skin.

During multiple washings, linen loses the tiny particles of plant matter that initially remain in the fiber, and the cloth takes on a lovely rich luster. The more it is washed, the softer and smoother it becomes. Silica in flax fiber protects linen against rotting, which explains why Egyptians wrapped mummies in fine linen cloth to preserve them for thousands of years. Linen rejects dirt and does not pill or teasel. Pilling occurs when tiny balls of fiber appear on fabric after wear or washing breaks down yarn fibers, ruining the quality and smoothness of a garment. The process of combing fabric to raise the surface nap is teaseling. When teaseling is intentional, as on fabrics such as flannel, the result is desirable, but if teaseling occurs unevenly, it spoils the look and feel of the original fabric.

Linen does not fade or lose its shape as cotton does. Its stability and permanence make it the ideal choice for many household items, such as toweling, bedding, wall coverings, and, in heavier weight, upholstery and wallpaper.

Makers of linen cloth were also users and wearers of the wide variety of linen-based products. Whatever talents or skills each individual or collective family possessed for making and marketing cloth, these skills were important attributes as the textile industry across Ireland developed and found financial success farther afield. Emigrant families used knowledge gained from processing fiber into cloth in the old country to establish a viable textile trade in the northern colonies of North America. For pioneer families who settled in the backcountry of North America, spinning and weaving skills handed down from generation to generation were crucial for survival.

James Gregg, descendant of a family of linen bleachers in Aberdeen, Scotland, and his wife, Janet Cargill, also a Scot, moved to county Londonderry in Ulster province in 1690. In Ireland, Janet gave birth to four sons, and in 1718, the Gregg family of six joined more than a hundred other Scots-Irish families to board a ship for Boston. By 1719, Gregg was in the New Hampshire settlement of Nutfield, later renamed Londonderry in memory of the old country. The New Hampshire community quickly became a renowned center for linen production, and some of the highly accomplished professional weavers developed their craft into a thriving business. For example, in 1729 and again in 1736, John McMurphy was commissioned to weave linen for the town fathers to present to the governor. Decades later, Congress paid four pounds and a diamond ring to John Montgomery for linen woven for George Washington's army officers.[27]

At least five families of wheel makers resided in Londonderry, New Hampshire, to meet the demand of spinners. Three wheel makers were from the Gregg family. In 1760, Samuel worked making wheels for only a year before deciding that farming was more to his liking, but Joseph Gregg, who learned to make foot wheels (treadle spinning wheels) from his older brother James, stayed on the family farm in Londonderry after James moved to central New York and continued to make wheels in his new home. In the collection of the American Textile History Museum in Lowell, Massachusetts, are two examples of Joseph Gregg's craftsmanship signed by the maker: a spinning wheel and a clock reel, which was used for winding yarn into prescribed lengths. Other wheels signed by a Gregg remain in American museums, indicating that this Scots-Irish immigrant family had a valuable trade that supported the family in North America and contributed to the flourishing textile industry in New England.[28]

In some cases, successful Irish linen-making families encouraged their sons to emigrate to gain religious freedom, giving them enough money to buy property and start a new life on other side of the Atlantic Ocean. For example, Andrew Jackson, seventh president of the United States, was born to Presbyterian Scots-Irish immigrants Andrew and Elizabeth Hutchinson Jackson on March 15, 1767, approximately two years after they emigrated from Carrickfergus, a seaport located on the western shore of Belfast Lough along the Irish Sea. Jackson's grandfather was a fairly affluent weaver and merchant in

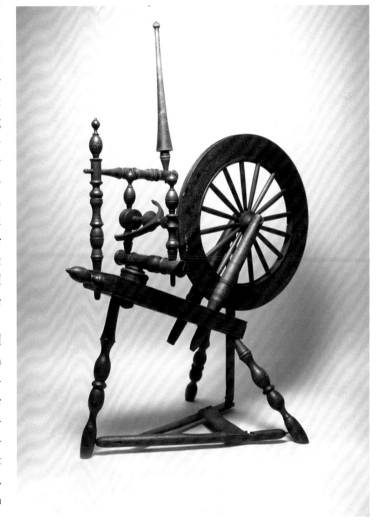

Saxony flax spinning wheel made by Joseph Gregg, Londonderry, New Hampshire, United States, late eighteenth century. *Courtesy of American Textile History Museum, Lowell, Massachusetts.*

Carrickfergus with social standing in the community. In 1765, Jackson's father sold his property near the town of Castlereagh, county Antrim, and led a large group of Presbyterians who immigrated to Pennsylvania. The group traveled overland to settle in North Carolina's mountainous Waxhaw region, named for the Native American tribe that originally inhabited the land. Andrew purchased two hundred acres of farmland in the settlement, and Elizabeth gave birth to three sons during the next three years. Elizabeth was fiercely anti-British, and young Andrew and his two older brothers fought in the American Revolution on the side of the colonies. Young Andrew Jackson never followed his grandfather's weaving trade in the wilderness of North America; the closest he came to using any skills that may have required a needle and thread was when he worked in a saddle-maker's shop in 1781. However, Jackson's descent from a family with social standing in the old country enabled him to use his family heritage to advance his career in the new country.[29]

Increasing Connections to North America

From 1717 to 1775, a quarter of a million people left Ireland for North America; the great majority of them were Ulster-Scots. At midcentury, immigration was not undertaken as a fearful exploration into a vast unknown territory but instead consisted of moving to a country where friends and relatives had already established close-knit communities and stood ready to welcome newcomers into their midst. For nearly three hundred years, people across the island of Ireland used the phrase *going to America* in vernacular dialogue to express a youthful desire to leave home, find employment opportunities, escape poverty, and seek financial independence.

Letters Share Good News and Sorrow

Letters written to business colleagues or loved ones across the ocean were the lifeblood of communication for immigrants. Many records remain to tell the story of business partnerships, costs of purchasing goods, profits made and lost, and the structure of international financial dealings. However, commercial correspondence rarely included the specifics of social or domestic life, and although women's letters stored in trunks and attics are tangible evidence of a family's history, the public rarely has access to the letters that describe the daily life of our foremothers.

Ships sailed across the Atlantic, taking immigrants from Ireland and bringing passengers back to visit, conduct business, or on occasion to marry a sweetheart. When William Cumming returned to county Antrim in 1811 to marry twenty-year-old Mary Craig, the daughter of a Presbyterian minister, he was already an established wholesale broker in Petersburg, Virginia, and could afford to book comfortable accommodations for

the newly married couple on board the *Lydia* when the ship sailed from Liverpool for the return trip to New York. From the day she left her home, Strawberry Hill in Lisburn, Mary wrote long letters filled with the minutiae of daily life in early nineteenth-century Virginia, her travel experiences, personal triumphs, and heart-breaks; it was her way of staying intimately connected to loved ones back home.

Mary Cumming suffered severe seasickness on the forty-one-day Atlantic crossing to New York, but by November 1811, the couple had traveled to Philadelphia, then through Baltimore and Washington, to settle in Petersburg. William brought his bride to a home that simultaneously functioned as their living quarters, his office, and storage for goods he purchased for resale. Besides tobacco, William bought and sold flour, salted pork, and other foodstuffs. Mary delighted in comparing the cost and quality of Virginia produce and shared her observations. In December 1811, she wrote to her father, "Provisions are cheaper here than in Ireland, our flour is superior to anything I ever saw, potatoes are tolerably good, but they will not keep so well during the Winter as in Ireland."[30]

Mary was greeted by her household staff of slaves upon her arrival in Petersburg:

First there is old Nancy, the cook, who is an excellent good one, [and] Jenny the housemaid, who seems to be a very decent woman. She has four fine children, the eldest a little girl about twelve years old, who is to be my little attendant, her name is Mary. Then there is Betty, Cora and Joseph. They can all do something. Mary is a pretty good worker at her needle, she is now sitting beside me making a slip for herself. . . . Nancy bakes our bread. The American flour is extremely fine, I like the cornmeal bread very well, it is much better than we had in Ireland at one time.[31]

Uncomfortable with the concept of slavery, Mary wrote, "I like the black servants, (I cannot bear the word slaves) very much."[32]

Mary could afford to purchase lengths of fabric in the newest designs to sew into fashionable garments, and she was proud of her proficient needlework skills. "You cannot conceive how very much my white tippet is admired, it is the only one in Petersburg of the kind. I have told many people how it was done, but they are afraid to begin so troublesome a job. Pelisses of fine cloth trimmed with gold and gold buttons are very much worn here. This I think too showy a dress for the street. I have never seen any velvet as handsome as mine. I send you a little bit of the trimming [tatting] Agnes Freeland taught me to do."[33] Mary tried to explain to her sisters the process for tatting with cotton yarn used to trim bonnets and sleeves, and she promised to send some examples of her work.

Mary noticed all manner of style and dress worn by her contemporaries:

Their hair, ever since I came to this country[,] has been worn in what is called an Indian knot. It is twisted in this form as close to the neck as possible, I did not like this fashion much at first, but I am reconciled to it now. The Americans dress much more in the morning than is customary in Ireland, I have seen ladies fine enough to go into a ball-room paying morning visits. Perhaps this is owing in some measure to their

using carriages so much. There is a beautiful kind of silk to be got in this country, called the French Levantine. . . . I got a very handsome figured pink one for the last birth-night ball, which I paid fifteen shillings a yard for. Mercy upon us![34]

She gardened in the warmer months, but during the winter Mary concentrated on needlework. "I have been busy lately getting the black people's winter clothes, which is a very troublesome business. The women and children have all to get gowns and frocks of cloth, to keep them warm during our piercing cold weather."[35]

Mary's numerous letters to her sisters are filled with nostalgia for Ireland and her longing to return to her family. The anguish she felt when her first child, a daughter (whom she called "her little pet"), died before she was five months old is heartbreakingly clear in letters to her sister Margaret.[36] Mary describes the hostilities that developed into the War of 1812, as well as Petersburg's social life and minute details of daily domesticity. She frequently added packets of seeds with her letters so that her father could attempt to grow vegetables and flowers that thrive in Virginia, such as clematis and watermelon. As William's business prospered, Mary planned to start importing linen to Virginia with her father acting as their broker in Lisburn.

Mary's carefully penned letters of love and longing intimately express her yearning to stay connected to family and friends in Lisburn and a heartfelt desire to permanently relocate to Dublin within the next few years. Unfortunately, the embargo during the War of 1812 disrupted Mary's hoped-for family reunion in Ireland, which was never to be realized given her untimely death in 1815 at age twenty-four, four months after her second daughter was stillborn. Mary had remained in Baltimore after collapsing on a trip home from New York with William. She was well cared for in the home of Mr. and Mrs. Alexander Brown, who were longtime family friends from Ireland, where Alexander had been a successful linen broker before emigrating to Baltimore in 1800.

As her health steadily declined, Mary wrote to William, who had returned to Petersburg for business. Mary cut a lock of her hair, wrapped it in a piece of Irish linen, and tucked it inside the final letter to her beloved William, knowing she would never make the journey to rejoin him.

Frontier Settlers

For settlers in North America who chose to make their homes in the wilderness of the Appalachian Mountains, life was not nearly as comfortable or refined as it was for the Cummings. In 1806, the famous frontiersman David (Davy) Crockett (1786–1836) married an Irish girl named Mary Finley, nicknamed Polly. The young couple settled in a log cabin in Jefferson County, Tennessee, and over the next few years, Polly gave birth to two sons and a daughter. In his autobiography, Crockett mentions his wife's spinning and weaving skills with the words, "My wife had a good wheel, and knowed exactly how to use it. She was also a good weaver, as most of the Irish are, whether men or women, and being very industrious with her wheel, she had, in little or no time, a fine web of cloth, ready to make up."[37]

During the American Revolution, some Irish soldiers fought for the English and others against them. Youthful English landholders in Ireland such as Denis Mahon served in the British Army's Twenty-ninth Regiment of Foot and fought in battles in the colony of Maine during the final stages of the War of 1812. Thousands of soldiers, merchants, and settlers alike were moving back and forth across the Atlantic, becoming increasingly familiar with lifestyles and cultural traditions in both countries. It might be a long, difficult, and often dangerous crossing, but an insatiable appetite for adventure and the anticipated opportunity for financial betterment were worth the risk for people who had nothing to lose and others who had everything to gain.

Individuals within the constantly increasing Irish diaspora served as ambassadors for the emergent linen industry in Ireland. With new technology for bleaching, increased linen cloth production, and moderate economic stability at the end of the eighteenth and beginning of the nineteenth century on both sides of the Atlantic, manufacturers of Irish linen had an army of buyers, agents, distributors, and wholesalers poised to take advantage of the growing demand for Irish linen.

Domestic Life and Factory Work Grow Side by Side

A T THE END of the eighteenth century, the process of making lengths of linen cloth from the flax plant produced three different lifestyles and labor environments for men, women, and children who did the work: individual workers, a cottage industry of handworkers, and a growing commercial enterprise. The transition from spinning yarn or weaving cloth at home to full-time employment in textile mills and factories took place gradually and at different times in different parts of Ireland. Men who farmed and wove during only part of the year expanded their linen production with the invention of better, more efficient equipment and increased sales opportunities. If prices for linen were high, agriculture was put aside in favor of weaving, and when the demand for linen slowed, farmers could go back to the land to make a living. Individual weavers unwilling to leave self-employment at home found a niche market for handwoven cloth. However, most people took whatever work they could find with whoever would hire them to feed the family. A few clever and courageous men gambled on the changing times and expanded small linen operations by moving to bigger cities that offered a larger workforce and shipping opportunities. Fluctuating economies and individual financial needs determined choices made by the Irish in the eighteenth century, but traditional ways of making a living were changing.[1]

Facing page: Seal for stamping cloth. *Courtesy of Irish Linen Centre and Lisburn Museum. Photography by David Pauley, Belfast.*

A Domestic Industry

Until the Industrial Revolution, linen making was a cottage industry performed for the benefit of and by the entire family unit. To understand the lifestyle of people, especially women, during the early days of linen making in Ireland, one must connect daily labor with basic survival.

People shared their lives in the most intimate way with the paraphernalia of textile processing by which they made their living. This term, *made their living,* was chosen deliberately to reflect a mode of existence that is all but unknown today; their work was weaving and spinning, but work was so inseparable from life that it literally made their lives. They shared their small living spaces with looms and reels, raw flax, thread, paste-pots, pirns [bobbins], shuttles and heddles; if they were indoors, there was nowhere, morning or evening, where they could get away from the noisy loom or whirring wheel.[2]

Some women spun the short flax fibers called tow and wove it into coarse linen on narrow bandle looms.[3] The cloth was sewn into clothing for family members or sold to other households. Women's primary responsibility was to spin the fine, long-stapled flax fibers into yarn for their menfolk to weave into yards of linen cloth. If a woman did not have a male weaver to spin for, she could readily sell her yarn to another household, because numerous spinners were necessary to keep one full-time weaver working on a handloom. Many women became experts at their task, spinning great quantities of the finest (thinnest) yarn. It was a desirable and marketable skill that enhanced the family's income potential. Men took woven cloth to market or sold it to other families who did not have a male weaver. In some households, everyone was either a weaver or a spinner. The tasks were usually divided along gender lines, with women as spinners and men as weavers. Young children wound bobbins, and many preteenagers became proficient spinners and weavers; it was a family business in every sense of the word. This social structure allowed women to maintain the family unit by carrying out household duties, caring for children, and contributing to the family income without leaving home, a structure that would dramatically change with industrialization of the textile industry. Whole families shared in the work, and gender-specific roles were scrupulously adhered to; women were excluded from weaving linen cloth for the marketplace or working in the finishing processes of textile production, with one notable exception. The widow of a weaver could take over her husband's work and tools as long as she did not remarry. In all likelihood, widows who carried on their husband's trade were already weavers before they became widowed. Home production of linen yarn and cloth survived longer in less-populated areas located in the west of Ireland, beyond the orbit of the larger entrepreneurs.[4]

Women's Life and Textiles in Poetry

Poetry written in the eighteenth century allows contemporary readers to envision how people at an earlier time thought of themselves. It was not commonplace for people to be introspective or to question their place within a broader social context, for there was little time in the day for self-reflection. Nevertheless, throughout history, poets have used a few well-chosen words to tell of love, fear, and hope with insight and passion. In the late eighteenth and early nineteenth centuries, the folk tradition of songs and stories in Ireland and Scotland also included the published works of weaver poets. The writings of this particular group of poets indicate ways in which people viewed their lot in life and the work of spinning and weaving, which

was endless labor. Weaving was acknowledged as an honorable profession; a good weaver made a decent living working at home and adhering to his own schedule. Weavers tended to be better educated and considered themselves above most other tradesmen. Some weaver poets were eloquent wordsmiths, while others were quite average in their use of language, but as a group, weavers found poetry to be a means of describing personal joy and sorrow, marital relationships, and the daily struggle to make a living within the constraints of an unpredictable economy. Flax is a natural material, its growth and harvest subject to the whims of Mother Nature. For men and women who were processing the plant into finished and salable cloth, capricious weather and fluctuating market prices often determined a condition of feast or famine for a household that might include the immediate family, servants, apprentices, and members of the extended family, all relying on linen cloth for the necessities of life.

Weaver poets, song and ballad writers, satirists, and storytellers began to seek opportunities to publish their artistic endeavors as a way to preserve them. Ireland had a relatively high rate of literacy beginning in the early eighteenth century, and increasingly, even poor people could read (though they were not always able to write). Both men and women read poetry, and a few women purchased the work of locally published poets, as one poet in 1818 remarked: "Anne Harbison, Rockfield, is meaning to pore / Some nights on my book, when her spinning is o'er."[5]

Although some women were able to read and write, they undoubtedly had little time for such a frivolous pastime; if they were not spinning or weaving, their days were filled with child care, food preparation, and farm duties. Most weaver poets were men, so it is particularly illuminating to read words penned by women. In 1769, Olivia Elder, the well-educated daughter of a relatively wealthy family in county Londonderry, had some of the same complaints voiced by women in the twenty-first century when she wrote in verse to her neighbor describing how she spent her days.

> . . . Oft from my hand the Pen I whisk out,
> And in its place take up the dishclout;
> For spite of all sublimer wishes,
> I needs must sometimes wash the dishes.
> No wonder if my work but trash is
> When I'm obliged to lift the ashes; . . .
> Unfinish'd I must leave a fable
> To go and scour the kitchen table . . .[6]

Many daily household chores have changed over the centuries, and most women today purchase the variety of textiles needed for clothing and household items. Elder's poem is filled with textile references, but her sentiments remain the same as her modern-day counterpart; a woman must simultaneously accomplish a wide variety of tasks to successfully fulfill her role in society as well as manage her household duties.

Yet Beauty's Queen, and wisdom's Goddess,
I quit, to mend my whale-bone bodice; . . .
I sometimes sew and sometimes knit
And oft in social circle sit . . .
What need I speak of candles dripping,
Of brewing, baking, and tea sipping
With Ladies, then entreat excuse
Till I shew Nan to kill a goose;
Or how I went from spinning tow
To entertain a Paris beau . . .

Nor would believe with what art
I play the Manteaumaker's part, . . .
How catgut envied work have wrought on
For working muslin, now thin cotton,
Now sprig a gown, and now an apron,
And now a steed I sometimes leap on,
Or learn to do some Dresden stitches,
Then go and mend an old man's Britches,
And then begin the very trade
In t'other world of ancient Maid.[7]

Male weaver poets who shared their lives with women spinners wrote some interesting descriptions of domestic life, adding to the scarcity of women's own words. In 1831, Joseph Carson of county Down wrote of a pleasant home life of shared labor.

My Bess the house trims up full-tidy,
An' wi' her wheel sits down beside me
While I maun make the shuttles play
To crack an' wile the time away.[8]

There are, of course, less flattering images of the spinner and her work, particularly toward the end of the domestic linen industry period. It was a demanding life for weavers and spinners alike, working endless hours in cramped, dimly lit spaces that were more often the size of a hut than a cottage. The words of a father testifying before a parliamentary committee in 1840 proclaim the hardship of one family's efforts to survive: "I have a wee girl who never gets off the loom from daylight in the morning until ten o'clock at night. She is only 13 years of age. She can earn 8d or 10d a day."[9]

Poet Sarah Leech

The work of poet Sarah Leech is another example of how some women viewed their existence when spinning was all-important to the family's survival. By the time she was three years old, Sarah's father, Thomas, a linen weaver in county Donegal, had died, and the family was too destitute to provide a proper education for Sarah, the youngest of six children. An older sister taught Sarah to read, a neighbor loaned her a few books, and during a brief episode of schooling, she learned to write. Sarah Leech was one of the few Irish women to publish her own poems; her contemporaries called her the "spinster poet" and "peasant girl."

Spinning was the monotonous work that Sarah performed throughout her life, and she was able to continue to earn a living by spinning yarn even after she become lame. While her hands fed the flax fibers onto the bobbin, Sarah's mind was free to memorize and compose poetry in her native Ulster-Scots dialect. Her small volume of poetry, published in 1828, has a frontispiece featuring Sarah at her wheel, a book in hand, and an inkwell on a stool beside her.[10]

> Wi' heck weel-teeth'd and spit renew'd
> I sat me down to spin contented:
> And your address to me reviewed,
> Which set my head amaist demented.
>
> My muse kens naught o' Sappho's lays
> Who sung sublime on soaring pinion
> O! how the neighbours round would gaze
> If I, love-struck, should leap off Binion![11]

Sarah's poem reveals her matter-of-fact attitude toward her work, both the flax spinning and the poetry. The rhyme between the poetic use of "pinion" and the local place-name is particularly appealing; Binnion Hill, the second most northerly summit in Ireland, overlooks Binnion Bay, county Donegal.

Linen Becomes a Commercial Enterprise

Development of the linen industry on a commercial basis in seventeenth-century Ireland began primarily in the Lagan Valley, located in southern county Antrim, northern county Armagh, and northeastern county Down. The fertile valley surrounding the River Lagan is not affected by extreme weather conditions, and the thirty-mile-long river flowing from Slieve Croob in county Down to Belfast Lough, an inlet of the Irish Sea, served as a valuable communication and transportation route connecting people and goods to the coast, the rest of Ireland, and trade routes across the world.[12]

Spin, spinner, and *spindle* have been used to describe the process for making yarn since the earliest days of the English language. The same words are spoken in twenty-first-century society to express new meanings that only vaguely echo past usage. A *spinner* was, and is, a woman who spins fibers together to make yarn. Images of a woman sitting serenely at her spinning wheel, with one foot on the treadle as she feeds fibers onto a bobbin, are featured in textbooks, seen at art museums, or demonstrated at craft fairs. Various components of the image have taken on new meanings through the centuries: the storyteller *spins* a yarn, a car might *spin* out of control, and sometimes people feel as if they are *spinning* in circles without accomplishing anything.

Women who never marry are known as *spinsters,* but the word was originally used to denote their occupation, not their marital status. During the first wave of Irish migration in the late seventeenth century and early eighteenth century, many women traveling with children but without a husband listed themselves as *spinster* on the ship's manifest. This designation may have contributed to the belief that a spinster was always a single woman who stayed at home to spin yarn and missed the opportunity to marry; however, some spinsters were undoubtedly widows who supported themselves and their children by spinning.

On a spinning wheel, the *spindle* twirls as fibers are twisted into yarn and fed onto a bobbin. Drop spindles are rods, tapered at one end and weighted at the other, used to hand-spin yarn without benefit of a wheel. More recently, the word *spindle* is used to describe the sharp-pointed rod kept on the desktop, impaled with saved messages. Curving, tapered bedposts are called spindles, and so are narrow rods that support a handrail.

Words that explain the spinning and weaving process follow us through the ages, changing over and over again as people give new meaning to familiar words in an ongoing effort to describe the world around them. For example, at a wedding, the bride's family sits on the *distaff* side of the aisle. A distaff is the staff or pole on which wool or flax is wound before spinning. Because women, not men, were spinners, *distaff* has come to mean a characteristic of women similar to feminine intuition. It is also used to refer to women as a group.

Similarly, the word *warp* has been used as a weaving term since the eighth century. The many individual lengths of yarn that bend across a beam at the back of the loom to the front are warp threads and usually have a tighter twist than the cross yarn, which is called the weft or woof. If a person has a *warped* personality, then it is somehow twisted or bent out of normal shape.

The River Bann falls into two distinct parts.[13] The upper Bann flows northwest from the Mourne Mountains to Lough (lake) Neagh. The lower Bann carries the waters of Lough Neagh to the sea below Coleraine. Upstream, the waterpower from the river played an important part in the industrialization of the Ulster linen industry. Water-powered spinning frames were used for spinning yarn after its invention in 1769, but the cloth continued to be woven on handlooms for another fifty years. The population grew steadily in the valleys of the River Lagan and the upper Bann as the quality of Irish linen improved and demand for the cloth increased. By the middle of the eighteenth century, linen handloom weavers were able to earn a reasonable living, and many prospered sufficiently to employ other workers in their homes as apprentices or

journeymen, or they spun yarn under contract to nearby weavers. Such weavers became known as "manu-facturers" and tended to spend more time weaving than on farm work. As independent craftsmen, they set their own work schedule and traditionally kept Saint Monday as a day of rest, making up for the long hours toward the end of the week or a Sunday night at the tavern.[14] As a group, they were usually literate, and some wrote poetry and belonged to reading clubs. Their houses were well furnished, with clocks and china; they had plenty of food; and their womenfolk wore the latest muslin or cambric dresses.[15] Although the work demanded long hours and would be judged difficult labor by modern standards, the domestic linen industry in Ireland at the end of the eighteenth century provided a relatively secure livelihood that enticed more and more families to become involved in its production.[16]

Lord Conway of Lisburn and Arthur Brownlow, squire of Lurgan from 1665 to 1710, were landowners based in the heart of the Lagan Valley who encouraged their tenants to begin producing linen cloth. Their two estates covered a large part of southern county Antrim and northern county Armagh. Conway and Brownlow had to convince their tenants that linen production could provide a livelihood because no mar-keting opportunities had yet been established within the province. To create a viable linen trade, Brownlow personally bought all the woven cloth his weavers brought to Lurgan market and took it to Dublin to resell. In Lisburn, Lord Conway built a market house, and in 1627, King James I granted permission for a weekly market to be held every Tuesday in the town. By the last quarter of the century, their efforts to create a steady economic base for linen manufacturing had proved successful enough that the number of weavers in coun-ties Down, Antrim, Armagh, Tyrone, and Londonderry increased to more than five hundred, each weaver selling a better quality of cloth than had been woven previously. A 1696 London trade compendium referred specifically to linens made in the north of Ireland as "of great use and wear very white and strong."[17]

Huguenot Weavers Immigrate to Ireland

This embryonic stage of spinning and weaving linen in Lisburn was boosted by the arrival of Protestant Huguenot refugees forced to flee France because of religious persecution after the mid-seventeenth century. When Protestant King Henri IV came to the French throne in 1589, he was forced to adopt the Catholic faith, but being sympathetic to Protestants, Henri signed the Edict of Nantes in 1598 to offer Protestants protection against Catholic persecution in a few towns in northern France. The great majority of French people, in the north as elsewhere, remained Catholic. Henri's grandson Louis XIV, known as the Sun King, subscribed to the popular European belief that to achieve national unity he had to first achieve a religiously unified nation. After 1665, the king was persuaded by his Roman Catholic advisors to send royal troops on raids to force French Protestants, known as Huguenots, to convert to Catholicism. In 1685, Louis revoked the Edict of Nantes and banned the practice of any religion except Roman Catholicism in France. More than two hundred thousand French Huguenots fled during this time. Some of the ten thousand refugees who went directly to Ireland were successful financiers and textile manufacturers.

Louis Crommelin, a Huguenot from St. Quentin in Picardy, France, came from a family with a long history as linen merchants and bleachers. In 1698, King William III of England invited Crommelin to settle in Ireland and establish linen manufacturing under his royal patronage. Crommelin probably chose to settle in Lisburn for two reasons: the region already had an established reputation as a linen production center, and former soldiers who fought in Huguenot regiments under King William III during the Jacobite wars of 1689–91 had settled in the area. Some Huguenots had been skilled weavers in France, and the small community was already connected by marriage and friendship. A number of specifically trained workers, such as a reed maker and a shuttle maker, came with Crommelin to the new settlement.

Crommelin set up a weaving operation and bleach yard, and in 1705, he published *Essay towards the Improving of the Hempen and Flaxen Manufactures in Ireland,* the first book in English on the subjects. Crommelin advocated improved techniques in spinning, weaving, and bleaching based on Dutch and Flemish practices. Although his recommendations were mildly criticized by later experts, Crommelin is credited with playing an important role in attracting both royal and government interest in further development of an Irish linen industry. Recent historians have realized that Crommelin received more recognition as the founder of the Irish linen industry than he deserved, in large part because of his close affiliation with the government to promote Irish linen as a viable industry; his fame undoubtedly influenced public policy.[18]

The Quaker Influence

Another group of immigrants who had an even greater impact on the Irish linen industry were Quakers, members of the Society of Friends. The first Quaker settlers who arrived in the mid-seventeenth century in Lurgan and Lisburn brought values of hard physical labor, frugality, and an independence of spirit to their work. Forbidden to enter professions, Quakers made their livelihood in commerce and trade. Many of the most significant merchant families in the eighteenth-century Irish linen industry were Quakers. They were strongly encouraged to marry within the faith, and many did so for generations, strengthening the ties between personal and professional life. The Quaker network of business and family connections extended throughout Ireland to Britain and North America, forming immensely important relationships for matching buyers to sellers. Before commercial banking, this expansive network of families provided a trustworthy financial network as well. There were especially close links between Pennsylvania and Ireland because William Penn, founder of Philadelphia, had become a Quaker during time he spent in Ireland in his youth. Later in the nineteenth century, Quaker families employed thousands of workers in linen mills and factories and exerted an immense influence on the development of the industry.[19]

Among the fifty-two households located on the vast estate centered around Lisburn and granted to Sir Fulke Conway about 1610 were Steven Richardson, Symon Richardson, and John Ap Richard. The Richardson

name is English, and these early settlers are believed to have immigrated to Ireland as part of the plantation movement. Jonathan Richardson (1781–1851) was the first member of his family to join the Society of Friends.

The Richardson family became one of Ireland's oldest linen families, and generation after generation of sons worked in the business. Within this prolific family with numerous male descendents, there was opportunity for each son to find his role within the industry. At one time or another, a Richardson descendant imported flax and grain, invented a better bleaching process, opened new firms in England and America, partnered with competitor manufacturers, participated in establishing the Inman Line of steamships, and married into other successful linen families across Ireland. The Richardson family became wealthy, successful, and respected as producers of fine Irish linen.[20]

Skilled Handwork of the Leisure Class

As the quality of linen cloth improved and production and sales increased, a new generation of wealthy textile entrepreneurs was born. Fortunes made in linen provided families with grand homes lavishly furnished, numerous estate properties, fine food and wine, and travel opportunities. Their wives and daughters were elegantly dressed and accomplished in art and music skills commensurate with their station in society. Men's wigs (worn for the sake of fashion, not to cover up baldness) made of flax fibers (circa 1716) came in various shades, with the more expensive, lighter colors preferable. Theft was not uncommon, but most flax wigs fell off easily.[21] Beyond the very wealthy class, there was also an upper middle class that associated with popular artists and authors of the day. None of the women in this class needed to work for a wage or contribute handwork skills, such as spinning, to household economies. But women who were conscientious and artistic had time and talent to create magnificent textiles for personal use or to commemorate special events. Fine Irish linen was a suitable and desirable cloth to demonstrate exquisite embroidery skills.

Mary Delany (1700–1786) chose finely woven cream-colored Irish linen to make a quilt to celebrate the 1765 birth of Thomas Sandford, the son of close friends. Working with cream cord, she used knots and couching to create a central medallion of flowers surrounded by a trellis of flower heads on the nearly eight-foot-square bedcover.[22] Mary was English by birth, and after the death of her first husband, she met author Jonathan Swift and her future husband, Patrick Delany, on a trip to Ireland. Delany was the author of religious writings, and the couple was friendly with important English and Irish writers of the day. Patrick was appointed dean of county Down soon after their marriage, and the Delanys divided their time between the north of Ireland and a home in Dublin.

Mary Delany was an enterprising artist beyond her exquisite work as an embroideress. At seventy-one years old, she began to create cutout paper artworks highly regarded by ladies of the court. Her paper artworks were exceptionally detailed, with botanically accurate depictions of plants. She hand colored

Girl's waistcoat (vest). Very fine linen fabric embroidered with gold silk thread in an overall stylized floral motif, late eighteenth century. The bleacher's mark—"William Henderson, Antrim"—is stamped on the plain linen lining. *Courtesy of Irish Linen Centre and Lisburn Museum. Photography by David Pauley, Belfast.*

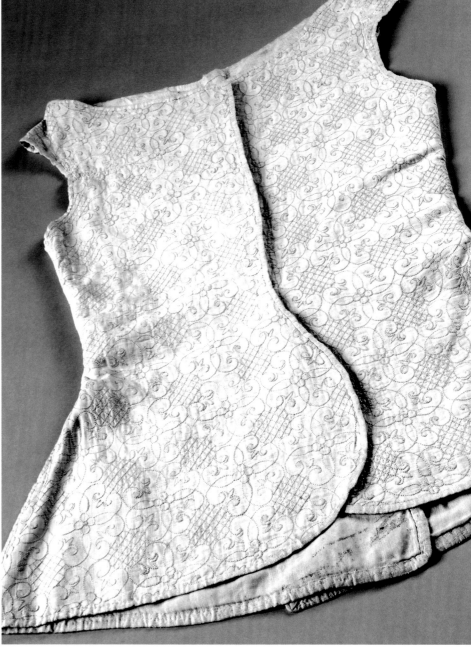

Detail of girl's waistcoat linen and embroidery. *Courtesy of Irish Linen Centre and Lisburn Museum. Photography by David Pauley, Belfast.*

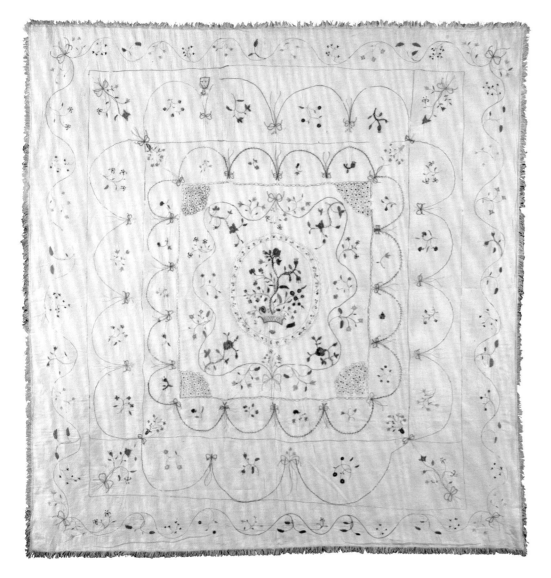

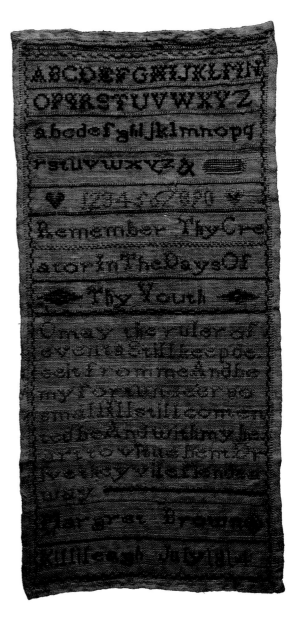

The Myra bedcover. This delicately embroidered bedcover remained in Myra Castle, Downpatrick (county Down), from the time it was made in 1775, passing through the female line of the Anderson and Craig Laurie families, until 1990, when it was purchased by the Ulster Museum. Although it is often referred to as a quilt, the Myra bedcover is not actually quilted but backed with another layer of linen. The embroidery is fine wool, done primarily in a chain stitch. The decoration is floral in the main with bows and swags; there is a single little figure of a lady in contemporary dress (1775) and a feathered headdress, possibly instead of a signature. The edging is linen fringing. © National Museums Northern Ireland 2011. Collection Ulster Museum.

Linen sampler stitched by Margret Brown in 1814 at Killileagh (Killyleagh), county Down. Embroidered in silk yarn on coarse-weave linen, the verse reads, "Remember thy creator in the days of thy youth—O may the ruler of events still keep deceit from me—And be my fortune e'er so small I'll still contented be—And with my heart to vi[r]tue bent—Drive they vile fiends away. © National Museums Northern Ireland 2011. Collection Ulster Folk & Transport Museum.

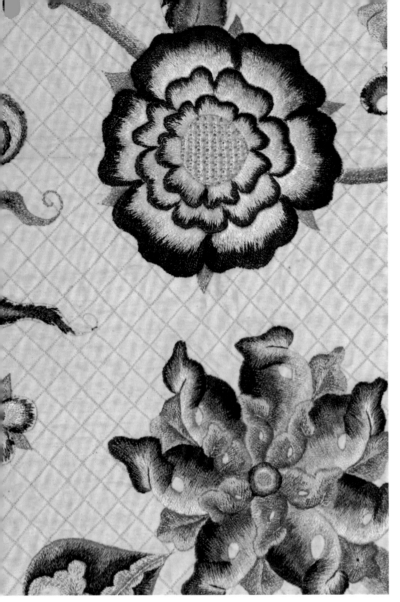

Detail motif of quilt signed by the maker, Martha Lennox, and dated 1712. The quilt was made of cream-colored fine linen, backed with a slightly coarser linen and narrowly quilted diagonally in pale green silk with brilliantly colored embroidery overall. © *National Museums Northern Ireland 2011. Collection Ulster Museum.*

tissue paper to produce her paper mosaics, all 1,700 of them. She also left six volumes of autobiography and letters that give a vivid insight into life, tastes, fashion, and gossip of eighteenth-century society.[23]

Another artistic woman skilled with a needle and thread was Martha Lennox (c. 1686–1729). The daughter of John Hamilton, Lord Mayor of Belfast, and the third wife of Robert Lennox (b. 1660), Martha chose finely woven Irish linen to make a six-foot, six-inch square quilt in 1712. The brilliantly colored French silk embroidery is executed with long and short stitches, stem stitch, French knots, and cross-stitch. The many different shades of each color are blended and matched with great skill. The quilting is done in tiny backstitches of pale green silk, and the edges of the quilt are bound with a band of narrow green silk ribbon. Because it was counted as "household linen," the quilt was passed down through the female line of her family until it was acquired by the Ulster Museum in Belfast, Northern Ireland.

The interaction between Irish people and Irish linen had many facets. Linen was a fabric that enriched the lives of the upper classes and provided a livelihood for others. Embroidered linen bedding and lace collars were fashioned by working-class mothers and sold to middle-class women as wedding gifts for someone else's daughter, but they could never aspire to make such a gift for their own children. Martha Lennox could afford to purchase silk thread for her embroidery, so, conceivably, she could have afforded a more luxurious fabric to use as the background for her stitches if she had wanted it. Her choice of finely woven linen indicates that it was a desirable fabric available to upper-class English and Irish women in the first decade of the eighteenth century.

Linen Exports

At about the same time that Crommelin settled in Lisburn in 1698, the English government removed import duties payable on plain linens from Ireland, which gave Irish linen production a strongly competitive edge over linens produced in European countries. Linen cloth was mainly exported to England through the port of Dublin. Exports of linen cloth increased from 92,000 yards in 1685 to over half a million yards by 1705.[24]

By the mid- to late eighteenth century, market forces were beginning to turn household textile activities into a semi-industry; farmers in rural settlements set up their own weaving sheds to turn out salable cloth. In counties Londonderry, Fermanagh, Tyrone, Cavan, and Donegal, weavers used a ready supply of linen yarn spun by hand from flax grown on small local farms. The towns of Lisburn, Lurgan, and Dungannon constituted the core of fine linen sales, and because of their close geographical proximity, the area became known as the linen triangle.

By an act of Parliament in 1710, Irish linens took on specialized names relating to their places of origin. Lisburns, Lurgans, Coleraines, and Droghedas referred to cloth of specified widths and lengths, stamped with elaborate insignias for further identification. This gave recognition to small towns for their cloth production and also meant that distant buyers could rely on a recognized insignia as proof that they were receiving the same quality of linen with each purchase.

Throughout the whole of the eighteenth century, linen exports to England, and through England to colonies in the Caribbean and North America, continued to rise sharply. Many small harbors along the Irish Sea coastline were used for exporting linen, but it was the major English port cities of Bristol and Chester, and later Liverpool, that became great centers of the Irish linen trade.

The Irish Linen Board

In 1711, the English government established the trustees of the Linen and Hempen Manufacturers of Ireland, known as the Irish Linen Board, to regulate every aspect of flax growing, processing from fiber to cloth, and selling. Board representatives traveled across the island to make sure industry standards were adhered to, and a detailed record of Linen Board meetings and correspondence was published annually. Based in Dublin, this body settled disputes between growers, determined who received premiums (subsidies), and made economic policy for each province. The board also gave money to erect spinning schools to be administered under the patronage of a landlord or his wife.

The Linen Board had seventy-two male members, with eighteen representing each province. Membership was sought after, for it was considered an honor by the gentry and aristocracy, who were well traveled, well educated, and almost always members of one or other house of Parliament. Fortunately, only seven members made up a quorum to conduct business, enabling the Linen Board to be a surprisingly effective organization, considering the high rate of absenteeism and eighteenth-century road conditions that made travel difficult at best.[25]

Seal Masters

Hogsheads of flaxseed had to be inspected and stamped before the seed could be sown; brown linen was inspected and stamped for quality before it was sold to the bleacher; and before the finished white linen

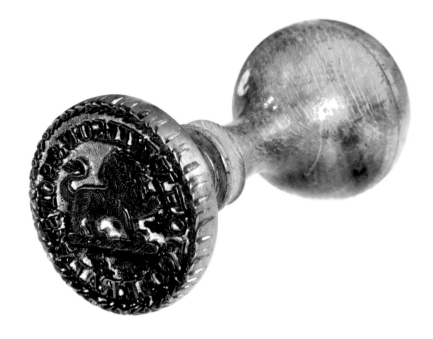

Seal for stamping linen cloth. The wooden-handled seal has a lion in the center and a leaf design around the edge, with "John Wilson & Sons / Colerain" wrapped around the central lion. *Courtesy of Coleraine Museum, Causeway Museum Service, Northern Ireland.*

Seal for stamping linen cloth. The seal bears a design of shamrocks above flax plants framing "John Orr Jun. Warranted All Pure Linen Registd. Bleacher" written in the center. *Courtesy of Coleraine Museum, Causeway Museum Service, Northern Ireland.*

Seal for stamping linen cloth. This round seal, surmounted by a crown, has a harp with a figurehead frame in center, encircled by "Samuel Wilson / Colerain." *Courtesy of Coleraine Museum, Causeway Museum Service, Northern Ireland.*

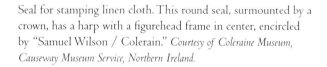

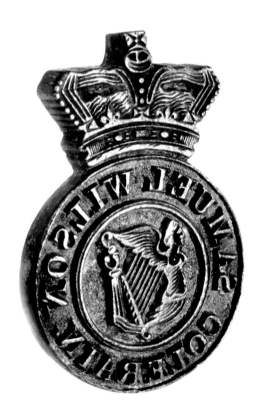

was exported, another seal master inspected, measured, and stamped the cloth. The law of 1733 demanded that each bolt of brown linen sold on market day was to be folded, untied with a lap-yard turned out,[26] and stamped with the seal of a bonded seal master. Every activity of linen production came under inspection.

For weavers, bleachers, and drapers, the market system did not always function harmoniously. The intense demands on drapers to work hurriedly to buy the best-quality linen at weekly fairs meant that inspectors had to examine and measure every web[27] of brown linen on the afternoon of fair day. It was a job that proved too demanding to be reliable, and the system was easily abused. Seal masters were paid one penny for each inspected web of brown linen, not to exceed twenty-five yards in length, but some weavers were dissatisfied with a seal master's measurement. In 1820, Samuel Jenkins and John Graham were charged with damaging a measuring machine belonging to seal master James Bradshaw, who was working at the Ballybay linen market. Both men were found guilty; Graham was sentenced to a whipping in Ballybay and one year in jail, while Jenkins got off with a lighter sentence of three months' imprisonment.[28]

With all these controls in place, there were still conflicts between the varying factions of the growing linen industry, and weavers chose passive resistance or sold their webs outside established market hours if they felt that regulations were too intrusive. It was an ongoing struggle for the board to successfully regulate a dispersed cottage industry with no guild structure. Inspectors traveled through the four provinces of Ulster, Leinster, Munster, and Connaught and reported their findings to the trustees. In response, the board tried to sort out truth from allegation and deception.[29]

The Linen Board constantly instituted new rules to ensure a higher standard of cloth. After 1719, white linen was stamped with a harp and crown motif, plus the name and location of the seal master, who was appointed by the Linen Board. Private seal masters were allowed to stamp webs from their own bleach greens if there was no local public inspector within six miles. Seal masters carried a tin box containing fifteen numerical figures used to stamp the number of yards after measuring. For white linen, seal masters were paid one yard of cloth per stamped yardage of uncut piece or web. Once Dublin's White Linen Hall opened in 1728, commission merchants and drapers began showing their linen for sale in assigned rooms and no longer dealt with the hassle of country fairs.[30]

To encourage more farmers to grow flax and spin yarn for the expanding industry, trustees of the Linen Board awarded annual subsidies called premiums. In 1796, looms and spinning wheels were allocated according to the amount of land put aside for sowing a quantity of good, sound flaxseed between March 10 and June 1 each year. For every one rood (approximately a quarter acre) planted, a farmer received one spinning wheel; for every five acres cultivated in flax, he was given a loom, reels, or hackles equivalent in value to fifty shillings. In 1796, the Linen Board listed more than 2,500 names of flax growers in county Louth, the smallest county in Ireland, with only 317 square miles.[31]

Postcard of Belfast's White Linen Hall, built in 1785. *Courtesy of Monaghan County Museum, Republic of Ireland.*

Old Linen Hall. Belfast.

White Linen Halls

The White Linen Hall was a meeting place for linen bleachers and merchants to sell their cloth to English buyers who supplied Irish linens to specialized drapery shops in London and across England. As linen merchants and bleachers in the north of Ireland gained prosperity, they became increasingly dissatisfied with shipping their goods to Dublin to sell, for they were convinced that the future direction of the industry lay in the north of Ireland. To prove that linen's potential would be better served from the north, linen halls were built in Newry and Belfast to provide regional drapers and bleachers an opportunity to deal directly with English buyers.

New Bleaching Technology

While some aspects of linen production as a cottage industry adapted easily to the more organized manufacture work as new equipment was developed, bleaching continued to be a demanding, time-consuming, hands-on endeavor until skilled bleachers arrived from Holland along with Huguenot refugees from France in the early decades of the eighteenth century. Standards of bleaching soon improved with the introduction of bleach yards constructed with funds given by the Irish Linen Board so that weavers no longer had to bleach their own linen.

In 1821, the movement into factory production was already well under way in some northern counties, as people went to work in cotton and linen mills built in larger cities. Spinning and weaving were still unmechanized work, but many workers came together under one roof. The word *factory* is a shortened version of *manufactory* and literally designates a place of manufacture. Within the Irish linen industry, spinning and supplementary processes took place in a mill, whereas weaving and its related processes took place in a factory. *Mill* and *factory* were not only specific terms denoting the work but also distinctly separate facilities.

From Cotton to Linen

In the last quarter of the eighteenth century, developments in the English cotton industry encouraged the spread of cotton weaving in and around Belfast, and by 1825 there were approximately twenty cotton mills in the town. The growth in cotton production made it the principal textile industry in Ireland, and linen manufacturers struggled to compete with cheap raw cotton imported from the southern states in North America. Competition from cotton led Irish linen merchants to experiment with powered spinning techniques for flax; with the development of mechanized wet spinning, a process of thoroughly soaking the flax fibers to make them slippery enough to be drawn by machinery into a very fine thread in the 1820s, spinning fine flax yarn by machine became possible.[32]

One of the most crucial events in the emergence of the mechanized linen trade in Ireland was the decision of Thomas and Andrew Mulholland to rebuild and convert their cotton mill in Belfast into the first steam-powered flax-spinning mill, following a fire in 1828 that nearly destroyed the building. The immediate success of the new mill proved a catalyst for several other mills and factories to convert to linen production. In 1831, John Hind and his brother-in-law, Captain John Boyd, built the Blackstaff Spinning and Weaving Company on the Blackstaff River in Belfast at the corner of Durham Street and Sandy Row—then known as Tea Lane. The demand for Irish linen as a global product was well under way, sales were gaining momentum, and the reputation of the cloth was becoming increasingly prestigious.

Hand Spinning Declines

The linen industry was highly unpredictable, and even periods of great prosperity were interspersed with sharp and sudden contractions. A great depression for hand spinners followed the invention of wet-spinning machinery, which was used primarily in mills in Ireland's northern counties. Mill-spun yarn cost the weaver less money, making his cloth proportionately cheaper; weavers who purchased mill-spun yarn undersold competitors who used hand-spun yarn. Machinery and hand labor were rivals, and machinery won at every crossroad as the Industrial Revolution built momentum throughout the nineteenth century.

The slide into unprofitability for linen spinners and weavers in rural counties accelerated once the cotton mills of Belfast switched to wet spinning in the late 1830s, and many families were thrown into irreversible poverty. The Ordnance Survey memoirs of the 1830s note the changes in economic conditions. In one parish in county Fermanagh, females of all ages were accomplished hand spinners, but spinning afforded "a very scanty profit for incessant labour."[33] Though dealers from areas farther north still sought hand-spun yarn, prices fell off one-third from previous years.[34] The future for hand spinners in county Fermanagh and elsewhere had become hopeless.

The dwindling earnings of domestic hand spinners spelled the beginning of the slow demise of cottage textile production. Some women spinners took up handloom weaving alongside their menfolk. Other women found employment in spinning mills; some families moved to towns and others emigrated. The shortages and destitution of the first famine years in the 1840s created more difficulties because of the high price of foodstuffs and the spread of disease. The introduction of mechanized weaving in the 1850s led to further destitution among weaving families, and many more moved to Belfast and the surrounding area or out of Ireland altogether.[35]

The Putting-Out System or Outworking

With the end of hand spinning in most communities, a growing number of women found work hand embroidering all types of household items for the commercial textile industry. White linen sheets, pillowcases,

christening gowns, priest's robes, handkerchiefs, and clothing were embellished with ornate designs or simple initials appealing to a wide range of buyers. Women were outworkers, and the system of taking goods to workers in rural communities surrounding textile centers was called the *putting-out* system. This aspect of the textile industry flourished in nineteenth-century Ireland and remained a valuable source of income for families into the early twentieth century. Beyond the financial rewards, many female outworkers took great pride in their needle skills, which provided a creative outlet for their artistic talents.[36]

In the putting-out system, a woman worked in her own time, fitting embroidery around domestic chores of child rearing, cooking, and farm work. Agents distributed the work through the countryside. Some agents worked freelance, but most were employed directly by a linen manufacturer; they were all men. Agents went to a predetermined location on a regular basis, usually weekly, to distribute parcels of work among women willing to complete it. Embroidery

Detail of red cotton embroidery on a linen chasuble that was part of a set of clerical vestments provided to Clonard Monastery, Belfast, c. 1970s. Church laywomen frequently used their needlework skills to decorate clerical garments, altar cloths, and kneeling cushions. © *National Museums Northern Ireland 2011. Collection Ulster Folk & Transport Museum.*

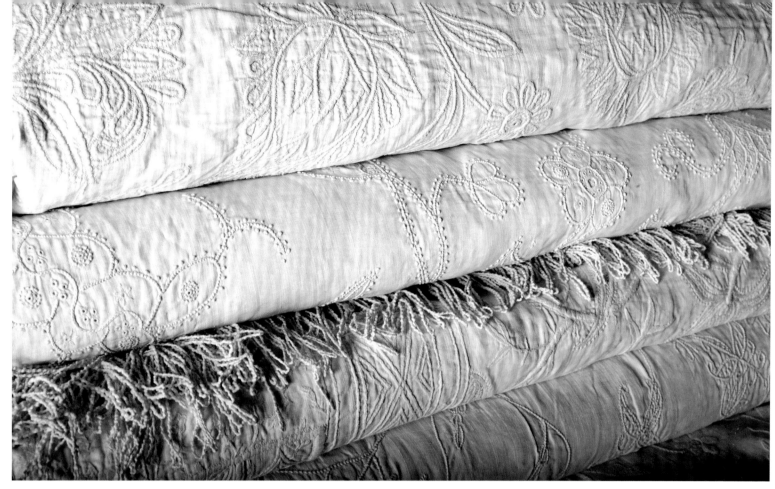

Irish linen bedcovers. *Top:* Documentation suggests that this quilt was made by a sewing maid in the household of the Richardson family of Bessbrook, county Armagh, c. 1790. The quilt is made of two layers of handwoven linen, quilted with cording (a type of relief quilting, begun in England but made famous in Italy, that places a measured piece of cording or thread into a quilted channel) and embroidered. *Second from top:* Irish linen bedcover embroidered in Ballyhosset area, near Downpatrick in county Down, known for flax mills and early linen production, c. 1790. *Bottom and second from bottom:* Both were embroidered in stylized floral designs based on imported Eastern textiles of the period, c. 1770–80. Such bedcovers were popular as wedding gifts. © *National Museums Northern Ireland 2011. Collection Ulster Museum.*

Pair of child's mittens, eighteenth century. The outer fabric is linen trimmed with Valenciennes (bobbin) lace, and the lining is silk. *Courtesy of Irish Linen Centre and Lisburn Museum. Photography by David Pauley, Belfast.*

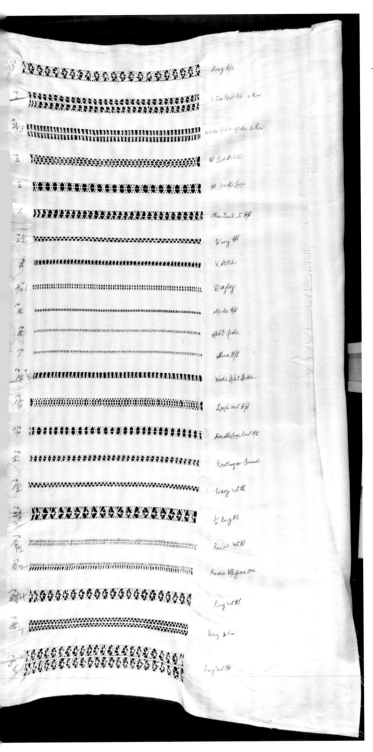

had to be kept clean, or the worker was paid at a reduced rate. The term *parceling* also became a common name for embroidery work. Other names for the handwork—*flowering* (usually pronounced "floorin") and sprigging—reflected popular embroidery designs. Embroidery workers generally walked from their homes, often a journey of several miles, bringing with them completed work from the previous week. If the worker was embroidering sheets or bedcovers, the weight of multiple pieces of linen fabric was considerable. The agent inspected the finished embroidery to determine the quality of the work and paid at a preestablished rate if it met with the agent's standard for workmanship and cleanliness. Occasionally, a small group of women could make a large commission by working together to embroider a set of bed linens to fill a rush order in a single day. When work was slow, embroiderers returned home empty-handed. In some cases, local shopkeepers paid for embroidery work with goods from their shops rather than cash.[37]

Such a high level of specialization is directly related to the cost of production and to the levels of payment received by the embroideresses. While it can be said with some certainty that embroidery was not a highly paid skill, many families depended heavily on needlework to augment their incomes. During the years of the Great Famine, needlework money prevented starvation for many families. One observer estimated that in the 1860s, a total of 320,000 women earned their income from needlework. However, an intricate piece of work completed quickly, cleanly, and to the required quality standard provided the worker with a bonus of only a few pence. It was highly skilled work that paid poorly, but there were few alternatives for women to earn an income.[38]

With the industrialization of linen production and the rise of Belfast as a thriving center of Victorian commerce, embroidery crafts were organized on a large scale, particularly as a source of employment for women. Early in the twentieth century, so many women were involved in producing prized decorative work, especially done in white thread on a white background, that a map published in 1907 represented the entire northern region of the island as a source of needlework. As the twentieth century progressed, machine-decorated linens increasingly dominated the market, but the finest goods were always hand decorated.

Linen fabric with sample stitches and corresponding descriptions, given to outworkers as a reference guide for drawn-thread work, early twentieth century. Outworkers undertook to work many styles of embroidery on both linen and cotton handkerchiefs and domestic textiles, but linen was the most appropriate fabric for drawn-thread work. © *National Museums Northern Ireland 2011. Collection Ulster Folk & Transport Museum.*

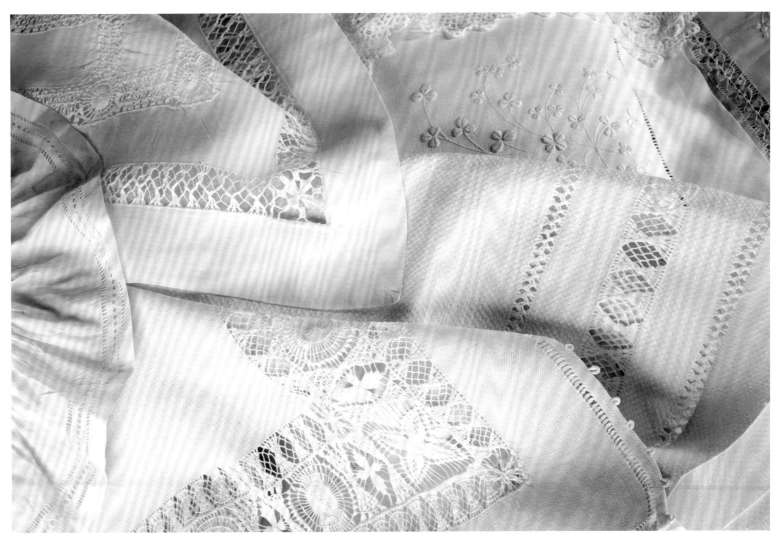

Plainly woven linen, even if it is sheer handkerchief weight, is often embellished with some form of design to make it an attractive and desirable commodity. The emphasis on good design for decorated linens, and for Irish needlework in general, illustrates the widespread view that this was essential for the commercial success of the industry. Prior to the mechanization of the linen industry, prizes were awarded for damask design and probably for embroidery designs. Embroidered white thread on white linen is usually thought of as a traditional craft, but most embroiderers worked for the marketplace and according to the dictates of fashion and an agent's instruction. Women seldom owned an example of their own work; it was too costly for their meager salaries.

Women and girls were increasingly attracted from the countryside into the larger towns to become factory workers and earn a steady wage. While piecework rates paid to home-based workers might be

Linen pillowcases decorated with embroidery, cutwork, and lace trimmings, late twentieth century. © *National Museums Northern Ireland 2011. Collection Ulster Folk & Transport Museum.*

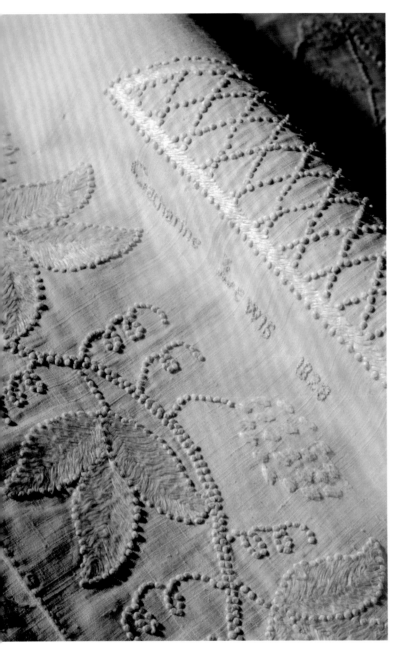

Linen bedcover, hand embroidered and signed by maker, Catharine Lewis, 1828. © *National Museums Northern Ireland 2011. Collection Ulster Folk & Transport Museum.*

slightly higher than rates paid to factory workers, factory girls had the advantage of a more secure employment.

Promoting Irish Linen

Throughout the eighteenth and nineteenth centuries, the Linen Board received a steady stream of complaints from farmers, manufacturers, and buyers looking to the government-controlled agency to find resolutions for unfair practices or to demand compensation for a wide range of crimes. Trustees' correspondence and their records trace the linen industry's expansion through the invention of new technology, describe crop failures, note competition between rival manufacturers, promote efforts to self-regulate, embrace tax reforms or efforts to oppose them, and devise plans to present Irish linen in a worldwide marketplace.

Edmund and Henry Shanahan claimed the requisite bounty (subsidy) from the government for the 73,245 yards of linen cloth they supposedly shipped from the Custom House of Cork (Ireland) to Barbados and Jamaica in 1803. A dispute arose over the recorded weight of each shipment entered into the account books by Landwaiter (customs official) George Knapp; Edmund and Henry Shanahan registered a complaint with Inspector General Charles Duffin stating that Knapp's illegible penmanship, not intentional fraud, was the cause of the discrepancy. In his report to the trustees, Duffin rejected their claim: "I am of the opinion, was all your spindles constantly at work twelve hours in the day, they would not produce yarn sufficient to make the number of pieces of Duck claimed."[39]

Shipments were lost on land and at sea, and errors occurred in filling orders. At any stage, linen could be damaged, and the party at fault had to be determined. If flaxseed mildewed, did the damage occur on board ship (in transit), or was it left in a damp warehouse too long before being transported? Was the shipping company or the seller liable? It was a long journey from the flax fields in Connecticut and seed warehouses in Pennsylvania to Ireland, and any number of delays or mishandling could cause a shipment of flaxseed to lose value. Shipments of linen cloth packed tightly below deck for weeks at a time in all weather conditions were equally susceptible to mishandling and damage in transit. Stiff fines were levied if the trustees found in favor of the complainant.

In 1816, about five hundred weavers attended the weekly linen market in the town of Omagh, county Tyrone. Approximately sixty buyers were available to

purchase both brown and white linen after it was stamped by a seal master.[40] If the seal master was unpopular, ineffectual, or measuring incorrectly, a complaint was lodged against him to the trustees with an application for a replacement. In addition to these major concerns, trustees oversaw administration costs of the board and dealt with mundane issues such as Anne Burnett's request in 1813 for additional pay after she kept the linen market coffee room open extra hours.[41]

Over 91,000 acres (142 square miles) of flaxseed was sown in all counties of Ulster province in 1815. By 1818, 1,500 acres in county Armagh were devoted to flax production: 36.5 percent of the seed came from America, 32 percent from Baltic countries, and 38 percent from the Dutch, with slightly more than two-tenths of 1 percent being British and an insignificant .0007 percent being Irish seed saved from the previous year's crop. With flaxseed imported from so many different countries, fluctuating global weather patterns determined the cost and quantity of seed available for export to Irish farmers. The quality of the seed in turn determined the quality and quantity of the crop yield. Linen Board inspectors noted for the record that the flax crop in 1818 was much superior to that of the previous year; better fiber resulted in better cloth and a higher selling price. In years with too much rain, the flax crop rotted in the fields. Whether flax was grown on Irish soil, came from Russia, or was imported from America, weather patterns meant financial success or failure for everyone in the linen trade, from mill worker to factory owner.[42]

To encourage linen manufacturers to improve their product and promote industry growth, trustees held competitions with financial benefits to the winners. In 1816, linen inspector Robert Fowler suggested that the following premiums should be given in county Down: "I would recommend that a loom, with reed, gears, temples, and shuttle, be given to the person (male or female) who shall have woven the greatest quantity, and of the best quality of linen." Although it is commonly believed that weaving in Ireland was exclusively men's work, it is interesting to note that Linen Board trustees thought females were expert enough at weaving to win such a prize.[43]

In 1821, £20 was given to the person who wove the best eight pieces of sheeting from mill-spun yarn that most closely resembled in color and fabric Russian sheeting. In a letter to the trustees in 1820, the inspector general for Ulster province was flaunting the success of the linen industry in his province when he declined to request more looms or equipment from the Linen Board, stating that help should be given to the other three provinces "where the cultivation of flax and the manufacture of linen is in its infancy, compared to that of Ulster."[44]

Expansion of the Linen Industry in the North

The alternating boom and bust for a textile-based economy is best illustrated during the 1860s, when the American Civil War and its aftermath resulted in a severe cotton shortage that created a huge demand for linen as a substitute. There was only one power loom factory in Ireland in 1850, but thirty-four factories running approximately 5,000 power looms in 1862; there were 15,000 power looms and 800,000 wet-spinning

spindles in operation by 1868.[45] In January 1866, the Falls Flax Spinning Company reported that they had bought thirty-two houses for their workers, and plans for an extension to the weaving sheds designed to accommodate a further 150 looms were well under way. But 1866 turned out to be a disastrous year for many textile firms in a constantly fluctuating economy. The York Street Flax Spinning Company abandoned plans for new weaving sheds in early 1867. In the six-month period ending January 27, 1868, the firm lost £2,920; in the following six months, the company made a profit of £12,336. In an era before unemployment or welfare benefits offered an effective safety net, these fluctuations had a profound impact on textile workers.[46]

Although records for the period are very limited, surviving sources suggest that nineteenth-century handloom weavers resisted making the transition to factory production. Men had enjoyed a long period of independence as weavers, and many continued to work alongside the factory system until the pressure of competition forced them out of existence. Cloth produced on early power looms could not compete in quality with fine cloth woven on a handloom, and although the factory system quickly came to dominate the trade, handloom weaving remained an important aspect of the industry until the late nineteenth century. A demand for traditional methods and quality ensured that a small number of handloom weaving factories survived well into the twentieth century.[47]

Once the income derived from hand spinning ended, many women were forced to work in mills and factories. Women are generally more pliable workers than men, and as such they were the desirable workforce in the textile industry, willing to accept low wages and countless hours of hard labor under the authority of male bosses. Mechanization in textile manufacturing during the Industrial Revolution significantly altered the family unit and its function within society as many thousands of women moved from traditional domestic roles into factory jobs that meant long periods away from home.

The Ewart Family of Linen Weavers

Many of the emigrants who settled the Ulster Plantation made a significant impact on the growth of the Irish linen industry for the next three centuries. The Ewart family came to Ireland from the county of Northumberland, on the border between England and Scotland, about 1603.[48] Their story is representative of the path from farmer to successful linen merchant for many families in Ulster province.

In 1716, Thomas Ewart was granted a lease on a twenty-acre farm in the small village of Anahilt near Hillsborough, county Down. Thomas farmed the land and obtained spinning wheels and handlooms from Linen Board subsidies to produce linen fabric on a small commercial scale. He was undoubtedly growing his own flax to spin into yarn for weaving. Thomas's son leased a nearby farm in 1746, and father and son bought yarn from local spinners, distributed it to cottage weavers, and sold it to bleachers who finished the cloth and marketed it.

In the third generation, William Ewart was far more ambitious than his father or grandfather. William moved in 1796 to a village outside Belfast, where female labor was plentiful and he could recruit and teach men to weave linen. He purchased locally spun yarn but finished the linen cloth at his own factory and sold it through English agents. He also kept the Hillsborough cottage-weaving operation and took the cloth to Belfast to sell. In 1859, William moved his operation, William Ewart and Son, to a large new building that included offices, a warehouse, lapping (folding) rooms, and storage rooms. With spinning, weaving, bleaching, and finishing works located on a large site nearby, the third-generation William Ewart was in charge of a fully contained organization; he reacted swiftly and successfully to the boom in the linen trade during the American Civil War.

In 1937, the firm of William Ewart and Sons Ltd. could proudly boast of their yarn output that it went "[r]ound the globe in 30 minutes" and of their cloth production, "2 million yards a month."[49] In the twentieth century, the firm was one of the largest manufacturers of Irish linen in the western world.[50]

Constant Instability

During the eighteenth and nineteenth centuries, fluctuations in profitability for the textile industry were, however, extreme and difficult to forecast. The decade of the 1870s was a period of retrenchment; several firms that had overextended themselves in the hope of cashing in on the temporary unavailability of cotton during America's Civil War found themselves in considerable financial difficulty once supplies of cotton were restored on both sides of the Atlantic.[51]

Despite the highs and lows of the economy, the Irish textile industry experienced monumental growth throughout the nineteenth century. Wet-spinning mills were opened in many small towns and villages. Women who lived in rural areas or were unable to find work in the industrial sector were able to earn a wage and contribute to the textile industry as lace makers or embroiderers. Linen makers in rural settlements, towns, and cities increasingly found opportunities to expand production and improve the quality of their product, striving to position Ireland as a major player in the expanding global market.

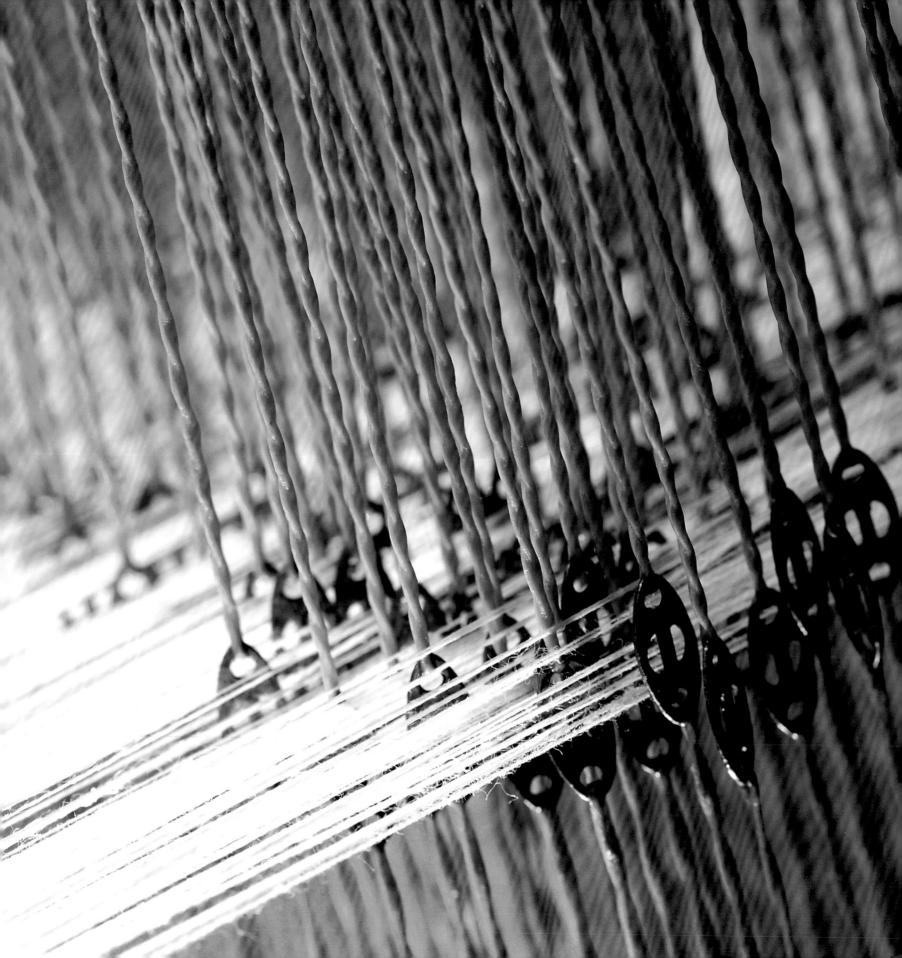

Irish Linen as Cargo and Coverings on Land, Sea, and Air

T HE INDUSTRIAL REVOLUTION enabled manufacturers of Irish linen to take advantage of greater production output and develop worldwide marketing opportunities. Travel became easier and more luxurious; magnificent ships were built to carry passengers back and forth to Ireland and to other lands as tourists and permanent emigrants. Those who could afford it traveled first-class, enjoying fine Irish linen that covered dining tables and decorated elegantly appointed staterooms. Linen production was moving alongside a more global population. The financial discrepancy between workers who stood at the looms to weave linen or those who embroidered pillowcases made of linen and the men and women who dined in the ship's elegant salons at tables adorned with it continued to widen. Linen was a job, a status symbol, or an opportunity to gain wealth; the phrase *Irish linen* had come to signify both a quality product and a country of origin.[1]

The Industrial Revolution did not happen suddenly, as the word *revolution* might suggest. It was an era of change that came about as a result of fundamental developments in agriculture, textile, and metal manufacture, improved transportation, and economic policies during a period of more than a hundred years. As inventors discovered new ways to manufacture necessities of life, the structure of society changed, and so did the world's desire for manufactured goods. The manufacture of cloth played an important role in changing the way people lived, worked, and spent their leisure time. The old ways of earning enough money or trading goods to shelter, feed, and clothe a family no longer fit with the demands of an emerging international populace of wealth, affluence, and sophistication.

Facing pages: Loom heddles. *Courtesy of Irish Linen Centre and Lisburn Museum. Photography by David Pauley, Belfast.*

In the twentieth century, technical linen had applications in the automotive, rubber, shoe, and even aircraft industries. Linen was used for the production of tarpaulins, sailcloth, driving belts on machinery, hoses, and fishing nets; with its waterproofing properties, flax fiber found an application as a base for manufacturing roofing materials. In World War I, the British used linen as the outer skin on airplanes. The shorter flax fiber, called *tow*, has been tested as possible filtering material in waste-cleaning processes. The woody bark of flax, or *shives*, has been used in the production of boards and construction blocks similar in style to wood chipboard and fiberboard. Flax growers in county Donegal once used flax to thatch roofs on homes and barns, and a few homeowners who prefer to be "green" in their use of building materials continue thatching roofs in the twenty-first century.

Because linen absorbs moisture and is air permeable and aseptic, linen textiles are widely used in medicine as an absorbent cloth to prevent the development of infection and microflora. Linen has been used for traumatic dressings, woven bandages, and surgical thread that readily dissolves in the human body. It can be washed repeatedly in boiling water for sterilization and ironed on the hottest setting without burning; in previous centuries, it was an ideal fabric for hospital bedding, gowns, and surgical masks.

In addition to its uses as fiber, linseed oil made from flax seed is used in manufacturing foodstuffs, soaps, paints and varnishes, and rubber. Linseed oil is an important component in the production of oilcloth, linoleum, waterproof cloth, and top-quality leather goods. Linseed oil is also widely used in medicine and cosmetology, and linseed meal is an excellent feed for livestock. Linen is an incredibly versatile material, and its by-products have served civilization extremely well for hundreds of years.

As well as its little-known industrial uses, fine Irish linen cloth was used to furnish one of England's more spectacular homes, a three-story dollhouse built for Queen Mary (1867–1953), wife of George V. The firm that made the cloth for the dollhouse, Old Bleach Co. Ltd., won the commission to weave linen for thirty-six separate miniature household pieces, including a seven-inch by twenty-two-inch damask banquet-size tablecloth complete with the royal crest. Designed by Sir Edwin Lutyens and exhibited at the British Empire Exhibition in 1924, the dollhouse was intended to serve as a model home for future technology and included fully functioning lifts, electricity, and plumbing. Bleached white linen sheets and pillowcases for the personal use of the doll royal family had the cypher of George V hand embroidered in white, and damask patterned linen tablecloths and napkins were intended for use when the doll royal family held luncheons or dinner parties. The royal cypher was embroidered in red for linen toweling and household cloths to be used by the miniature royal household and its servants. These items were woven in diaper pattern (a small diamond shape) and the overall coarse-surfaced huckaback pattern, both textures used for absorption. All the items were woven on a fully functional, small model loom borrowed from the Belfast Municipal Technical Institute. Miss T. M. H. Leblanc meticulously hand stitched the hems on each tiny piece, embroidered initials, and made a lace coverlet for the child's cot. The sets of miniature linens were placed in specially made boxes ornately trimmed and embossed with the Old Bleach emblem. Old Bleach was a company that

Facing page: Queen Mary's dollhouse, Windsor Castle, London, England, 1926. Everything in the dollhouse was fashioned in the scale of one inch per foot. Note the large center room on the top floor devoted exclusively to linen storage. *The Royal Collection* © 2011 Her Majesty Queen Elizabeth II.

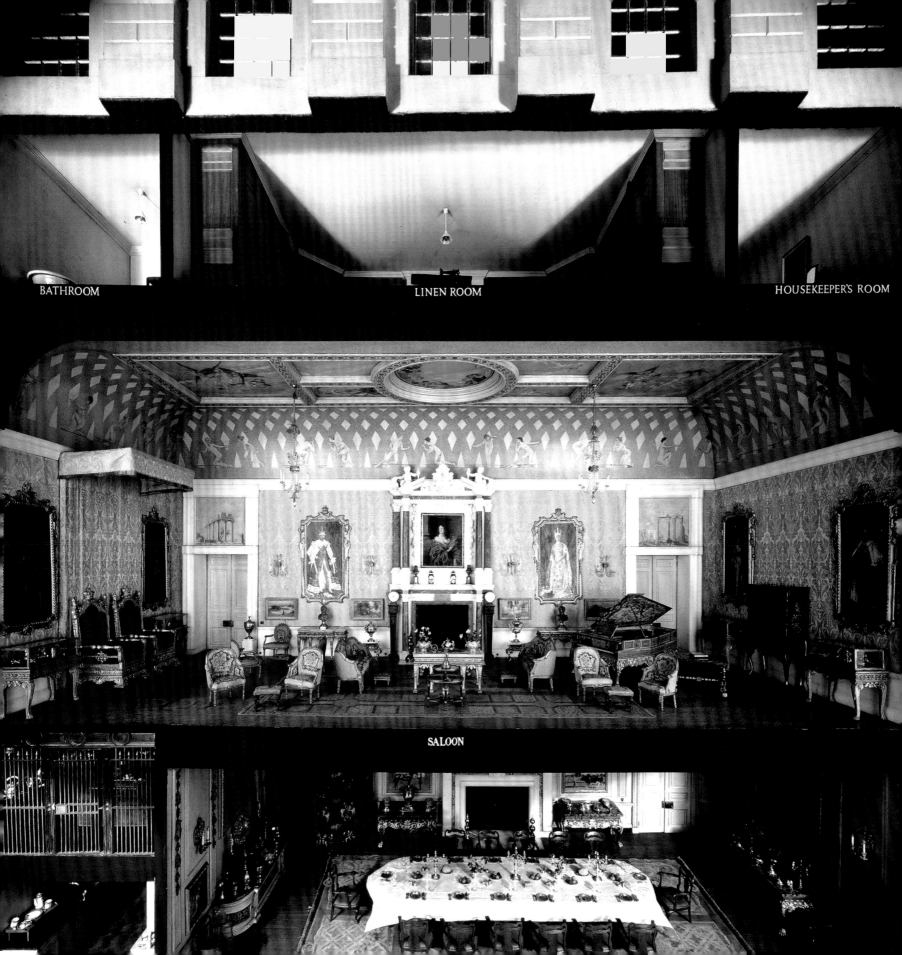

BATHROOM LINEN ROOM HOUSEKEEPER'S ROOM

SALOON

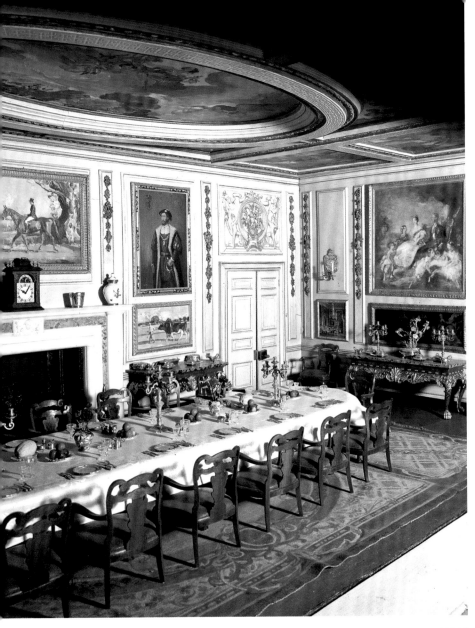

The dining room in Queen Mary's dollhouse. Everything in the dollhouse was fashioned in a scale of one inch equals one foot. *The Royal Collection © 2011 Her Majesty Queen Elizabeth II.*

excelled in marketing its many linen products both in the United Kingdom and abroad, and the queen's dollhouse was an excellent opportunity to use finely woven Irish linen to demonstrate ingenuity and quality workmanship that was seen and appreciated by thousands.

The dollhouse was displayed at the international exhibition to showcase the very best of Britain's architecture, craftsmanship, and design capabilities, serving as a token of national goodwill and a means of raising funds for charity. Queen Mary's dollhouse remains on display at Windsor Castle, where it has enchanted audiences, young and old, for over eighty years.[2]

Consumerism Gains Momentum

In the eighteenth century, Britain's emerging middle class desired to own luxuries and novelties, far beyond practical necessities; members of the middle class established a soaring level of consumerism that continues into the twenty-first century. New inventions and technological advancement during the Industrial Revolution made mass-produced articles affordable to a new wealthier middle class that was in pursuit of possessions. Having wealth meant spending it on domestic goods such as tea ware and

Miniature linen damask tablecloth for the dining room table of Queen Mary's dollhouse, woven by Old Bleach of Randalstown, 1924. *Courtesy of Irish Linen Centre and Lisburn Museum. Photography by David Pauley, Belfast.*

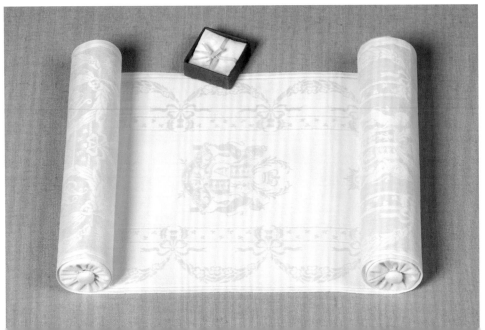

Miniature linen bedsheets, pillowcases, dresser mats, and towels for Queen Mary's dollhouse, 1924. Royal linens were marked with a white hand-embroidered cipher of King George V. Servant towels are of coarser linen, with the red royal crest of King George. *Courtesy of Irish Linen Centre and Lisburn Museum. Photography by David Pauley, Belfast.*

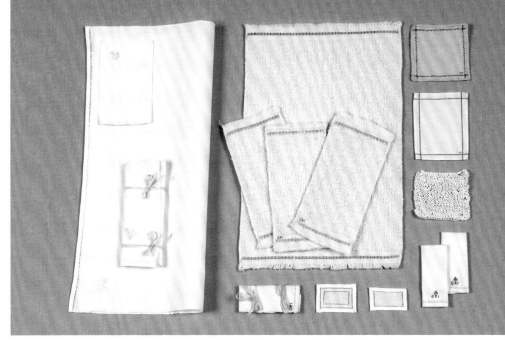

Miniature dollhouse textiles folded in custom-made presentation boxes, 1924. *Courtesy of Irish Linen Centre and Lisburn Museum. Photography by David Pauley, Belfast.*

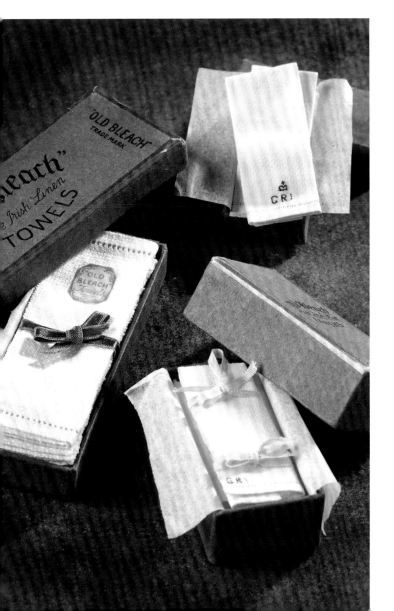

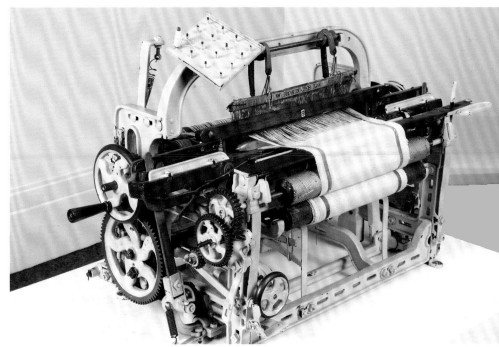

Sample loom. This model of an Atherton power (two-box) loom, c. 1930, was used at the College of Technology in Belfast to demonstrate weaving. *Courtesy of Irish Linen Centre and Lisburn Museum. Photography by David Pauley, Belfast.*

dinner services, glassware, brass and silver, cutlery, buckles, buttons and medallions, upholstered furnishings, and carpets. Fashionable decorative ware was sold in the context of room settings and architecture. Merchants displayed fine linens on sideboards to illustrate the correct way to use them. Printed wallpaper was designed to complement new linen and cotton patterns, matching upholstery, carpets, and portraits. Buying and selling took place in sprawling industrial villages, urban workshops, and rural factories.

Consumers from all social groups made spending decisions, but for the increasing number of middle-class British consumers, luxury items were not merely possessions but were purchased as part of a shopping experience. Buying became a pastime in itself, more than just the act of owning an item. It was about going places, meeting travelers from foreign lands, and seeing new sights. Markets and fairs were primarily centered on agricultural goods, but the scope of available decorative accessories was expanding as demand for more luxury goods increased. Hawkers and peddlers began to sell the newest decorative fashions at markets filled with spectacles and events that enticed the buyer to spend money while enjoying a shopping experience. In 1756, innovative and aggressive salesmen and saleswomen were pushy, driving hard bargains to sell their wares at 3,200 English fairs.[3] The latest ornamentations for home and dress were also purchased at auctions, through catalogues, by mail order, at galleries, and in shops. The middle class desired possessions, and the marketplace met the mounting demand.

Shopkeepers needed to appeal to clients wanting to be entertained while spending, so window displays educated and intrigued shoppers and suppliers who designed and furnished interiors for country houses and in-town residences. Retailing luxurious consumer goods was dependent on advertising, and in the eighteenth century, advertising was a sophisticated economic and cultural activity in its own right. Inventors understood that advertising made their product accessible and fashionable. The ornately printed graphic advertisement, a trade card, not only provided clients with basic shop information but also targeted specific audiences of affluent local, metropolitan, national, or international customers, other tradesmen, and merchants as an expensive tangible sales tool.

Society embraced the civility and manners that went with a greater adornment of domestic interiors and dress. Luxuries formerly associated with foreign imports began to be associated with an English national identity, and Britain expanded its export markets for its own manufactures, thus increasing middle-class wealth.[4]

From a visual standpoint, it could be said that the end of England's Victorian era (c. 1890) was the height of consumerism in domestic decoration. At that time, any empty space in a room was considered in poor taste; thus, every available surface was filled with objects that reflected the image the homeowners aspired to project to their peers. Fabrics and exotic wood furniture filled the parlor and dining room; expensive porcelains, sterling silver, china, and crystal on the family sideboard, beautiful wall coverings, paintings on the walls, and oriental rugs over parquet hardwood floors created a setting of opulence and excess. To project a sense of proper family values, women covered tables with family pictures and their own needle-work. The overall decoration was dark and heavy in the middle Victorian era, more feminine at the end of

the period, and then lighter and with cleaner lines in the Edwardian era (1901–10). Nineteenth-century lavishness in home décor was in direct proportion to the new wealth seen throughout the British Empire—much of it acquired by exporting products to the colonies.

Irish Linen for Overnight Guests

Sumptuous interior décor for the home encircled the burgeoning middle class at the end of the nineteenth century, and successive generations expected the same level of luxurious surroundings when they traveled on trains, ocean liners, and airplanes to stay in the world's most exclusive hotels. Patterned and printed linen was perfectly suited for decorating hotel lobbies, bedroom suites, and lounges in cities across the globe. The magnificent, sprawling Mount Nelson Hotel in Cape Town, South Africa, was built in 1899. Surrounded by lush gardens within the heart of the city's vibrant cultural center, the hotel was designed and built to provide elegant and luxurious accommodations for first-class passengers who traveled from Europe to South Africa aboard Union–Castle Line ships. When it opened, and for many years thereafter, the hotel was filled with linen used for upholstered furniture, curtains, bedding, tablecloths, and napkins. Before World War II, the magnificent Manila Hotel in the Philippine Islands was completely redecorated with Irish linen fabrics, which were particularly suitable for hot-weather climates.[5] Linen fabrics could be custom designed to meet any color specification the client might choose; linen was machine monogrammed or screen-printed in colors that coordinated with every decorating style or period to complement a luxurious steamship, a modernized railway train car, a sleek airplane, or the architecture of an old or newly designed building. Linen was woven as the sheerest lightweight curtains or as heavy, lined draperies. For the foyer curtains at the Rivoli Cinema in Cairo, Old Bleach wove a heavyweight, two-tone linen fabric in the firm's Rathmullen pattern.[6] The fabric held up well under pressure from constant use, heat, and repeated washings, making it ideal for all commercial uses, including public and government office buildings.

Manor Houses Decorate with Irish Linen

Irish linen had many applications in the home as bedding, kitchen cloths, toweling, upholstery, drapery, and even as wall coverings. For the more affluent consumer, linen was trimmed with lace, embroidered, printed, painted, and woven in patterns and colors that adhered to current fashion trends in home decorating.

Across the island of Ireland, grand manor houses were built in the seventeenth and eighteenth centuries by descendants of the English and Presbyterian Scots who came to Ireland to populate the early plantations. Some ruling families gained great wealth and status through marriage, while others found power and affluence by associating with British nobility and royalty. These families built or inherited homes and estates

in England, Scotland, and Ireland. Sometimes these damp, cold stone edifices were left for months or years without proper attention or maintenance, but green hills and the sea were alluring to men and women who wanted to escape the city for a period of time to enjoy the physical activities of country life. The spacious interiors of manor homes were filled with furniture and fabrics popular during each decorative period, providing a gracious lifestyle for the owner and elegant spaces to entertain guests, who often stayed well beyond a one-day visit.

Fashion Styles Have Longevity

Throughout history, political events or political figures, social culture, scientific discoveries, and advances in technology have influenced home decorating styles and fashion. If women's skirts were too wide for the current style of chair, then furniture makers designed new ones. When original botanical specimens were discovered, artists included them in portrait and landscape paintings; printmakers designed fabrics that illustrated the newest floral and faunal rage. In the twentieth century, the high-collared, straight-fitting linen jacket, worn by and named for Jawaharlal Nehru, the prime minister of India from 1947–64, became popular with men and women in the 1960s when the Monkeys and the Beatles popularized the garment. Today, the name "Nehru jacket" has become less about the clothing style favored by India's first prime minister or his work as a radical leader for India's independence and more about style and current fashion trends. Color has also been a big part of fashion style, and design in home furnishings and new printing techniques over the centuries have made fabrics more interesting to use.

Printing Linen

The technology for printing on cloth was developing in Europe in the seventeenth century, and the smooth surface of linen was dyed in early block printing. As printing techniques advanced, so did the demand for patterns that were more intricate and complicated, but until printing was mass-produced and cost-effective, only the very wealthy could afford to pay the price. During the long years of the Industrial Revolution, new methods for dyeing, printing, weaving, and finishing cloth developed simultaneously, and Irish inventors and chemists were often at the forefront of innovative developments in textile technology.

In the twenty-first century, the average consumer can select from a wide range of colorful fabrics, so few people consider how patterns are applied to the cloth. Understanding the process for block printing is necessary to appreciate the importance of Frances Nixon's introduction of copperplate printing on Irish linen in Dublin in the mid-eighteenth century.

The first textile woodblock print works in Great Britain is believed to have been founded by a Frenchman toward the end of the seventeenth century, working in a location on the banks of the River Thames

near Richmond; soon afterward, a more considerable factory was established in Essex, and many other print works were opened in Surrey early in the eighteenth century.[7]

Woodblocks for textile printing were generally made from the wood of boxwood, lime, holly, sycamore, or pear trees, cut two to three inches thick to prevent warping. Several pieces were tongued and grooved together, securely glued under pressure into one solid block with the grain of each alternate piece running in a different direction. The block was planed smooth and perfectly flat; a design was then drawn on or transferred to it.

The block was prepared as a relief matrix, which means that areas to remain bare (without ink) were cut away with a knife, chisel, or sandpaper, leaving the characters or image to show on the original surface level. When the block was inked and firmly pressed onto paper or cloth, it made an acceptable print. Fine details of the design were very difficult to cut in wood and, even when successfully cut, wore down rapidly or broke off during printing. Smaller designs were made with strips of brass or copper bent into shape and imbedded edgewise into the flat surface of the block. This method was known as coppering, and by its means, many delicate little shapes and letters could be printed that would otherwise be impossible to produce by this method of printing.

In addition to the carved block, a printing table was needed to complete the process. At one end of the table, iron brackets held the roll of cloth to be printed; at the other, a series of guide rollers, extending to the ceiling, were used to suspend and dry the newly printed goods. Color was spread evenly with a brush,

Left: Woodblock with metal inlay for design featuring William of Orange surrounded by the phrase "The Glorious & Immortal Memory of 1688 & 1690." The woodblock was used for printing fabric and wallpaper in the nineteenth century. *Private collection, Denise and George Gray, Bangor, county Down. Photography by David Pauley, Belfast.*

Right: Woodblock with brass inlay for a harp, crown, and shamrock design used for printing fabric and wallpaper in the nineteenth century. *Private collection, Denise and George Gray, Bangor, county Down. Photography by David Pauley, Belfast.*

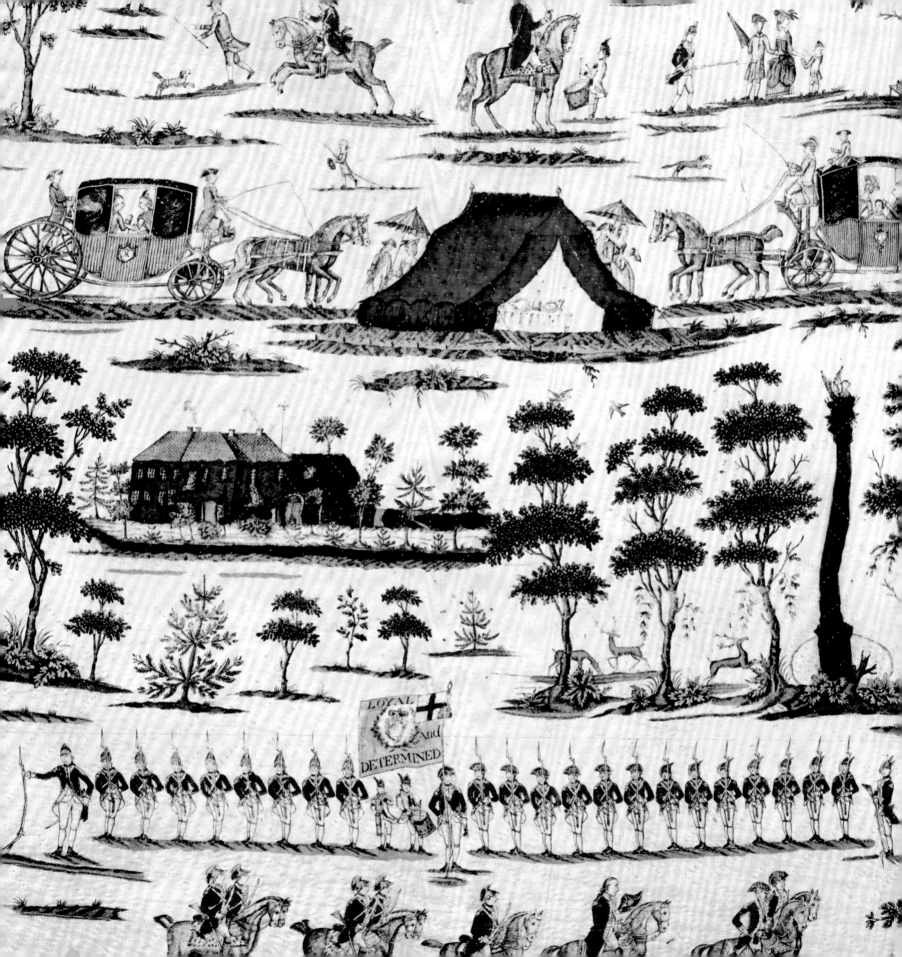

and a filter screen was used to ensure a uniform application of color on the block. The printer drew a length of cloth from the roll and over the table and marked it to indicate where to apply the first impression of the block. He then applied his block in two different directions to the color and pressed it firmly and steadily onto the cloth, ensuring a good impression by hitting it with a wooden mallet. The second impression and each succeeding impression were made in precisely the same manner until the length of cloth on the table was fully printed. When this was done, the cloth was wound over the drying rollers, advancing a fresh length to be treated similarly. If the pattern contained several colors, the cloth was usually printed throughout with one color, then dried, rewound, and printed with the second color. This process was also used to print wallpaper. Block printing by hand was a slow process but capable of yielding highly artistic results, some of which are unobtainable by any other method.[8]

In 1752, Francis Nixon introduced copperplate printing of textiles at the Drumcondra works near Dublin, and by 1754 the secret had been transmitted to England. For the next twenty years, it remained virtually a monopoly of Dublin and London printers.[9] In copperplate engraving, lines and dots that make up the picture are cut into the surface of a piece of copper. To print from this, the whole plate is inked over. The ink is then carefully wiped off from the surface of the plate, leaving ink only in the lines or dots. The sheet is then laid upon the plate, which is passed under a roller exerting heavy pressure, thus forcing the cloth down into the lines to absorb ink from the design. The process is slow, and the rubbing involved in wiping the plate rapidly wears it out, so that only a comparatively few impressions can be taken with each engraved plate.[10]

Windows were covered with these printed fabrics to block out the heat, keep out the cold, provide privacy, and add color and style to a room. Printed drapery fabric also created an opportunity to make a personal or political statement. The print works in Drumcondra was producing fabric printed with varied colors that were more fade resistant than had previously been possible, making it a fashionable curtain material. In the late eighteenth century, troops stationed in Ireland were sent to fight in the American Revolutionary War, reducing the size of the defense force at home. This prompted local noblemen to raise part-time units in a practice known as the Volunteer Movement. Catholic peasants and Protestant descendants of British settlers, all civilians, constituted the majority of men drafted for the militia. The role of these forces was to supplement the English garrison of regulars in Ireland so that, together, they could guard against rebellion at home as well as a potential invasion from France and Spain, both of which were fighting against Britain in the American War of Independence. The Volunteer print was the best-known product of Thomas Harper from Leixlip, county Kildare, and was probably designed by Gabriel Beranger. Originally used as curtain material, the fabric printed in 1782 was pieced, quilted, and made into an eighty-six-inch-square bed covering at a later date. The fabric is significant both as an example of the printing method at an early date in Ireland and for the depiction of the Volunteer Militia; scenes closely resembled descriptions of early battles with the British Army that included Irish soldiers during America's War of Independence.[11]

Facing page: Linen drapery fabric printed with a stylized design of the Irish Volunteer Militia. Printed in 1782, this was the best-known product in the workshop of printer Thomas Harper from Leixlip, county Kildare; it was probably designed by Gabriel Beranger. © *National Museums Northern Ireland 2011. Collection Ulster Museum.*

Garden Flowers and Floral Prints

Mount Stewart and Castle Ward, both situated on large estates in county Down, are excellent examples of impressive manor houses filled with beautiful furniture and decorative accessories, including linen. Alexander Stewart (1700–1781) and his wife, Mary Cowan (sister of the governor of Bombay, India), purchased the county Down acreage in 1774 to build Mount Stewart. Bernard Ward settled in the county in 1570, purchased land from the Earl of Kildare, and renamed the estate Castle Ward. In the twenty-first century, both estates are National Trust properties and open to the public. On both estates, construction lasted over a number of consecutive generations, and the houses were remodeled to reflect changing styles and finances. Depending on the personal preference of each occupant, the houses were lived in only sporadically, usually during the summer months.

The grandiose scale of Mount Stewart was intended to dazzle visitors with its lavish interior spaces and magnificent gardens, and it did just that. The design and construction of outdoor garden gates, patios, trellises, reflection pools, and flowerbeds were as important to the overall ambience of the estate as the manor house itself. It was a golden age of luxury, travel, and excess for those who could afford it. Early generations of the family spent a limited time at Mount Stewart, but Edith, the 7th Marchioness of Londonderry (1879–1959) and granddaughter of the Duke of Sutherland, fell in love with the estate, especially with the extensive grounds, where she spent a tremendous amount of time with gardeners and landscape designers. She was often seen on the grounds wearing her multicolored linen gardening apron with its large, serviceable leather pockets. Mount Stewart is situated on a peninsula jutting out between the Irish Sea and Strangford Lough, benefiting from the warm Gulf Stream air, which contributes to a subtropical climate perfect for growing a wide range of flowers, vegetables, and trees. Lady Londonderry loved to

Mount Stewart, county Down. Portico side of house. 2008 © *Courtesy National Trust. Photography by the author.*

garden and worked with gardeners to create a landscape unequaled in beauty and diversity; her vision transformed the open space into one of the great gardens of Europe and a living legacy for all who visit Mount Stewart.

Mount Stewart was richly decorated with furniture, paintings, and fabrics throughout the magnificent home. In the sumptuous Rome bedroom, Lady Londonderry chose a floral printed linen fabric to cover a sofa, overstuffed chairs, a chaise lounge, and lampshades and as the material for a dressing table skirt. The deep blue background color matched the royal blue carpet and painted inset panels on the ornate bed and side tables. Sanderson Fabrics of London supplied the fabric, a fashionable cottage garden style popular in the 1930s. More and more firms were producing furnishing fabrics in a wide variety of designs during the period when printed linens were popular in manor houses throughout the British Empire, especially in country estates.

Gardening apron of Edith, Lady Londonderry, granddaughter of the Duke of Sutherland and wife of the 7th Marquess of Londonderry, c. 1950. Woven in multicolored, coarse linen, the apron has large and small leather pockets for gardening tools, along with linen twill tape ties. *2008 © Courtesy National Trust. Photography by the author.*

Far left: Overstuffed club chair, upholstered in floral printed linen by Sanderson Fabrics, London, c. 1970s. The chair is in Lady Londonderry's bedroom at Mount Stewart. *2008 © Courtesy National Trust. Photography by the author.*

Right: Detail of floral printed linen fabric used for a dressing table skirt, two lampshades, a chaise longue, and lounge chairs at Mount Stewart. *2008 © Courtesy National Trust. Photography by the author.*

Castle Ward is also filled with beautiful furniture and fabrics. The family maintained a large collection of tablecloths, bedding, and personal clothing made out of Irish linen kept in a large upstairs storeroom. The family crest was embroidered on linen handkerchiefs, bedsheets, pillowcases, and personal accessories or was woven into damask tablecloths and napkins. To maintain the supply of clothing and household linens needed to keep a house of this size running smoothly, separate laundry rooms attached to the main house by an outside entrance were located at ground level. The bright and airy rooms with large windows were filled with tubs of steaming water, stoves to heat flat irons, and racks for drying bed linens and clothing (see chapter 8 illustrations).

Ocean Liners Filled with Irish Linen

Until commercial airlines developed reliable and regular travel routes across the oceans, people traveled by ship between continents. Early sailing ships relied on strong winds filling linen canvas sails to carry them to their destinations, but storms, rough seas, or lack of wind made travel by this means long, unreliable, and often extremely dangerous. Many sailing ships fitted with auxiliary steam power were on the oceans after 1819, but genuine transatlantic steamship travel did not begin in earnest until 1838, with a ship named the *Great Western.* This was the first ship designed specifically as a transatlantic passenger vessel built to use steam as the primary source of power. Two ships, the *Great Western* and *Sirius,* raced from England to New York, competing for the new Atlantic steam passenger business. From that crossing until the 1960s, steamships crossed the world's oceans with scheduled regularity, and Irish linen manufacturers found a huge new market for their high production of goods. Irish linen was suitable for decorative furnishings on the high seas, where it provided luxury and elegance for first-class passengers traveling on the great ocean liners.

There was scarcely a ship sailing in any direction from Great Britain that did not use Irish linen in one form or another. White damask graced grand salon dining room tables; printed linen upholstery covered club chairs and lounges; crisp white linen sheets, pillowcases, and counterpanes covered beds; and patterned linen hung across portals and provided travelers with absorbent toweling. Linen upholstery was particularly popular on shipping lines that sailed to the Far East, where linen was appreciated for its cool, smooth surface and its imperviousness to insects, two important factors in hot climates.

Irish linen played a part in many historically significant events that were famous for reasons unrelated to the fabric or its use. When Hollywood made the motion picture *Titanic* in 1997, the passionate love story and title song "My Heart Will Go On" brought worldwide attention to the ship, which sank on its maiden voyage in 1912. Built in the Belfast shipyard of Harland and Wolff, RMS *Titanic* and its sister ships RMS *Olympic* and RMS *Britannic* were designed to provide a weekly express service that would dominate transatlantic travel for the White Star Line Company. *Titanic* was the largest ocean liner ever built at the time, and the world watched in horror as the unthinkable happened to the unsinkable. For that fateful maiden voyage,

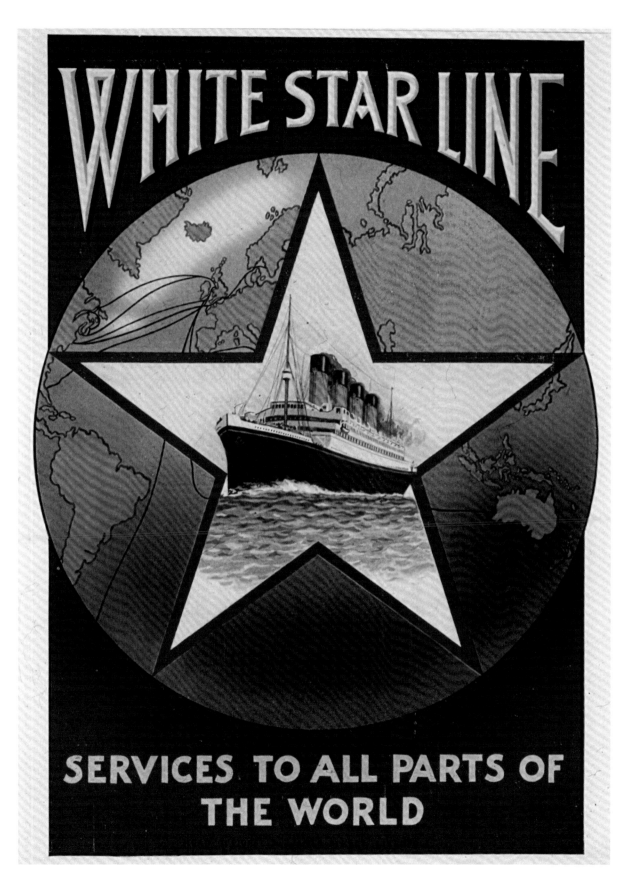

White Star Line poster, c. 1920. *Courtesy of Paul Louden-Brown, White Star Line Archive Collection, county Fermanagh.*

Diaper is a familiar word to most English-speaking people, used to describe any disposable cloth needed for incontinence. In the fifteenth century, however, *diaper* referred to a type of linen cloth woven in a small, diamond-shaped pattern that makes it highly absorbent. It was particularly suited to toweling and napkins that were folded and used to keep babies dry. The word *diaper* is still used in design and architectural terminology for any pattern of diamond shapes. In Great Britain, baby diapers are known as nappies, a word that evolved from *napkins*, once made of linen.

The expression *on tenterhooks* is used in the twenty-first century to mean that someone is stretched or stressed to the limits of his or her ability or beyond acceptable standards because of a situation usually beyond his or her control. It also is used to describe anxiously awaiting a future event. In previous centuries, *on tenterhooks* was a textile term referring to the hooks or bent nails set in a row along the top and bottom of a wooden frame to stretch cloth tightly so it dried evenly without shrinking.

The word *fugitive* is a contemporary word with a textile history. Although people currently think of a fugitive as a person hiding to avoid police arrest, textile people know that some dyes, especially early synthetic dyes, were called *fugitive* because they faded away or disappeared sometime after the original color was set. Dyes that remain strong and true to the original color are called *fast*; eventually this meaning became captured in the word *colorfast*.

Dried flower heads of the *teasel* plant were once widely used in textile processing. Attached to spindles, wheels, or cylinders (sometimes called teasel frames), the prickly spines provided a natural comb for cleaning, aligning, and raising the nap on fabrics. By the twentieth century, metal cards or combs had largely replaced teasels. The textile use of the word *teasel* or *tease* may be lost in common usage, but the meaning has survived to describe backcombing bouffant hairstyles or needling another person.

the Belfast linen manufacturer William Ewart and Sons was commissioned to weave forty thousand white damask linen dinner napkins, along with thousands of linen tablecloths, sheets, pillowcases, and towels, to provide quality and lavishness for passengers traveling on the great ocean liner to New York—now lying at the bottom of the ocean.

After 1909, steamship technology reached its height with the new Olympic class of ships, which were powered by a combination of expansion and turbine engines. Stylish, colorful, and popular patterned linen fabrics were used to decorate the interiors of passenger steamships.

The *Titanic*, the *Britannic*, and the *Olympic* were examples of this type of engineering achievement. Passengers traveling in style slept under smooth white linen sheets and ate at dining tables covered with patterned damask tablecloths. During the voyage, travelers filled linen canvas laundry bags with garments to be washed and returned by stewards the next morning. Steamships moved millions of passengers and untold tons of cargo (including Irish linen products destined for warehouses and retail stores in the

Point paper drawing for damask table linens. This pattern, designed especially for the White Star Line, was woven by Ewart Liddell Ltd., Donaghacloney, county Down, in 1931. The pattern was painted by John Peden, and Agnes Armstrong cut the punch cards from his pattern. *Courtesy of Irish Linen Centre and Lisburn Museum. Photography by David Pauley, Belfast.*

Americas) over the world's oceans and were the contributing factor to a great Irish migration to America in the mid-nineteenth century. From the utilitarian, no-frills freighter to the most luxurious transatlantic liner, steamships had a vital impact on world history.[12]

Ships were divided into three classes, and passengers were barred from moving between classes situated on different levels of the ship; at the top was first class, then came second class, and at the bottom was steerage, or third class.

Shipping companies, striving to please wealthy travelers, outfitted first-class decks with decorative furnishing as luxurious as any in a gracious resort or elegant hotel, which, of course, meant fine linens. In the first-class lounge of the Cunard Steam Ship Company's *Franconia,* Old Bleach Company wove linen card-table cloths with a wide border design, hand painted to correspond with the chair fabric.[13] From 1912 to 1916, the *Franconia* transported thousands of emigrants in steerage class, in accommodations that did not include fine linens. Ships sailed from Liverpool to Boston in the summer and autumn months and ran the New York to Mediterranean route with tourists and business travelers during winter and spring. The *Franconia* was not the fastest ship, but it was built to embody the most modern passenger accommodations.[14] It was torpedoed and sunk on October 4, 1916, by a German submarine.

For the Sun Lounge of the steamship *Ceramic,* Old Bleach wove a bright and cheerful fabric in a two-tone undulating pattern of printed linen for tablecloths and seat covers on surrounding rattan chairs. Built in the Belfast shipyards of Harland and Wolff in 1913 for the White Star Line, the *Ceramic* traveled the Liverpool to Australia route with accommodations for six hundred third-class passengers, most of them Irish emigrants.[15]

Ocean liners were completely self-sufficient floating towns, offering passengers a wide assortment of luxuries and necessities for the ten to fourteen days at sea. Despite the tragic loss of the *Titanic,* the *Olympic* continued to sail across the Atlantic until 1935. The *Olympic* departed on its maiden voyage from Southampton Harbor, England, on June 14, 1911. It picked up additional passengers at ports in Cherbourg, France, and Queenstown, Ireland, arriving in the United States seven days later, which was plenty of time for first-class passengers to expect to sleep on the most luxurious linen bedding and enjoy elegant dinners, each course placed on a crisp, white linen tablecloth.

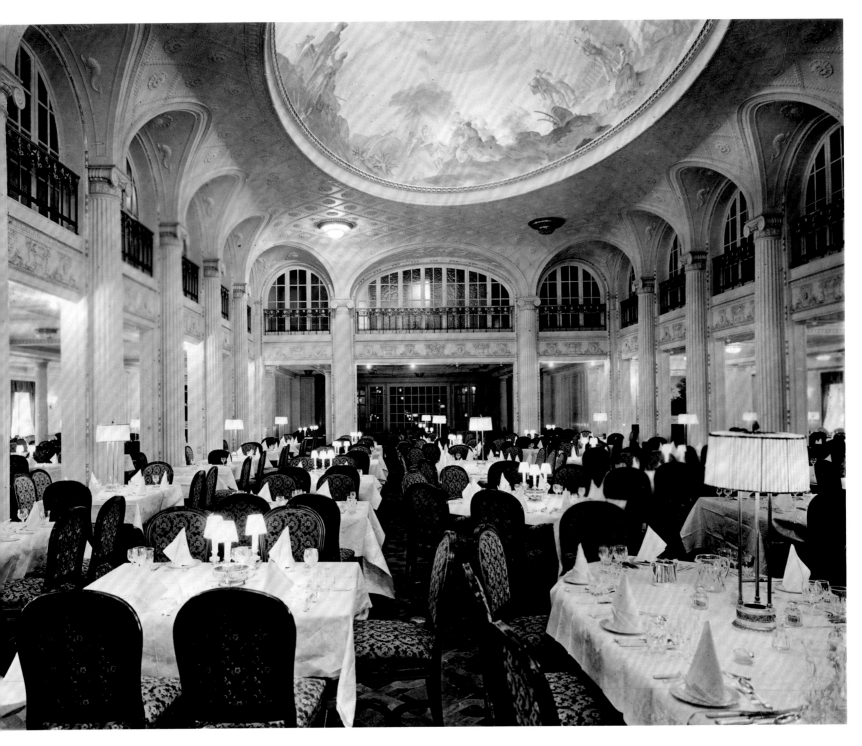

Grand salon for first-class dining on the *Majestic*, White Star Line, c. 1922.
Courtesy of Paul Louden-Brown, White Star Line Archive Collection, county Fermanagh.

The Southampton to New York route via Cherbourg was the most important transatlantic route and the most prestigious for the rich and famous and powerful businessmen. Linen agents, wholesale brokers, salesmen, and entrepreneurs socialized with passengers, making vital contacts valuable for future business dealings. The *Olympic* was associated with two other luxury liners belonging to the White Star Line: RMS *Majestic* and RMS *Homeric.* Each of these ships had a dining salon built to replicate the grand hotels of Europe, which were the height of nineteenth-century extravagance and neoclassical architecture. The grand salon on the *Majestic,* with its painted ceiling, Ionic columns, carved plaster frieze, and ornate wrought-iron railing set in front of arched windows along a balcony that surrounded the dining room, was typical of the opulence of first-class shipboard travel. Upholstered dining chairs, patterned carpet, and soft table lighting all served to accentuate the extreme luxury that travelers could enjoy on sea as well as on land. The three ships sailed together from 1922 to 1935, a time of profound class distinction and elegance that was drawing to a close as other modes of transportation began to provide more people with cheaper, faster ways to travel for business and pleasure.

Replacement and Theft at Sea

The linen firm of Wm. Liddell and Company, Belfast, supplied the *Olympic,* the *Majestic,* and the *Homeric* with a combined total of 440,000 pieces of Irish linen: 17,000 tablecloths, 110,000 napkins, 172,000 towels, 35,000 sheets, 25,000 blankets, and 15,000 counterpanes (blanket covers). The company purchased approximately 113,000 replacement pieces of linen annually. The amount of linen passing through the White Star laundry at Southampton, which did the washing for the three ships, was impressive, around 3.5 million pieces per year. Attached to the laundry was a sewing room outfitted with electrically driven sewing and darning machines, where nearly 200,000 pieces of linen were repaired annually.

Wm. Liddell advertisement of linen goods, published in the White Star Line's guide for shipboard passengers, dated 1930. With offices in New York; London; Melbourne and Sydney, Australia; Christchurch, New Zealand; Montreal, Canada; and Cape Town and Johannesburg, South Africa, the company was poised to supply fine linens to all international customers traveling across the seas. *Courtesy of Paul Louden-Brown, White Star Line Archive Collection, county Fermanagh.*

Wm. Liddell & Co.
Limited,
LINEN & DAMASK MANUFACTURERS
BELFAST, IRELAND.

TRADE MARK

UNUS ET IDEM

Head Offices : 42-44 Upper Queen Street, Belfast.
Works : Donacloney, Co. Down.

GOLD MEDAL TABLE DAMASKS. LINEN SHEETS AND :: :: SHEETINGS. PILLOW LINENS, TOWELS, ETC. :: :: EMBROIDERED BEDSPREADS, SHEETS, PILLOW SHAMS and PILLOW CASES. EMBROIDERED TEA and LUNCHEON SETS.

Hemstitched Linen Goods of every description. We make a speciality of Weaving Insertions in DAMASK TABLE LINENS, NAPKINS, TOWELS, Etc., for :: Hotel, Steamship, Railroad and Club purposes ::

Designs and full particulars on application.

London : 5 Carey Lane
New York : 51-53 White Street
Melbourne : 183-185 Flinders Lane
Canada : Montreal— 922 Victoria Square
Sydney : 279 Clarence Street
Christchurch : 69 Lichfield Street
South Africa : Cape Town— Argus Buildings, St. George's Street Johannesburg—28-29 Olga Buildings 121 President Street

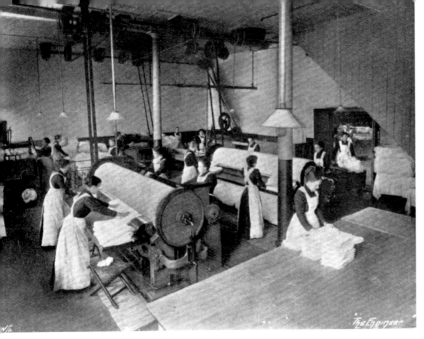

White Star Line laundry facility, Bootle, Liverpool, England, c. 1900. The White Star Works in Bootle was a large three-story building with four hundred workers employed exclusively to make alterations and repairs to the company's ships. The laundry on the first floor comprised a sorting room, a linen repair area, and storerooms and was capable of dealing with three thousand linen articles per day. Many women working in this laundry and White Star's similar facility in Southampton were the widows of crewmen who had lost their lives in company service. *Courtesy of Paul Louden-Brown, White Star Line Archive Collection, county Fermanagh.*

Fine linen table settings supported a tradition of fine foods on the luxurious ocean liners. The food was as important and carefully prepared as the table was carefully set. More than 1.3 million menus were printed each year for use on the three ships, the *Majestic, Olympic,* and *Homeric.*[16] On all great passenger ships, extravagant meals were prepared for first-class passengers, and preferred seating was determined by the passenger's celebrity status, wealth, and prestige. An opportunity to dine as a guest at the captain's table was a coveted invitation.

Unfortunately for the shipping companies, a favored souvenir for first-class passengers was the silver-plated napkin ring that held a freshly washed and starched white linen napkin at every meal. In the early years of luxury steamship travel, companies individually stamped napkin rings with the passenger's seat number in the dining salon or restaurant. With the napkin rings stacked in numbered order each night, the missing ones were readily identified, and the table steward's enquiry in the morning, "Has sir forgotten to leave his napkin ring?" usually resulted in its swift return. Breakfast in the cabin on the morning of arrival or a tray left in the passageway, however, offered opportunities for would-be souvenir hunters to slip napkin rings, linen hand towels, and other items into steamer trunks. Stewards, too busy attending passengers to be bothered with clearing away dirty crockery, often threw items out of portholes rather than cleaning and returning them to the pantry. One steward recalled that so many pieces were thrown out of portholes that it would be possible to follow the trail of silver plate from the Essex deepwater port of Tilbury, England, to Sydney, Australia, if a magnet were fitted to the bow of a ship. Destruction and theft of company property were severely dealt with, but in the case of first-class passengers, companies turned a blind eye to the odd item being taken. When U.S. Customs officers examined the contents of one American lady's baggage, this passenger was discovered to have taken collecting to new heights: several dozen pieces of china, glassware, and silver plate were discovered, all carefully wrapped in the company's fine Irish linen. The customs officers were perplexed as to what to do. Should they charge duty on these items? Should they call the police? In the end, White Star's marine superintendent was summoned. After glancing at the passenger list, he told officers that if the lady wanted some souvenirs, the company was more than happy to oblige, deciding that the embarrassment of reporting a first-class passenger for theft would cost the company far more in bad publicity than the actual financial loss sustained.[17]

In 1923, the White Star Line Company reported that approximately 380,000 pieces of china, earthenware, and glassware had to be replaced every year to make up for combined breakage onboard the *Majestic,* the *Olympic,* and the *Homeric.* Rough weather and wear and tear accounted for the largest proportion of losses, but not all;

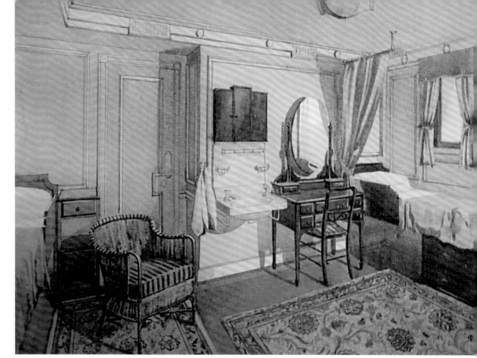

Stateroom, MV *Britannic*, c. 1930, White Star Line's third ship named *Britannic*. After her maiden voyage (Liverpool-Belfast-Glasgow-New York) on June 28, 1930, MV (Motor Vessel) *Britannic* spent her summers on the North Atlantic and winters cruising in the warmer climate of the Caribbean. *Courtesy of Paul Louden-Brown, White Star Line Archive Collection, county Fermanagh.*

passengers' fondness for taking souvenirs was an ongoing problem and one that all steamship companies had to contend with. A liberal number of linen hand towels monogrammed with the name of the ship or the company name were distributed in first-class staterooms and changed daily. For passengers who traveled frequently, it was an amusement to collect hand towels as souvenirs from all the different ships and shipping lines they traveled on. Back home, towels with different styles and logos were displayed in powder rooms, serving as charming reminders of ocean travel across the world.[18] However, if even a small percentage of passengers took just one linen towel, linen napkin, or other souvenir, the loss to the company was significant.

Railway Passengers Also Desire Elegance

Not only shipping lines but also railway companies used Irish linen as decorative furnishings. For many travelers, railways provided a convenient and accessible mode of transportation to get to a destination. For

royalty, it became another opportunity to travel in luxury and comfort. Steam engines and railroads developed separately, but it was not until railroads adopted steam technology that they began to flourish. By the 1870s, railroads were displacing steamboats as the major transporter of both goods and passengers over land.

When Edward VII became king in 1901, his son George inherited the title Duke of Cornwall and was named Prince of Wales; his role was to visit the far-flung British Empire. When the prince and his wife, Princess Mary, toured Canada traveling east

Signal flags used by Great Northern Railway signalmen in county Monaghan, 1950s. The flags, woven of a blend of wool and linen fabric, have wood pole handles. *Courtesy of Monaghan County Museum, Republic of Ireland. Photography by David Pauley, Belfast.*

to west and back again on the Canadian Pacific Railway, Old Bleach Company designed a small figured pattern weave in linen that was used for curtains and valences in the royal bathrooms on the custom-built train.

In 1936, London and Midland Scottish Railway introduced a new train for travel between London and Glasgow, Scotland, named the *Coronation Scot* (to celebrate the coronation of George VI in 1937). Old Bleach was commissioned to weave linen and cotton fabrics for use in dining cars and cocktail lounges on the *Coronation Scot* and on other trains of Britain's Great Western Railway. A variety of colors and patterns were woven for train use, but a popular style of tablecloth for the cocktail lounge was woven in oatmeal-colored Irish linen with an embroidered monogram. The diagonal jacquard weave gave a rough surface to the cloth that kept plates and cutlery from sliding off the tables.

Linen Takes to the Air

As luxurious as it was for first-class passengers traveling by sea, linen always functioned as a fabric of strength and durability—the workhorse of natural fabrics. In the early days of passenger airline travel, linen was used to cover head and arm rests and for window curtains. It was light, cool, and not likely to pill or fluff up like cotton, making it easier to keep clean. Because linen tends to repel dirt, it stayed cleaner longer. Linen could be fireproofed, an added benefit for airplane use. For food service, plain linen tray cloths and napkins were standard fare. The starched white fabric gave passengers a sense of luxury at a time when airline travel was affordable by only a relative few and luxury and propriety were still paramount for travelers. Old Bleach supplied linen used for airline interiors as the industry grew and prospered.

The Sopwith Camel (an airplane known to millions of *Peanuts* cartoon readers) was, in reality, the most successful fighter aircraft in the history of the British Royal Air Force during World War I. The Sopwith Aviation Company of England built 5,500 Camels, named for the hump behind the propeller that housed twin Vickers guns. The Camel is credited with shooting down 1,294 enemy aircraft, more than any other Allied plane, but was nearly obsolete by 1918. The outer skin of the Camel was covered in lightweight, unbleached, unsized, tightly woven Irish linen with a thread count of approximately 152 threads per inch, making it exceptionally strong.[19] The linen was glued over the airplane frame, and ribs were laced together at the seams with linen cord, reinforced with linen tapes (strips). Water was applied to the linen, and when it dried, the fabric shrank drumhead-taut against the frame. After several coats of clear nitrate dope (plasticized lacquers) were applied to the entire surface, the fabric had been transformed from a limp shell to a glossy tight surface, ready for final painting and stenciling. The entire process was very labor intensive. When used as an airplane skin, Irish linen was an unforgiving fabric that required hand sewing and finishing to ensure an exact fit for all the fabric panels, known as bags. To enable future inspections, flaps were glued in place on one side to form a hinge and had metal snap-closures.[20]

It was soon discovered that enemy cannon shells could easily penetrate the linen-covered wood frames of the wings and fuselage but did not detonate. This meant that Camels could be, and were, shot many

times while the planes were in the air without affecting their ability to fly. Once a damaged plane landed, each hole was covered with a small square of frayed linen and brushed with a single coat of dope, and the plane was back in the air within an hour.[21]

When the famous and ill-fated *Hindenburg* zeppelin lifted off from Frankfurt, Germany, on May 3, 1937, passengers were cocooned in luxury in the largest flying machine ever built. The ride was so smooth that wine glasses in the dining room remained upright without trembling on tables covered with linen tablecloths—the expected fabric for an elegant dining experience on sea and in the air.[22]

British Overseas Airways Corporation (known as BOAC) became Britain's state airline at the end of 1939, taking over from Imperial Airways and British Airways Limited; BOAC met the challenge of starting operations in wartime, which was no easy task. On May 28, 1945, BOAC scheduled the first civilian flight from London's new Heathrow Airport to Karachi, India (now Pakistan), at which

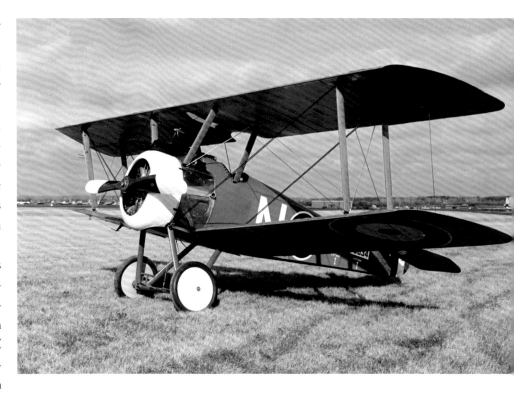

Reproduction of a World War I Sopwith Camel airplane (http://militaryhistory. about.com/od/ worldwariaircraft/p/sop- withcamel.htm). Irish linen was used as the outer covering on the wings and body of the plane. *Photo courtesy of the U.S. Air Force.*

point a Qantas aircraft continued on the so-called Kangaroo route to Sydney, Australia. With civilians on board, Irish linen manufacturers found new ways to use their fabrics to decorate aircraft interiors and provide a semblance of fine dining for travelers. Of course, luxury in flight could not begin to compare to luxury on the high seas, but in the early years of passenger airlines, only the wealthy could afford this mode of travel, and airline companies attempted to make it as pleasurable and elegant as possible.

During World War II, the growing aircraft industry continued to utilize unbleached Irish linen to cover the control surfaces (rudders and ailerons) of many famous airplanes, including Hurricanes, Spitfires, Lancaster Bombers, and Wellingtons. On the Lysander and Tiger Moth, practically the whole fuselage and wings were covered in Irish linen. Linen was not only lightweight and affordable but also malleable, enabling it to be stretched around intricate shapes.[23] On the ground, sentries guarded the planes day and night, not against the Germans but to prevent local camels from licking the dope off the linen fabric. During World War I, sheep and cows in France were the livestock that had to be kept away from linen-covered airplanes.[24]

While the nimble Spitfire was used to engage German fighters in the air, Hawker Hurricanes attacked inbound bombers and saw extensive use during the Battle of Britain (July–October 1940). The Hurricane incorporated many older construction techniques still used in existing aircraft, including a fuselage built from high-tensile steel tubes supporting a wooden framework covered with Irish linen. This technique was easier to build and repair than the all-metal planes, but eventually the wings were made entirely of steel,

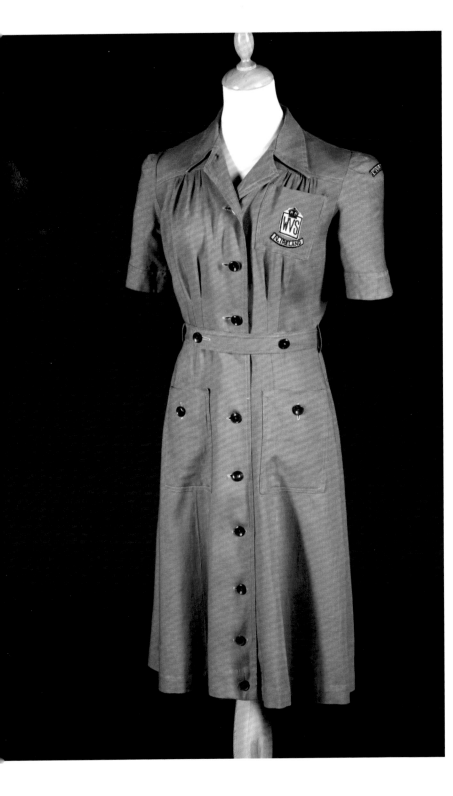

which greatly increased the plane's performance. Wood and linen structural parts of the plane that had the advantage of being penetrated without detonation were prone to burning quickly in case of fire, and a fuel tank located in front of the pilot caused severe burns to the pilot if it was hit. Spitfires primarily stayed to protect Britain, but Hurricanes were used overseas.[25]

For Prime Minister Winston Churchill, Irish linen continued to supply beauty and comfort after some of the darkest hours of war. The Avro York, a British transport aircraft used for both military and civilian roles between 1943 and 1964, was an adaptation of the famous Lancaster wartime bomber. As a military transport plane for Churchill, a special York was built and outfitted to a high standard of luxury for the time. It could sleep up to nine people in comfortable, if noisy, surroundings; there was a small galley in which to prepare meals, and fireproofed Irish linen fabric was used as the interior wall covering. Churchill flew to the Yalta Conference in Moscow on May 23, 1943, in the customized York; he also used it for trips to North Africa, Italy, and the Middle East for various conferences and visits to his troops. Other airlines followed the trend, and Irish linen curtains were installed in all Canadair liners shortly after the war ended.

In 1946, the British Air Corporation Act nationalized the country's airlines. British European Airways was formed to take over domestic and European routes, and British South American Airways (BSAA) was formed to fly routes to South America, where Irish linen shirts were extremely popular in the hot climate. BOAC passengers enjoyed the cool comfort of furniture covered in Irish linen at the company's airport lounge in the Brunel Hotel in Bristol, England. One of BOAC's chief hubs for travel to the East was the Augusta Airport in Sicily, where the majestic Augusta Hotel was completely redecorated with fabrics woven by Old Bleach Company. The long, heavy linen curtains were screen-printed with a pattern named Corale.

To many people, the essence of Irish linen is the smooth and glossy figured tablecloth. In the twenty-first century, it may be tucked away in a chest or back closet, brought out only for holiday dinners. More often, it is kept, unused, because the owner does not want to wash and iron out the wrinkles on such a large piece of fabric, which re-creases before the whole cloth is ironed smooth. Millions of those lovely old tablecloths and napkins were woven in a damask pattern, the most widely acclaimed and luxurious use for Irish linen. When fine examples of damask tablecloths were lit by candlelight, the flickering flame caused highs and lows of the white-on-white pattern to appear and disappear as it was viewed from different angles across the table. It was an enchanting and romantic woven surface that richly complemented exquisite cut crystal and fine china.

A damask textile is characterized by its contrasting dull and shining surfaces that define figured patterns of flowers, coats of arms, or a particular scene, woven usually in a single color, white-on-white. Damask was one of the five basic weaving techniques of the Byzantine and Islamic weaving centers of the early Middle Ages, and the name *damask* supposedly comes from the city of Damascus, Syria. By the fourteenth century, damask was being woven in Italy.

The quality of the yarn, the skill of the weaver, and the cloth's finishing process make a tremendous difference in the final product. Damask patterns are particularly visible on linen cloth because of the hard finish and sheen that occurs during the finishing (beetling) process.

Damask designs were carefully thought out and diagrammed before weaving began. First the pattern was drawn on paper with pen and ink to represent whatever subject was desired; there are no limits as to the subject matter or the complexity of the design. Next the design was transferred to graph paper so that each tiny square determined the position of the warp threads at that juncture. Mounted on the loom above the weaver, the graph paper design was equivalent to one pattern block, precisely repeated over and over for the length of the woven cloth. Weavers used very precise mathematical calculations for damask patterns, although the design woven into the cloth appeared to be free flowing.

Weaving an intricate design into an all-white fabric made it nearly impossible to determine whether a mistake had been made in the drafting of a pattern, so a colored sample piece, called a *proof cloth*, was woven and inspected for flaws before final weaving began. Proofs are beautiful colored examples that embody the elegance and complexity of this style of weaving used primarily for tablecloths, napkins, and commemorative pieces. Although damask patterns were essentially reversible, the right side was where the glossy design was dominant.

In the eighteenth century, damask linen was woven on a draw loom. The weaver needed a helper—one or more *draw boy(s)*—to sit on the loom above the weaver and pull cords that manipulated individual warp (vertical) threads according to a diagrammed pattern. The weaver was in charge of the treadles that controlled two harnesses; he threw the shuttle back and forth and swung the beater to compact the threads together. The versatility of a loom using a draw boy to control the order in which the warp yarns were raised changed designs

from being purely geometric repeats, based on right angles and diagonals, to figured patterns drawn from natural surroundings or representative of architectural structures. The replication of an entire town plan could be designed and woven into a damask cloth if the weaver was skilled enough to accomplish the feat.

An example of what could be produced by a remarkably skilled weaver is an Irish linen damask tablecloth of exceptional size, eleven feet long by nine feet wide, woven on a draw loom in Waringstown, county Down, circa 1727. The design comprised three sections with a border around the outside; two side panels, designed to hang down on the long sides of the table, were repeated twice on each side. The subject of the design was the coronation and inauguration of George II. The damask pattern was full of royal symbols, a city map of London, and the inscription "Wrought in Warrings town in the County of Down in the north of Ireland."[26]

William Coulson's Damask Linen Manufactory, renowned for its handwoven damask, was established in Lisburn in 1764 and continued in business until the 1950s. Plain linen cloth in twill and diaper patterns was also woven at Coulson's, which employed two hundred people. Royal patronage ensured the firm's international reputation for quality when Queen Charlotte, wife of George III, ordered a full set of damask table linens from Coulson's. In 1811, William's three sons (James, Walter, and William) were appointed damask manufacturers to the Prince of Wales, the future George IV, and the firm's royal patronage continued during the reign of Queen Victoria. Nobility in Britain, Europe, and as far away as Russia ordered their coats of arms to be woven into damask table linens on handlooms operated by Coulson's weavers. The complicated threading needed to weave an intricate design required finely spun yarn because it took many threads, tightly packed together, to make a glorious damask design. An excellent example of Coulson's workmanship is a tablecloth made for the Prince of Wales, the future Edward VII. It has a warp count of 170 threads per inch and a weft of 200 threads per inch.[27]

Until the middle of the nineteenth century, only persons of nobility, great wealth, and power could afford the magnificent damask tablecloths that were woven on draw looms. The process from start to finish was long and laborious, making each tablecloth an expensive status symbol to own and a powerful display of the owner's position when used for dining. In 1801, the Frenchman Joseph Marie Jacquard invented a power loom that could automatically read hand-punched wooden cards held together horizontally in a long row by cords tied to each side of the card. The woven design was determined by the placement of holes in the cards; a different set of cards was needed for each different design. In a sense, this was the first pseudo-computer because the punched cards told the loom how to manipulate the warp threads for each shuttle crossing. Later in the nineteenth century, English mathematician Charles Babbage (1791–1871) realized that punched paper could be employed as a storage mechanism, holding computed numbers for future reference. Because of the connection to the Jacquard loom, Babbage called the two main parts of his analytic engine the *store* and the *mill*, both terms used in the weaving industry. The store was where numbers were held, and the mill was where they were woven into new results. In a modern computer, these same parts are called the memory unit and the central processing unit (CPU).

By the 1879s, Coulson's had adapted the French Jacquard mechanism, which was attached to the top of a handloom, replacing the need for draw boys to manipulate warp threads. Use of the Jacquard head

greatly speeded damask weaving, increasing production and decreasing the cost. With improved production came a flood of orders for damask linen, which was newly affordable for use in the dining rooms and sleeping quarters of hotels, clubs, shipping lines, and railway cars, adding elegance and sophistication for the traveling public. Suddenly, anyone who traveled in first class could enjoy the opulence of crisp white damask, which had formerly been available only to royalty and nobility. Power-loomed damask linen tablecloths and cambric linens for fine handkerchiefs did not surpass the quality of handloom production, however. Jacquard woven damask could not match the intricacies of design that are possible with handwoven cloth, but place-names and recognizable logos began to brand table linens and establish recognizable identities for consumers on a scale that had never before been achieved. In the mid-twentieth century, computerized damask looms produced a length of fabric in six days that would have taken six months a century earlier.

Queen's Royal Regiment linen damask proof cloth for napkins, woven by William Coulson's Damask Linen Manufactory, c. 1910. The Queen's Royal is England's oldest infantry regiment, formed in 1661. The design is of the regimental color, with battle honors encircling one of the regimental badges, surmounted by the crown. The napkins date from after the Boer War (c. 1899–1902), in which the regiment took part in the relief of the town of Ladysmith, South Africa. *Courtesy of Irish Linen Centre and Lisburn Museum.*

Linen damask proof cloth depicting the victory of King William of Orange at the battle of the Boyne in 1690. Attributed to William Coulson's Damask Linen Manufactory, c. 1880s, the cloth was probably woven to commemorate the two hundredth anniversary of the famous battle. The cloth was placed in a wood frame to serve as a fire screen. *Courtesy of Monaghan County Museum, Republic of Ireland. Photography by David Pauley, Belfast.*

Although it is commonly assumed that most damask weavers were men, Elizabeth McCoy, a fifty-three-year-old widow, and her nineteen-year-old son, James, both listed themselves as damask weavers in county Down in a 1901 government census. Unfortunately, there is no way to know where they were working or on what kind of loom.

Promoting Linen Damask Globally

Old Bleach Linen Company of Randalstown was a prominent and successful firm that won awards at exhibitions and contracts to weave for the most high-profile and prestigious clients. In the 1920s, Old Bleach hired women to hand paint damask tablecloths and napkins. The floral designs were richly colored to coordinate with popular English china patterns. The appearance of a wide range of Old Bleach's vibrant hand-painted damask table linens in shop windows on New York's Fifth Avenue in the 1920s caused quite a stir for buyers and sellers of home furnishings. To further promote the craftsmanship of the hand-painted linen, Old Bleach sent a few of its women artists to conduct "in store" demonstrations in New York and London. Other companies also hired women to hand paint linen tablecloths, but the product was too labor intensive to be profitable for the manufacturers on a long-term basis and too expensive to be successfully marketed to the general public.[28]

Irish Linen Damask Graces the Table in the Twentieth Century

England saw a great expansion of wealth, power, and culture during Queen Victoria's long reign, from 1837 to 1901. Society across the British Empire was rigid beyond what most people in the twenty-first century can imagine, a social order painstakingly straitlaced and reserved. There were rules for every conceivable occasion and the appropriate behavior associated with each event, no matter how trivial. For the socially conscious, entertaining was not an occasion to get together with a few friends to share good food and conversation, but rather consisted of highly structured, detail-oriented procedures that took days of preparation by a staff adhering to an expected standard of decorum.

The table setting was of utmost importance, and Irish linen damask tablecloths added grace and sophistication to the meal. Family coats of arms surrounded by pleasing floral designs sparkled on damask in the candlelight. Hostesses were scrupulously judged on their ability to set the proper table with the required tablecloth, cutlery, glassware, and china, with further adornment in the form of an appropriate centerpiece and candles. For breakfast, napkins had to be lap-folded and placed across the plate, the sugar spoon had to rest on the bowl at a precise angle, and if fruit was served, a finger bowl was to be positioned directly above the service plate, with the bowl a little less than half filled with water (tepid in cold weather and cool in warm weather). Damask linen tablecloths and napkins were a necessity; each meal required a different size

and pattern. For dinner, tablecloths hung over the table ten or more inches, and napkins to match the table-cloth were twenty-four to twenty-eight inches square, folded four times, and placed to the left of the service plate. Luncheon cloths hung over only six or seven inches and were paired with matching napkins measuring thirteen to seventeen inches square, folded in a triangle, and placed at the left of the plate with the point toward the plate.

There were also rules governing the placement of the salad fork, meat fork, fish fork, and oyster fork, all knives, and the bouillon spoon, fruit spoon, and grapefruit spoon. Each plate was served from the left by a maid or butler, and the hostess was served first. The same standards for dining in Britain were maintained, to a great degree, for passengers traveling on shipboard—at least for those in first class.

After World War I, new ocean liners replaced those destroyed during the war. Colonial trade was reestablished, and mail runs were more important than ever in the postwar economy. Britain had the largest fleet of luxurious ocean liners, with the Cunard and White Star Line dominating the North Atlantic route, but the thousands of emigrant passengers traveling to America in steerage class were what made ships profitable, not the elite passengers traveling on the top deck enjoying the well-appointed salons and staterooms filled with Irish linen. After the war, new quotas curtailed immigration, and ships were built smaller and more comfortable but not nearly as luxurious as they had been before the war.

In 1927, the great French ocean liner *Ile de France* was launched, a floating grand hotel filled with extravagance unlike anything that had been seen before in transatlantic travel. The *Ile* started a fierce competition

Linen bedsheet hand embroidered with the cypher of Queen Mary, c. 1935. In the 1930s, King George V encouraged the cultivation of flax on the royal Sandringham estate in Norfolk, England. When Sandringham-grown flax was mature, it was processed, spun, woven, bleached, and finished in Northern Ireland. *Courtesy of Irish Linen Centre and Lisburn Museum. Photography by David Pauley, Belfast.*

between shipping companies to see who had the biggest, longest, fastest, and most lavish ocean liner. Interiors were designed like palaces, each ship more spectacular than the last. Grand salons were filled with marble columns, vaulted ceilings, fireplaces, Lalique crystal chandeliers, and glass dance floors with colored lights that changed patterns and color with the music (a precursor to the disco age to come). Dancers followed the ship's gentle roll in harmony with the sea, moving from one side of the dance floor to the other as big bands played through the night. Each ship was a symbol of glamour, romance, and high society at play.

Queen Mary, wife of King George V, launched a new ocean liner bearing her name in 1934, providing a weekly express mail service from Southampton, England, to Cherbourg, France, to New York and a return along the same route. The interior design of Cunard–White Star Line's RMS *Queen Mary* was mostly Art Deco and seemed restrained and conservative compared to the ultramodern French liner *Ile de France.* Onboard amenities on the *Queen Mary* varied according to class, with first-class passengers dining in a grand salon, which spanned three stories in height and was anchored by wide columns. Linen and linen-blended fabrics woven by Old Bleach were used in the *Queen Mary*'s grand salon and first-class lounge.[29]

Ships sailed the world, moving passengers from all continents as they traveled for business and pleasure. Some travelers held the cheapest steerage ticket as they emigrated to a new life in a new land; some were returning home to visit family across the water; and others wanted to see the world's greatest sites in faraway lands. To compete for passengers, shipping lines published expansive color brochures with pictures and descriptions of newly decorated dining salons, reading and writing rooms, libraries, and gymnasiums, many filled with linen tableware and bedding. Passengers received newsletters explaining shipboard etiquette and appropriate fashion attire, describing tourist attractions to visit at each destination, and containing advertisements extolling the virtues of Irish linen and where to buy it.

Wealthy first-class passengers had money to spend on themselves and to buy gifts to take home. Shipping lines understood that they had a captive audience onboard, and official guidebooks offered excellent advertising space. When passengers slept luxuriously under Irish linen sheets, they discovered that they could purchase the same quality of bedsheets to take home. The luster of the damask tablecloth they so admired in the elegant dining room could be purchased at the gift store onboard. Embroidered tea and luncheon sets made marvelous gifts for family members back home. Wm. Liddell and Company manufactured linen goods for many shipping companies and made all the linen products used by the White Star Lines in 1930.[30]

A Stopover in New York City

Many travelers spent a few days in New York City before or after overseas excursions, shopping along Fifth Avenue, sightseeing, enjoying a Broadway play, or dining at one of the city's world-famous restaurants. In the 1920s, the Waldorf-Astoria Hotel was the place to see a fashionably elite class of patrons. The Waldorf's dining room was legendary for fabulous food in a lavish setting, especially when "Oscar" personally supervised all the details for a private dinner party. Oscar Tschirky (1866–1950) had been maître d'hôtel of the celebrated Delmonico's restaurant in Manhattan before moving to the Waldorf-Astoria. He was widely known by name and produced a large cookbook. Although Oscar was not a trained chef, he is credited with creating Veal Oscar and the Waldorf salad and with popularizing Thousand Island dressing.

Bountiful meals at the Waldorf were presented on an Irish linen damask tablecloth of superb quality and luster, manufactured by William Adams and Company under the trademark brand Derryvale Linen Co. Inc. In 1885, William Adams opened a linen warehouse in Belfast, and by 1904, Adams had built or purchased a weaving factory and installed 220 Jacquard damask looms. The firm primarily manufactured linen goods, specializing in the highest-quality double damask, a style woven with double the number of threads, producing thicker cloth that featured a more pronounced pattern. The firm grew quickly, and three of

Paper packaging label for William Adams and Company under the firm's trademark brand Derryvale Genuine Irish Linen, c. 1900. The labeling was intended to assure customers of Old World–style weaving and handmade quality. *Courtesy of American Textile History Museum, Lowell, Massachusetts.*

"*Typical scene in the Irish linen country.*"

DERRYVALE

Registered United States Patent Office

Genuine Irish Linen

William's sons carried on the business after his death in 1908. Albert (1884–1943) moved to the United States to run the Derryvale Linen Company's offices on East 22nd Street in New York City. Albert was an astute marketing director; the firm advertised in women's magazines and, in 1921, published a book to promote the wide variety of tablecloths, table settings, and occasions for the consumer to use Derryvale linen damask.[31]

For anyone fortunate enough to dine at the Waldorf, Oscar prepared a sumptuous menu of eight courses. His elegant menus were complemented by the fine Irish linen on the table and in the lap of the diner; the event was a long, drawn-out affair with patrons dressed formally to conform to society's highest standards of decorum. One of Oscar's dinners included fruit cocktails, sorrel soup with toasties, celery, olives, salted almonds passed during the soup course, mousse of shad roe formed in the shape of fishes, cucumbers sautéed in cream, new asparagus with hollandaise sauce, Supreme of Chicken Colbert, salad of hearts of romaine and beets, bombe of fresh strawberries with Chantilly cream, and assorted cakes. Smoking was acceptable throughout the meal, and cigarettes were passed around the table repeatedly. During Prohibition, Oscar concocted his famous Astoria Cup served in a juice glass, consisting of equal parts of cider, grape juice, loganberry juice, and sparkling water. After dessert plates were cleared, finger bowls were placed next to each diner, then cigars and coffee were served to the gentlemen while women retired to a reception room for their coffee.

IRISH PEOPLE and Irish linen crisscrossed the oceans in ever-increasing numbers throughout the nineteenth and into the twentieth century. The social class divide between makers and users of Irish linen would always be vast, a difference between worker and owner. But many Irish emigrants traveling in steerage class who landed in North American ports found opportunities to make a living, not necessarily in the textile industry located in northern states, but by claiming available land to farm or by working on the expanding railroads or in the growing steel industry. As they established themselves in new surroundings, the Irish of the growing diaspora stayed connected to their homeland through letters, literature, and song—a people determined to retain their Irishness through the generations.

Facing page: "Chrysanthemum" pattern linen damask tablecloth woven by Ulster Weavers, county Down, late twentieth century. *Courtesy of Ulster Weavers, Ltd. Photography by David Pauley, Belfast.*

A Social Experiment in Two Mill Villages

I N T H E United States, the word *mill* describes a building where both spinning yarn and weaving cloth took place, whereas in Great Britain, spinning was done in a mill and weaving in a factory, two distinctly different environments for workers. The word *mill* was usually attached to the name of the firm, while a weaving facility often used the name of the company, leaving off the word *factory*. For example, Herdmans Flax-Spinning Mill processed raw flax into linen thread, but the firm of Richardson Sons and Owden wove cloth.

Industrial or mill villages came into being when textile production became increasingly mechanized and manufacturing moved away from the domestic system of work and into a mill system. These villages, commonplace in Britain during the early stages of industrialization, were associated with textile, coal, and iron industries where manufacturing was at the heart of the village or town. In Ireland, most mill villages were built around the linen industry and with few exceptions came into existence between 1730 and 1870.[1] As Ireland's agrarian economy strengthened in the eighteenth century and into the nineteenth century, towns and villages across the island were reshaped, rebuilt, and repopulated to accommodate flax-growing industries and the increasing production of linen cloth, which was subsidized and promoted by the British government.

The mill system changed the social structure of local communities as people came to work for one employer instead of working at home and selling their output in the marketplace. The spirit of cooperation as an ethical and practical solution to employer/employee relations undoubtedly appealed to families who viewed village camaraderie as a continuation of the neighborhood spirit of domestic textile production.

Two nineteenth-century utopian villages for textiles in Ulster province still retain much of their original physical characteristics in the twenty-first century. Sion Mills (on the River Mourne, county Tyrone) was renowned for spinning flax into yarn, and Bessbrook (on the Camlough River, county Down) was notable

Facing page: Hank of linen yarn. *Courtesy of Irish Linen Centre and Lisburn Museum. Photography by David Pauley, Belfast.*

for spinning and later also for weaving. Both villages were created by industrialists with a strong sense of philanthropy and moral integrity, Sion Mills by the Herdman brothers and Bessbrook by John Grubb Richardson. The villages had similar geographical settings because spinning requires copious amounts of water and a nearby supply of raw material to process. Each village was clustered around a green space, promoting a sense of domesticity, and was within walking distance of (but not attached to) the mill or factory to give residents of the community a sense of place.

During the last quarter of the nineteenth century, the great flax-spinning mills and factories were linked to ports by single-gauge railways. In Sion Mills, the railway siding ran right into the mill building, providing a direct link to the nearest port, a feature that was essential for a company located in a rural district selling to international clients.[2]

Sion Mills, County Tyrone

The first Herdman came to Ireland in 1688 from Herdmanston in Ayrshire, Scotland, to farm a tract of land in Glenavy, county Antrim. Nearly 150 years later, Herdman men were involved in shipping, tanning, and flax spinning. By the 1830s, Herdman brothers James, John, and George were running the Wine Tavern Street Flax (spinning) Mill and a tannery in Belfast when they decided to establish a new spinning mill in a rural district of northwestern Ireland. County Tyrone had high unemployment and was ideally located close to the flax-growing fields of Donegal. The brothers purchased a grain mill from the Marquis of Abercorn in 1835 on land leased for three lifetimes plus thirty years (making the lease probably ninety to one hundred years); the lease was eventually increased to five hundred years. The grain mill was converted to spin flax into linen yarn, and the two families agreed not to compete with each other: Abercorns would not spin flax and Herdmans would not mill grain. The agreement was rescinded only once, during the years of the Great Famine, when the Herdmans had to grind corn to feed their workers.

Brothers James and George Herdman stayed in Sion Mills to establish the new operation while John moved back to Belfast to continue running the Wine Tavern Street Mill; by 1840, the firms had merged into J & J Herdman & Company. From the very beginning, all three brothers envisioned a planned community for the village, undoubtedly influenced by the work of social reformer Robert Owen (1771–1858), manager of New Lanark Mills (situated in a village on the River Clyde, near Glasgow, Scotland), a cotton mill employing nearly two thousand people. In 1800, Owen introduced a more humane and progressive employment regime to improve the environment for workers at home and on the job. New Lanark Mills attracted the notice of many industrialists in Britain and Europe when Owen's social and economic experimentation increased productivity and company profits. With New Lanark considered the epitome of utopian socialism, Owen visited Ireland in 1823 to lecture on his principles as embodied there.[3]

The Herdman brothers' plan for their own utopian village began with a row of workers' cottages based on the Irish vernacular style of single-storied buildings.[4] In 1839, they built a gasworks to light the mill, and by 1842 every house in the village had one gaslight, the store had four, and streetlights were installed. In the early years, Herdmans Flax-Spinning Mill owned and operated a hundred-acre farm outside the village that supplied a store cooperative to help feed residents. In 1843, seven hundred workers (five hundred of them women) were living in small cottages in Sion village. Herdman built a school in 1848 (replaced in 1879), and in 1851, he built 66 additional row houses for employees. Sixty years later, employees were living in 213 row houses, and many families took in lodgers, which enlarged the workforce even more. The expansion of the village was tightly controlled to ensure that the ratio of employees to mill production was carefully maintained, an obvious advantage for both worker and manager.[5]

The Herdmans increased the village neighborhood with another store, a community hall for adult education, and a Presbyterian church. James Herdman was a progressive thinker intent on educating his workforce and proved quick to incorporate new technology into the village. The school provided education for employees' children, while the community hall was used to improve workers' skills and provide cultural entertainment. There was a village band as early as 1842, and George Herdman led singing classes for girls who worked in the mill. His aim to produce a literate community was supported by his religious zeal, for he believed that church and Sunday school were central to community spirit. For the first thirty years, everyone in the village attended church together in a converted building, and James Herdman beat a drum to call people to worship. The Herdmans were Presbyterians and personally enjoyed fine wines and liquors in moderation, but they created a temperate community as a matter not of principle but of practicality, believing that alcohol decreased the motivation of the workforce and affected production at the mill. Until 1896 when they lost a court case, there was no public drinking house allowed in the village.

Although personal religious beliefs helped form the basis for their social experiment, the Herdman brothers were fair-minded enough to hire equal numbers of Roman Catholic and Protestant workers, as they were convinced that the policy would make for a more peaceful community. Company records in March 1889 show that sixty-eight households were Roman Catholic and an equal number were Protestant.

All three brothers married and had large families to carry on the business. John Herdman was running Wine Tavern Street Mill in Belfast, and his wife, Elizabeth Finlay, was raising their fourteen children while James and George ran the flax-spinning operation in Sion Mills. In 1856, the youngest brother, George, died suddenly of meningitis, and James brought his two eldest sons, John and Emerson, into the business to replace George. Six years later, the second brother, fifty-one-year-old John, was murdered—shot and killed by his cousin William Herdman during a family argument in Belfast. The Herdman partnership consisted of two mills at the time, but the family divided the businesses after John's death. John's son Alexander took over the management of the Belfast mill, renaming it Smithfield Mill. Unfortunately, Alexander and his bride both died terribly young of typhoid, but Smithfield Mill continued to be run by John Herdman's

descendents until 1902, when another tragedy struck: a wall at one end of the mill collapsed suddenly, killing a number of workers.

James, the only survivor of the original three brothers, continued to run the spinning mill in Sion Mills until 1866, when he had an extramarital affair that led to a court trial and widespread scandal. He was forced to retire to England, leaving the management of the mill to his sons John and Emerson as equal partners.

THE VILLAGE GREEN was a recreational area for employees based on the principle that open-air activity would contribute to the mental and physical well-being of workers. Sport was a central activity in the village. The Herdmans strongly believed that cricket transcended all creeds and classes, so they encouraged and sponsored the sport by establishing a cricket club and field in 1864, thereby strengthening the integrated community they had created. Football fields, a bowling green, and tennis courts were added later as part of the altruistic dedication to provide facilities for work and play in one location.

The village did not include a specially built residence for the mill owner until 1846, when James and George built Sion House, an Italianate-style house, designed by Charles Lanyon, a renowned Belfast architect. The house was built to one side, between the village and the mill buildings. After James moved to Bath, England, his son Emerson occupied Sion House, and John (his brother) lived in nearby Strabane. With the growth and success of the spinning mill, Emerson expanded the house into a fifty-room mansion and added stables and a gatehouse in 1884. The architectural style for the owner's compound was an interpretation of fashionable English home styles rather than an Irish country house tradition. William Unsworth, a friend and contemporary of the famous English architect Edward Lutyens (designer of Queen Mary's dollhouse, described in chapter 4) and brother-in-law of Emerson Herdman, designed an addition to Sion House in the Arts and Crafts style. The proportions and combinations of bay windows and pitched roofs were reminiscent of an oversized cottage that typified Lutyens's style of the period. The stables and gatehouse complemented Sion House architecture, establishing a visual juxtaposition of money and quaintness, a style associated with the elegance and conspicuous consumption typical of England in the 1880s. Men with the social position of the Herdmans were expected to build grand homes in a fashionable English style rather than in the Irish vernacular.

When Herdmans Flax-Spinning Mill switched from dry to wet spinning in 1853, a larger structure was needed to contain new equipment and an expanding business. Designed by Belfast architect William Lynn and completed in 1855, the five-story building was constructed of locally quarried gray ashlar stone,[6] calculated to be fireproof. Situated on the bank of the River Mourne at the end of a tree-lined street, the mill was a mammoth structure, a beacon on the otherwise pastoral landscape, its grandeur visible long before the village came into view. In contrast to the quaintness of the village, the architecture of the mill building signified international flavor—a clear intention by the owner to tell the world that Sion Mills was spinning world-class yarn. The original mill building, known as the Tow Mill, was then used for the hackling process (see chapter 2). A major shortage of cotton imports as a result of the American Civil War caused a huge

demand for linen that greatly increased the need for flax spinning. To meet the demand, two large yellow brick extensions were added to the main mill in the 1880s. The fast-moving River Mourne powered four huge water-wheels that provided hydroelectricity for all mill machinery until modern turbines were installed in 1900.

The elegant old mill with levered glass windows on the roof for ventilation (an outdated function from another century) was used until 1989, when it was abandoned. In contrast, the international architectural style of the new mill favored simple geometric lines and spacious interiors; the construction of steel and reinforced concrete could more easily be expanded and altered to accommodate technological developments and marketing trends in the ever-changing textile business.

Life in Sion Mills village revolved around work, church, sport, and family life. The company offered a single vacation day per year, when all employees traveled by train to the Antrim coast for a picnic and day

Herdmans Flax-Spinning Mill, Sion Mills, county Tyrone, c. 2005. *Courtesy of Sion Mills BPT Collection.*

Workers leaving Herdmans Flax-Spinning Mill at the end of a shift, c. 1940. *Courtesy of Sion Mills BPT Collection.*

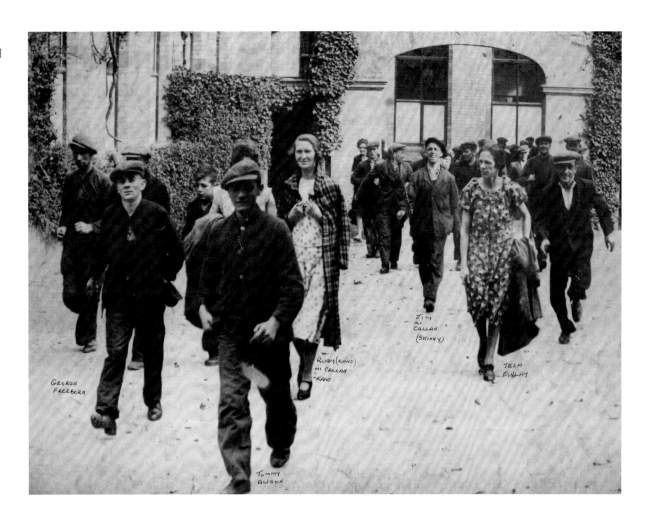

at the beach; in some years, an excursion to the Donegal coast was offered. Life, work, and even leisure activities were closely dictated and monitored by the owner. In return, employees and their families had a guarantee of housing, steady employment, and pay equal to or better than that of other textile workers.

In the 1860s, the first official cricket team was established, and by 1888, the team (organized under the sponsorship of the North-West Cricket Union) was winning awards. Matches were first played on the grounds of Sion House, a typical setting for Irish-style cricket matches when the game provided social entertainment for landlords and elite industrialists in the surrounding area. Sion Mills residents still claim that the 1969 match against the West Indies team resulted in the longest hit in cricketing history when the ball landed in the rail car of a passing freight train that transported it to Derry, seventeen miles away!

Generation after generation of village families in Sion Mills lived in the same small, close-knit community where everyone worked for the same employer, giving the village a sense of identity and unity. In a

place where houses shared a common uninsulated wall and a neighbor's footsteps foretold each coming and going, there were no secrets; the most intimate fact was told and retold, good and bad alike. If a man stepped out on his wife and into the house up the row, his neighbors knew about it. Each house had a tiny entryway, a small main room with the kitchen attached, and a ladder to a sleeping loft. Washing was done in the kitchen, and toilet facilities were outside. Women were expected to keep the single large stone placed at the outside entrance of the front door spotlessly clean and polished. The stone signified a woman's domain, and it was to be washed, scrubbed, and honed with pumice until the center wore down into a depression that resembled a half moon and it shone spotlessly clean. The area was just wide enough for a woman's arm to reach the farthest point while she knelt in the open doorway. This was the public space that indicated her success or failure as a tidy homemaker and determined her overall standing in the community; her efforts were highly praised or severely criticized by family and neighbors alike. Likewise, women in the mill were expected to keep machinery at their workstation spotless, and the same neighbors who judged their cleanliness at home also criticized slovenly work at the mill. Mothers and grandmothers taught young girls what was expected of them and how to meet those expectations. To families in the twenty-first century who desire privacy and distance from each other, the idea of multiple generations in a small house with neighbors living in such close proximity seems abhorrent, but many women found security in the multiple layers of opinions, information, and knowledge as they became wives and mothers.[7]

Workers' housing on Albert Street, Sion Mills, county Tyrone, c. 1912. The housing was built in the nineteenth century for employees of Herdmans Flax-Spinning Mill. *Courtesy of Sion Mills BPT Collection.*

With workers' welfare the apparent philanthropic reason for creating Sion Mills village, the Herdman brothers (like all socially conscious industrialists of the time) had practical reasons for wanting to create a healthy, contented workforce. They understood that loyal workers could be relied on to produce a quality product in sufficient quantity to satisfy increasing marketplace demands. This, in turn, would support a prosperous lifestyle for owners and their families.

At its height, the mill employed fifteen hundred people. Linen yarn spun at Herdmans Ltd. was exported all over the world, although the majority of it went to weavers in Belfast and the surrounding areas in the early years of the twentieth century.[8] During the life of the mill, yarn was spun in all weights (thicknesses), but Herdmans was considered the world's leading producer of very finely spun yarns, used for nearly transparent linen handkerchiefs and liturgical vestments. When flax was no longer produced in sufficient quantity in Ireland to meet the demand for the raw material, the company purchased flax from Russia and the Baltic countries. During World War I, Herdmans spun yarn used for linen cloth to cover the Sopwith

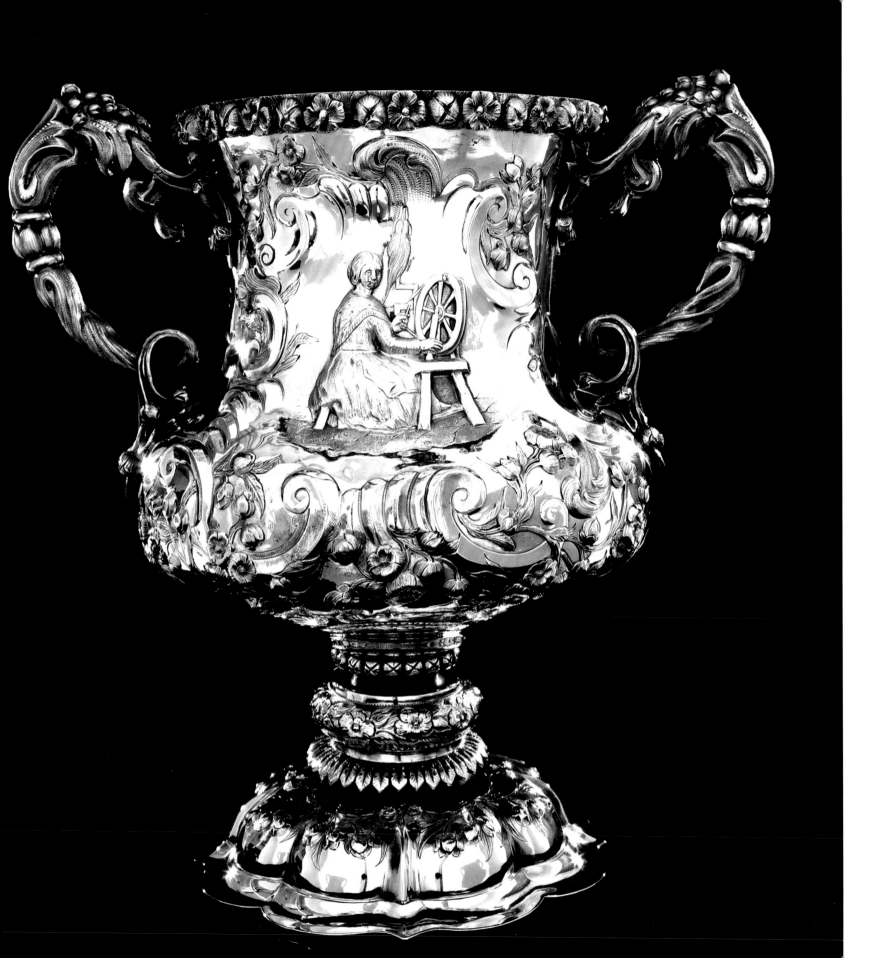

Camel airplane (see chapter 4). In World War II, Herdmans supplied linen yarn for parachute cords and to factories weaving linen for airplanes, and the company also retooled to make brass shell cases for James Mackie and Sons, a textile machinery engineering plant and foundry in Belfast. One of the finer replicas of the Turin Shroud was woven from Herdmans linen yarn.[9] With a family board of trustees to guide Herdmans Ltd., descendents of James Herdman remained at the helm of the family spinning mill through consecutive generations.

In 2004, after a couple of poor flax harvests caused by bad weather raised the price of the raw material beyond profitability, and with China cornering the world's linen market, Herdmans finally laid off the last 270 workers and stopped all production. Thus ended 170 years of spinning flax into yarn in Sion Mills.[10]

Sion Mills village survives, along the Northwest Passage from Monaghan to Derry, living proof of James, John, and George Herdman's vision for a different style of living and working, a small, industrial community nestled in the rolling green hills of county Tyrone. The village name remains a symbol of the great legacy of flax spinning in western Northern Ireland; the imposing mill buildings continue to tower above the landscape long past the time when spinning fiber and weaving cloth moved to distant shores.

Bessbrook, County Armagh

In 1846, John Grubb Richardson (1813–90) decided to build a spinning mill in county Armagh to expand the family textile business. He purchased a six-thousand-acre estate where flax growing and linen bleaching were staple activities and where his Nicholson cousins had been bleachers since 1802. John Pollock established the first bleach green on the land in 1761, and by the time his son William Pollock leased the land to Nicholson, the enterprise was capable of bleaching 18,000 webs (lengths) of cloth annually.[11] The village of Bessbrook was established for workers' housing when the large spinning mill was built and power loom weaving added in 1852–53.

The name Bessbrook is believed to be a combination of *brook*, from a nearby stream, and the name Elizabeth, or *Bess*, referring to either Elizabeth Nicholson, the wife of Joseph Nicholson, a distant relative, or another Elizabeth, the wife of Joseph Pollock, who was also a local weaver. When John G. Richardson developed the scheme for Bessbrook village, the land was rural, an ideal setting for Quakers, who regarded planned social communities as the cultural expression of their belief system. Similar to Sion Mills village, Bessbrook was conceived as an experiment in social planning alongside industrial development, with Quakerism rather than Presbyterianism supporting the philosophy behind the village model. There were approximately one hundred Quaker meetinghouses in 1750 in Ireland, and in 1800, Quakers were mainly involved in grain mills and textile production.[12] John G. and his brothers were continuing a Quaker tradition of families working together in textile manufacture and production, and they were businessmen highly regarded for their honesty and integrity.

Facing page: Sterling silver trophy (originally presented by William Smith O'Brien in 1864) awarded to the owner or tenant of the greatest number of acres of flax produced during three successive seasons in county Limerick. It is now a Perpetual Challenge Cup awarded for the best collection of Irish-made fabrics out of native materials exhibited at the Royal Dublin Society's annual show. *Courtesy of Royal Dublin Society Archives. Photography by Barry McCall, Dublin.*

In common usage, the word *yarn* is used to describe a soft, fuzzy fiber used for knitting and weaving; *thread* is a smooth, twisted strand used for sewing. In actuality, both *yarn* and *thread* can consist of a single strand or multiple strands twisted together or plied and made from natural fibers such as flax. Long strands of man-made fibers of glass, plastic, and metal are also called yarn and thread. The image of a long, continuous length also describes everyday situations, as with *spinning a yarn,* which indicates a story told in too much detail.

A *hank* refers to a circular coil or loop of anything flexible. A hank of hair is a bunch of hair held tightly in place, but a hank of linen is a coil of yarn or thread of a definite length (3,600 yards) wound and twisted together.

The words *shaft* and *shed* are words used by handweavers that also have common contemporary meanings. *Shaft* describes rectangular frames that move up and down, making a narrow opening of warp yarns to allow the shuttle to pass through. A shaft of sunlight, the shaft of a mine, or the contemporary slang phrase *he gave her the shaft,* emphasizing a sudden separation, are all phrases whose meanings indicate the same kind of narrow opening for something or someone to pass through.

John G. envisioned a company that totally controlled all aspects of making and selling linen cloth, from spinning and weaving to exporting and marketing the final product. John G. inherited Richardson Sons & Owden of Glenmore Bleachworks at a young age, and the Bessbrook enterprise was built to function in association with the bleachworks and Richardson Sons & Owden's warehouse in Belfast.[13] He anticipated having a family member owning or managing each operation at home and other relatives acting as importers of his goods abroad. Four years before establishing Bessbrook Spinning Co. Ltd., John G. and his brother Thomas traveled to New York, planning to open the American firm of Richardson Watson & Company of Philadelphia and New York. Although the venture never materialized, Thomas stayed in New York to become a linen agent, so John G. had his New York agent in place at the start of his Bessbrook endeavor.

John G. Richardson was the most energetic and possibly the most intuitive of his six siblings. His ideas for the family textile business were visionary and far-reaching. Before his thirtieth birthday, he had already assisted his brothers James and Joseph in founding the firm of Richardson Brothers & Company of Belfast and had opened an office in Liverpool to import flax, grains, and other raw materials and to export linen yarn and cloth.

The Camlough River provided the waterpower for Bessbrook Spinning Company, and the steep surrounding hills gave the village a distinct character. Two squares, or greens, were central to the village; as at Sion Mills, the village green served as a recreational area for employees based on the principle that open-air activity kept workers healthy and contributed to their sense of community spirit. When textile work was a home-based endeavor functioning alongside farming, green spaces were necessary to the work of independent bleachers. Within the village itself, the green spaces appealed to families moving from a rural setting to

a mill system of work and lifestyle. The village functioned on the Quaker principle that no public drinking houses and no pawnshops meant that no police would be required.

According to the 1841 census, 37 percent of Ireland's rural laborers (85 percent of the population) lived in single-room, cabin-type housing.[14] Floors were bare earth, and the stone interior walls stayed perpetually black with smoke from peat fires, the only source of heat. The other traditional Irish dwelling was a small farmhouse consisting of two to four rooms. Richardson built cottages for his workers of a much higher standard. The earliest workers' houses in Bessbrook, highly desirable housing for workers compared to the alternative, were built on Fountain Street in the 1850s. They resembled traditional rural laborers' cottages only visually, in being rectangular structures with thick walls of stone or mud, a thatched roof, and an open hearth. Each was built with a granite façade. From 1867 through 1870, Richardson added more houses as mill production increased and more workers were hired. James Street housing consisted of two rooms (one on top of the other), a small scullery, and an enclosed yard, whereas the houses on Frederick Street, built at the same time, had two bedrooms. Managerial housing, with three to five rooms, was naturally larger than workers' housing; size reflected a worker's job, not family size. The granite façades on the housing in Bessbrook created a strong unified character that matched the impressive mill structures looming over the village. These houses were more austere than their Sion Mills counterparts, as the lack of ornamentation was typical of Quaker utilitarianism. In the case of Bessbrook, granite was also a practical solution because a nearby quarry provided a ready supply of building material.

As each new row of houses was built to accommodate additional workers, a combination of terraces, streets, and open spaces on the hillside above the river ensured pleasant surroundings. The architecture of the school echoed a domestic dwelling and lent quaintness to the village. The school was nonsectarian and fully staffed with accredited male and female teachers; children were expected to attend regularly, be clean, and behave in an orderly manner. Each household was charged a penny for education, and the mill (aided by a government grant) paid the balance due. An infirmary, a nursery school, and a large playground were attached to the main building. In addition to the in-town amenities, Bessbrook Spinning Company owned a three-hundred-acre farm, and allotments were made for each household to share in the labor to grow and harvest the fresh produce. Milk, a real luxury, was available to all workers.[15]

Row of stone cottages built for mill workers, Bessbrook, nineteenth century. *Courtesy of W. Porter.*

Bessbrook had a Quaker meetinghouse, a bank, a post office, a milliner's shop, a bakery, a general store, and a food cooperative, adding to the sense of community that Richardson wanted to create. By far the most imposing building was the town hall and institute for adult learning that dominated the village green, symbolizing both civic control of Quaker patriarchy and the caring role of Richardson as benefactor and employer.

As a Quaker colony based on the production of yarn and the manufacture of cloth, Bessbrook village developed over four decades, expanding with the success of the Bessbrook Spinning Company. Nearly seven hundred houses were built in Bessbrook, and census records show a population of three thousand residents in 1890. By providing decent housing and ancillary buildings that were needed to create a fully functioning village community, the Richardsons not only reaped financial rewards but also satisfied their idealistic goals. The success of the company depended on its workers, and a good working and living environment meant increased productivity plus employee loyalty, both of which were deemed crucial to long-term economic achievement.

Bessbrook Spinning Company manufactured all classes of linen goods from raw flax to finished cloth and, through government contracts, supplied leading aircraft manufacturers with Aero fabrics. For more than a hundred years, the brand names of Richlin, Lion and Wreath, Model Village Linens, and Superlin were well-known labels that ensured customers worldwide that they were buying linen cloth and yarn of the highest quality.[16]

By 1970, the Irish linen industry had ceased to be financially profitable. The mill buildings in Bessbrook were converted into a military base for the British Army. In 2007, nine years after the Good Friday Agreement was signed, ending the long political conflict known as The Troubles, the army vacated the mill. The spinning mill is gone, but Bessbrook village remains, its sturdy granite houses occupied by many descendants of the original families that once came together to live, spin flax, and weave linen cloth for the Richardson family.

The Great Famine in Bessbrook and Sion Mills

John Grubb Richardson started Bessbrook during the first full year of the potato famine. The blight began in 1845 with an airborne fungus originally transported in the holds of ships traveling from North America to England. Wind carried fungus spores the short distance across the water to Dublin's countryside, where it settled on the leaves of healthy potato plants, feeding on the fermenting tuber until the plant was a disgusting rotted mass that emitted a nauseating stench. The blight moved so quickly that in a matter of months the potato crop that was intended to feed the majority of the peasant population throughout the coming year had become inedible; the country faced possible starvation by the following year.

Although populations in counties Armagh and Tyrone were not as decimated by the Great Famine as in some counties, nonetheless the Herdman brothers at Sion Mills and John Grubb Richardson of Bess-

brook had to deal with the countrywide food shortages and keep mills and weaving operations running. Starving employees could not work, and only the revenue from sales of yarn and cloth kept food on the table for employer and employee alike. Social reformers such as the Herdmans and Richardson considered it their moral and ethical duty to provide for the village residents and the entire community of workers.

Amazingly, during the Great Famine (1845–50), the Herdmans managed to keep the village residents from total starvation. In 1847, James Herdman wrote to his brother John in Belfast,

> You cannot imagine the misery I endure, being here at present. Constantly surrounded with a parcel of clamorous starving wretches, naked and cold, and these too, observe, our own workers, and in employment. I am sick at heart of wretched Ireland. In the meantime, I send the most hungry to the house where we make broth every day. I am cleaning out a boiler here that Robert had set to boil yarn & have sent in to Strabane to buy heads & houghs [hocks] & will make a large supply of broth on the premises. I will buy a large quantity of Indian Corn in Derry & sell it to them in the shop at cost price. If we are able to keep the mill going, I hope to keep death by starvation away from our own people. My opinion however is, that in districts where there is no steady employment, a very large percentage of the population will perish. You can have no idea how one's heart is rent living in the midst of the poor. I cannot refrain from an almost constant shedding of tears.[17]

The Great Famine changed the fabric of Ireland forever and brought yet another ripple effect from Irish shores outward across the Atlantic waters as thousands upon thousands of Irish peasants, old and young alike, left their homeland on ships, packed like sardines in steerage class, sick, penniless, and very hungry. But not everyone in Ireland starved to death, nor did everyone leave—some people could not leave, and some people would not. By 1851, the population of Ireland had dropped from over 8 million to about 6.5 million.[18] Many women and girls were taught marketable skills of handwork embroidery and lace making during the famine years. Pure white embroidery and lace-trimmed linens were sold in England, Europe, and North America to women who had money to spend on finery. Whether the buyer knew it or not, a piece of lace purchased in New York or Philadelphia that framed a delicate handkerchief or trimmed a ball gown might have meant life itself to the maker in Ireland. During the last half of the nineteenth century, Irish lace and embroidery sustained many families while the peasant population struggled to find a way out of extreme poverty in the aftermath of the Great Famine.

Chapter 6

Famine for the Poor, Lace for the Rich

IRISH LACE is unlikely to have developed and flourished if not for the Great Famine, when a potato blight nearly obliterated the main food source for the Irish.[1] As a commercial enterprise, Irish lace came into being when various styles of lace were introduced as income-producing labor in the famine years.

Nearly every English-speaking person will encounter the words *lace* and *embroidery* and view examples of the workmanship during their lifetime. Few people actually know or want to know how the decoration is constructed, but beautiful lace and embroidery can be enjoyed without knowing the details of the complicated techniques used to manipulate threads into artistic designs. Many men were (and are) skilled makers, but lace and embroidery are primarily considered to be women's work.

Before cotton became cheap and readily available to lace makers in the nineteenth century, linen thread was used to create exquisite, delicate designs for collars, sleeves, and ruffles and to decorate all types of household linens. Linen thread was very strong but brittle, making it more difficult for makers to use and proving harder on their hands than cotton; however, linen lace made by an expert was smooth, had clearly defined designs, and was durable far beyond its delicate appearance.

Facing page: Linen lace detail. *Courtesy of Irish Linen Centre and Lisburn Museum. Photography by David Pauley, Belfast.*

What's in a Name

The words *lace* and *embroidery* are broad terms used to describe decorative work made with yarn or thread by hand or machine. Styles of lace are named for places (such as Venetian and Belgian lace) or for the instruments used in their creation (such as bobbin or needle lace). Lace can be made out of any kind of thread that is wrapped, twisted, and knotted using a crochet hook, a tatting shuttle, spools, or a needle. Lace can

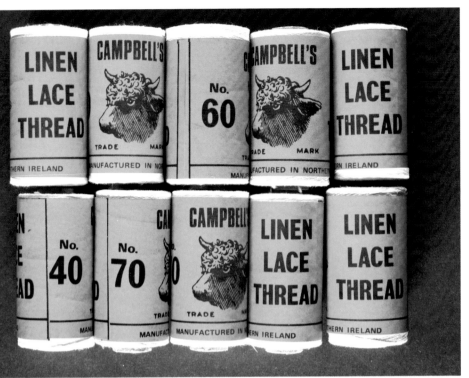

Spools of fine linen thread, manufactured by Barbour's (county Down) under the label Campbell's (the trademark used for the American market), used for lace making in the early twentieth century. © *National Museums Northern Ireland 2011. Collection Ulster Folk & Transport Museum.*

be thick and coarse or very fine and delicate. It can be fashioned on top of paper or net that is cut away when the design is complete. Embroidery consists of many styles, stitches, and construction techniques that are used to create a design on top of or worked into fabric, and distinguishing lace from embroidery can be very difficult. Truly magnificent lace and embroidery come from good design and quality workmanship. Lace and embroidery enthusiasts know the difference between styles, motifs, and characteristics associated with each technique, but the layperson refers to the whole genre of handwork as lace.

During the Middle Ages, embroidery was one of several craft skills protected in Dublin by the formation of guilds, and there was a strict penalty for stealing an embroiderer's needle. Several centuries later, largely as the result of the industrialization of linen production coupled with the rise of Belfast as a thriving center of Victorian commerce, the craft became organized on a large scale as a source of employment for women. According to the 1851 census, there were 31,137 embroiderers working just in county Down.[2] Early in the twentieth century, so many people were involved in producing prized decorative work, especially that done in white thread on a white ground (background cloth), that a map published in 1907 represents the entire northern region of Ireland as a source of needlework.

Everyone Should Make Lace

Lace making that evolved in European centers in the sixteenth century was introduced to Ireland sometime in the 1630s when the luxury of linen lace was required by the wealthy and fashionable elite. Various techniques were applied to dress, household, and church linens. In the early eighteenth century, the Irish parliament, through its agent the Dublin Society, tried to reduce the demand for imported lace by encouraging the development of an Irish lace industry. Pillow lace (so called because it is worked on top of a pillow), or bobbin lace, was considered appropriate employment for "some thousands of useless females."[3]

Founded in 1731, the Dublin Society (renamed the Royal Dublin Society [RDS] in 1820) grew out of the eighteenth-century desire for agricultural and industrial improvement in Ireland. In the 1740s, there were

three hundred members, and the society was offering subsidies (premiums) for land reclamation, livestock breeding, fisheries, and textiles. Beginning in 1838, the RDS annual spring show at the society's headquarters included exhibitions of Irish manufactures. The present-day society has a membership of about seventy-five hundred, and in addition to agricultural and other exhibitions, the society organizes concerts and lectures and maintains a fine library.[4]

In an attempt to increase local production of lace for fashionable Irish men and women who were wearing imported lace, economist Arthur Dobbs of Carrickfergus and philanthropist Rev. Dr. Samuel Madden of county Fermanagh urged the production of pillow lace and of linen (or Dutch) thread, and they were able to influence the Dublin Society to pay subsidies for quality linen lace and fine linen thread used for lace making after 1739.[5] Sisters Jane, Ann, and Elizabeth McClean of Markethill, county Armagh, were jointly awarded a subsidy in 1742 for spinning the highest-quality thread.[6]

Machines for Lace Making

In the late eighteenth century, when dress fashions became simpler, demand for both local and imported lace declined and attempts were made to develop a less expensive substitute.[7] When John Heathcoat invented a machine, patented in 1809, to make hexagonal net (bobbinet),[8] the handworker suddenly had to compete with machine-made products. In the 1820s, when net machines were improved, English manufacturers looked to Irish centers for women who would embroider on machine-made net more cheaply. In 1829, Charles Walker started Limerick lace production as a purely commercial enterprise,[9] and women were trained to make lace on vast amounts of machine-made net. Crochet work and tatting were introduced to Ireland at the time of the Great Famine (1845–50);[10] fortunately for the worker, machines could not copy either kind of lace.

The Great Famine

The potato was the main food source for nearly all tenant farmers and landless laborers in Ireland. Potatoes were easy to grow and required little effort to harvest, and a small plot of land planted in potatoes could sustain a large number of people. This enabled the continuance of tenancy, which was a complex matter of estate hierarchy that encouraged overlapping layers of tenants and subtenants who lived on bits of land that sustained an ever-increasing population of peasants. A small number of middlemen, both Protestant and Catholic, were also a part of estate hierarchy. Some middlemen rented their land to tenants, who sublet to undertenants, while other middlemen managed large grazing farms and sublet only a portion of the land. The layer of tenants and subtenants was a fluid kind of residency that changed constantly, making it difficult

Lace and *ground* are both words used frequently by a vast majority of people in English-speaking countries, but each word also has a textile meaning. An image of lace—something not solid and having open spaces or being sprinkled or crisscrossed—is used in expressions from tying shoes to adding a little alcohol to a drink such as coffee. *Ground* is a word with many meanings that is used often in everyday language, but for lace makers, the *ground* is any fabric they create their stitches on top of—the ground fabric is on the bottom, and it holds the lace stitches together until, in the end, the fabric is cut away, leaving a finished piece of lace.

If trying to find something is like looking for a *needle in a haystack*, this means that finding it among all the clutter around it is very difficult, if not impossible. To a needleworker in the seventeenth century, a single needle was a valuable tool for making an income and supporting a family; as such, it was carefully guarded and not misplaced or casually discarded.

When discussing clothing, the word *threadbare* means worn out, so that some of the threads are missing or the garment is generally shabby. The same word in contemporary nontextile usage refers to something having lost its influence, freshness, or force by much use; becoming trite from constant repetition; or being commonplace.

Today, *out of the loop* suggests that a person was not privy to a conversation or not part of a process. The phrase comes from the mid-sixteenth-century meaning of the word *loop:* the doubling or returning into itself of a portion of a string, cord, or the like, to leave an opening between the parts and fastened at the ends. Inside the loop is surrounded and outside the loop is excluded.

to ascertain who owed the rent and who was in arrears—but landlords expected rents to be paid, and if they were not, eviction was a swift and final response.

There was a constant adversarial relationship between Protestants, Catholics, and the absentee English landlords who built grand country homes in Ireland but spent much of their time abroad, letting land agents handle the management of estates that included thousands of tenant families. Rents were increased frequently, but leases were not easily broken, so as long as the rent was paid, a landlord had little recourse but to let a tenant stay on the land. Landlords and their agents across Ireland began to devise ways to decrease the population by moving tenants off the land to open up larger parcels for the more profitable pastureland and grain crops. The famine proved to be the perfect opportunity to evict tenants and establish new leases that were more to the liking of landlords. Some landlords paid the cost of passage to America to get rid of tenants, while others simply ignored the starving, homeless masses. The famine claimed more victims in some areas of Ireland than in others, but every county was affected profoundly. With a starving population, the economy was in danger of total collapse. Without food, the people could not work to produce goods, and without goods to sell, the landlord lost income.[11]

In 1667, King Charles II had granted 12,000 hectares (29,652 acres) of land in county Roscommon, located in the middle of Ireland, to Nicholas Mahon.[12] Major Denis Mahon, not a direct descendent of

Nicholas but a distant nephew, was landlord during the famine years. Part of the vast estate that Mahon inherited in 1835 included the market town of Strokestown, one of the most productive suppliers of bleached linen cloth in western Ireland.[13] Milling and brewing industries were also central to the town's economy. With no potatoes to sell, Mahon's tenants could not pay the rent, so eviction was inevitable, and without land they had no shelter, no food, no work, and no hope. Mahon's land agent evicted thousands of starving peasants who could no longer contribute to the estate coffers, and he chartered disease-ridden ships, known as coffin ships, to transport them out of Ireland.[14] In November 1847, Major Mahon was shot and killed while driving a horse-drawn carriage through his property. The intended target was believed to be his land agent, who was in charge of the evictions.

Most Irish women who went to North America during the famine and in the years following were in a desperate situation. Some traveled with family members, but many more went alone. If a woman had saved enough money as a linen embroiderer to buy a steerage-class ticket and lived through the transatlantic journey, she might find work as a seamstress—maybe. Her choices were not abstract, and her personal predicament was more than just a statistic in the history of the Great Migration; her options were fraught with danger, fear, and the limitations of being female. The reality was that she had to figure out how to feed and shelter herself with no marketable skills, no money, and no friends or relatives unless she was lucky enough to have the name of someone to contact and the ability to make the contact. If she could find work, the work was endless and exhausting and did not pay enough to improve her circumstances. On both sides of the Atlantic, a main source of employment for women was domestic service. Some women undoubtedly aspired to becoming sewing maids in the households of wealthy families, for which skills at mending and even producing fine needlework could be a decided advantage. Few employment choices existed for women until the twentieth century, but not all women had the skill or patience to work with their hands, as in the case of Jennie Hodgers (1843–1915), who immigrated to America sometime before 1862.

Desperate Choices

Most modern readers would find it difficult to comprehend the desperate circumstances that faced a young woman such as Jennie Hodgers, daughter of Sallie and Patrick Hodgers and granddaughter of Patrick Hodgers Sr., all of whom were flax growers in Termonfeckin, county Louth.[15] Flax growers relied on the linen industry to buy the annual crop so they had money to support the family, pay the rent if they were tenant farmers, and buy seed for the following year. When the market for their flax crop dwindled due to the country's potato blight, the farm could no longer support the whole family, so they sometimes drew straws to decide who would stay on the farm and who would emigrate. When Jennie emigrated, she had no intention of working as a sewing maid or seamstress (and as a teenager living on a farm, she probably lacked the sewing skills to be hired into even those lowly positions). Looking for alternative employment with better pay, Jennie learned that a private in the Union Army made thirteen dollars a month, more than double

what a woman could make as a laundress or a seamstress. Instead of following a traditional path, Jennie changed her name to Albert Cashier and her outward appearance from female to male, joined the 95th Illinois Volunteer Infantry, and fought as a Union soldier from 1862 until she was mustered out in 1865.[16]

Lace Making Provides an Income

At this desperate time in Ireland's history, people (particularly peasants) who stayed in Ireland needed some means of income to purchase basic necessities. Lace-making centers across Ireland provided an economic opportunity that enabled many women to earn enough money to keep starvation at bay for themselves and their families. Lace, which was sold by the piece, could be made at home with virtually no equipment beyond a needle and thread, usually supplied by a buying agent or lace-making center. Although some men were lace makers, it was primarily a women's industry. Women maintained their roles as wife, mother, homemaker, and farmworker, adding breadwinner to an already heavy burden.

Children and Lace-Making Schools

Lace and crochet centers were established with a minimum investment: the price of a needle, a crochet hook, and materials. Because cheap cotton thread was used regularly and crochet hooks were often homemade, the cost was negligible. Children as young as six to eight years old were trained to work simple stitches, and elderly women continued working as long as their health permitted. From a financial standpoint, the problem lay in competition from inexpensive commercial products that, to the layperson, appeared comparable to handmade lace; even gentlewomen who supported lace-producing charities expected to purchase handmade lace and crochet inexpensively. However meager the income, rural families depended on the money from this work for subsistence, and lace- and crochet-making centers multiplied, particularly in the late nineteenth century.

A Compelling Story Told

Italian, Belgian, and French laces have always been exquisite, but how did Irish lace and crochet become so well known? During the last half of the nineteenth century and especially during the famine, promoting women's handwork was fueled by the popularity of human-interest stories used for marketing purposes. An engaging story made a purchase more desirable, and regardless of whether the narrative was false or based on a fragment of truth, it was told over and over, year after year, until it became accepted as truth, a charm-

ing and appealing anecdote for the buyer. This kind of marketing was not unique to Irish lace: it has been used worldwide, frequently applied to marginalized women's work that is considered of little value to the buyer or maker, such that the human-interest story associated with the product becomes the sales pitch. If a story evokes enough sympathy, compassionate women of means buy the handwork to help those less fortunate and assuage their conscience; they know they have financial security and the poor, unfortunate lace maker does not.

The Carrickmacross Story

For middle-class women in the nineteenth century, organizing a lace or embroidery school was an appropriate way of becoming involved in philanthropic work. It provided an acceptable outlet for their organizational and artistic skills without carrying the implied stigma of "earning a living," since the proceeds went not to the organizer but to the women directly producing the needlework. Each woman had an assistant to teach the particular technique to the poor, while she organized sales and was much admired for her resourceful charitable endeavor.

Slightly different versions of one particular theme were repeated and associated with the beginnings of each well-known Irish lace style, but the true story is no longer discernable. In every case, a respected lady of some social standing, a clergyman's wife in the Protestant north or a mother abbess in the Roman Catholic south, purchased a piece of old ecclesiastical lace from a peddler. Peddlers were said to have had these expensive laces—Italian or varieties known as Spanish, Jesuit, Venetian, or Flemish—because of the dissolution of monasteries in Spain. Independently, each woman is said to have laboriously unraveled or picked apart a sample of lace to learn the secret for constructing it and taught the special needlework technique to her subordinates, who then passed on the art to the "deserving poor" of the district.

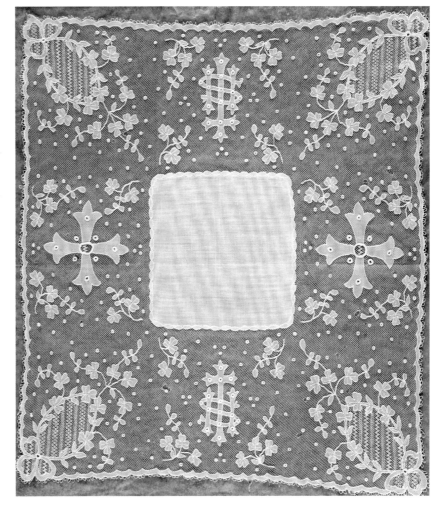

Linen chalice cover of Carrickmacross lace. The chalice cover was one of the first pieces of Carrickmacross lace made by the Sisters of Carrickmacross, St. Louis Convent, c. 1892. *Courtesy of the St. Louis Heritage Centre, county Monaghan.*

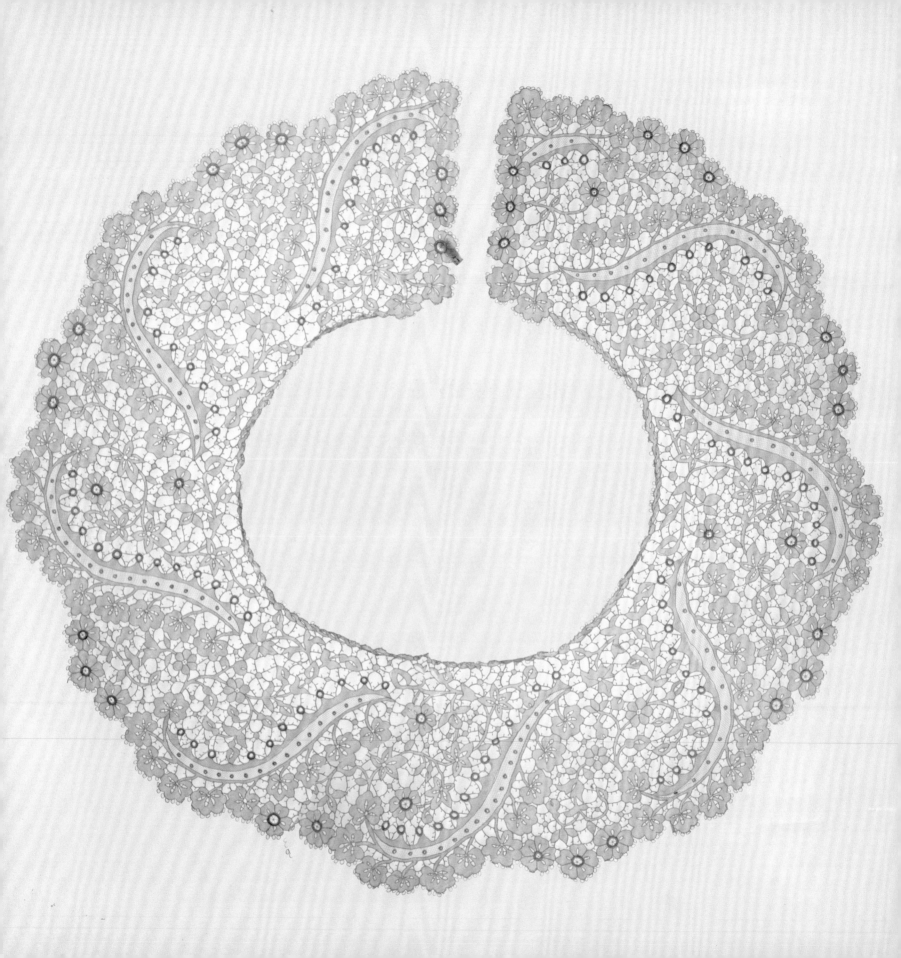

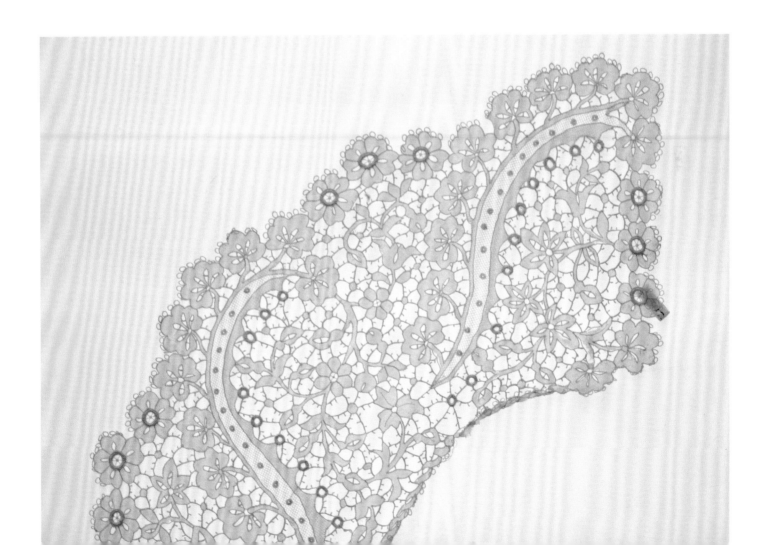

Detail of Carrickmacross linen lace collar. © *National Museums Northern Ireland 2011. Collection Ulster Folk & Transport Museum.*

In one story about the beginning of Carrickmacross lace, Mrs. Grey Porter, a rector's wife in Tynan, county Armagh, is said to have inherited a piece of Venetian point lace that she learned to replicate while on her honeymoon in 1816; she taught the technique to Anne Steadman, a maid working in her household. When the first large-scale famine struck the Carrickmacross district in county Monaghan in the 1820s, Anne Steadman taught a version of that particular appliqué net lace to the poor, and it eventually became known as Carrickmacross lace.

Another version credits Miss Reid of Rahan Estate, county Armagh, with the invention of Carrickmacross lace. Her sample to copy was a piece of old Flemish lace, which she unraveled, and then her assistants taught those "plying the needle by the little windows which do not admit much light."[17] Not only did Reid's story portray her as a philanthropist, but it was heart wrenching to think of young lace makers sitting close to tiny, dirty windows to work by the last rays of sunlight. The Reid sisters established a school in their brother's farm at Rahans and taught lace making to his tenants; as the industry prospered, a schoolhouse for teaching lace making was built in the nearby village of Culloville, county Armagh.

Amidst the devastation of the Great Famine, lawyer Tristram Kennedy became manager of the vast and densely populated Bath Estate in county Monaghan in 1846.[18] A principled man and a caring reformer, he sought ways to alleviate poverty in the district. In one project, he established schools where lace making was taught, with the materials provided to lace makers on credit. Aware of the importance of design, Kennedy was probably the one who encouraged a member of the renowned architectural family Papworth to draw designs for Carrickmacross appliqué.[19] In 1850, Kennedy established a class to train young girls in lace design and acted as an agent to sell area-made lace, crochet, and sewed muslin (embroidery) to London merchants. He also purchased guipure lace in Belgium, traced the design with a thread onto cambric, and joined the motifs with point stitches before cutting away the superfluous cambric.[20] This introduction of guipure lace to Carrickmacross proved successful, and "Royal" Irish guipure became highly desirable. James Forrest, a silk mercer (selling agent) in Dublin and Limerick, displayed examples of Royal Irish guipure at London's Great Exhibition in 1851 and showed "magnificent specimens" to Queen Victoria on her visit to Dublin in 1853. It was a great loss to the district when Kennedy left to pursue a career in parliamentary politics. After 1866, Mrs. Donaldson controlled the production of Carrickmacross lace and crochet at Crossmaglen until fashion styles changed and sales declined. In 1897, the St. Louis Convent of county Monaghan became the main location for Carrickmacross lace, training the convent's own design teachers and promoting sales.[21]

Crochet work is a generic term for lace made with a crochet hook and linen or cotton thread; occasionally wool and silk were used. Traditional Irish crochet is usually made using thicker thread than the thread used for the delicate Carrickmacross or bobbin lace, resulting in Irish crochet being a coarser style of lace regardless of pattern, motif, or design.

Clones crochet, named for the town of Clones, county Monaghan, began in Ireland during the famine years. The conventional belief is that Clones crochet was started in 1847 by Cassandra Hand, the wife of the local rector and a woman with impressive business skills, aided by Mrs. W. C. Robert, a trained crochet teacher from county Kildare. In keeping with the typical theme, it was said that designs were developed by copying samples of ecclesiastical lace, guipures (needlepoint lace), and old point laces bought from peddlers. Consequently, the crochet styles that evolved in Clones were known as Greek, Spanish, Jesuit, and (in Paris) *point d'Irlande*.

Tea cozy of Clones lace, lined in purple silk. Clones lace crocheted by Mary Ellen McMahon, Clones, county Monaghan, nineteenth century. *Courtesy of the St. Louis Heritage Centre, county Monaghan.*

Left: Jabot collar (dress neck insert) of Clones lace crocheted using linen thread, late nineteenth century. *Courtesy of Monaghan County Museum, Republic of Ireland. Photography by David Pauley, Belfast.*

Tea cozies, gloves, handbags, and antimacassars were popular items in crochet; blouses and dresses have also been made out of crochet work. The popularity of crochet making spread so quickly throughout Ireland that the Irish Work Society sold specimens from Donegal and other localities at London's Great Exhibition in 1851. Irish crochet was promoted very successfully, and by the 1860s, it was being worn by members of the royal family and sold across Britain, France, and America. The industry survived the invention of a machine for making imitation Irish crochet borders (circa 1877) because handmade crochet remained cheaper to purchase and could be custom designed for individual clients.[22] Until the 1906 earthquake, San Francisco was one of the major distribution centers for Irish crochet articles such as parasols and blouses.

Inishmacsaint Lace and Tatting Trims

Maintaining high standards of lace making was especially difficult during the early years of the industry. The exception was Inishmacsaint lace.[23] Inishmacsaint, the smallest lace center in Ireland, is located in county Fermanagh, and water divides much of the land area of the parish.[24] The center enjoyed royal patronage and was renowned for using very fine linen thread and quality designs to produce some of the most desirable and expensive Irish lace.[25] Examples of Inishmacsaint were exhibited at the 1893 Chicago World's Fair in conjunction with the Irish Industries Association.

Tatting is another form of lace begun as a domestic industry during the famine years, in 1847. Tatting is a technique for handcrafting a sturdy style of lace formed by a series of knots and loops. It is usually used as edging and for doilies and collars. Dating to the early nineteenth century, tatted lace is made with linen or cotton thread wrapped around a small shuttle about three inches long with a point or a hook at one end. The tatter holds the thread in one hand and manipulates the shuttle with the other hand to form the ring and chain patterns over a core thread.

Sophie A. Ellis, daughter of the rector of Kildemoc, county Louth, is credited for introducing tatting into Ireland. Tatting was easy enough for children to learn quickly, and mothers soon taught sons and daughters to tat small fashionable accessory items, such as ladies' and children's caps. In only four years, Irish tatting was of high enough quality to be demonstrated and sold at the Great Exhibition in London in 1851.[26]

Lady's crochet gloves made with linen thread, trimmed with tatted lace on the ruffled edge, late nineteenth century. *Courtesy of Monaghan County Museum, Republic of Ireland. Photography by David Pauley, Belfast.*

Nearly forty years before Sophie Ellis was teaching tatting to help home workers in Ireland, Irish immigrant Mary Cumming was learning the same skill in Petersburg, Virginia, and described the work to her sisters back home in Lisburn, Ireland. In her letter of January 9, 1814, Mary tries to explain how to make the new type of lace she had learned from her neighbor Agnes Freeland. "I did a little bit of the tatting last night, which I send you, you will find if you draw the long end of the cotton which I have left it will form the little loop. This trimming makes a handsome finish to any kind of work, it always looks well round the sleeve or neck of a morning gown. If you cannot find out the manner in which it is done, as soon as I have an opportunity I will send you and Rachel some."[27] Mary's letter indicates that tatting techniques were being sent back to Ireland, at least between individuals, more than thirty years before Sophie Ellis is credited with introducing tatting in Ireland. It was a lace-making technique that provided employment during the famine, but it is not Irish in origin.

Drawn-Thread Work on Linen Cloth

The strength of linen fabric makes it particularly well suited to drawn-thread work, a technique that involves removing some threads from the fabric and exposing others, which are then secured by being sewn into patterns that can be remarkably intricate and stunning. This work was produced in various centers during the second half of the nineteenth century but is particularly associated with Rathfriland, county Down, in the late nineteenth century. Sarah Jane McAuley, who lived near the town, was well respected for her drawn-thread skills, and her agent sometimes asked her to create sample ideas for designs according to a specified budget, rather than always working on a predetermined pattern, an indication that some embroideresses were encouraged to contribute creatively to their work.

Alternative Fibers

Before the invention of synthetic fibers, experiments were made with natural fibers to determine whether a strong cloth could be woven out of various plant materials, in the hopes of discovering a plant that was renewable, easy to grow, and more cost-effective than linen. Over the centuries, many natural fibers (including flax) had been twisted into yarn or thread for weaving cloth, making baskets, or as decoration. Some experiments with these fibers were moderately successful, while many more were unsuccessful. At an industrial school in county Leitrim, Letitia Veevers had thread made from nettles, sweet pea, nasturtium, and daisies in an effort to develop a native lace fiber alternative to flax. These botanical threads were used to produce knitted and lace shawls, counterpanes, and mittens and sold at both the 1850 Industrial Exhibition in Dublin and the 1851 Great Exhibition in London.[28] However, linen maintained its predominance as a fiber and cloth with many benefits for mankind, with only cotton as its competition in the global marketplace.

Linen and lace handkerchiefs from the firm of Robert McBride and Company, Belfast, c. 1910–20. © *National Museums Northern Ireland 2011. Collection Ulster Folk & Transport Museum.*

Facing page: Detail view of slipcase of finely woven white linen to hold personal items, such as a folded nightgown, and be displayed on a bed; made in Northern Ireland, c. early to mid-twentieth century. The cover is decorated with drawn and pulled thread work to form regular patterns secured with needlework using fine white linen thread. In 2001, the Royal Mail used a small portion of this piece as the image for one of a series of postage stamps. *Courtesy of Irish Linen Centre and Lisburn Museum. Photography by David Pauley, Belfast.*

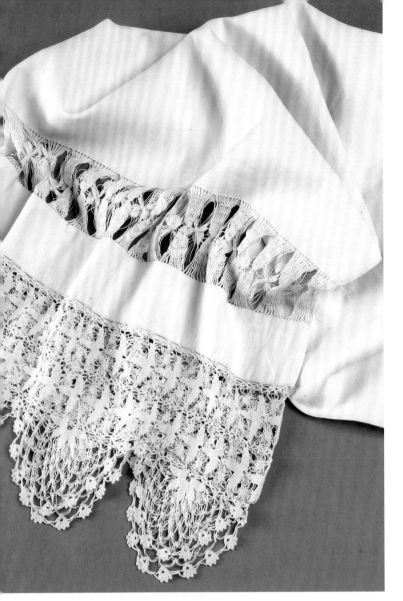

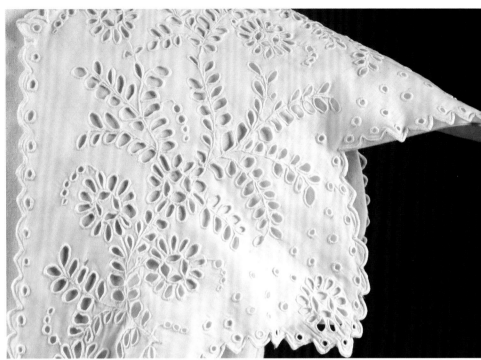

Left: Linen pillowcase with elaborate drawn-thread work and lace trim, late nineteenth century. *Courtesy of Monaghan County Museum, Republic of Ireland. Photography by David Pauley, Belfast.*

Above: Lady's large linen collar with scalloped edge, mid-nineteenth century (section of collar shown). The cutwork decoration is a form of embroidery in which holes have been cut in the linen and are hand finished with whipped and buttonhole stitches. *Courtesy of Irish Linen Centre and Lisburn Museum. Photography by David Pauley, Belfast.*

Mountmellick Embroidery

Many religious establishments, irrespective of denomination, became centers for the production of needlework, and particular convents became almost synonymous with certain types of work. The sisters often drew the designs and maintained quality control over production standards. In lace-making schools, young girls were taught the craft, then worked at home making the lace; convents and schools handled sales of the finished pieces. Commissioned work was also organized through the lace schools, rectories, and private houses.

The Quaker settlement of Mountmellick, county Laois, gave its name to an elegant form of white embroidery that was usually worked in white cotton thread on a heavy white linen or cotton jean (twill

fabric) background cloth, examples of which were displayed at the Great Exhibition in London during the 1850s. Most of the stitches were similar to crewel embroidery and coarser than the usual white work. Mountmellick primarily relied on naturalistic designs, mainly flower heads, worked in a wide stitch repertoire on a heavy satin cotton or linen ground. The cable plait (braid) and Irish thorn stitch are believed to be peculiar to Mountmellick work. The introduction of Mountmellick work is generally credited to Johanna Carter, who played an important part in its development. This craft was deliberately established as a means of providing work for "distressed gentlewomen." It fell out of fashion for a time during the twentieth century but later became extremely popular as a hobby craft when a large number of handcrafts were reintroduced into the American marketplace. The expansion of hobby shops coincided with the wide variety of mass-produced fabrics available to handcrafters as background material for embroidery work.

Embroiderers and Lace Makers Work Long Hours

Embroiderers in Ireland developed a range of techniques to assist them in their work. For example, if an order for handkerchief initials was received, four hankies would be loosely stitched together at the stamped corners and placed in an embroidery hoop so they could be finished quickly. Working initials, even severely plain ones for men's handkerchiefs, was known as *sprigging* or *flowering,* as were the floral designs characteristic of white linen embroidery. Whether the work was done on a relatively large scale such as an ornate monogram for bed linens or on a much smaller scale for handkerchiefs, only the size varied for the repetitions of veining, seeding, and raised satin stitches. Little girls learned to lay down the embroidery padding stitches for their mothers to cover with the more demanding satin stitch to finish the design. In the early twentieth century, many young girls came home from school each day to find that they were needed to assist with needlework to help the family earn adequate income.

To continue working into the night, lace makers improved dim light by placing a lit candle near a glass globe filled with water on a table in front of them. As

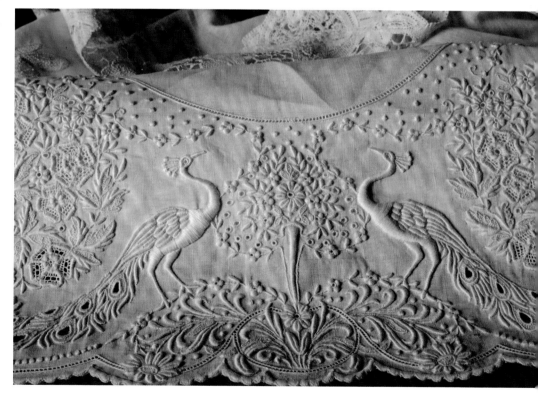

Section of peacock-embroidered handkerchief. This handkerchief, displayed at one of the many embroidery and lace exhibits at the Irish International Exhibition held in Dublin in 1907, received an Award of Merit. © *National Museums Northern Ireland 2011. Collection Ulster Folk & Transport Museum.*

light filtered through the globe, it was magnified, allowing lace makers to work together and for a longer time by the light of a single candle. Some makers used a piece of hollowed-out cow's horn for a thimble, but many makers found another way to toughen the skin. They held the middle finger, the one used to push the needle, just above the flame of a candle to slightly burn the flesh. In time, the flesh hardened and calloused so that the maker could work without pain as she pushed the needle through the work. However, continuous burning turned the flesh a yellowish-brown color that did not fade or wash off. During the Great Famine, young men who had no work or prospects referred to local lace makers as the "laying hen." Recalling the story of the hen that laid the golden egg, bachelors sought to marry a woman with a marketable skill and took note of any woman with a stained finger, knowing that her lace-making talent might support a family.[29]

In Spite of the Difficulties

Carefully posed photographs of industrious and happy lace workers were valuable marketing tools. It is hardly surprising that these photographs show workers in modest Sunday-best clothes, a style of dress that suggested they had other ambitions and opportunities for a brighter future. The story of the quick-witted girl who was summoned to a priest's parlor and managed to learn a new crochet pattern by copying his wallpaper design while she waited was appealing, but photographs or fanciful stories did not acknowledge the hardship of workers' lives.[30] Marketing propaganda did not address circumstances that drove a wretched girl to address the hostile atmosphere of a courtroom in an attempt to get payment from an agent for her work.[31] Buyers did not want to hear about the difficulty in keeping lace clean when there was no running water in the house and the turf fire needed tending, or of the agent's anger if the work had to be washed before it could be sold. Buyers were oblivious to the pain of orphans in foundling hospitals forced to spend their days making lace trimmings for underwear or of a teenager who had to wait until her first good piece of crochet was sold in Paris before she was paid a paltry sum for her labor. Needlework training did qualify them for a sewing job when they emigrated, but that hardly made a difference to a girl or her family who needed immediate income for food and shelter. No doubt many women who found themselves in the Magdalene asylums and without other income possibilities turned to needlework as a way of contributing toward expenses.[32] Some women inmates of workhouses and prisons also produced embroidery needlework. For buyers in Paris, Vienna, Brussels, New York, and London, Irish lace was viewed nostalgically with little regard for or understanding of the lives of the women and children whose constant toil at lace and embroidery, however badly paid, was essential for the basic survival of the family.

Lace schools placed great emphasis on the need for clean hands and tidy habits. While an embroideress might have had many domestic and farm chores, she would need to take care of her hands to ensure that the quality of her work was maintained and therefore salable. Needle skills were taught at lace and embroidery schools, but these crafts did not necessarily provide even a rudimentary education to girls during the

Tallying iron for ruffling lace and miniature bellows used by lace makers to blow away bits of discarded thread, mid-nineteenth century. The tallying iron was still in use by the owner in the early twentieth century. *Courtesy of Monaghan County Museum, Republic of Ireland. Photography by David Pauley, Belfast.*

nineteenth century. Although perhaps some females learned basic literacy during their training, lace and embroidery schools were essentially industrial exchanges at which girls learned handwork skills and their work was traded.

One observer estimated that in the 1860s, 320,000 Irish women earned their income from needlework, yet the pay for a piece of nineteenth-century embroidery completed quickly, cleanly, and to the required high standard would have amounted to only a few pence. Very few commercial embroideresses ever aspired to actually own a piece of their own work, which was produced according to fashionable standards, purely for the market—much of which was American.

Designing the Patterns

In most centers, lace makers and embroiderers had no say in the design aspect of the work and were given specific designs to work based on their level of aptitude. They were encouraged to complete their work quickly, and with constant repetition, needle workers became proficient at a few specific motifs. If a large number of lace makers or embroiderers were constantly using a single pattern, it became overworked and ultimately undesirable to the buying public, so the lace centers tried to follow fashion trends to come up with new designs. Some of the most developed needle skills demanded a very high level of expertise, and in the mid-nineteenth century, top-quality Irish embroidery was regarded as equivalent to work produced in France even though payment to the embroiderer did not reflect the years that were required to perfect the necessary skill level. As early as 1856, when the Cork School of Design was reopened after the famine and awards were made for lace designs, the need for more training in the art of design became obvious. After about 1883, lace designers began to avoid repeating antique patterns and concentrated on styles that were more contemporary; to ensure that a design was appropriate to the product, sample pieces were submitted with each new design.

In the 1880s, lace expert Alan S. Cole (1846–1934) at the Science and Art Department of the South Kensington Museum in London traveled throughout Ireland, identifying the characteristics of contemporary embroidery production and how Irish lace could be marketed to a wider audience. Cole was influential

in the development of Irish needlework skills during the late nineteenth century. He appreciated the charitable motivation of many of the women involved in organizing embroidery enterprises, but he criticized their lack of understanding of the importance of good design and high standards of production, which were needed to improve sales. His emphasis on good design for decorated linen and for all Irish needlework illustrates how well he understood that improved lace designs were essential for commercial success; his books and lectures encouraged lace-making centers to develop a higher quality of work in design and appearance. Certainly, Alan Cole's concern with this aspect of the industry led to prizes for needlework being awarded to several Irish designers during the 1880s.

Linen manufacturers had already realized that good design was a fundamental element to marketing and selling linen to their discerning clientele, and the Normal School of Design in Belfast was established in 1849 in response to requests from local businessmen who needed a school to train artisans in design for damask, lace, and pattern making for all aspects of the swiftly developing industries in the north of Ireland.[33] By 1900, the school had come to enjoy an excellent reputation for the quality of its artist training and was celebrated for designs in the Celtic Revival style. Despite the decline in mass linen manufacturing in the twentieth century, the school, now the Belfast School of Art and Design at the University of Ulster, continued to work with artists and manufacturers to develop innovative responses to the needs of both linen and fashion industries.

The Luxurious Handkerchief

In the mid-nineteenth century, cambric was produced by approximately thirteen thousand handloom weavers, of whom more than eight thousand made handkerchief-weight linen; the annual production of handkerchiefs alone was estimated to be twenty-four million. Late in the nineteenth and early in the twentieth century, Irish linen fabric of various weights was decorated with a range of techniques to produce all kinds of goods, from bed linens to handkerchiefs.

By the early twentieth century, Irish linen manufacturers had come to realize that they could not compete with machine-produced lace and embroidery work. Several established firms invited Swiss designers and technicians who had more-advanced equipment to come to Ireland, and before 1920, Swiss embroidery was introduced in Ireland on a commercial scale. Numerous firms developed close links with the Swiss companies, and designs created in Ireland were also put into production in Switzerland under the supervision of Belfast-based firms. Many linen firms had warehouses where handkerchiefs and a wide range of other items were decorated and packaged for the trade. Women and girls were increasingly attracted from the countryside into the larger towns to become factory workers and earn a steady wage. As the twentieth century progressed, machine-decorated linens increasingly dominated the market, but the finest goods continued to be decorated with handmade lace and embroidery.

Hand embroiderers were usually women, but men generally operated the Swiss embroidery machines, which could decorate dozens of handkerchiefs simultaneously. In the production of Swiss embroidery, women became auxiliary workers whose jobs included loading the machine with fabric and threading needles, unloading the machine, checking the work, and making necessary repairs. Swiss embroidery flourished in Northern Ireland for a substantial part of the twentieth century, but by the 1990s it had almost completely disappeared, replaced by computer-generated decoration.

Linen firms generally employed their own designers, and while some women qualified as designers, the majority were men. One well-known embroidery designer celebrated in the early twentieth century was Herbert Lilley. Lilley came from a modest background in East Belfast. After his father's death when Lilley was twelve years old, the two eldest sons, William and Herbert (nicknamed Bertie), were soon forced to go to work to help their mother and four younger siblings. Lilley attended Belfast School of Art and, at age fifteen, became an apprentice designer with Robert McBride and Company Linen Manufacturers in 1901. Lilley was a prolific designer, and his embroidered linen handkerchiefs were exquisite examples of hand embroidery, drawn-thread work, appliqué, and lace. The high standard of workmanship was an indication of the skill of local needle workers and of Lilley's talents as a designer, as well as a valuable illustration of the kind of embroidered textiles produced by linen companies in Ireland at the time. Designers were responsible for estimating the cost of the work, a process that included taking into account the number of stitches needed to complete each decorative motif; rates of payment for various stitches and combinations of stitches were tightly regulated. For more than fifty years, Lilley designed for hand and machine embroidery in a market where fashion constantly changed and the demand for new ideas for decoration and for solving cost-related questions was incessant.[34]

Selling the Handwork

Marketing handmade lace was a constant problem because many centers relied on a network of agents to sell to clients; dealers commissioned Irish lace and crochet from various Irish centers, provided their own designs, and supplied the products to fashion outlets. Monaghan and Armagh schools were dependent on private orders, while some lace centers sold directly to merchants in London and Nottingham (England).[35] Official government organizations took over much of the marketing of Irish lace in the 1880s. The large Irish convents of New Ross, Kenmare, and others developed independently using their trained designers and built up their own valuable export business. With a degree of independence and control of exports, some convents in the south made fashion garments. Identifying lace with royalty was excellent publicity for marketing purposes; Clones crochet in cotton and silk and Inishmacsaint lace in flax thread were purchased for Princess Louise, Duchess of Argyll (the sixth daughter of Queen Victoria and Prince Albert), in 1889.[36] The Youghal Co-operative Lace Society Ltd. was commissioned to make a needlepoint lace gown and train

in fine linen thread for Queen Mary in 1911. Industrial exhibitions were vitally important for marketing lace and embroidery; the most successful may have been the Chicago Exhibition of 1893, where Clones crochet and lace flounces and veils were displayed.

The fickle consumer was usually responsible for the rise or decline in the popularity of one form of embroidery or lace technique over another. Government organizations that wanted to promote lace and embroidery industries tried to predict fashion trends, sometimes successfully and other times not so well. In 1905, the Department for Agriculture and Technical Instruction for Ireland predicted "a good demand for sprigging and Broderie Anglaise" and discouraged production of Carrickmacross lace because the market for that particular work had declined substantially.[37] In general, the department was keen to foster branches of the industry that were apt to be financially solvent and did not particularly care which it promoted—embroidery work or lace making.[38]

Their Personal Stories

In county Fermanagh, Ellen Connolly made crochet lace water-lily motifs in the 1930s and sold them for a half a crown a dozen, not for the pleasure of learning a new technique but to help support her family. As a child, Ellen's daughter Tessie helped by crocheting hearts, roses, and shamrocks to embellish the center of the lilies. Even little boys in the family crocheted small heart motifs. When Tessie (Leonard) was a young married woman, she used to go to a weekly céili gathering where women sat around the fire crocheting while the men played cards. Tessie soon learned to crochet more difficult patterns and had them ready on Friday nights when Mrs. Cunningham came by the house to pick up a week's worth of hankies with crochet edges and tablecloths with crochet inserts. The linens were delivered to businesses in Belfast and Portadown that sold the work to many American clients. Tessie remembered her grandmother "peggin'" (a local nickname for wool crochet made with a bone hook). Tessie's daughter Louise was the fourth generation to carry on the family tradition, making crochet baby booties and small wedding bags.[39]

Sarah McCabe (1889–1983) was a woman able to support herself and keep the family farm with income from her expert lace-making skills, artistic designs, and willful determination. Sarah never married or moved away from the family farm on Dairy Brae lane in Cootehill, county Cavan. Nearly six feet tall, she had wide, strong hands calloused from milking cows and doing the endless chores that were necessary to keep the farm running. At night, Sarah and her sister Mary made lace by candlelight using a homemade lace hook fashioned out of a #12 needle, a hook slender enough to make her delicate lace designs. Sarah worked well into her eighties without ever needing eyeglasses.

As a young woman, Sarah learned to design and make lace at the Franciscan Art School in Broad Lane, Cork. She was naturally artistic and learned the skill easily, creating many designs from images she saw on

frosted windowpanes; she found inspiration for ways to connect lace motifs by looking at the hedgerows along the lane to the farm. In 1935, Sarah entered the Daily Mail Ideal Home Exhibition in London, sending in a hand-painted drawing of a complicated lace design of grapes and leaves with her entry fee. It was returned to her with a note saying that her entry was rejected because the design was technically impossible to make into lace and therefore did not qualify. Undeterred, Sarah completed a small section of the design, attached it to the drawing,

Sarah McCabe (*far right*) standing in front of her "house that lace built," c. 1935. *Courtesy of Kathleen and Arthur McCabe family, Cootehill, county Cavan.*

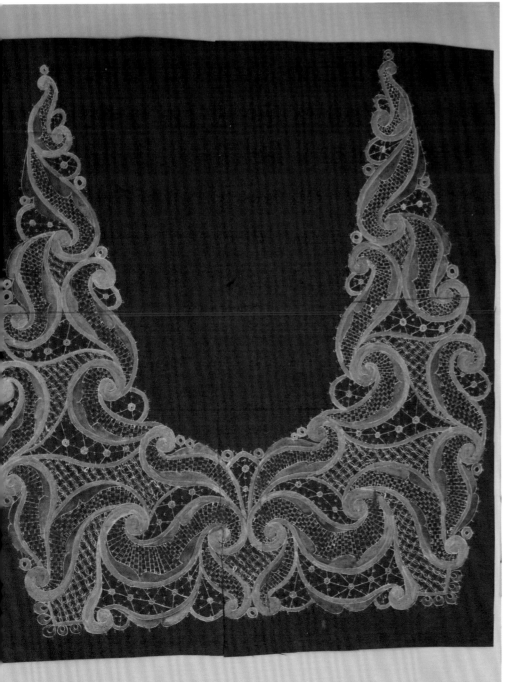

Hand-painted design on paper for a lace collar by Sarah McCabe, c. 1930s. *Courtesy of Kathleen and Arthur McCabe family, Cootehill, county Cavan.*

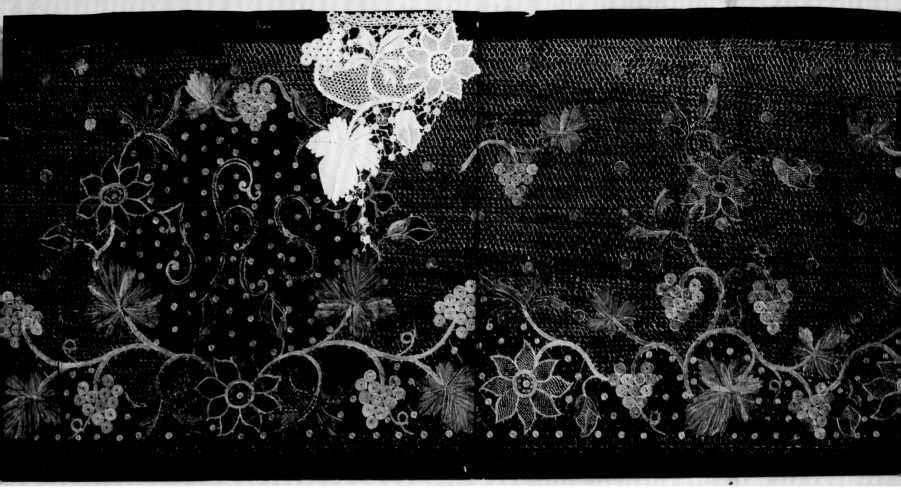

Hand-painted design on paper with a small sample of lace by Sarah
McCabe. This design was awarded first place in the United Kingdom's
Royal Mail Contest, c. 1930s. *Courtesy of Kathleen and Arthur McCabe family,
Cootehill, county Cavan.*

Linen table mat surrounded by cotton lace by Sarah McCabe, c. 1920s.
Courtesy of Kathleen and Arthur McCabe family, Cootehill, county Cavan.

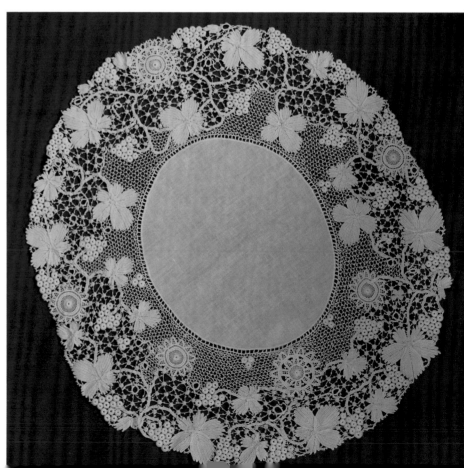

and returned it to the judges. She won first prize in that competition and many others. Clients in North America, England, and Ireland purchased many of the laces Sarah made, but perhaps her most notable client was the famous Irish tenor John McCormack (1884–1945). McCormack became landlord of Moore Abbey, county Kildare, in 1925 when he leased the estate from Lord Drogheda. A boxed set of lace mats was just some of the lace work that Sarah McCabe made to enhance the McCormacks' lavish entertaining style. She was paid just over twenty-eight pounds for the work commissioned by Countess McCormack in 1929.[40] In 1937, Sarah built a large two-story stone home on the family farm, proudly referring to it as "the house that lace built."[41]

Craft and Needlework Magazines

For hundreds of years, women traveled by ship from Ireland to North America and beyond. Some were poor emigrants with no money, no hope, and no skills, leaving the land of their birth forever. But on the upper decks, other women traveled for pleasure, eating delicious food and wearing the latest clothing styles. From 1830 to 1878, fashionable attire for women was illustrated in every issue of the *Lady's Book,* a magazine published in Philadelphia by Louis A. Godey. It was the most popular journal of its day and had numerous articles appealing to women; almost every issue included the picture of a particular garment, its pattern with measurements, and instructions for how to sew it at home. *Modern Priscilla* magazine was filled with detailed instructions for how to crochet, knit, make lace, embroider, and sew the latest styles and fashion accessories that wealthy customers wanted someone else to make for them and middle-class readers wanted to make for themselves. For much of the twentieth century, Irish lace and embroidery workers were paid such a nominal amount for incredibly beautiful workmanship that it was well worth the cost to have a custom garment made by a woman in county Monaghan and worn by a client in New York or Chicago. *Modern Priscilla* magazines were kept, copied, shared among needle workers, and worn out with use.

Craft and needlework magazines were first published in the nineteenth century, and ever since, they have been a source of inspiration for women who love to create beautiful objects with the labor of their hands. Before shopping was a global experience and every imaginable craft was accessible through the Internet, women who loved handwork and traveled abroad purchased patterns, materials, and examples of new styles and designs to copy and share with like-minded friends at home. In the final decades of the twentieth century, handwork in general and a variety of homemade crafts became increasingly popular, fostered by a wide range of organizations hoping to increase sales of the supplies that were needed to complete the craft, which were available through catalog sales and at local craft stores. With more leisure time, women took craft-making courses at museums, continuing education centers, and retail stores and bought new supplies with each new endeavor.

Mountmellick across the Atlantic

In an area of the Appalachians thought to be poverty-ridden and remote, Tazewell stands out with beautiful homes, elegantly furnished with fine antiques, textiles, china, and silver. Tazewell's affluence was due partly to the famous beef cattle raised on bluegrass rich in nutrients from the Clinch Mountains and exported to England from 1890 to the beginning of World War I.[42] Many residents of this area of Appalachia are descendants of the early Scots-Irish settlers and are proud of the connection to both Scotland and Ireland.

At the turn of the twentieth century, in a small town in the farthest corner of southwestern Virginia, Gertrude Jones and her sister, Ida Black, learned to embroider Mountmellick table mats and runners from Mrs. George McCall, who followed instructions printed in a craft magazine passed along to her by another town resident. Mountmellick embroidery was featured in *Needlecraft* and *Priscilla* magazines in the early twentieth century, connecting Irish lace and embroidery styles to women across the world who had an abiding interest in handwork, Ireland, and Irish linen. In the twentieth century, most women used cotton thread for embroidery and lace projects, and cotton fabric was commonly used as the ground material for Mountmellick motifs. Cotton was readily available and easier to work with than linen, though Mountmellick embroidery was still physically difficult to work. Gertrude's husband used pliers to pull the embroidery needle through the fabric when Gertrude was working the heavily padded flowers. All three women were residents of Tazewell, Virginia, and none of them had traveled outside the community, but handwork patterns, like recipes, have a way of crossing land and sea to find a happy recipient willing to experiment with a new technique.

Royal Brides Choose Irish Lace

The great era of Irish lace making ended with the outbreak of World War I. Carrickmacross lace continued to be handmade by a few skilled makers, but it was most often associated with wedding dresses. Princess Diana's wedding dress, for example, had sleeves trimmed with Carrickmacross lace for her 1981 marriage to Charles, Prince of Wales. When Catherine Middleton married Prince William in Westminster Abbey on April 29, 2011, the famous Carrickmacross lace technique was once again chosen for a royal wedding dress, designed by Sarah Burton at Alexander McQueen. Workers at the Royal School of Needlework, based at Hampton Court Palace, London, hand cut rose, thistle, daffodil, and shamrock motifs from English lace and French Chantilly lace, then meticulously hand appliquéd each delicate lace motif with stab stitching every two to three millimeters into ivory silk tulle, giving the dress an ethereal, timeless character.[43] Skilled workmanship, keen eyes, scrupulously clean hands, and patience were necessary to create fine Carrickmacross lace for the bodice and skirt of the wedding dress, reminding a worldwide audience of Ireland's long lace-making tradition.

In the 1920s, statistics produced for the Congested Districts Board claimed that needlework in one form or another accounted for approximately 35 percent of the annual family income, but lace centers faced difficult challenges that were accelerated by social and economic changes after the First World War.[44] Even the crochet industry suffered when it was faced with competition from inexpensive so-called Irish crochet, which was actually made by poor women of Syria or India. Across Ireland, young women who received training with a needle and thread qualified for sewing work when they emigrated. How many female immigrants were actually employed to use their handwork skills is unrecorded, but it is safe to assume that nearly all of them used the knowledge to provide some income or necessities for their families.

It is a great paradox in history that many of the most cleverly designed and skillfully executed handmade laces, quilts, and weavings are purchased by wealthy collectors but made by the poorest members of society and sold for a nominal price. The idea that an untrained, uneducated woman should be paid a large sum of money for work she made with her own hands, in her own home, is still a difficult concept for many patrons of craft work. While beautiful, handmade textile crafts have been given as gifts and treasured for generations, using needle and thread to create a product to sell is the only opportunity that millions of women have to increase family finances at home while caring for their children, the sick, and the elderly. Many a woman across the globe has supported her entire family with the output of her needle, crochet hook, or spinning wheel. An idea deeply embedded in the psyche of many buyers is that a woman who stays at home by choice and has little else to do in her spare time should not expect to get paid much for handwork. Furthermore, the buyer rationalizes that handwork is a labor of love, not a labor for monetary gain. After all, if a woman wanted money, she could get a *real* job—one outside the home.

The development of lace making into a major Irish industry mirrors the economic and social progress of rural Ireland, a pattern similar to the development of women's handwork industries in Appalachia, China, Mexico, and other impoverished societies. The context in which linen embroidery was produced in Ireland in the nineteenth and twentieth centuries presents a contradictory picture. Embroidery was poorly paid, yet it often accounted for a substantial proportion of a family's income. It is usually thought of as a traditional craft, but most of the embroideresses of the past worked for the marketplace according to the dictates of fashion; they were not creating heirlooms for family members.

Linenopolis Leads the Industrialization of Irish Linen

D URING THE American Civil War, the South did not produce enough cotton to meet the demands of the Irish textile industry and was unable to manufacture cotton cloth. Ireland took advantage of the opportunity to expand its linen production and increase the global marketing of Irish linen. The number of power looms in Ireland increased from fewer than 60 in 1860 to 17,000 by 1875, with a workforce of over 43,000. Belfast doubled in size between 1841 and 1871 and doubled again by 1901, while four thousand new houses were built annually to accommodate a growing population that exceeded 350,000 at the turn of the century. In the northern counties of Ireland, 70,000 people toiled in the dust, damp, noise, and dangers prevalent in all textile mills.[1]

Between 1870 and 1914, Ireland was the undisputed center of linen production worldwide, a position held unchallenged not only in terms of sheer scale and output but also in terms of prestige and quality of linen produced. Belfast became known by the descriptive term *Linenopolis.* In 1892, enough linen was woven in Ireland to wrap a nine-foot-wide belt of cloth around the earth at the equator. Over twelve million miles of linen yarn was spun every week, and the total amount of cloth woven in one year would have covered an area totaling thirty-two thousand acres.[2]

Early power looms could not compete with the quality of fine handloom-woven cloth, and even though the factory system quickly came to dominate the trade, handloom weaving remained an important aspect of the industry until the late nineteenth century. The consumer demand for traditional methods to achieve the finest-quality linen ensured that some handloom weaving factories survived well into the twentieth century; Penningtons, Ireland Brothers, and McCollums were arguably the best known, while William Walkers of Banbridge (owned by Robinson and Cleaver) retained a single handloom until the beginning of

Facing page: Jacquard pattern punch card. *Courtesy of Irish Linen Centre and Lisburn Museum. Photography by David Pauley, Belfast.*

147

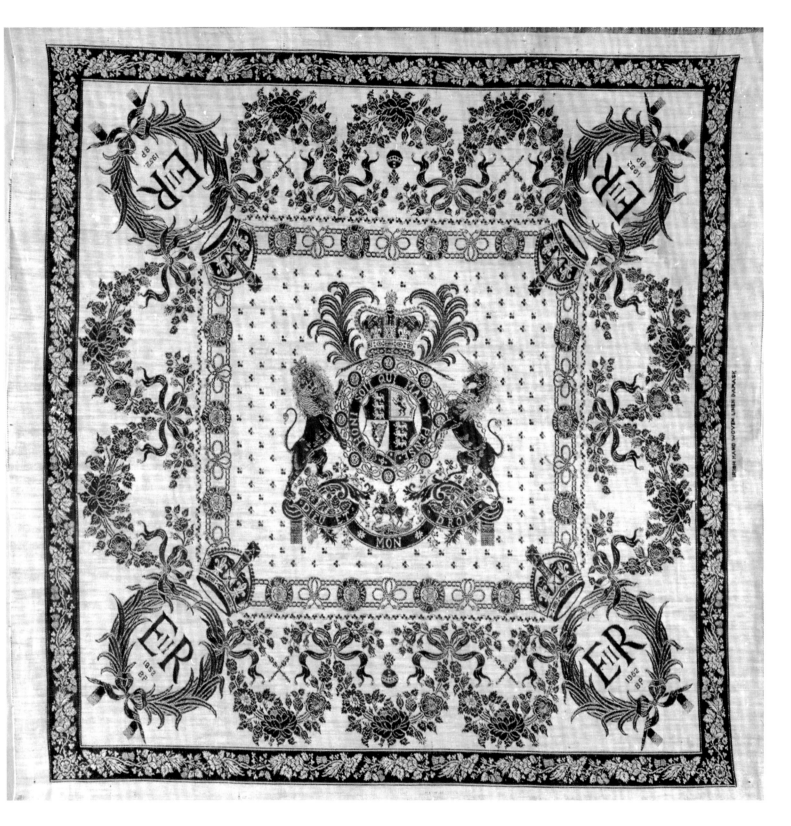

Facing page: Linen damask proof cloth for a set of dinner napkins woven in celebration of the 1952 coronation of Queen Elizabeth II. Handwoven at John McCollum's Hand Loom Damask and Cambric Factory, Lurgan, county Armagh. *Courtesy of Irish Linen Centre and Lisburn Museum.*

World War II. Upon Queen Elizabeth's accession to the throne in 1952, John McCollum's Hand Loom Damask and Cambric Factory in Lurgan, county Armagh, was commissioned to weave a magnificent set of large white damask linen napkins for Buckingham Palace. The ornate design included the royal insignia and the date to commemorate the occasion. McCollum's factory received regular orders for handwoven table linens from the royal household until the factory closed in 1968.

Irish Linen in Belfast and the North

During the mid-nineteenth century, most linen companies were located in the north of Ireland, and they tended to specialize in bleaching, spinning, or weaving rather than combining all three processes on one site. In rural towns, linen manufacturing stayed within the confines of their specialization, but Belfast expanded its warehouse facilities and became the export center of the industry and the fastest-growing city in the British Isles during the second half of the nineteenth century. Its merit as a center of machine production and shipbuilding mirrored the needs of the linen industry. Industrial spinning equipment and looms required metal fabrication, factories were constructed for textile production, and an increasing number of ships were built to transport the vast quantity of linen produced. As the demand for steel to build textile machinery, ships, and factories increased, employment opportunities in Belfast soared for men and women.

The postfamine period of the mid-nineteenth century freed up significant labor resources as displaced tenant farmers and families who did not migrate to England, the United States, Canada, and Australia moved closer to towns where there was the possibility of work. Irish law dictated that land was inherited through the male line, so large numbers of unmarried women, either singly or in small groups, traveled to industrial centers such as Belfast in search of work. Unsurprisingly, Belfast and other linen centers soon contained significantly more women than men.[3] It had been a long-standing practice for young women to leave their rural homes to work as live-in maids in the large houses of Belfast, Dublin, Edinburgh, and London. The linen industry fulfilled a similar function, and although women workers were poorly paid, their wages made an often-crucial contribution to the household income.

Gift box for handwoven handkerchiefs by John McCollum, Lurgan, county Armagh, c. 1950. © *National Museums Northern Ireland 2011. Collection Ulster Folk & Transport Museum.*

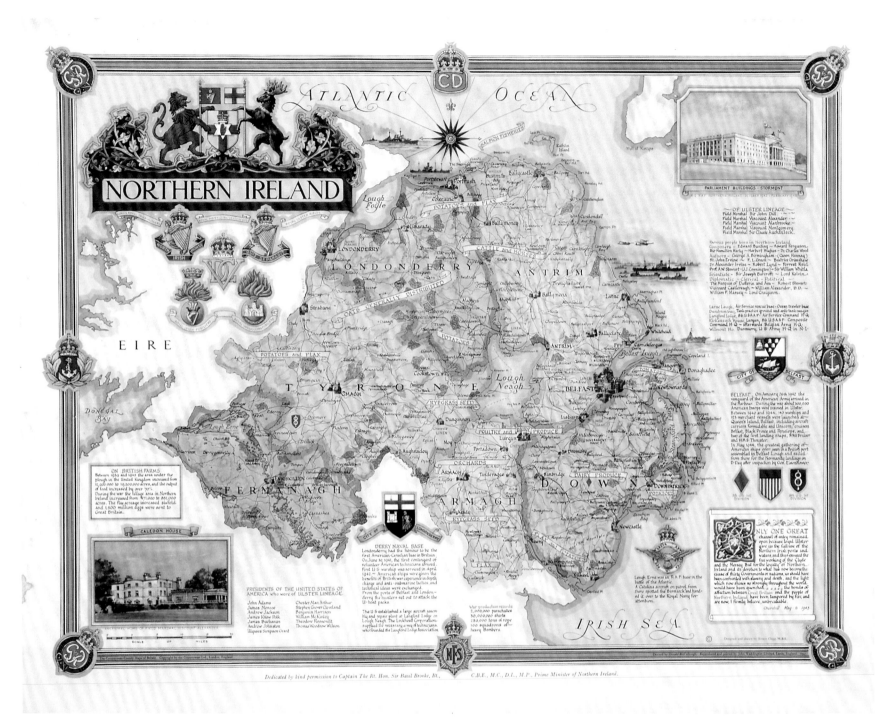

NORTHERN IRELAND

ATLANTIC OCEAN

EIRE

IRISH SEA

LONDONDERRY

ANTRIM

TYRONE

FERMANAGH

ARMAGH

DOWN

Lough Foyle

Lough Neagh

Lough Erne

Donegal Bay

Belfast Lough

PARLIAMENT BUILDINGS · STORMONT

CALEDON HOUSE

ON BRITISH FARMS
Between 1939 and 1943 the area under the plough in the United Kingdom increased from 12,250,000 to 19,200,000 acres, and the output of food increased by over 70%.
During the war the tillage area in Northern Ireland increased from 471,000 to 851,000 acres. The flax acreage increased sixfold and 1,500 million eggs were sent to Great Britain.

DERRY NAVAL BASE
Londonderry had the honour to be the first American-Canadian base in Britain. On June 30, 1941, the first contingent of volunteer American technicians arrived. First U S warship was serviced in April 1942. American ships were given the benefits of British war experience in depth charge and anti-submarine tactics, and technical ideas were exchanged.
From the ports of Belfast and Londonderry the hunters set out to attack the U-boat packs.

The U S established a large aircraft assembly and repair plant at Langford Lodge on Lough Neagh. The Lockheed Corporation supplied the necessary army of technicians who founded the Langford Lodge Association.

PRESIDENTS OF THE UNITED STATES OF AMERICA who were of ULSTER LINEAGE

John Adams
James Monroe
Andrew Jackson
James Knox Polk
James Buchanan
Andrew Johnston
Ulysses Simpson Grant
Chester Alan Arthur
Stephen Grover Cleveland
Benjamin Harrison
William McKinley
Theodore Roosevelt
Thomas Woodrow Wilson

OF ULSTER LINEAGE
Field Marshal Sir John Dill
Field Marshal Viscount Alexander
Field Marshal Viscount Alanbrooke
Field Marshal Viscount Montgomery
Field Marshal Sir Claude Auchinleck

CITY OF BELFAST

BELFAST: On January 26th 1942 the vanguard of the American Army arrived in the harbour. During the war about 300,000 American troops were trained in Ulster. Between 1940 and 1944, 140 warships and 123 merchant vessels were launched at Queen's Island, Belfast, including aircraft carriers Formidable and Unicorn, cruisers Belfast, Black Prince and Penelope, and two of the first landing ships, H M S Bruiser and H M S Thruster.
In May 1944, the greatest gathering of American ships ever seen in a British port assembled in Belfast Lough and sailed from there for the Normandy landings on D-Day after inspection by Gen. Eisenhower.

NLY ONE GREAT channel of entry remained open because loyal Ulster gave us the full use of the Northern Irish ports and waters and thus ensured the free working of the Clyde and the Mersey. But for the loyalty of Northern Ireland and its devotion to what has now become the cause of thirty Governments or nations, we should have been confronted with slavery and death, and the light which now shines so strongly throughout the world would have been quenched ... the bonds of affection between Great Britain and the people of Northern Ireland have been tempered by fire, and are now, I firmly believe, unbreakable.
Churchill May 6, 1943

Lough Erne was an R A F base in the battle of the Atlantic. A Catalina aircraft on patrol from there spotted the Bismarck and handed it over to the Royal Navy for attention.

War production records: 2,000,000 parachutes, 50,000,000 shirts, 250,000 tons of rope, 100 squadrons of heavy Bombers

Designed and drawn by Ernest Clegg M.B.E.

Drawn by Donald McCullough. Reproduced and printed by John Waddington Limited, Leeds, England.

The Countryman County Maps of Britain. Copyright by the Countryman Ltd, London, England.

Dedicated by kind permission to Captain The Rt. Hon. Sir Basil Brooke, Bt., C.B.E., M.C., D.L., M.P., Prime Minister of Northern Ireland.

Through greatly increased levels of output and efficiency (in addition to the increased profit margins that could be realized through mechanized production), steam-powered mills effectively eclipsed the hand-spinning trade within a single generation. Large-scale, commercial linen production required unprecedented levels of control over the manufacturing process. To produce substantial quantities of cloth to an exact specification, adhering to strict deadlines, and at a profitable margin, manufacturers required a disciplined, centralized, and full-time workforce. Belfast was particularly well suited to linen production because it was a center of population as well as a commercial and banking center. In addition, as a port city, Belfast had a ready supply of fresh running water, which was important for processing and transportation. Because attracting people to a source of water was easier than moving water to a labor supply, the linen industry, like the coal industry, tended to develop around rivers and in areas with a concentration of skilled laborers. Consequently, mills and factories clustered purposefully in northern and west Belfast, where tributaries such as the Blackstaff, Colin, and Forth wound their way down from the hills above the city. The concentration of attached, terraced housing along the Crumlin, Falls, and Shankill Roads—built within a short walking-distance of linen mills, factories, and warehouses—accommodated a huge influx of workers. Thus, the linen industry was of paramount importance to the growth and development of Belfast. A similar concentration of textile concerns existed in the Lagan Valley, known as the linen triangle, and in northern county Antrim, particularly along the River Maine, because of the presence of an adequate water supply, a tradition of flax markets, and a sufficiently large and skilled labor force.

The flax-spinning trade was mechanized from the 1820s onward. One of the earliest examples of mechanized spinning in Ireland, and a pivotal event in the development of the modern linen industry, was Mulhollands' decision to convert its cotton mill to flax in 1828.[4] This conversion was almost certainly influenced by the English government's decision to remove all duty on goods moving between Britain and Ireland in 1826. While this opened the market in Britain to linen exports, it also rendered the Irish cotton industry extremely vulnerable, as it forced Ireland to compete with England's giant cotton mills in Lancashire. The Irish Linen Board had been dissolved the same year on the basis that the linen trade was firmly established in Ireland, so it was up to the industry itself to foresee future trends.[5]

The linen industry was highly unpredictable, and even periods of great prosperity were interrupted by sharp and sudden downturns. In January 1866, Belfast's Falls Flax Spinning Company reported that it had bought thirty-two houses "conveniently situated for persons employed in the concern,"[6] and plans were made for additional weaving sheds to accommodate another 150 looms, but because of the unexpectedly rapid restoration of cotton production in the United States, that year proved to be disastrous for the linen industry, and expansion plans were abandoned. Fluctuations in profitability were not only extreme but also difficult to foresee: a crisis would disappear as suddenly as it had arisen. For example, in the six-month period preceding January 27, 1868, York Street lost £2,920 and in the following six months made a profit of £12,336. In an era when no unemployment or welfare benefits offered an effective safety net, these fluctua-

Facing page: Map illustrating predominant flax-growing areas in Ulster province. The map was designed by Donald McCullough and reproduced and printed by John Waddington Ltd., Leeds, England, 1947. *Private collection, Denise and George Gray, Bangor, county Down. Photography by David Pauley, Belfast*

tions caused great hardships for workers. Although the 1870s was largely a decade of caution and economizing for many firms, the Irish linen industry had become more profitable and mechanized, replacing the cotton trade in Ireland and firmly establishing its international dominance.[7]

Mill Work for Women and Children

For hundreds of years, the majority of the flaxseed sown in Ireland was imported from other countries; the superiority of each country's annual crop was dependent on the weather (see chapter 2). Linen manufacturers imported the best seed, based on the current price and quality, from various countries, purchasing only a relatively small amount from farmers in Ireland. The seeds were planted in Ireland, and the flax crop was harvested prior to maturity, with the process repeated annually. By the time linen had become an industrialized commodity, harvested flax was no longer processed on site locally but instead was baled and shipped to spinning mills for processing.

Spinning mills were usually three or more stories high. The preparatory departments were on the ground floor and spinning rooms were usually on the middle floor(s), while reeling rooms were on the top floor. This arrangement, standard throughout the industry, was adopted to accommodate the weight and size of machinery and to enhance the flow of work between processes.

When bales of flax arrived at a mill from the Irish farms, they were graded and sorted. It took a skilled eye, and many years of experience, to know what grade or blend of flax would produce a particular type of yarn. The flax grader was a key employee, and his services were greatly valued. The preparatory departments (such as hackling, roughing, carding, and spreading; see chapter 2) were largely concerned with cleaning and combing the flax by drawing it through a series of metal pins. This process was repeated on ever-finer machinery until the fibers were lying in a single direction and the unruly bale of flax had been transformed into a sliver or ribbon ready for twisting and spinning into linen yarn. All tasks were gender specific in spinning mills: hackling and roughing were physically demanding processes, and these departments employed only adult men; operators in carding and spreading departments were female; and young boys, known as half-timers, fed the combing machines.

The half-timers system was created by the Factory Acts of 1844 as a means of reducing the chronic labor shortage in Belfast textile mills by using cheap child labor. Beginning at about eight years of age, the children worked from 6:00 a.m. until noon, had a half hour to an hour for lunch, then went to a school operated by either the mill or the church until 3:30 p.m. Half-timers had to maintain good school attendance to work in the mills, and families desperately needed their income, although the children were paid only a pittance. For many children, this was the first time they had gone to school, and they were therefore behind other children from the onset. Half-timers were tired, often hungry, and frequently separated from other students in the classroom. Subsequently, the half-day system was changed to alternate days, three days at

Nineteenth-century looms in a weave shed were powered by a single steam engine joined to a series of belts and pulleys that hung overhead and connected each loom to the main power source. Individual looms did not have an on/off switch, so if a weaver wanted to stop, she reached up and knocked the belt off the pulley; her loom stopped but the others kept running. The motion was known as *knocking off*. In the twenty-first century, *knocking off work* means basically the same thing, but today people close computers or mechanical devices by pressing a button.

As computers in the twenty-first century continue to get smaller, faster, and have more functions to tantalize the user, some people still remember the labor-intensive, time-consuming job of card-punching computer programs during the early years of the industry. *Punch cards* constituted all data processing for more than seventy years, with IBM and Sperry Rand the two major providers of punch-card equipment. Early punched cards in various forms have been used in a range of applications ever since Jacquard's invention of a mechanism mounted on a loom that controlled the pattern with wooden cards punched with holes to manipulate weft threads. Punch cards, although now generally considered an antiquated and error-prone system, continue to allow businesses to monitor and control employee time and attendance. The most recent, and possibly most notorious, use of punch cards was for Florida's election ballots during the 2000 presidential election. News coverage, mostly negative, about the "hanging chad" and the United States' reliance on such an outdated system was reported around the world.

We use *overshot* to explain why something went further than or in excess of an anticipated result, such as an airplane that overshot the runway. In weaving an overshot pattern, the weft thread passes over two or more warp threads before re-entering the fabric to give a raised appearance—in essence, the shuttle overshot the threads below.

In Middle English, *schede* meant a division such as the part in one's hair. On a loom, the shed is a narrow opening or division of warp threads, serving as a pathway for the shuttle to travel through carrying any type of fiber.

work and two days at school one week and the opposite pattern the next week. In 1907, there were three thousand half-timers working in Belfast.[8]

Preparatory processes were notoriously dusty and dirty, and the fine airborne dust given off by the flax fibers (known as *pouce*, the French word for "dust") contributed directly and indirectly to illness, depending on the amount of humidity and dampness in each department. The air in hackling and roughing departments contained a vast volume of flax dust that caused serious respiratory ailments such as byssinosis and a high rate of death from tuberculosis.[9] The damage to the throat and lungs caused by pouce became evident in a few months or a few years, depending on the individual. In the early stages, the throat and windpipe became overly dry; then the affliction spread to the lungs, causing coughing spells, acute nausea, and death at an average age of forty-five years.[10] Many male and female workers drank alcohol to control the nausea

and keep working. Severe lung problems in flax dressers were so well known that the military did not recruit men in this profession.[11]

Women were primarily employed in spreading, drawing, and roving, the next stage of preparing flax for spinning.[12] The dust associated with this operation was even more dangerous because the material was finer and the temperature in preparing rooms had to be kept above seventy degrees. As workers began to feel the debilitating effects of pouce, they asked to be moved into different departments where the air was somewhat better, but by then the physical damage was irreversible. In the nineteenth century, the average life span for women preparers was forty-eight years old in town mills and fifty-seven in rural mills, and a typical work life spanned twenty-nine years. For young women preparing the short linen fibers, or tow, the atmosphere was the most disagreeable, unwholesome, and dangerous of all the mill departments occupied by women; their working life lasted only seventeen years before the damaging effects of pouce rendered them incapable of work. They called it the "beautiful cruel linen."[13]

Flax could be spun either wet or dry, but for the finest Irish linen yarn, wet spinning was essential. In that atmosphere, spinning rooms were kept moist and water ran through hot pipes, causing steam to fill the air; troughs of hot water were placed beside each spinning frame to increase the moisture. When a girl brought a bucket of tea or leftover soup from home for lunch, she set the bucket in a trough next to her workstation to reheat the liquid. Revolving spindles covered workers with a fine spray of warm moisture and machine oil while they stood barefoot for long hours breathing flax particles—it was an exceedingly unhealthy vapor bath. The death rate was not as high as in other departments, but spinners fainted in the oppressive heat, suffered anemia, and experienced onychia (nail infection) from standing in hot contaminated water.[14] Painful split cracks in bare feet were aggravated by exposure to the combination of hot, wet floors inside and cold, wet streets outside. Spinners wore a distinctive heavy apron called a *rubber*—usually made from coarse meal sacks or flour sacks with the brand name bleached out—in an attempt to keep machine oil and water off street clothes.[15] Ultimately, a large oilcloth apron with a bib front and a long skirt became mandatory attire for all spinners. Although some workers fashioned face masks from pieces of dampened muslin, little was done to reduce the concentration of airborne flax particles until industrial legislation governing ventilation and dust extraction was introduced in the last quarter of the nineteenth century. Even then, however, the dust remained an occupational hazard, as working conditions were largely determined by the characteristics of the flax plant.

The final manufacturing process that took place in a spinning mill was reeling. Reeling rooms were comparatively light, airy, and clean. Consequently, reelers considered themselves to be at the top of the mill hierarchy. A reeling frame consisted of a large octagonal frame of exact circumference around which the yarn was wound. The purpose of reeling was to transfer the yarn from individual bobbins into manageable bundles ready for sale. Reeling also fulfilled the important function of measuring the yarn; a bell sounded to signify a full reel.

There were two distinct groups of women in textile manufacturing. Weavers and winders worked in the cleaner processes in factories, and doffers and spinners did the dirtiest work in the mills.[16] A social hierarchy developed between the two, and each group was loyal to its counterparts. Weavers considered themselves at the top of the social order; they were more refined in their behavior and far better dressed, with the women typically wearing a skirt, blouse, stockings, and stout shoes. Doffers and spinners were economically and socially at the bottom of the ladder, working in processes associated with being unclean and inferior. Clothing indicated the status of the worker within the linen industry. The differences caused rancor and divisiveness between workers on the two separate sides of the trade—the factory and the mill.[17]

To underline the low status of mill workers, factory workers gave them various derogatory nicknames, such as "Millies" (because they worked in mills) and "Shawlies" (referring to the black shawls worn tightly wrapped around their head and shoulders). Mill workers were also held in low esteem outside the mill because of their appearance: grimy hands and faces and clothes that stank from the greasy oil and steam that spewed out of their machines as they worked. Most of them had no shoes and walked barefoot to and from the mill year-round, their black shawls and bare feet serving as symbols of their poverty. Artists' renderings and novels of the day ensured that the black shawl and bare feet would become a look synonymous with quaint, pitifully poor, famine-stricken nineteenth-century Ireland. Their behavior outside the mill was as raucous as inside, as their language was coarse and racy and their singing boisterous; considered a nuisance on the streets, they were often described as "the lowest form of life."[18]

Telling Their Story through Song

An industrial song tradition specific to female textile workers emerged from the spinning mills, combining older rural folksongs and incorporating and reworking words and melodies from children's street games to make up new songs. For example, *You'd Easy Know a Doffer* was sung to a modified version of *The Grand Old Duke of York*. Songs such as *Doffing Mistress* and *You'd Easy Know a Doffer* were saved from oblivion in the 1960s in the wake of the folk revival that took root in Ireland, as it had in America, England, and Scotland. Local, national, and international folk singers and collectors such as Pete Seeger researching indigenous folk music and songs discovered the rich heritage of industrial songs that came from textile mills.[19]

Socially excluded both inside and outside the mill, rowdy singing by the Millies accentuated divisions within the social hierarchy and set them even further apart from other workers. For doffers and spinners, singing brought a social cohesion that made them a close-knit community with their own identity and sense of pride in and out of the mill. Linked arm and arm as they left the mill, doffers and spinners walked in

groups of four or five, projecting a street presence for all to acknowledge. When one of them left the mill, the group felt the loss.[20]

Advancements in technology and new inventions resulted in major alterations in the quality and quantity of products for global consumption during the nineteenth century. Mill songs were part of the movement from rural domestic life to an industrial work environment that changed the fabric of society in Ireland, Europe, and America. A typical description of this life comes from the song "I Am a Hand Weaver to My Trade":

> Oh where are the girls I'll tell you plain
> The girls have all gone to weave by steam
> And if you would find them you must rise at dawn
> And trudge to the mill in the early morn.[21]

Most spinners and doffers in Ireland (like their counterparts in America) hated the dirt and grime associated with their job. The American work song "Factory Girl," also titled "Pity Me My Darling," epitomizes the feelings of many spinners who were looking forward to marriage and the possibility of escaping the grind of working life and the eternal greasy mess on their clothes:

> No more shall I work in the factory
> To greasy up my clothes
> No more shall I work in the factory
> With splinters in my toes
> Pity me my darling
> It's pity me I say
> It's pity me my darling
> And carry me away
> No more shall I wear the old black dress
> Greasy all round
> No more shall I see the super come
> All dressed up so fine
> For I know I'll marry a country boy
> Before the year is round.[22]

The doffing mistress held the highest supervisory female role in the mill and was in charge of doffers and spinners in the spinning room. She was likely to be in her teens, and during the nineteenth century, spinners and doffers were also very young, so the doffing mistress was as much a mother or big sister as a boss. Workers were totally dependent on her goodwill and protection. If she was well-liked, the doffing mistress was held in high regard; workers knew they were fortunate to have a good working relationship with a supervisor who had a great deal of control over their lives. A celebratory ritual often accompanied the

departure of a doffing mistress. Characteristically, it was an occasion marked by the doffers and spinners singing riotously as they paraded in groups through the terraced streets, belting out their repertoire of mill songs in their own inimitable way.[23] The prospect of marriage was a favorite theme:

> There's a soldier on yon hill,
> Watching a girl in Ewart's mill.
> Although she's a doffer,
> And her wages is small,
> He'll marry that doffer,
> In spite of them all.[24]

Moving on to another mill was another cause to write or compose a song:

> Oh Lizzie Murphy when you've gone away
> It's every night for you we'll pray
> We'll send for you when you're far away
> And we'll bring you back and we'll make you stay
> Ra-de-ri-fill ra, ra-day-ri-fill-ray.[25]

Before the 1874 Factory Act increased the minimum age of working children from eight to ten, doffers and spinners were hired as young as six years old, so, in a sense, children were singing new lyrics to familiar songs they knew at home and sang during street play. In 1901, the minimum legal age of employment was twelve, but despite legislation, many families were in dire need of the extra income, and parents continued to send underage children to work in the mills and factories that exploited child labor throughout the nineteenth and much of the twentieth century.[26]

Boys rarely sang with female doffers and spinners; most of them left the spinning rooms after a few years and moved on to jobs repairing and building machinery in other departments within the mill. Nevertheless, mill workers as a whole were a tightly knit group, bound by hard work, shared experiences, family, and, for female doffers and spinners, the songs that wrapped them together in friendship and solidarity.

Mill songs were composed for singing among workers inside the mill, not for a wider traditional singing fraternity. People outside the industry did not understand the function or interaction between the trades or technical jargon such as "lay up your ends" and "the flats are in a steer." Neither would outsiders understand references to the tools of the trade, such as pickers, scrapers, and shuttles. This was in contrast to oral singing traditions based on a widespread usage of songs that were passed down through consecutive generations. These industrial songs were an integral part of working life and proliferated throughout mills in Ulster province with the expansion of the textile industry from the mid-nineteenth century onward; they all but disappeared with the demise of the industry.[27]

Groups of women of all ages walked to work, making up songs about their lives as they went—songs of defiance, songs of hardship, and songs that ridiculed or revered a special boss. If one girl was in trouble, everyone knew it. Whether her specific trouble was an abusive boyfriend or husband, an unplanned pregnancy, or money problems, she was reassured by the knowledge that there was often a community of friends at work willing to comfort, impart sage advice, or dig deep into their own pockets to give what money they could to ease her difficult situation.[28]

Children of the Mills

In the wake of the Great Famine, many Irish children left Ireland with entire families hoping to improve their economic status through emigration. When emigration wasn't an option, children in northeast Ulster province were sent to work in the mills and factories. For many, it was a family tradition. "When you were eight, you were old enough to work. . . . If you got married you kept on working. Your man didn't get enough for a family. You worked until your baby came and went back as soon as you could . . . and then you counted the years till your child could be a half timer."[29]

Great Long Lengths of Yarn

Whereas buildings for spinning flax tended to be several stories high, the weaving factory, known as a weaving shed, was built on one level. Most weave sheds had a "saw tooth" roof, which was designed to optimize natural daylight. One face of each "tooth" was glazed and the other slated. In the summer, these roofs were whitewashed to keep temperatures down.

Yarn from the mill arrived at a weaving factory in loosely packed bales or bundles, each containing 60,000 yards of yarn. The gauge (thickness) of linen yarn was measured by the lea system. Yarn came in specific gauges, such as 25s lea, which was ordinarily used for kitchen towels, and a finer gauge of 40s to 60s lea, which was used for table linens. The lea number was multiplied by 300 to determine the number of yards of linen yarn in one pound. Therefore, while one pound of 25 lea yarn measured 7,500 yards (25×300), one pound of 290 lea stretched to an incredible 87,000 yards, or over fifty-five miles. Yarn of this caliber was extremely rare but not impossible. Higher counts of yarn were reserved for the cambric handkerchief cloth that was woven with very fine yarns.

Spinning mills calculated production by the total number of individual spindles in the mill. A bobbin was held upright on each spindle, and row upon row of bobbins rotated as spun yarn filled each bobbin to capacity. Doffers replaced full bobbins with empty ones, and experienced spinners moved quickly up and down the long row of the giant machines, repairing breaks and snags. Spinning frames were not usually

disengaged to replace bobbins or repair breaks, so agility was vital. In 1844, there were 155,000 spindles running in Belfast mills, and in 1868 there were 905,000 spindles in all of Ireland, compared to 474,000 in England and 264,000 in Scotland in the same year.[30] In the years before World War II, spinners at Bessbrook Spinning Co. Ltd. worked a forty-eight-hour week running 20,590 spindles to produce 380,000 bundles of yarn (average 40s lea) that consumed one thousand tons of flax per year.[31]

Factory Work and Weavers

Processes that took place in a factory saw the raw linen yarn turned into *cuts,* or pieces of cloth. The yarn first went into the warp and weft winding departments, where it was prepared for weaving. The winding master was invariably male, while winders were mostly female. Woven cloth is made up of two sets of threads: the vertical, or *warp,* threads that run the length of the cloth and the horizontal, or *weft,* threads that run across the cloth. The warp is wound onto a circular beam that sits behind or above the loom and slowly revolves unrolling warp yarn toward the front of the loom to be woven into cloth. Weft yarn is wound onto *pirns,* or bobbins, and inserted into the shuttle—a roughly cylindrical device with metal-tipped ends. The shuttle is then propelled back and forth across the loom, passing between the parted warp strands, called a *shed.* As the shuttle crosses the loom, it leaves a weft thread, which, when compacted, makes the woven cloth. The order in which the warp yarns are raised and lowered causes patterns to be woven into the cloth.

Shuttles were made from holly, beech, sycamore, and mahogany woods, which were preferred because the wood of these trees was free from knots, wore evenly, and resisted splintering. Shuttles were also polished to allow them to glide easily between the individual threads of yarn. To aid this process, warp yarns were *sized,* or *dressed,* immediately prior to weaving. Dressing (sizing) involved coating the yarns in a solution of hot starch and then squeezing out the excess moisture. This process made the yarn more pliable and slick, helping to prevent breakage.

Although keeping weaving sheds warm and humid was necessary to prevent the pectin of the flax from congealing and to keep the yarn pliable, overall working conditions were generally better and, with the relative absence of dust, decidedly cleaner than in the mills. Noise, more than anything else, characterized the weaving sheds. Until the 1950s, most factories were powered by a single steam engine, which transmitted power to the looms via a complex series of overhead pulleys, shafts, gears, and leather belts. The noise was so intense that verbal communication was almost impossible. Weavers devised a form of sign language that varied from factory to factory; the series of simple hand gestures allowed them to communicate with one another. Whereas ordinary workers went bareheaded, supervisors invariably wore caps, and in the earlier part of the twentieth century, the foreman was often referred to as *the hat.* One of the most common gestures was placing a hand, palm down, on top of the head. This warned the other workers that *the hat* was coming.[32] Deafening noise and heat were so overwhelming for adults and children when they began working in weave

sheds that they suffered from a disorientation called *mill fever* for a few days until they became accustomed to the disturbing atmosphere.[33]

The weave shed was also a potentially dangerous working environment. Looms were arranged back to back in tightly packed rows, with narrow intervening alleyways running the length of the shed. Fingers or hands could easily become trapped, while long hair and loose sleeves could pull the operator into moving machine parts. Despite clear instructions laid out in the factory acts in the late 1850s and constant reminders by visiting inspectors, fashion often proved a more compelling factor than safety, and enforcement of safe working practices for dress proved difficult. A flying shuttle could also injure workers, sometimes seriously and occasionally fatally. These accidents were particularly prevalent until 1896, when laws were passed to ensure that each mechanized loom was fitted with loom guards to protect against injury to the loom operator. However, loom guards were rarely repaired when damaged or malfunctioning, and when they were replaced, they were often mounted too high or too low, which caused injury to fingers or hands caught between the guard and the temple roller at the side of the loom.[34] A heavy, steel-tipped shuttle careering through the air could cause such significant damage that finally laws forced owners to install machine guards on all looms. One woman stated, "When I worked in the mills, I suffered many injuries while working on the machines. I was hit many a time with the shuttle. When I was a spreader I developed a really bad cough because of the very fine dust and even today I still have this cough."[35]

Although men and women rarely worked side by side on identical looms, most provincial factories employed both male and female weavers out of necessity, with men often weaving on the large and cumbersome sheeting looms. The allocation of tasks by gender depended largely on alternative employment opportunities. In villages and smaller provincial towns where employment opportunities were limited, competition for jobs in the linen industry was much greater, whereas in Belfast, weaving was largely women's domain. The ready availability of work in shipbuilding, engineering, transport, and construction meant that men were neither as directly nor as heavily reliant upon the linen trade for their livelihoods in Belfast as elsewhere in Ireland.

Hard Work and Long Hours

The 1901 law that raised the minimum age of employment to twelve allowed children aged twelve to fourteen to attend school and work in the mills on alternate days. At age fourteen, girls could, and usually did, work full-time. Girls in Belfast's linen mills and factories worked from 6:00 a.m. to 6:00 p.m. or from 7:00 a.m. to 7:00 p.m. Monday to Friday and from 6:00 a.m. to 1:30 p.m. on Saturdays. Office workers, including those in the various administration and sales departments, started at 9:00 a.m. Female workers, young and old, would rise between 5:00 and 5:30 a.m. to the sound of the factory bell or horn. In other cases, a small fee secured the services of the *knocker up,* a woman who rapped on bedroom windows with a long pole

capped with a ball of rags or paper and waited for some form of acknowledgment—often abusive—before moving on to the next house.[36]

Most girls lived within walking distance of the factory and had time for a small breakfast before leaving for work alone or with a sibling, meeting friends and colleagues along the way. Factories operated some type of clocking-in system, so the first person the girls encountered was the gateman and timekeeper. One common procedure involved moving personalized metal tags from one set of hooks to another when the worker passed through the gatehouse, so that unmoved tags indicated absentees. All employees had to be at work on time, because the main gate was closed and locked at the prescribed time. Even if a girl was seen running toward the factory, the gateman would slam the gate in her face to prevent her from getting in to work. For obvious reasons, the gateman was one of the most reviled persons in the trade. Not only did workers lose wages for the time they were locked out of work, but they also had to pay a severe penalty, known as an *out fine*, throughout mills and factories in England, Scotland, and Ireland. Being locked out of work by a mean gatekeeper was one of the most painful memories of both mill and factory workers: "The gate man pushed her out and the last I saw she was crying on her way home."[37]

The more modern factories provided cloakrooms for their employees. In most cases, however, the worker placed her outer garments in a box or on wall pegs. Factory inspectors criticized the box and peg systems because a lack of ventilation in boxes meant that coats failed to dry, while those left hanging on pegs became damp in the humidified factory environment.[38] In both cases, workers left a warm factory and ventured out into the cold evening air wearing damp clothing. Factory workers were plagued with coughs, colds, and respiratory ailments, which were usually attributed to donning damp outer garments. While poor diet and close living conditions probably accounted for most of the normal colds, lung-related illnesses are now recognized as having been caused by spending many hours each day breathing damp air full of fibrous particles.

Workers had to be at their station when the power was switched on and the horn sounded to mark the start of a workday. They were allowed brief breaks throughout the day, and most factories closed for an hour at lunchtime. Again, factory gates closed promptly after the lunch break, and latecomers were shut out for the rest of the day. Many married women used their lunch hour to go home to deal with household chores, eating on the run—not unlike working women in the twenty-first century who struggle to balance the demands of work and family responsibilities.

Missing work for any reason was particularly hard on weavers, who were paid according to output or by the piece. If she was paid by the completed cut of cloth, her wages varied considerably from week to week, depending on how many full cuts she had woven. A much fairer system was the *pick rate*, whereby weavers were paid according to the number of shuttle passes (or *picks*) completed, calculated by a counter attached to the loom.

It was customary for handweavers and power-loom weavers to place a full bobbin in the shuttle, place her lips against the opening, and, with a light intake of breath, suck out the end of the yarn; this was known

as a *weaver's kiss*. The shuttle was positioned in the loom with the end of the yarn hanging from the edge of the material, and the loom was turned back on. Every time a bobbin ran out of yarn, a new bobbin was replaced in the shuttle and the end was pulled through the hole at the side of the shuttle by the same method. The weaver's kiss was an efficient way to thread a bobbin into the shuttle, but it probably added to the spread of tuberculosis, which was common among workers; the practice was officially terminated in 1958. In the factory, a weaver's kiss came to mean a light touch.[39]

Yarn breakage occurred for various reasons, including poorly spun or erratic yarn, a natural weak spot in the flax, an old shuttle, or a misaligned loom. Breakage was most likely to occur in dry or cool conditions, so to avoid downtime and maximize earnings, workers tolerated the hot, humid air. In the case of loom malfunctions, weavers asked for assistance from a *tenter,* a loom mechanic who supervised the running of a number of looms. Loom tenters were always male, and each was responsible for twelve to seventy looms. They were in constant demand, and a skilled fixer was considered a major asset to a firm because he could keep production running smoothly.

If a weaver had to leave her station to go to the *parliament,* as the toilets were commonly termed,[40] she would entrust her looms to a colleague to watch rather than "knock them off," which left them idle and unproductive. Factories operated a strict quality-control system, and weavers were fined for producing poor cloth. To be called in front of the cloth passer was a source of great shame and embarrassment. The cloth passer's assistant—well known in the factory—would walk down the aisle in a slow and deliberate manner, stop beside a weaver, crook a finger, motion to her, and say, "The cloth passer wants to see you." The cloth passer had extensive powers; he could issue fines on the spot or fire a weaver. To most women, the insult to their sense of pride is what hurt most, with the knowledge that the factory floor was abuzz with talk about them. Despite its relatively low pay, weaving was a skilled job that took several years to master. Weavers had to remain attentive in case a thread broke or a shuttle tore threads by ripping through the warp. Traditional shuttle looms did not stop automatically when a thread broke, so the weaver had to stop the loom herself, disconnecting the power by throwing the drive belt onto an adjoining free wheel.

Worker Loyalty

A system of informal apprenticeships operated within linen factories whereby young women tended to follow their elder sisters and mothers into the factory, often working in the same department. Existing workers told supervisors when a sister or cousin was due to leave school and ready to work. At a time before résumés and formal interviews were used to determine the credentials of a prospective employee, a personal recommendation by a respected worker was regarded as an excellent character reference. The newly hired girl was trained by the family member or person who had recommended them, and although training allowances were sometimes granted to the experienced hand, a trainee was not paid until she was able to earn her own

money. Trainees were generally attentive and punctual and less likely to become involved in trade unions, because any infraction of the rules jeopardized not only their personal employment but also that of other family members working in the factory. This was especially problematic when the family occupied a house owned by the employer. In that case, bad behavior risked the family's home and their jobs. Finally, this system ensured that mature workers remained loyal and did not flit from one factory to another, because they knew that the employment prospects for younger relatives depended on their performing to the manager's satisfaction.[41]

Few factories had designated training departments, so a new worker was put directly onto production looms until she satisfied her mentor and overseer that she had grasped the fundamentals of weaving. Then she was allowed to operate a small loom of her own. As her abilities improved, the weaver was given additional looms producing more complex patterns with finer spun yarn. By the twentieth century, a skilled weaver could work up to eight shuttle looms at one time. Expert weavers were chosen to work on special orders and considered it an honor to apply their talent to a new or unusual project. The linen company of John Shaw Brown, located in Edenderry village, county Down, was commissioned by the shah of Iran to weave a silk and linen damask tablecloth with a design featuring shamrocks and his personal crest. Only one of their weavers, Mrs. Sadie Grime, operated the loom to weave the largest single cloth ever woven in Ireland. Either Davy McCullough or Billy Press was the loom tenter responsible for making sure the loom ran smoothly for the huge project. The shah's personal envoys came to inspect the finished tablecloth on display in Belfast, and they agreed that there was not a single flaw in the magnificent piece; it was delivered to the shah shortly before his overthrow in 1979.[42] When a particular company was given a unique request or a high-profile commission, the company used that finished product and the skill of the individual weaver to promote the company's expertise to other international buyers; John S. Brown and Old Bleach were the two linen companies always at the forefront for marketing linen to an ever-expanding audience.

Mossley Mill, County Antrim

Country mills and factories in a rural setting were similar to their counterparts in larger towns or cities—hard work, long hours, and loyalty prevailed. Mossley Mill in Newtownabbey, county Antrim, is one example of how technologies, product demands, and ownership changed through the centuries as the textile industry advanced from cotton production to become a worldwide icon of linen fame. In the twentieth century, Mossley Mill was converted into contemporary office space and a heritage center for Newtownabbey Borough Council, but in 1810, Aaron Stanton and Company was producing woodblocks for printing flowered muslins and calico on the property. By 1821, Thomas and Edmund Grimshaw had purchased the business to continue printing cottons, but the enterprise was converted to flax spinning in 1834 under the name Mossley Mill. The Grimshaws kept the business going through the famine years by heavily mortgaging

the land and mill buildings. When Edmund Grimshaw died in 1853, Ulster Bank, the main creditor, took possession of the firm. The property was sold to the cousins John and Henry Campbell six years later. The sale included "[t]wo mills for spinning for flax and tow, 22 workers' houses, [a] Manager's house and garden with a Dwelling House and grounds, ornately planted. The machinery consist[ed] of 2 steam engines with boilers, 25 H.P. each, with shafting and a great gearing attached." The Campbells immediately built a new engine and boiler house, new workers' houses, and a school. More houses were built in 1865 and 1871, and a shop and public house were acquired. A technical night school was provided to instruct adult employees and local farmers. A third story was added to the mill building in 1871, and a new mill was constructed eight years later. Mossley Mill added thread making to yarn spinning in the 1880s, and the firm became a limited partnership in 1897.[43]

The Patton Girls

Eight (four girls and four boys) of the nine children of John and Sarah Patton worked at Mossley Mill. Sisters Nellie, Lizzie, and Teenie Patton worked there for a combined total of a hundred years. Teenie started working in the twisting room at the mill the day after her fourteenth birthday. True to her name, she was proud of being the smallest player on the mill's field hockey team. Joining nearly a hundred other women, Lizzie started in the spinning room, where she stayed for months until she had enough training to move on. During her time as a spinner, a coworker taught Lizzie to crochet little pieces of lace during lunch break, and another spinner cut the girls' hair. The sisters attended the mill school and took the few pence they were allowed to spend out of the pay packet to buy chewing gum or candy or to attend a dance. Particularly for women workers, there was a sense of shared identity and camaraderie within a mill, undoubtedly heightened by the overlap between residential and industrial communities. Workers knew each other from birth to death; they attended the same churches and schools and socialized together on Saturday night.[44]

The workday was 8:00 a.m. to 6:00 p.m. and on Saturdays 8:00 a.m. to 12:30 p.m. with no paid overtime or paid holidays. Leaving the machines running, girls made a mad dash for the toilet while avoiding the stern eye of the foreman. Lizzie remembered, "Can McCullen was the Spinning Master then, and you were heart-scared of him. You would have hidden in a mousehole in the days." The girls got fresh milk at the dairy every morning, and when corn was thrashed on the mill-owned farm, they filled their bed ticks with fresh cornhusks. All three sisters loved their time at the mill. They lived nearby or in mill housing, and as they grew older and married, they either kept working or returned to the mill after their babies were born. Their time at the mill was about being together. It was hard work without a doubt, but in the context of other industrial factories in the early twentieth century, Mossley was a good place for Lizzie, Nellie, and Teenie to live and work.[45]

In another small town mill, a spinner who started working in 1917 recalled, "I remember my first pay. I brought it home to my mother. She spit on it for luck. . . . All our mothers done it, when we were

all young. . . . Out of seven and six, I got sixpence. Well, we went to a dance, and that left fourpence. Well, then . . . bought a tuppence worth of cherry lips . . . so that when you danced with a fella and leaned up to talk with him, there was a lovely smell."[46]

Women First

Sectarian violence associated with Northern Ireland during most of the twentieth century was often put aside in the workplace. Some firms that were located on the divide between Catholic and Protestant communities had separate entry and exit doors leading directly to that particular housing community, thereby providing workers with a separateness that was neither expected nor given inside the factory. This should not be taken to imply that the entire workforce was one big happy family. Petty jealousies, disagreements, and personality clashes were inevitable, but during the workday, in this large female workforce, most women considered themselves women first and Protestant or Catholic second. Their main concerns centered on husbands, children, parents, illness, and finances; sectarian discrimination could be left for outside work. The male overseer was more likely to be their enemy than was the woman working beside them.[47]

The close proximity between employment and housing, and the peculiarities of the familial hiring system, meant that linen factories effectively employed entire communities, so everyone knew of a commission for new work, knew who was chosen to weave the special order, and more than likely was friendly with her and her family. Women weavers were remarkably loyal and identified with the firm in which they worked. Many firms rewarded loyalty by guaranteeing to take back skilled workers of longstanding employment after lengthy absences due to marriage or illness. The favored workers were also the last ones to be laid off and the first reinstated after a recession.[48]

In the urban mills and factories, women also had a sense of belonging to a community of women who worked the same long hours and physical labor, sharing the ups and downs of their lives with other women who had similar problems at home or grievances in the workplace. "My happiest hours were passed in the factory, so they were. I loved my work and my looms. I always got a thrill when I saw the pattern forming; often it would be flowers that took me back to my childhood's days. Some say it's slavery, but I always liked it; and cannot tell of my feelings of satisfaction as I carried my web to the Cloth Office, and knew I had little to fear from its inspection."[49]

The three Patton sisters in front of the renovated Mossley Mill in 2003. *Left to right:* Nellie McKinstry (1916–2005), Teenie McKeown (1919–2010), and Lizzie Hamill (b. 1915). *Private collection of the author.*

Female Organizers in the Workforce

John Hind and Captain Boyd established the Blackstaff mill in Belfast, and from its early beginnings, the business grew rapidly, taking over smaller or failing concerns, including Milfort Mill (also in Belfast), Dromalane Mill (in Newry), and the Lurgan Weaving Company (in county Armagh). The Boyd family's involvement in the business covered several generations and stretched well over a hundred years before Blackstaff Flax Spinning and Weaving Ltd. closed permanently in 1990.

A major fire in 1890 necessitated an almost complete closure of the works for a period of thirty weeks, and in the late 1890s, no dividends were paid to shareholders. At that juncture, owners decided to relocate to the Springfield Road, a move precipitated by a need to modernize facilities and utilize the labor pool of women living in west Belfast.

Linen was the primary source of employment for women in Belfast, and although Blackstaff had moved barely half a mile away, the dense population of the new site meant that the company would be accessing an entirely new labor market. The 1901 Census for Malcolmson Street, which ran alongside the Blackstaff complex, demonstrates the extent to which localized communities and linen factories were interdependent; 56 of the 72 households on the street included at least one individual working in the linen industry, and 153 of the 270 people living on the street were female. Blackstaff was a huge facility producing a larger selection of linen than most local mills; cambric and sheer linen, duck and drill,[50] airplane linen, dress linen, embroidery linen, fancy linen, household linen, tailoring linen, and thread were all produced by Blackstaff.

Well into the twentieth century, the linen industry was almost completely without organized unions. Female workers were easily replaced and in a weak position when it came to joining unions. Despite attempts to organize them, in 1914 only about one-tenth of the female textile workers belonged to a union. Apart from employer hostility, mills and factories were scattered across the north of Ireland, making it difficult for organizers to operate effectively. Not only were workers involved in a variety of jobs within the industry, but groups engaged in similar work in different mills and factories had little contact with each other.

Probably the major difficulty for union organizers was the religious sectarianism, which overshadowed common grievances among segments of the working population. For Protestant workers to overcome religious loyalties and join with Catholics in action against (mainly Protestant) management was difficult, and there was also the fear of losing the factory house, which went with the job. Saidie Patterson and May Blood are two examples of women activists in the linen industry, illustrating the efforts of many who worked to bring about significant changes in the textile industry.

Saidie Patterson: A Women's Advocate

In 1906, fourteen-year-old Saidie Patterson began working at Ewart's factory. It didn't take the young woman long to recognize how ill-treated workers were and what huge profits were made at the expense of poorly

paid, poorly fed women, toiling in poor working conditions to make expensive cloth ("the beautiful cruel linen") for international consumers. Fortunately, Saidie did not live in factory-owned housing, so she had no fear of eviction when she began to speak out for reform. She was a high-spirited and determined woman, strongly motivated to make changes in the working environment for women, who were a downtrodden group in a lower-class society. Men working on the mechanical side of the industry already belonged to powerful trade unions, so Saidie concentrated her efforts on behalf of women.

When Saidie began to organize women in Northern Ireland, every management shortcoming, every poorly organized department, every delay, every breakdown, and every problem with production was reflected in the wage packet of women workers. If machines broke down or production stopped for any reason, a weaver might stand around for days waiting for repairs and leave work at the end of the week with hardly any money. In general, it was dangerous to confront management. Saidie understood that she needed the support of male trade unionists and recognition from Ewart's management before she could make any headway. In her efforts, she was assisted and encouraged by Ernest Bevin and Bob Getgood from Amalgamated Transport and General Workers Union. Both men were anxious to widen the textile section of their union workers, and they needed the support of women to do so.

For years the union grew slowly and in secret, until 1939 when it went public with a formal demand for Ewart's to have 100 percent trade union membership. Ewart's refused, but by 1940, only twenty-six employees continued to resist membership in the trade union. When Ewart's still would not relent, nearly two thousand workers (male and female) went on a strike organized by women. The strike brought the proudest textile mill in Europe to a standstill for seven weeks. The sight of nearly two thousand female marchers, dressed in their Sunday best and dubbed the "linen lassies," was an impressive sight, even in marching-prone Belfast.

War news out of London convinced Saidie and strikers to return to work, but the women had succeeded in instigating a revolution for better working conditions, pay equality, and welfare not only in Ewart's but also in every linen firm in Northern Ireland. By the end of 1940, Saidie could proudly report an increase of 15 percent in wages along with an agreement for holidays with pay, minimum payment rates for women, regular performance reviews, and sickness benefits; accident and legal aids for workers were also in place. Saidie acknowledged that it was a "memorable year in the life of the weaving trade," and for the next twenty years, she built on foundations laid down by the strike she had organized and led in 1940.[51]

May Blood's Lifelong Commitment to Change

Until she could decide what to do with her life, May Blood planned to work in her local linen mill for a few months after high school. Thirty-eight years later, when Blackstaff Flax Spinning and Weaving closed in 1990, May was still there, working in the warehouse as a cutter. One of six children, May was born and raised in west Belfast in a religiously mixed neighborhood, socializing with both Protestants and Catholics.

In the 1940s and 1950s, the community was united by poverty, not divided by religion. A hard worker with a strong social conscience, May took the job of shop steward in the Transport and General Worker's Union in 1968 against her father's objections, moving through the ranks until she was the union arbitrator, dealing with conflict resolution for the whole factory, including both male and female union employees. When she discovered that the office staff was being underpaid, May called the entire factory out on strike. "We were one day out, a very long day," she said, but the strike worked, and Blackstaff management, agreeing to pay office workers the minimum wage, asked May to negotiate a settlement. She actively campaigned for better wages, fair pay for women doing the same job as a man, safer working conditions, and vacation pay. May's education was nurtured in the workplace, and her trade union experience taught her about the political process, through which she developed the skills to find solutions to problems rather than deadlocking in confrontation. May worked side by side in a linen conglomerate staffed with Catholics and Protestants, experiencing firsthand the way women were able to transcend distrust and animosity and relate to each other as women with women's issues. During her adult life, May has been a passionate advocate for the under-served and marginalized segment of Northern Ireland's population, particularly concerned with the effects of poverty related to housing, unemployment, and childhood education. She has actively campaigned for integrated education in Northern Ireland since 1998.

May Blood's thirty-eight years in the mill influenced and guided her adult decisions; the people she worked with were her community of family and friends. "I would go back to those conditions tomorrow," she told me. "I am still friendly with the girls I worked with, even throughout The Troubles. We came through some really serious troubles. The factory bordered on the Springfield and the Falls Road. When The Troubles were at the height, my Catholic workmates would have seen all the Protestants out to safety. We would have to come out and walk up the Springfield Road to the Shankill, where most of the girls lived, and we had no trouble. Even during the hunger strikes, we all supported one another, and even today we still have strong links with each other and keep in contact."[52]

In 1994, when Protestant and Catholic factions responsible for the thirty years of violence (The Troubles) called a ceasefire and began negotiations, May Blood was determined to see that women had a voice in that arena. She organized a coalition of women, Catholic and Protestant, to participate in the political process; the Northern Ireland Women's Coalition (NIWC) gained two seats at the negotiations, where they vehemently argued for safer communities and greater support for integrated education. When the Good Friday Agreement was signed on April 10, 1998, it included provisions that the NIWC had fought to attain.[53]

May, the first woman in Northern Ireland to be given life peerage, was elevated to the House of Lords in 1999. Baroness May Blood continues her work in Belfast, seeking solutions to the problems (particularly those affecting disadvantaged youths) facing communities on the peace line. In Parliament, she is a strong advocate for change to address the social and economic challenges that face Northern Ireland in the twenty-first century.

The glory days of the linen industry were from 1870 to 1914. Thereafter, the trade entered a slow but inexorable decline. Although the post-1914 period was interspersed with bouts of prosperity, the trend was undeniably downward. Over the years, however, fortunes in the linen trade had always been cyclical, and this pattern caused the trade to remain unduly optimistic, believing that every revival was a possible renaissance heralding a return to better days.

The decline of the Irish linen industry must be viewed in terms of an overall decline in linen production worldwide. Not only was the central position of Ireland within the industry assailed by increasing overseas competition, but also the overall demand for linen cloth was shrinking. The Irish linen industry therefore found itself competing for a share of a significantly reduced sales market.

Besides weavers and spinners, there were workers in departments for dyeing, cutting, assembling, inspecting, sorting, and shipping, to name but a few. Raw materials and cloth had to be moved between departments, and machines had to be built, repaired, and maintained. As the Industrial Revolution gained momentum, huge numbers of workers moved into cities to work together for long hours in massive buildings, changing the way people had previously lived, worked, fed themselves, and raised their children. In Ireland, as in all other industrialized countries, new social structures developed to address issues of housing, pay rates, long hours, child labor, and health and safety concerns.

The great Irish linen industry developed from a rural, domestic, family-based cottage industry in the seventeenth and eighteenth centuries to a nineteenth-century industrial giant, at the center of which was Linenopolis, forever linking linen with the island of Ireland. During the hundred years between the beginning and the end of the nineteenth century, Irish linen fabric and the Irish people who made it lived a story of contrasts and inconsistencies: some families moved to find work, while others stayed on the land; the poor got hungrier, and the affluent increased their holdings; and opportunities developed where sameness had once prevailed. Reformers May Blood and Saidie Patterson learned to appreciate the strength and resilience of all women regardless of religious affiliation. With determination and tenacity, they used the united voices of a tight community of women to bring about much-needed reform in the textile industry.

The Industrial Revolution did not merely change habits and lifestyles, however, but caused a new kind of national identity to emerge—people selling hundreds of thousands of yards of linen cloth, along with clothing, yarn, and household furnishings, until the phrase *Irish linen* had become synonymous with Ireland and Irish people.

Chapter 8

Smoothing Out the Wrinkles . . . or Not

Colonel Grangerford was a gentleman you see. He was a gentleman all over. . . . His hands was long and thin, and every day of his life he put on a clean shirt and a full suit from head to foot made out of linen so white it hurt your eyes to look at it: and on Sunday he wore a blue tail-coat and brass buttons on it. . . . There weren't no frivolishness about him, not a bit, and he weren't never loud.

Mark Twain, *The Adventures of Huckleberry Finn*

IN THE TWENTY-FIRST century, soiled or worn clothing is sent to the cleaners or washed and dried at home, and within a couple of hours, it is put away for the next wearing. Rarely do women refer to a particular day in the week as washday. Clothes are washed at all times of the day and night, often as other household duties are being completed. When no one has to maintain a wood- or coal-burning fire to heat water, washing is as easy as turning the dial on a machine; a beeper signals the time to put clothes into the dryer. Clotheslines and clothespins are relics of the past, and few American women under the age of fifty remember the fresh, clean scent of sheets drying on a clothesline as they flutter in the breeze of a warm afternoon sun, or the quick dash outside to remove clothing when a sudden rain shower occurs. Manufacturers frequently label clothing made of natural fibers *dry clean only* to avoid dealing with complaints from a public unfamiliar with hand washing and ironing techniques. The activity of ironing out wrinkles in cotton and linen items, once so time-consuming, is almost nonexistent today. Contemporary men and women consider wrinkle-free clothing, bedding, and table linens to be an entitlement, not the novelty it was fifty years ago. Clothes washers and dryers have permanent press settings, and the members of many households

Facing page: Detail of finely pleated linen dress ruffle. The full dress appears later in the chapter. *Courtesy of Irish Linen Centre and Lisburn Museum. Photography by David Pauley, Belfast.*

Lady's tin hip bath and foot bath, both with white enameling on the inside and wood graining on the outside, mid-nineteenth century. Castle Ward. © *Courtesy National Trust. Private collection of the author.*

rarely, if ever, use an ironing board or iron. When an article needs pressing, taking it to the cleaners is often easier than ironing it at home.

In addition, Western women in the twenty-first century cannot conceive of wearing clothing that purposely restricts their mobility. Sitting, standing, walking brusquely along a sidewalk, and getting into and out of an automobile are activities taken for granted, hardly worth a moment's hesitation. Some women change clothes frequently during the day for personal pleasure, but standards of dress in the twenty-first century are vastly different from the set of unbreakable rules for fashion mandated during the rigid Victorian era.

Before man-made fibers and wrinkle-free fabrics became commonplace, clothing and household fabrics were made of all-natural fibers—silk, wool, cotton, and linen.[1] Linen does not lose its strength when wet, which allows it to withstand repeated washings. During much of the past three centuries, linen was the preferred fabric for handkerchiefs, sheets, towels, tablecloths, and napkins. For most of its history as a clothing fabric, linen was used primarily for underwear and shirts and only occasionally for outerwear. Linen underwear and shirts protected fine outer clothes from bodily dirt, and at a time when personal cleanliness was not a priority, the wearing of clean linen was thought to be an acceptable substitute. The crisp white shirt for men has long been a mark of distinction and a status symbol. A hundred and fifty years ago, maintaining a shirt's whiteness and starched finish required a great deal of time and effort; today, shirts are taken to the dry cleaners to keep them clean and smooth. No matter how it is kept clean, sparkling white, and crisply starched, the shirt, properly cared for, has been evidence of prominent social standing for more than a century.

Linen for Clothing

Throughout history, linen as a clothing fabric has been used according to its weight and fineness primarily as underwear, women's accessories, men's neckwear, and full gowns, depending on the relative wealth of its wearer. Coarser linen was used for foundation garments such as panniers and corsets and has long served as a durable lining and interlining material in everything from footwear to the finest silk dresses. Huge quanti-

ties of linen were used as underwear.[2] When funds permitted, it was the fabric always worn next to the skin—fine for the wealthy and coarse for the poorer, with wool underwear worn only by the poorest and those doing penance. The visible edge of underwear at the sleeve or neck ruffle could be a focal point in the design of an outfit. For fashionable female accessories, linen was used for a wide variety of caps, cuffs, ruffles, aprons, veils, and collars, often dominating the outfit. In late medieval times, the starched and ironed linen headdress was a principal feature for both fashionable and regional female dress; in the late eighteenth century and into the 1820s, the variety of accessories was so extensive that the actual dress was barely noticed.[3] Accessories were a relatively inexpensive way to update an outfit, and milliners who bought and sold the materials to create hats were important figures in fashion retailing, especially during the eighteenth century. In male dress, neckwear and, to a lesser extent, cuffs were the most important fashionable linen elements. The ruff developed from a neck frill in the late sixteenth century, becoming an exaggerated feature of dress for both men and women by the early seventeenth century. The linen cravat started as casually tied neckwear and developed into the precisely knotted starched object of sartorial desire sought by Regency dandies.[4]

Coarse unbleached linen undergarments: stays (corset), c. 1770; panniers, c. 1760–70. © *National Museums Northern Ireland 2011. Collection Ulster Museum. Private collection of the author.*

For the past 250 years, people all across Ireland have made and worn linen clothing; some garments were of high quality and others were strictly utilitarian. Prosperous Irish people in the eighteenth century wore expensive clothing in public and private; both men and women were equally interested in presenting a flamboyant appearance that seems quite outrageous compared with present-day fashions.

Outrageous Fashion

Hoop petticoats made of linen, buckram, or canvas and shaped with whalebone or cane distended the skirt to give an exaggerated hipline. A Dublin pamphlet published in 1730 lectured women, saying that they should not wear these cumbersome hoops when riding, walking, standing, or lying down because the skirts, when raised, displayed the owner's legs all the way up to the calves. There was, however, sufficient flexibility about the hoop-wearing fashion that authorities could put notices in newspapers before events that were expected to be crowded, requesting women not to wear hoops—and men not to wear swords.[5]

In the latter half of the 1800s, Irish fashion was influenced by English styles that were more conservative, and by the end of the century, political and social changes had brought about much simpler styles for men and women. Socially prominent men were more active in international business and in public and civic affairs, and their clothing developed into the somber dark three-piece suit and white shirt uniform. Women were confined to domestic affairs, but their clothing continued to be an elaborate display that reflected the wealth of their husbands or fathers. Middle-class women had large wardrobes that included a very different set of items from what is predictable in today's closet. Shoes and boots made of leather or fabric were often lined in linen. When Anna Pim married Edward Jacob in 1878, her trousseau clothing included one dozen linen collars, one dozen linen cuffs, and three sets of collars and cuffs. Her one pair of shoes, three pairs of walking boots, and three pairs of satin and velvet boots would not be nearly enough footwear for a modern bride.

In the twentieth century, men's clothing stayed basically the same, but women's fashions changed as dramatically as their lifestyles. Women wanted greater freedom of movement in their clothing, and they favored styles that were easier to maintain. Women were working in all sectors of industry, had taken over jobs traditionally held by men during wars, and afterward demanded emancipation from the restricted domestic role that had once been a woman's only choice, especially for the upper and middle classes.

Clothing says a great deal about people, particularly how they perceive themselves and how they want to be perceived. Fashion through the centuries has reflected men's attitudes about women and the roles women are expected to play within society. Stays, corsets, hoops, and all manner of shapes and styles of garments controlled women's range of movement for much of history. If a woman's clothing restricted her movements to the point that she could not bend down to tie a shoe or even dress or undress herself without help, then she was certainly unable to participate in physical activities that were thought suitable only for men.

Black leather shoe lined in coarse linen, c. 1790. © National Museums Northern Ireland 2011. Collection Ulster Museum. Private collection of the author.

The making of fashionable garments and accessories out of linen and other fibers moved from being a domestic industry that involved the entire family to full industrial work in which lives were dominated by the factory owner, not the head of the family. Tailors, seamstresses, and dressmakers turned bolts of fabric into clothing until eventually these jobs were nearly eliminated by mass production. Nineteenth-century middle-class Irish women working at home excelled in making fashion accessories, including bags, purses, and gloves. Knitting, lace making, and embroidery were considered by society to be appropriate "women's work" for the homemaker, but in reality most women used their handwork skills as a source of income, not for personal adornment.

At one time, a bolt or length of cloth was used to make clothing for an entire family, resulting in a certain sameness for all wearers of the garments. In the twenty-first century, the expression *cut from the same cloth* refers to individuals who share essential characteristics, good or bad. The slightly different phrase *cut or made from whole cloth*, in contrast, means that a person is taking one piece out of the whole truth (referring to the full-size piece of cloth), then using that piece to fabricate a lie or fib.

The expression *to wash one's dirty linen at home* refers to keeping family matters, arguments, or scandals private, not speaking of them outside the family unit. *To air one's dirty linen in public* is quite common in the twenty-first century when politicians and movie stars attempt to justify their misdeeds to the media in an effort to gain public support for their actions. Again, the word *linen* has come to be applied to undergarments or shirts regardless of the material they are made of. To wash one's laundry at home prevents anyone outside the family from knowing the quality and condition of the garments—especially if they would cause embarrassment because they are worn and tattered. The opposite is true for washing laundry in a public facility.

Women today shop for undergarments and sleepwear in a lingerie shop or the lingerie department of a clothing store, but in the nineteenth century, the French word *lingerie* referred to the making or selling of linen cloth, things made of linen, and linen articles collectively: all the articles of linen, lace, and so forth that could be found in a woman's wardrobe or trousseau, including both underwear and outerwear.

In the twelfth century, another French word, *pannier,* described a basket, generally used in pairs for transportation across the back of a beast of burden. In the eighteenth century, the word was applied to an oblong, cage-like structure covered with linen and worn under a woman's formal gown, extending the width of the gown at either side to display the rich fabric and possibly an embroidered apron over it. After the first part of the twentieth century, panniers were mounted on either side of a bicycle or motorcycle packed with enough equipment for self-sustained tours of days or weeks. Today, commuters who bicycle have panniers designed to hold laptop computers, files and folders, changes of clothes or shoes, and lunches.

A consumer instinctively reaches a hand out to touch a piece of cloth regardless of fabric content. The instinct is so strong that merchants, museum curators, and antique dealers are forced to post "Do not touch" signs in plain sight and keep a vigilant watch to see that a stray hand does not violate the sign's instruction. The way a fabric feels is known as the *handle,* or fabric *hand.* A textile, especially linen, may have a rough, smooth, soft, or satiny hand depending on the fibers, age, finishing, and quality of the weave. The hand is how we judge the desirability of fabric.

In the sixteenth century, the word *pounce* referred to a hole pinked, punched, or cut out as an adornment on a garment made of linen or other fabric. As a verb, *pouncing* refers to decorating cloth by cutting or punching out a design, then sprinkling a powder on the punched-out design to mark the cloth before cutting. Not until the seventeenth century was *pounce* used to describe springing upon something or someone.

Linen's use in clothing and fashion is inextricably linked with its qualities as a fabric. Its individual characteristics—beauty, washability, wet strength, comfort, absorbency, and speed of drying—have suited it so well for domestic and clothing uses that for many years the fabric has been synonymous with products made from it. *Household linen* means all forms of bedclothes, tablecloths, napkins, dish towels, and other small washable domestic fabric products, while the single term *linen* was used to describe all underwear and nightwear including shirts.[6] Linen's disadvantages (notably, its propensity to crease and the relatively high labor costs involved in its production and maintenance) have also had an impact on its use.

Linen apparel required pristine cleanliness to be an indicator of status. The laundering of linen was an unremitting accompaniment to its wear. Because it could be washed repeatedly and effectively, linen was always associated with high standards of hygiene. The contrasting fresh, starched, white linen shirt seen at the neck and wrists became a distinctive sign of a gentleman for all of the nineteenth and much of the twentieth century. Women's wear had to be equally snowy. Although linen's washability gave it a distinct advantage over wools and silks, the effort needed to keep it white made it very high maintenance. Soaking, soaping, washing, bleaching, rinsing, drying, starching, and ironing meant that washday in middle-class and working-class homes became a physically demanding ordeal. Apart from the variety of linen wear—drawers, chemises, petticoats, nightgowns, camisoles, night and day caps, collars, cuffs, aprons, and so forth—the number of sets of each item is astounding to modern minds. The idea was that washday would come around less often the more linen a household owned, and so the infrequency of washday in itself became a form of status symbol. The wealthiest households had a separate laundry area, where laundry maids worked full-time.

Castle Ward (built in the early 1760s), county Down, viewed from Strangford Lough. © *Courtesy National Trust. Photography by Chris Hill.*

Washroom in Castle Ward laundry, 2008. © *Courtesy National Trust. Private collection of the author.*

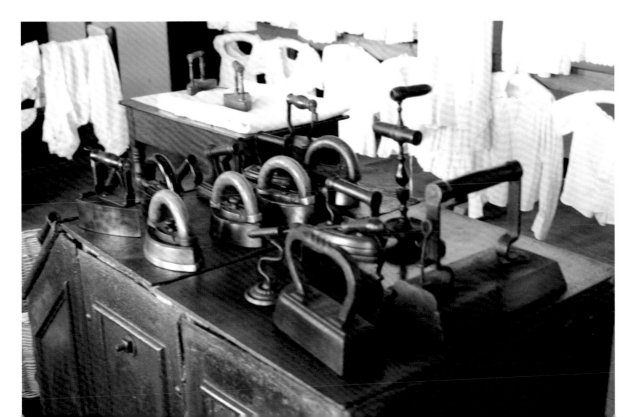

Examples of various early hand irons for garment pressing, displayed on a wood stove in Castle Ward's laundry, 2008. © *Courtesy National Trust. Private collection of the author.*

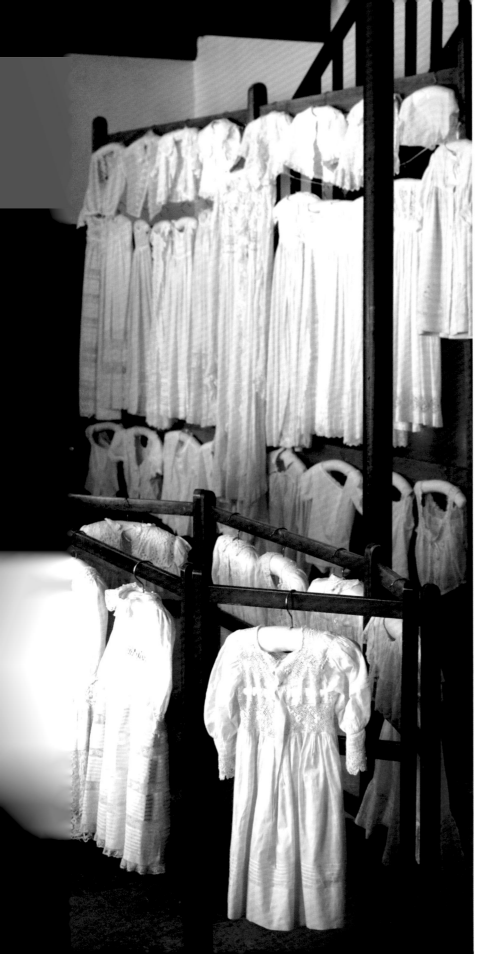

Linen damask tablecloth featuring the Ward family crest.
The tablecloth, handwoven in 1837 by William Coulson's
Damask Linen Manufactory (established in 1764), is shown
in the dining room of Castle Ward. © *Courtesy National Trust.*
Photography by Peter Muhly.

Linen and cotton dresses displayed in Castle Ward laundry,
2008. © *Courtesy National Trust. Private collection of the author.*

Historically, fabrics of linen, silk, wool, and cotton share an intrinsic value that is hard for present-day consumers (who are used to cheap, man-made fabrics) to appreciate. At one time, cloth and clothing were financial assets to be appreciated and cherished, and relatively ordinary shops in Ireland stocked a tremendous variety of weights and styles of linen for sale.[7] In the late eighteenth century, when a workingman's wage could be 50–75 pence per week and 240 pence equaled £1, a secondhand linsey-woolsey (linen/wool mix) petticoat could cost 22.5 pence and a silk dress could cost £10 to £60 (with a court dress costing much more). Because of the cost, fewer clothes were purchased than today; for most people, each item needed to last a long time.

Until the twentieth century, there was a universal availability of servants to all but the poorest, and these servants were vital to the upkeep of clothing. Unwanted linen garments were passed down to servants, who wore them for as long as possible before selling them to someone poorer or giving them to the ragman when they were no longer wearable. The etiquette of dress is another aspect that affected the use of fabrics.

Clothing defined in the eighteenth century as informal wear was worn at home or casually in the daytime, and formal wear was worn for public or evening occasions. Court dress was the most formal and ostentatious style of dress.[8] If linen was used as the material for a full garment, it was always worn for informal wear, called "undress," although fine linen accessories could be worn formally. At that time, *undress* did not mean to remove one's clothing but referred to a kind of outer garment.

Outerwear

For female fashionable dress,[9] linen has a somewhat checkered history. Its use in fashionable clothing over the centuries was strongly related to the attitudes, styles, technology, social position, and expectations that were then current. Its great disadvantage was its tendency to crease, or wrinkle. Creasing either prevented its use or was tolerated, although some strategies were devised to prevent creasing. Before the mid-twentieth century, coarse linen was an alternative to wool for the lower classes, and in varying weights it was used by all levels of society for a variety of garments from doublets to leg-wear to jackets. As the full outer garment, linen was usually not associated with high fashion and was featured mostly in lower-class and regional dress. In Ireland, a distinctive form of linen garment was the *leine*, a saffron-dyed shirt worn by the native Irish in the sixteenth century, best recognized from images on what are known as the Derricke woodcuts.[10] The shirt was extremely voluminous, with huge falling sleeves and heavy pleats below the waist to control the fullness in the body; its inevitable creases must have been tolerated. About the same time, a fashionable linen garment emerged that illustrated one solution to the creasing problem. This was a jacket heavily embroidered

with an appealing variety of plant and insect life typical of late Elizabethan and early Stuart embroidery. Linen was an ideal foundation for embroidery, and the embroidered linen attached to a lining prevented creasing and formed a fabric solid enough for tailoring. These were the first fashionable linen garments to survive in any quantity.[11]

Printed Linen

At the end of the seventeenth century, Indian chintz printed on colorfast, washable cotton was imported into western Europe in increasing quantity and became so popular as a dress fabric that silk and woolen producers began to fear losing their livelihoods. They convinced the government to impose an excise duty on Indian imports, and the import and sale, use, and wear of all printed cottons were prohibited by 1721. English printers who were already in production evaded the duty by printing on linen or linen mixed with cotton. This gave a huge boost to both the Irish and Scottish linen industries. Ships from Belfast took linen to London to be printed and reimported it. From at least 1727 on, linen had also been printed in Ireland with government encouragement. After the 1750s, there was printing in the Dublin area at Donnybrook, Leixlip, and Drumcondra, where copperplate printing for furnishing and garment use began about 1752. In 1774, an act finally lifted the ban on the home sale of printed all-cotton goods, and by the 1780s, cottons were being printed in Ireland. By that time, printed linen and cottons had become very fashionable undress (that is, informal wear).

Linen for Royalty and Court

The popularity of informal linen wear resulted from several factors. Court life had become increasingly stiff and repressively formal in France, and the relatively casual lifestyle and dress of English aristocrats began to be admired. Informality itself was becoming fashionable at this time. This Anglomania encouraged the wearing of softer silk, cotton and linen blends, and wool for men. The French queen Marie Antoinette wore the first light white cotton chemise dress in the mid-1770s and caused a scandal by wearing the style in her portrait by Vigée-Lebrun in 1783. The simple white dress echoed classical dress at a time when neoclassical taste was gaining in popularity, partly inspired by excavations at Pompeii, which were seen by many young European aristocrats as the highlight of their "grand tour." Perceived democratic values of the classical era, viewed as a simpler and more egalitarian time, also encouraged fashions that were more modest. After the start of the French Revolution in 1789, both dress and politics came to more directly reflect classical modes. The revolution made ostentatious and costly fashions—the most obvious outward show of the ancien régime —unacceptable, and in some cases, showing allegiance to the opulence of the past was dangerous.

On a more practical level, mid-eighteenth-century advocates of printed linen and cotton gowns consistently and repeatedly acclaimed the virtues of the materials, including the premise that hygiene could be maintained more easily because of the garments' washability. To be able to keep an outer garment clean and therefore new looking was a huge boon, especially for those of limited means. Linen and cotton were cheaper than other fabrics (especially silk), so pretty new printed fabrics were not just for the very wealthy but inexpensive enough to be widely worn by working-class women, whose bed gown—a loose jacket-like gown with a wrap-over front—was typically made of printed linen or cotton. Many copperplate-printed linen fabrics were simple floral designs on bleached linen. After 1774, cotton began to supersede linen as the clothing fabric of choice, and by the 1790s, cotton had gained the upper hand.

In the nineteenth century, starched, lightweight linen gained renewed popularity for specific reasons that were practical, religious, nationalistic, and artistic. Unbleached embroidered linen dresses were washable and therefore practical for pregnant and nursing women.[12] Children's clothes, too, could be fashionably designed and made of linen, which was easily washed. Linen was an ideal fabric for men's and women's wardrobes in hot climates and was widely chosen for travel and everyday life in the expanding European empires; men's linen suits were an indispensable requirement and became a symbol of the well-dressed Briton living in India, South America, and the southern region of the United States. Lady Hay Drummond-Hay (1895–1946), the first woman to travel around the world by air (in a zeppelin, in 1929), is said to have traveled with a large linen wardrobe and to have hung her clothing in the damp air of a violent storm to remove the creases.[13]

The liturgical use of linen has a long history, but at a time of urban expansion and unprecedented church building in the nineteenth century, surplices were increasingly important.[14] Surplices of that period were typically made of linen lawn, lavishly trimmed with embroidery or lace in contemporary styles.

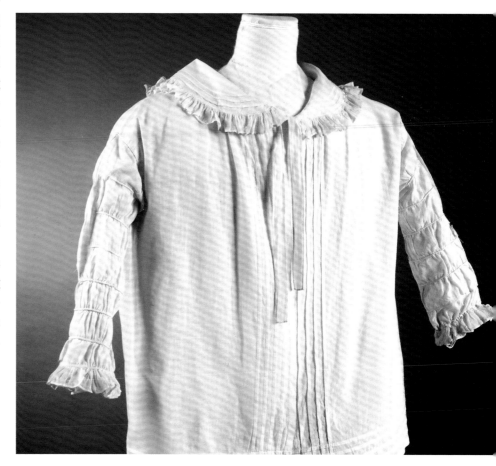

Child's handwoven linen shirt with gathered and corded sleeves and frilled collar, mid-nineteenth century. *Courtesy of Irish Linen Centre and Lisburn Museum. Photography by David Pauley, Belfast.*

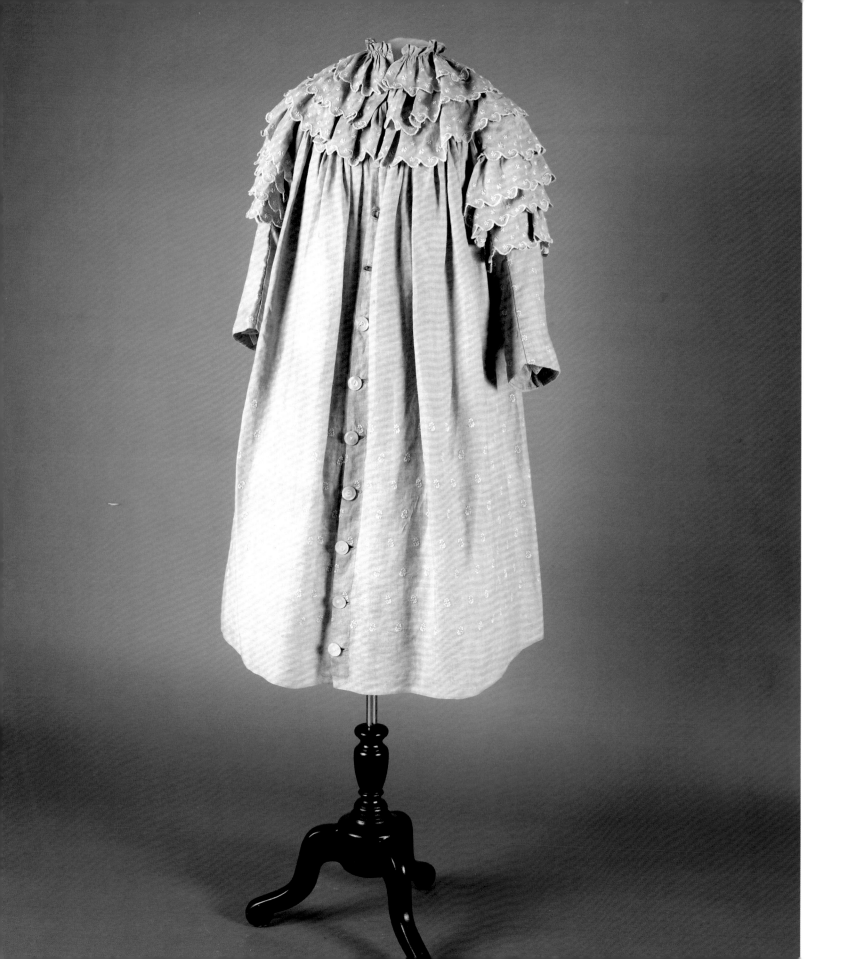

The Victorian era was considered a period of highly ornate styles in furnishings, architecture, and fashion. Rigid rules for behavior, dress, and lifestyle were sternly adhered to, and there was little forgiveness when the strict etiquette that was demanded of the upper and middle classes was ignored. The queen was in mourning for forty years after the death of Prince Albert in 1861, and her formality was visible in the dress for women, especially widows, who were expected to show wealth and respectability in their mourning dress and deportment. Even middle- and lower-class women went to great lengths to appear fashionable during mourning, a period that could last for over two years in nineteenth-century England.

Linen held a relatively minor role in mourning attire. Dresses were usually made of black crepe with no adornment during the first stage of mourning, but during the second year, fine linen caps, cuffs, and collars added a bit of modest decoration. Mourning handkerchiefs were extremely important to the weeping widow, and plain, soft linen cambric was the ideal fabric. Upper-class Americans also adhered to the Victorian rigid code of ethics until there were so many widows during and after the American Civil War that the nation relaxed mourning etiquette in an effort to lift the nation's morale. With the dawning of a new century and the death of Queen Victoria came a more relaxed society longing for gaiety and femininity.

A New Style and Fashion Designers

Fashion trends introduced in one European country were quickly adopted by another, and Irish linen gained and lost favor depending on current styles, the season, and the whims of the popular designers of the day. To make Paris into the showpiece of Europe, Napoleon III (1808–73) began to rebuild the city with plans to modernize and revitalize the French economy. The demand for luxury goods, textiles (including linen), and fashionable dress reached levels not seen since before the French Revolution (1789–99). When Napoleon III married Empress Eugénie (1826–1920), her tastes set the style at court. Until the mid-nineteenth century, seamstresses had designed and constructed clothing and high-fashion garments copied from styles worn at royal courts. Charles Frederick Worth (1826–95) was the first designer who was not merely a dressmaker but a fashion designer as well; he dictated to his customers what they should wear instead of taking direction from them. Empress Eugénie's patronage ensured Worth's success as a popular dressmaker of fashionable garments from the 1860s onward and opened the way for couture fashion designers.

Although the Victorian and Edwardian eras are conveniently separated stylistically, the line between the fashions of the two periods is blurred. The period from the 1890s through the early 1900s was an age of extravagance and style, appropriately called la Belle Époque, a time when fashion enjoyed its last true age of

Facing page: Child's unbleached linen coat with white cotton daisy embroidery, c. 1895. *Springhill Costume Collection:* © *National Trust. Photography by Michael McKinley.*

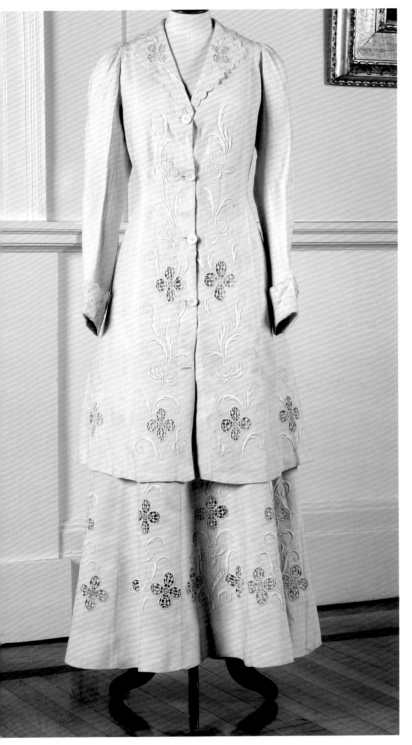

elegance in what has been described as one long Edwardian summer. Keeping up appearances to be considered "respectable" was not easy; it had to be maintained at home, on shipboard, and while traveling abroad. Linen might be fashionable and washable, but keeping it white and crisp-looking was not easy. Many reasonably fashionable women of all classes complained about the effort and expense required to maintain the number of costumes for the requisite number of changes during the day; a new and expensive hat, some of which were fashioned out of linen or lined in linen, had to be purchased to go with every costume; and a lady's maid was necessary to attend to the cleaning and repairing of a wardrobe. These costs taxed the purse of many fathers of upper-class daughters hoping to make good marriages and husbands with status-conscious wives.

Edwardian Linen Is an Outer Layer

The use of linen in the Edwardian era changed dramatically. Whereas previously it had been the mainstay for ladies' undergarments, Edwardian women preferred the luxury of lace, silk, and chiffon next to the skin. Linen did not go out of style; it became an exterior garment. Fashionable walking suits were made of linen, which was strong and durable but also pretty and stylish. Children's linen coats, likewise durable, sometimes featured embroidered decoration to make them more stylish. Embroidery also decorated linen parasols, an indispensable accessory for elegant Edwardian women. When automobiles were the rage, women wore linen "motoring" coats and hats. To protect hairstyles from road dust and dirt, women favored sturdy linen hats that were colorfully embroidered and sported long silk ribbons to hold them in place. Overall, however, Edwardian high society was too elitist to survive World War I and the rapidly changing roles for women. Fashions

Edwardian-style full-length skirt and longer-length jacket with scalloped-edged revere collar, c. 1908. The costume is made of white linen with same-color raised hand embroidery (probably cotton). Cutwork, drawn-thread work, and needle weaving make up the repeat decoration of flowers with curling stems and leaves on the skirt and jacket. *Courtesy of Irish Linen Centre and Lisburn Museum. Photography by David Pauley, Belfast.*

were elegant and feminine, but society was turning toward practicality, not elaborate afternoon dresses with flowing trains and cinched waistlines that contorted the physique.

Irish Linen Is a National Symbol in Fashion

In the eighteenth century, patriots began to recommend the wearing of Irish fabrics as a gesture of nationalism or as a support for home industries. In the nineteenth century, linen and poplin,[15] in particular, became fashionable, often made up into dresses that were further embellished with Irish lace or nationalistic embroidery such as shamrocks. Indeed, Celtic Revival embroidery designs inspired by illustrations in the Book of Kells were found on linen clothing and accessories beginning in the early 1880s. Late-nineteenth- and early-twentieth-century examples of linen dress in Ireland could range in formality from a linen outfit embroidered with brown Tussore silk thread worn at a viceregal garden party in 1886 to a linen tea gown with fine needlepoint lace insertions of 1895.[16] Loosely fitted linen gowns were linked with the artistic dress associated with the Arts and Crafts movement, and wearing medium and heavier weights of linen retained an "arty" overtone well into the twentieth century.

Light and Cool for the Summer

Lighter weights of linen appeared in so-called petticoat dresses and blouses of the early twentieth century, a fashion not confined to Ireland. These embroidered white linen or cotton dresses and blouses made an attractive choice for summer. During this time, blouses worn with skirts and matching jackets were becoming the outfit of choice for working women. Natural linen was used for summer coats, and colored linen was often used for informal summer dresses, sometimes called seaside dresses, which were popular before World War I.[17] From the 1920s through the 1940s, linen was not a major fashion fabric, but by no means was it unused. Linen summer dresses and blouses were widely stocked in stores, and many homemade dresses were adorned with colorful embroidery, a legacy of the art needlework movement.[18]

In 1947, after the austerity of the war and postwar years, Christian Dior's New Look—glamorous and feminine—was launched, and the 1950s Paris couturiers were at the height of their powers and skills. In constant competition with each other, they searched for new and original materials. Many designers looked to Ireland, where a new generation of talented fashion designers were revisiting the possibilities of using all native fabrics and handwork. Fabrics demanded by new designers forced Irish fabric industries to refine and develop their alternative fabrics to meet the demands of the fashion industry. In addition, lace-making centers such as Carrickmacross were encouraged to produce new designs and to provide the lace in colors.

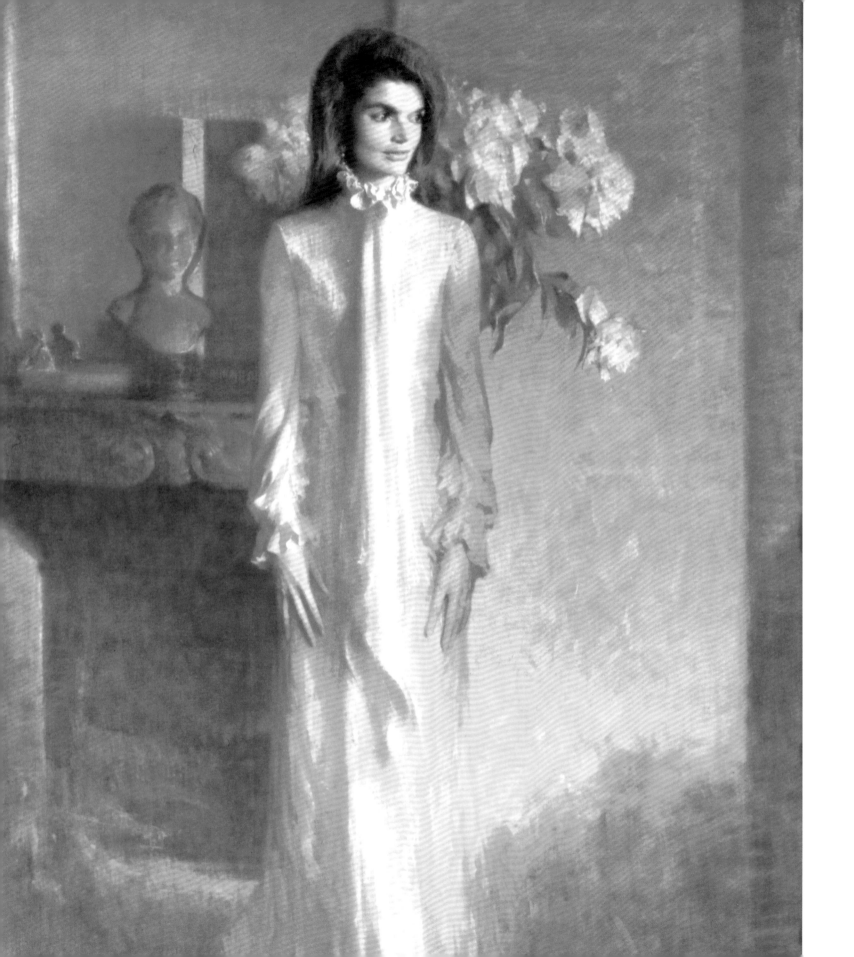

The most internationally known designer of this group was Sybil Connolly (1921–98). She developed a thriving market for her designs in the United States, where Irish fabrics were entirely suitable for current fashion trends and appealed to Americans who had an abiding interest in the home of their ancestors. Members of the American press noticed Connolly's designs at her first major show in Dunsany Castle in 1953, and over the next few years, she was profiled in *Time* magazine and her designs appeared in *Vogue* and *Harper's Bazaar* and on the cover of *Life* magazine. By 1957, she had established Sybil Connolly Inc. with workrooms in a magnificent Georgian house on Merrion Square in Dublin that also served as her personal residence.

Connolly created her collections based on traditional Irish heritage, using hooded cloaks, Clones lace (crochet) blouses, black shawls, and simple riding habits for her daywear. She also designed elegant ruffled evening gowns and a ball gown made entirely out of men's Irish linen handkerchiefs. Jacqueline Kennedy favored Connolly's handkerchief linen nightgowns, hand embroidered with flowers and tiny tucks. She wore a soft, flowing linen gown designed by Connolly for her official White House portrait painted by Aaron Shikler. Connolly's other notable clients included Merle Oberon, Elizabeth Taylor, and Fred Astaire.

Irish laces and crochet (see chapter 6), locally woven tweeds, and flannels were all used for Connolly's designs, but the fabric she will always be associated with is pleated Irish linen. Connolly used nine yards of fine handkerchief-weight Irish linen to produce one yard of hand-pleated fabric. The pleating was done secretly to prevent anyone from copying her process. The fabric was tacked onto taffeta lining material; narrow piped seams helped keep the pleated widths in shape. The end product was a fabric virtually crushproof and very lightweight, yet it still had body. Connolly dyed the fabric in rich, strong shades of wine and deep marine blue, as well as black, colors flattering to her designs for elegant, simple, and gracious evening gowns, cocktail dresses, and skirts. The fabric was magnificent and always the focal point of any costume where it was used. In white, the pleated linen was equally spectacular for a wedding gown. It is not surprising that many of Connolly's regular customers kept the pleated garments for years, returning them to her workrooms only for alterations. Sybil Connolly personally and professionally appreciated Ireland's heritage of beautiful crafts and fine workmanship; her legacy lives on through her books on Irish gardens, home interiors, and designs for wall coverings, clocks, and fabrics, as well as crystal, china, and pottery she designed for Tiffany and Company.

Facing page: Jacqueline Kennedy Onassis's official White House portrait by Aaron Shikler, 1970. The pleated linen dress she is wearing is by Irish designer Sybil Connolly. *Courtesy of the White House Historical Association (White House Collection).*

Native Irish Fabrics in Fashion

Irish designers Irene Gilbert, famous for handwoven fabrics, and Neilli Mulcahy used native Irish fabrics including linen in haute couture, as did Digby Morton, a film designer in Hollywood during World War I and vice president of Hathaway Shirt Company (1955–58). Parisian designers used Irish linen to make crisp

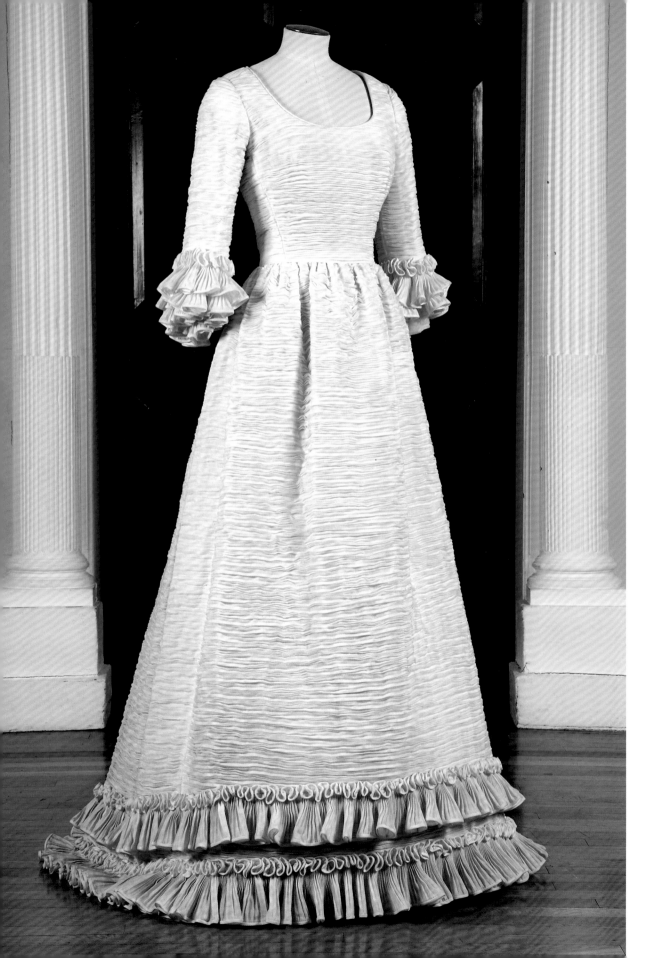

Pleated linen wedding gown designed
for an American client by Irish coutu-
rier Sybil Connolly, 1965. The gown is
made with fine cambric linen woven
by Spence Bryson, county Armagh.
The linen was hand pleated and con-
structed at Connolly's couture house
in Dublin. *Courtesy of Irish Linen Centre
and Lisburn Museum. Photography by David
Pauley, Belfast.*

day outfits and embroidered evening dresses. Christian Dior Couture, for example, fashioned a cream-colored linen suit with matching hat, and Balenciaga produced fine linen evening dresses.[19]

Fashion collections for the autumn/winter season tend to have a more specific design *look* than spring/summer styles do. Linen is indisputably a summer fabric, and its impact is thereby lessened for other seasons, but it is used in limited amounts in haute couture and department store fashions. In menswear, linen has been seen in both contemporary and conservative styling; linen and linen blends are associated with the unstructured Italian tailoring of designers such as Giorgio Armani and Prada. In London, Irish linen has maintained a cachet with tailoring establishments that are more conservative, and a good-quality linen jacket, creased or not, is always admired.

By the mid-1960s, lifestyles and technological developments had begun to change the face of fashion. Moygashel Ltd. of county Tyrone was especially well known for manufacturing crease-resistant linen suitable for the simply cut shift dresses and loose coats that became popular in the late 1950s and early 1960s, forerunners of the youthful styles associated with the 1960s. Cheap, man-made, easy-care fabrics in limited use at midcentury became available in much greater variety; styles were simple and mass-produced; and the cost of clothes fell dramatically. The new synthetic fabrics were uncomfortable because they did not breathe, but they also did not crease, they dried very quickly, and they needed little or no ironing—a bonus for the many women who were working outside the home. In the fashion world, linen enjoyed renewed acclaim when a printed linen and mesh dress by John Bates (aka Jean Varon) received the prestigious Dress of the Year award from the Fashion Museum in Bath, England, in 1965.[20]

Irish Designers Make a Splash

By the mid-1970s, recession had followed the buoyant, optimistic 1960s era, and there was a backlash to 1960s values. Fashion turned back to natural fabrics, reflecting a new concern for the planet and its resources. Once again, distinctive Irish fabrics were in tune with international fashion. By the early

Young man's jacket (part of a suit) in unbleached linen, c. 1830. *Courtesy of Irish Linen Centre and Lisburn Museum.*

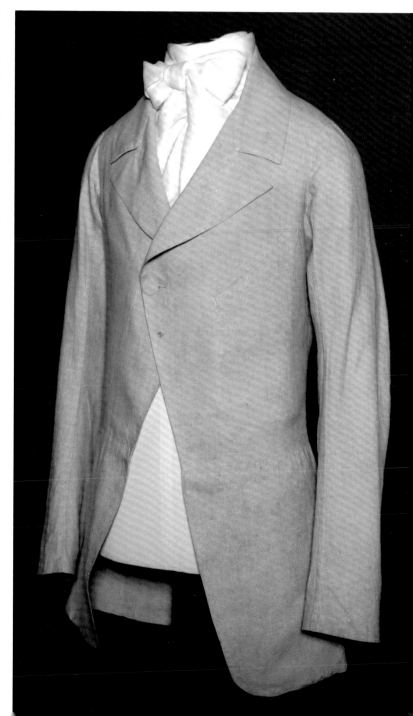

1980s, the next generation of Irish designers had entered the international picture, using native fabrics to give their designs instant individuality. Paul Costelloe, John Rocha, and Lainey Keogh all used Irish tweeds, linen, and knitwear in their collections. Flamboyant Irish couture milliner Philip Treacy (b. 1969) creates artistic fashions for the head that are far beyond the little pillbox hat worn by Jacqueline Kennedy during her days in the White House. Based in London, Treacy designs hats worn by royalty, rock stars, and film stars that are more costume and intrigue than chapeau. For example, Treacy created a brilliant feathered hat for Sarah Jessica Parker to wear at the opening of her movie, *Sex in the City*, in 2008.

Paul Costelloe was born in Dublin and returned to his native city to establish his own label in 1979. Since then, he has shown his collections twice a year in London, Paris, New York, and Milan during Fashion Week, and he also supported the emerging Dublin Fashion Week. Costelloe's emphasis on traditional crisp linens and tweeds has become his signature trademark and evidence of his philosophy that real women, not just wafer-thin models, should wear his designs. He received international acclaim when Princess Diana started wearing Paul Costelloe designs.

John Rocha was born in Hong Kong and trained in London in the 1970s. He used linen in his graduate collection, and the fabric inspired a visit to Ireland. In the 1980s, he moved to Dublin, where he lived for more than twenty years. Rocha has created beautifully constructed fashions decorated with hand knitting and crochet lace to give his designs special and eclectic appeal.

Knitting with Linen Yarn

As a knitting yarn, linen has a solidity that counteracts its tendency to crease. It can be combined with other yarns or used on its own. Several Irish designers have used linen effectively as a knitting yarn. In the 1970s, Cyril Cullen was one of the first to use linen, and in the 1980s, most of the well-known Irish knitwear designers, such as Lainey Keogh, Edel McBride, and Lyn-Mar, used linen yarns. Lainey Keogh, born in 1957,

spent her childhood on a farm outside Dublin and began her career hand knitting garments for friends. In the late 1980s, Marianne Gunn O'Connor, owner of Dublin's Otokia Boutique, served as Keogh's agent, heralding the beginning of her transition from homespun knitwear maker to international designer.

One of the most consistent patrons of linen yarn has been Maggie Jackson of Maggiknits Inc. Maggie was raised in county Antrim on a farm outside Lisburn, a town rich in linen-making history and part of the linen triangle famous for weaving the finest damask. As a six-year-old, Maggie learned to knit by watching the quick movements of her mother's knitting needles. She was an expert by twelve years old, when she began to create her own patterns and designs. Maggie studied fashion at the Ulster Polytechnic in the early 1970s: it became the University of Ulster in 1984 when the Polytechnic merged with the New University of Ulster. Jackson's professional career blossomed as she combined the design of ready-to-wear fashion with knitwear creations. Her entrepreneurial savvy and unique styles propelled her to international recognition. In the twenty-first century, the knitting industry as a whole was rejuvenated with the development of unusual blends of synthetic and natural yarn fibers in imaginative colors and combinations and readily available to home knitters.[21]

Asian Designers and Irish Linen

The layered, easy feel of some Irish fashion knitwear also owes much to the proportions and aesthetics of Japanese designs. An important revival of Irish linen as a fashion fabric came from Japanese designers who came on the Western European fashion scene in the early 1980s. Young Japanese designers looked to their own country for inspiration and concentrated on the clothing styles of the peasantry, using plain, untreated cottons and wools, rather than the silks of the aristocracy. Plain or complex layered outfits were made to fit loosely on the body. This concept of design was the antithesis of Parisian thought, but when Japanese designers such as Rei Kawakubo, Issey Miyake, Kenzo, and Yohji Yamamoto arrived in Paris, the fusion of ideas proved stimulating and fruitful to both sides. Crucially, the idea that a fabric should be left in its natural state meant that the creasing properties of linen ceased to be seen as a flaw, its virtues of beauty and comfort were appreciated, and it was again widely used as a garment fabric for both men's and women's wear.

Linen Mixed with Lycra

Combining the beauty of natural fibers such as linen with the easy maintenance of man-made fibers to weave into cloth was developed during the last decades of the twentieth century. In Ireland, a great deal of effort went into blending linen with Lycra to produce a fabric that has all the good qualities of linen but does not crease. Lycra, an elastic yarn with stretch and recovery properties, was invented in 1959 and used in

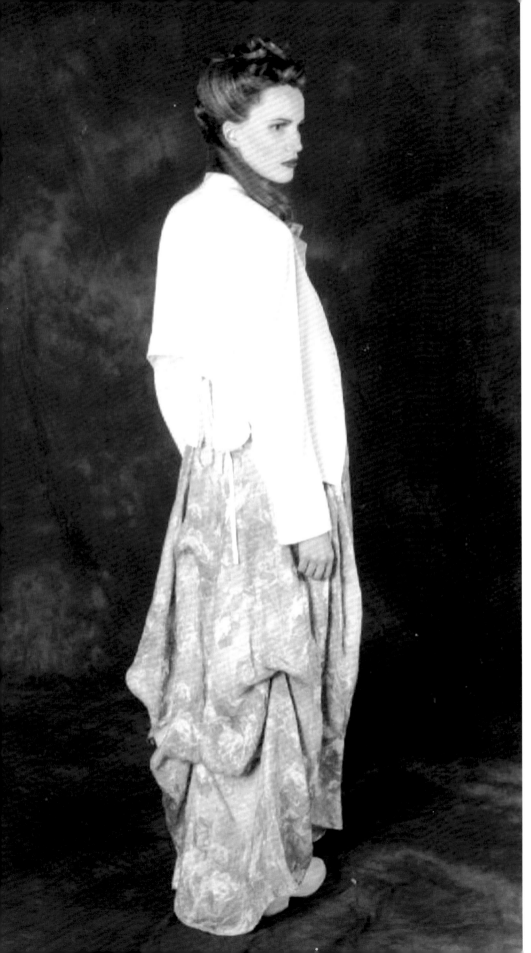

exercise wear, but it was not used extensively as a fashion fabric until the 1980s. When Lycra was combined with wool and cotton, it enhanced the fit and comfort of clothing made of these materials, but combining linen with Lycra was more problematic. A collaborative effort between the Irish linen industry (William Ross, Ulster Weavers, and John England Textiles Ltd.), DuPont, the University of Ulster, the Industrial Development Board, and the Industrial Research and Technology Unit (IRTU) successfully combined linen and Lycra yarns in 2002. Irish Linen plus Lycra was debuted at Premiere Vision, the international fabric fair in Paris the same year. As a fashion fabric, Irish Linen plus Lycra offered comfortable stretch and recovery qualities and exhibited minimum creasing yet still maintained the look of linen to allow innovative surface treatment and printing. It was also suitable as an upholstery fabric.[22]

In the twenty-first century, few international designers failed to use linen in their collections. Perhaps as a sign of national identity in an increasingly undefined global market, Irish designers continued to use some linen for classic, simple daywear; the younger generation was more experimental. American designers such as Ralph Lauren and Perry Ellis, whose work reflects nonurban values, use a good deal of linen, as do all the key Japanese designers. Belgium has a strong linen tradition, and designers from that country such as Dries van Noten, Ann Demeulemeester, and Martin Margiela also feature linen in their work.

Irish linen used for a two-piece dress, jacket, and shoes by Belgian fashion designer Ann Demeulemeester, 1994.
© *National Museums Northern Ireland 2011. Collection Ulster Museum.*

Linen has played an important role for men and women through the centuries as they decided what garment to wear for every occasion, day and night, work and leisure. Particularly in the Victorian era, a wealthy woman's day was governed by etiquette rules that demanded endless wardrobe changes. There was morning and mourning dress, walking dress, town dress, visiting dress, receiving visitors dress, traveling dress, shooting dress, golf dress, seaside dress, swimming costume, races dress, concert dress, opera dress, dinner dress, and ball dress. And the fabric and style of each changed with the season. During the first half of the twentieth century, most Americans and Europeans adhered to a code of dress deemed acceptable to social mores in society; it was a more relaxed etiquette, but urban and churchgoing women were still expected to wear hats and gloves, as were women dining out. Stockings covered bare legs, and slacks or pants for women were the exception rather than the rule. Businessmen were expected to wear a jacket and tie to work, and women wore dresses, suits, and evening gowns for a night at the ballet or opera. In 1962, women wearing slacks, culottes, or any type of full-length divided skirt, regardless of the fabric or formal design of the outfit, were banned from many hotels and restaurants, including New York City's famous Drake Room restaurant, located in the Drake Hotel.[23] Fifty years later, men and women in blue jeans and t-shirts are accepted in every restaurant, hotel lobby, and theater and on every mode of transportation. The huge increase in global travel is one of the factors that has maintained linen's popularity—for women, wide linen trousers and a loose-fitting top has become one of the new uniforms for summer attire and travel. Wrinkled, unbleached linen is as acceptable in twenty-first-century fashion as starched, white linen was required and desirable a century ago.

In the world of fashion, image is as important as substance. The physical and visual attributes of linen are important, but so are its associations with tradition, Ireland, unspoiled nature, freshness, summer, the countryside, open spaces, simplicity, quality—the list could go on. No other fabric has resonances that are so strong and so popularly perceived; the word *linen* has been used as the name for everything from perfume to soap and candles. When designers want to emphasize these values in their collections, they use Irish linen.

Chapter 9

Bright White and Crisply Starched

the linen shirt

TRANSATLANTIC CONNECTIONS between the town of Derry/Londonderry and North America have been tightly woven for the past four hundred years.[1] Through the port of Derry, emigrants left by the thousands, and flaxseed was often the return cargo. People and goods moved back and forth, making some people rich and giving others an opportunity to start anew. In 1767, Derry merchants owned sixty-seven vessels that mainly crossed the Atlantic, while side trips to Norway, England, the West Indies, or elsewhere represented a financial bonus to owners. The net profit to a ship owner from one emigrant voyage is estimated to have covered one-fifth of the construction cost of a 300-ton vessel. Fortunes could be, and were, made from transporting emigrants across the Atlantic, a fact not overlooked by Derry men. Derry merchant William Caldwell, for example, owned shares in sixteen Philadelphia vessels, and Samuel Carson of nearby Strabane (county Tyrone) owned shares in twenty Philadelphia ships.[2]

In 1791, a new bridge linking the city with the opposite bank of the River Foyle was built to move shipping into Derry's harbor. The swinging span bridge replaced an inadequate ferry service across the river and allowed increasingly important upstream navigation to continue. The wooden bridge was built by Lemuel Cox of Boston, Massachusetts, with timber brought from North America, a cargo that had become a significant element in the city's large trade with the United States and Canada. It was another ripple in the endless movement across the sea.[3]

Facing page: Top button on the Edwardian linen jacket shown in chapter 8. *Courtesy of Irish Linen Centre and Lisburn Museum. Photography by David Pauley, Belfast.*

195

The town of Derry had been part of the linen industry since the eighteenth century, with its hand-spun yarn representing half of Ireland's export in most years between 1740 and 1775 and nearly half from then until 1790. Derry-spun yarn was mainly used as warp yarn by the growing cotton industry in Lancashire, England. Mechanization for spinning cotton provided cheap cotton wefts for weavers, but the stronger hand-spun linen yarn was still required for warps. Over the next twenty years, new technology developed for warping all yarns, and Lancashire no longer needed hand-spun linen yarn on a large scale, causing sales of Derry-spun yarn to plummet after 1790. English and Scottish companies weaving with linen continued to purchase yarn from Derry but in substantially smaller amounts.[4]

Competition from cheap cotton cloth became a serious problem for linen manufacturers, and many firms across Ireland switched to cotton production to survive. Other linen producers in Belfast and the northeastern counties survived the depression caused by increased cotton production by weaving very fine quality linen for a specialty niche in the marketplace. By 1800, Derry had partly compensated for lost revenue by weaving more yarn at home and increasing exports of coarser varieties of linen cloth for slave clothing to the West Indies; supplying these markets forced weaving manufacturers to make a major investment in looms and other equipment.

Hand-spinning flax, as an industry, survived longer in northwestern Ireland despite the 1828 invention of wet spinning, which substantially reduced the price of machine-spun yarn compared to the cost of hand spinning. Independent weavers in the region who grew and harvested their own flax continued to provide work for some hand spinners, but as a whole, the linen industry in the northwest went into a severe decline in the 1830s and the majority of hand spinners were without work.

Families who had no work as hand spinners or as handweavers of the coarser types of linen cloth had two choices for survival: emigrate or develop agricultural produce for export. Many thousands of Irish citizens chose emigration. Rural families living close to port towns and cities knew of alternative employment abroad.[5] If a weaver had to abandon his farm and work for wages, he could expect higher pay in America or Glasgow, Scotland, and travel to Glasgow by steamer did not take much longer than traveling across Ireland. In 1841, there were 44,000 babies born to Irish mothers in Glasgow and another 10,000 in the Scottish towns of Paisley (famous for woven woolen shawls) and Dundee (known for its well-paid, well-respected weavers of fine cloth). Across Scotland, there was a demand for textile workers, and Irish weavers left their homeland in droves to fill the demand. Additionally, there was a constant movement of seasonal workers from county Donegal and county Londonderry to Great Britain, as men brought back news of employment opportunities there.[6]

The United States also sought workers for its growing clothing industry, and Irish immigrants initially dominated the clothing trade in New York City. Between 1832 and 1842, over a fifth of Ireland's transatlantic emigrants sailed from the port of Derry. At the same time, New England's textile industry was growing at a rapid pace, but the preference there was to use cotton rather than linen yarn. As the need for textile work-

ers increased, skilled Irish weavers and spinners found ready employment and new opportunities to better themselves. America's gain was Ireland's loss; the emigration of independent weavers substantially weakened the textile industry throughout Ireland.

Emigrants from Derry arriving in North America were anything but paupers. In 1826, they were reputed to have more capital at their disposal than emigrants from other parts of Ireland; they were better able to afford higher fares to Philadelphia and New York, rather than having to book cheaper passages on the more crowded ships that landed in the Canadian ports of Saint John (New Brunswick) or Quebec after 1816.[7]

Emigration also significantly affected the working population of northwestern Ireland before the famine years. In 1832, 7,643 passengers officially embarked in Derry alone, but an additional thousand or more may have made the crossing, because a child was counted as a half passenger. More than 20,000 emigrated from the port of Derry during the three years of 1831–34: this is 80 percent of those who left in the famine years (1846–48). During the emigrant season, approximately 50–100 passengers boarded the Derry steamer to Liverpool each week, most of them hoping to embark there for America. Similarly, around 4,000 emigrated from county Sligo in 1832, draining the population from the western linen districts in the counties of Donegal, Leitrim, and Cavan. Emigrants from the western counties also left from Belfast, increasing the loss of linen workers.[8]

If Not Emigration, How to Survive

The main alternative to emigration was agriculture. Regular steamship services between Derry and Great Britain after 1830 opened up many new opportunities for entrepreneurs in agriculture. Eggs proved to be a valuable new export, and women primarily ran the egg industry. In 1836, dozens of dealers in Derry were gathering eggs across the county, and in a good week, £2,000 worth of eggs were shipped out of the country. At that rate, egg earnings could replace the yarn revenue of 30,000 hand spinners—more than all the spinners in county Londonderry. In local markets, women got more from the sale of a dozen eggs than from a full day's work at their spinning wheels. Egg production quadrupled in the early 1830s in the parish of Clondermot, outside Derry. The egg business was considered a good substitute for linen income in towns such as Donegal (county Donegal).[9]

Egg exports, practically nonexistent until steamers provided a guaranteed and rapid means of transportation, continued to grow and became one of the most profitable exports from northwestern Ireland for the next hundred years. As the egg business grew and prospered, linen production dwindled. The handweavers' days of glory and prestigious social status had passed. Handloom weavers' accounts in the 1830s describe their craft as having been ruined over the previous two decades and present themselves as having been reduced from respectability to destitution. In reality, linen fabric continued to be handwoven for at least another two decades, but on a much reduced scale.[10]

The expression *white-collar crime* comes from a time in history when men wearing white linen shirts were seen as prosperous professionals of social standing. A man with a clean white collar and cuffs was not a laborer; he was a man with enough wealth to permit him the luxury of changing his shirt's detachable collar and cuffs at least daily and probably more often between weekly washdays. Today, anyone convicted of a white-collar crime is usually an educated person involved in illegal financial dealings rather than a violent crime. The expression is so commonplace that a criminal investigative association in Richmond, Virginia, is named the National White Collar Crime Center, and in 2009, a national television series, *White Collar*, began.

Children worked long hours in factories and mills until child labor laws banned the employment of very young children. Small hands and bodies maneuvered around adult weavers without taking up much space. Adept little fingers could remove an empty bobbin from a shuttle and replace it with a full one in the blink of an eye, losing no production time. Children also served as runners in the mills, moving quickly from one department to another, delivering verbal messages and written reports to foremen and office personnel. These children had access to all parts of the building, whereas adults worked at a specific task in an assigned department. Today, we comment that someone has the *run of the mill*, meaning that they are not specialized but quite average; we do not realize that the statement refers to a way of life before the introduction of communication by telephone, fax, and e-mail.

In 1386, Chaucer referred to an outer garment as a *slop*. Thereafter, the word was used to describe a loose-fitting shirt, jacket, tunic, cassock, mantle, gown, or smock-frock. In the fifteenth century, when shoes were made to fit either foot, *slop* was also used for footwear. Over the centuries, *slop* began to describe baggy pants or loose-fitting trousers, and the plural, *slops*, was the name for all shirts not custom made. By the nineteenth century, *sloppy* had become the more familiar form of the word; it continues to be used in contemporary language to mean oversized or rumpled clothing, unkempt personal habits, or untidy spaces.

The Derry Shirt Industry

Historically, shirt making was considered a division of the overall linen industry, but in Derry, a new shirt industry developed out of the earlier era of hand spinning and weaving that had very little connection to the linen industry in the rest of Ireland. The emergence of the shirt-making industry in Derry in the mid-nineteenth century involved a distinct design discipline of clothing manufacture and a separate industry, financially independent of the fabric manufacturers and spinners further up the supply chain.

In the space of fifty years, the shirt industry in county Londonderry grew from virtual nonexistence to become the largest center of the shirt industry in Great Britain and a major exporter across the world. The demand for shirts made in Derry—usually embroidered with decorative stitching on the front, collar,

When Joseph Brady (1828–1908) left Ireland and immigrated to Australia in 1850, he took an Irish linen shirt that had been hand stitched for his twenty-first birthday. The square-cut, voluminous shirt with a short stand-up collar is long sleeved and has white shell buttons to fasten the cuffs. Narrow pin-tucking and delicate braiding embroidery decorate the front yoke, which has button-holes to accommodate shirt studs. To commemorate his departure, "Christmas 1849, Joseph Brady" was written in brown ink on the lower left side of the shirt. In 1854, Brady married Adelaide Sarah Keck—daughter of Henry Keck, the first governor (warden) of Darlinghurst Gaol (prison), built near Sydney—and the couple had seven children. Having worked on many Australian railway and water projects (including Bendigo Waterworks, Brisbane-Dalby Railway, and the port of Melbourne), Joseph Brady is considered one of Australia's most accomplished nineteenth-century civil engineers. *Courtesy of the Collection (00608211), Powerhouse Museum, Sydney, Australia.*

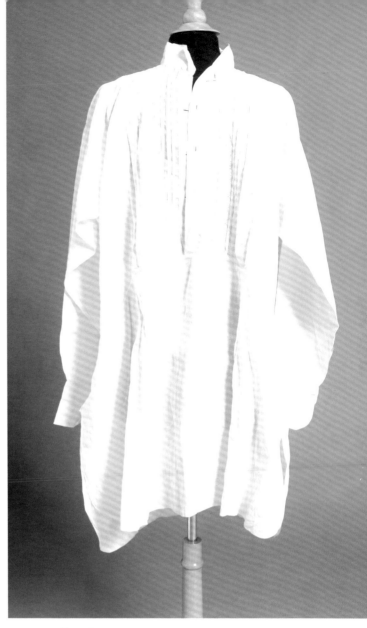

and cuffs—was so great that in 1860, the town of Derry had fourteen shirt factories shipping an estimated 100,000 shirts each week from the city docks. The shirt industry provided income for an additional fifteen thousand women outworkers who embroidered and assembled the shirts. Women constituted the vast majority of the workforce, both in factories and as pieceworkers.[11]

A Man with a Vision

William Scott, considered the founder of the Derry shirt-making industry, was a direct link between the old linen industry in northwestern Ireland and the new shirt-making industry that emerged in the mid-nineteenth century. The son of an old local family, he began his career as a linen weaver in 1790. Forty-five years later, he was the last independent weaver in Derry. The great era of linen in the thirty years before 1813 had been replaced by twenty years of gloom, and capitalists prepared to invest in steamships, railways, and land reclamation—not textiles. In the mid-1830s, large spinning mills were operating at full capacity across the island, particularly in Belfast, and it was not considered profitable for a businessman to start a new mill in Derry. Scott was determined to manufacture a new style of shirt, however, and would not be discouraged by his contemporaries. In the 1830s, he created his own small factory employing six weavers in the city, and in the next decade, he was affiliated with a much larger factory at Castlefin (county Donegal), where 250 workers wove cotton as well as linen fabric. Meanwhile, Scott had experimented with manufacturing a new style of shirt for a merchant house in Scotland and even exported some garments to Australia. He designed a shirt with a linen front, a detachable linen collar and cuffs, and a cotton body—a formula that ultimately became eminently desirable and highly profitable.

By 1840, Scott had gained a major presence in the shirt business. His weavers produced the fabric he needed, cutters in his establishment designed and prepared the shirt pieces, and hemming and sewing was done in individual households in the vicinity. In 1845, Scott employed five hundred people in various locations within a thirty-mile radius of Derry, producing two hundred dozen shirts per week.[12]

Sized to Fit

Before factory-made shirts were available, a man had two choices for owning a shirt: those who could afford the price had a tailor sew a custom-fitted shirt, and everyone else made do with large, square, one-size-fits-all garments referred to as *slops.* From the lowliest peasant to the highest nobility, men wore shirts that were generally made of durable, versatile, and comfortable linen. Social standing was reflected by the fineness of the thread and the whiteness of the color. Because linen had to be bleached repeatedly to maintain its snow-white color, the whiter the shirt the more expensive it was. A gentleman had to have one to two dozen shirts to last from one laundry day to the next, and because of the strain of laundering, shirts did not last long. Until the nineteenth century, the fabric of a man's voluminous linen shirt was square cut, with side vents and full sleeves.[13] For the gentlemen's custom-made (or bespoke) shirt, a tailor took as many as thirty measurements at the neck, front, and back, across the shoulders, down the arms, around the wrists, over the hips, and at the waist to construct a perfectly fitted shirt. When Scott decided to mass-produce a quality shirt that would appeal to a broad segment of the population, including the middle classes, his products had to fit the various sizes and shapes of the human frame significantly better than the one-size slops.

A table of uniform sizes was established once anthropometric studies in the United States at midcentury demonstrated that certain body types existed and could be categorized; this discovery led the way to mass-produced garments acceptable to the discerning customer. Mid-nineteenth-century shirt makers in Derry determined the destiny of the shirt industry by establishing a fashion standard for ready-to-wear that embraced quality and design excellence, producing affordably priced shirts available to the middle classes that fit individual body types. The resulting prosperity lasted for a quarter of a century.[14]

Factory Work for Women

Women were employed in two distinctly separate but equally important divisions of the shirt industry: factory workers and outworkers. Most females who went to work in shirt factories were young girls who did not come from a background of hand spinning for linen factories. The shirt industry developed its own generation of workers—women and girls who learned to sew by attending schools that had originally been

established to teach stitching skills for the decorative embroidery work that was applied to factory-made cotton sheets and pillowcases produced in great quantities across Ireland. In 1851, more than thirteen thousand women and girls were employed as outworkers for the Irish cotton industry in county Donegal; this was the largest number outside county Down, famous for its skilled embroideresses. Embroiderers/sewers of muslin throughout Ireland were usually young (a large percentage under the age of fifteen), and this was a ready supply of female labor for the shirt factory to utilize.[15]

Parceling Out the Work

Shirt making was only partly completed in factories where workers handled pattern making, fabric cutting, straight stitching, and some finishing processes, but until more specialized machines were developed to equal the quality of pieceworkers, much of the garment's final stitching, assembly, and finishing was still done more effectively outside the factory. Scott's putting-out system, the term for giving piecework to individuals working at home, was as applicable to the shirt industry as it had been earlier in the muslin trade in northeastern Ireland, although on a more structured and properly capitalized basis.[16]

Many finishing or warehousing firms employed both homeworkers and outworkers. Although both carried out processes such as embroidery, sewing, and drawn-thread work in their own homes, there was a clear and important distinction between these two groups of employees. A homeworker was employed and paid directly by the manufacturer for whom she worked, whereas outworkers were engaged and retained by agents. In the case of outworkers, the firm agreed on a price with the agent, who paid the women out of the agreed sum; the outworker was not employed directly by the firm, so she had to first satisfy the agent with the quality of her work. Homeworkers were able to collect white-work (unembellished, plain linen cloth) from the warehouse themselves, whereas outworkers relied on agents to distribute the cloth to them and collect the finished product. Outworkers were more commonly found in rural areas, while homeworkers were usually, but not always, based in the same town as their employers.

The distribution of outworking closely followed railway construction. At first oriented toward Limavady, Strabane, and Omagh, trains moved into county Donegal in the last decade of the nineteenth century as light railways were built down the Finn Valley and north through Inishowen to Carndonagh. Shirt manufacturing was labor-intensive, and the cost was always an important consideration when determining profit margin. Outworkers, as a group, became a safety valve for factories; more active when demand was high, less when orders slowed, the work was never steady enough to be a reliable source of income for the outworker. Toward the end of the century, factories considered setting up branches and training schools to meet a rising demand for shirts, but after a downturn in sales after 1900, the impetus to change the status quo was disregarded. In general, there were approximately five outworkers for every factory worker in 1860, around three

per factory worker in the 1880s, and no more than two per factory worker in the first decade of the twentieth century. Derry firms re-equipped their factories with the double-needle machine in the first few years of the twentieth century, a move that greatly increased the output of the factory machine worker and put the out-worker at a severe disadvantage. By 1904, the Singer Sewing Machine Company was making sewing machines with a built-in motor that required no universal belting system. This meant that powered machines could be used in the smallest workshops where electric power was available. In Northern Ireland, 71 percent of clothing factories had their own power systems in 1907, compared to an average of 47 percent of those in the United Kingdom. The putting-out system did not survive the arrival of electricity when clothing manufacture moved totally into factories across the United Kingdom during and after the First World War.[17]

A New Shirt Merchant

Shirt manufacturers were developing a new style of entrepreneurship by 1850 as the industry expanded across Derry. One company, Tillie and Henderson Ltd., described itself as linen merchants as well as shirt manufacturers. The reference to the role as merchants signified an independent status that the company's principals wanted to promote. Unlike the successful shirt-maker Scott, these merchants were not obligated to purchase fabrics from a particular establishment in Glasgow or Manchester; they selected linen, cotton, or woolen cloth from whatever source suited their garment designs. By having control of the supply sources, they maintained design integrity, production quality, and cost.

William Tillie and his associates were men looking to the future, as evidenced by the quality of the buildings they erected and the steam-driven machines they installed to make their product. By the mid-1870s, Tillie and Henderson and associated shirt manufacturers were operating twelve factories, employing over four thousand workers in Derry itself and about fifteen thousand rural outworkers.[18] At a time when wage levels were so low that productivity gains from steam-driven machines were scarcely worth the outlay for their purchase, Tillie believed that both quality and efficiency could be improved by using steam power, and he installed state-of-the-art sewing machines able to do the work of six hand stitchers. He was the first to couple steam power with sewing machines.[19] The technical staff at another firm, McIntyre Hogg Marsh and Company, developed effective steam-driven fabric cutters, making these two Derry firms world leaders for their ingenuity. Shirt factories also established employment practices that were relatively enlightened for the times. They instituted a fifty-one-hour week (nine hours shorter than the linen factories), and work began at eight o'clock rather than six, on the grounds that early starts were unacceptable to Derry women. Factories were well lit, doctors were hired to attend to workers' medical needs, and there were yearly social excursions to the seaside resort towns of Moville (county Donegal) and Portrush (county Antrim). No doubt there was commercial wisdom in the new employee benefits, because jobs for skilled machinery workers soon attracted a female labor supply that met the demands of the growing shirt industry in Derry.[20]

In 1844, Scotsman Peter McIntyre joined his brother-in-law, William Thompson, to establish a shirt whole-saling business with facilities in both Derry and Glasgow. Peter McIntyre moved to Derry permanently in 1850, and in 1855, he formed a new and long-lasting partnership with Adam Hogg. The firm ultimately became McIntyre Hogg Marsh and Company, but the date Marsh joined the partnership is unclear. Hogg was likewise a Scotsman, who had come to Derry as a manager for the shirt manufacturers Tillie and Henderson. McIntyre and Hogg were both experienced men who understood the linen business, and soon they had to use a London warehouse to distribute their shirts more efficiently.[21]

By 1863, Derry's leading shirt manufacturers had come to believe that Derry could become the primary shirt-manufacturing center in the United Kingdom, if not the world. Derry manufacturers successfully took much of the straight stitching (as opposed to fancy stitching) work away from the leading United Kingdom clothing center, in London, and their shirt output of 1860 was not surpassed until the Second World War.[22]

Like other shirt makers, McIntyre and Hogg had most of their fabric cutting and some sewing operations done in their factory on Foyle Street, but most of the other work was parceled out to countless homes and collected weekly from designated out-stations. With the installation of treadle sewing machines in 1857, McIntyre and Hogg wanted to employ more people in one central location, and the original factory was too small to cope with the increased productivity. In 1861, the partners embarked on an ambitious project for a new factory, known as the City Factory. Located in Derry at the corner of Queen and Patrick Streets, the factory was designed by architect Robert Young (1822–1917), who had served his apprenticeship with renowned architect Charles Lanyon,[23] and was built by William McClelland, a local contractor.

Impressing the Clientele

McIntyre and Hogg planned to project a global image to their clientele, so Young designed a huge three-story brick building that was upscale, well designed, and rooted in classical architecture but reflective of the Industrial Revolution. Considering the time and location, an interesting thing about the building was the brick bearing-wall construction with full Flemish bond of one stretcher and one header course that tie the wythes of brick together.[24] The walls, probably two feet thick at the base, were modeled red brick, and the accent trim was a cream-colored brick made from a local vein of clay. The stone entablature was traditional but without the supporting columns normally seen in classical architecture. Sawtooth brick was used in the frieze and as decorative corbelled brick supporting the continuous stone band course between the second and third floors.

One of the most noteworthy features of the structure was the seven keystone heads that supported brick arched windows across the front of the building. In classical architecture, carved keystone figures normally honored mythological gods or biblical figures, but in this case the seven stone carvings honored industry, marketing, and the wide world of commerce. Each head was carved to represent one of the seven continents: Asia, Africa, North America, South America, Antarctica, Europe, and Australia. The keystone over the front entrance may have represented the continent of Europe, but the crown of shamrocks above his curly hair indicated to all who entered the factory of McIntyre Hogg Marsh and Company that the island of Ireland considered itself to be a major player in international commerce.

The City Factory's keystones were also unusual as a feature on a building located on a side street in a primarily residential section of a city. Carved keystone heads were far more commonly used on urban buildings such as imposing private mansions, elegant hotels, government buildings, and linen warehouses—structures intended to impress the visitor, not accommodate masses of factory workers. Buyers came to large linen warehouses to inspect cloth, meet with executive staff, and place orders, so these commercial buildings were often elaborately designed and prominently located to emphasize the global influence of a company and its products.

McIntyre and Hogg shirt factory, Derry, county Londonderry, 2008. *Private collection of the author.*

Keystone sculpture over the entrance to the McIntyre and Hogg shirt factory. The seven keystones across the front of the building represent the seven continents. With a crown of shamrocks, this keystone represents Europe as an Irishman, symbolizing the globalization of Irish linen. *Private collection of the author.*

Derry shirt makers used every advantage at their disposal to manufacture and promote their product in the United Kingdom and abroad—a premier quality, starched white shirt. The chief feature of this perfect shirt was the application of the hand-ironed *Derry finish,* which, its producers claimed, could not be reproduced elsewhere despite the best efforts of factories in Germany, Austria, Australia, and England. Derry's first gasworks was set up in 1825, the same year as the first gasworks in Germany and just thirteen years after the world's first gas company in London. The functioning of gas appliances and burners was being constantly improved during the nineteenth century, and Derry installed the latest gas-fired irons and continued to upgrade to the best gas irons as they became available. Britain produced the first commercially used coal gas, a flammable gaseous fuel made from coal and supplied by pipeline to the user, and it was not until the 1960s that other companies began to produce better gas appliances than British firms. Derry shirt factories were also pioneers in the use of electric lighting; installed in 1886, it assuredly assisted in shirt finishing. The chemical processing of the shirts in their final stages at Ardmore and elsewhere and the quality of starch used also played a part. The crucial difference between the Derry finish and everyone else's shirts was unquestionably the ironing skill of the factory workers. Employers believed that their finishers were the most skilled in the industry, and they paid those employees considerably more than other operatives in the factories, who also earned more than their counterparts in England. From 1880 onward, first-class laundries were established across Derry, some on factory premises, some elsewhere to maintain the high quality on all Derry shirts.[25]

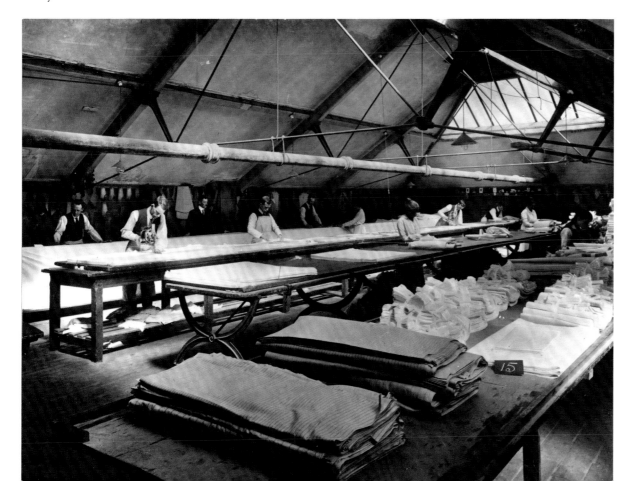

Cutting out material for shirt bodies in the McIntyre and Hogg shirt factory. *Courtesy of Public Records Office, Northern Ireland, Londonderry Shirt Industry (T3231/AE/1).*

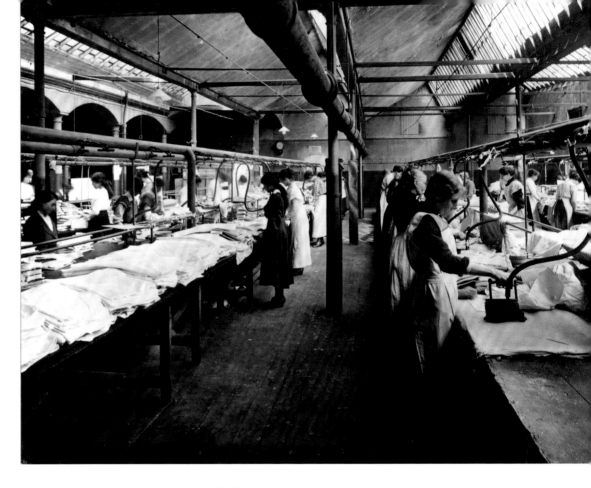

Pressing the cloth in the McIntyre and Hogg shirt factory. *Courtesy of Public Records Office, Northern Ireland, Londonderry Shirt Industry (T3231/AE/2).*

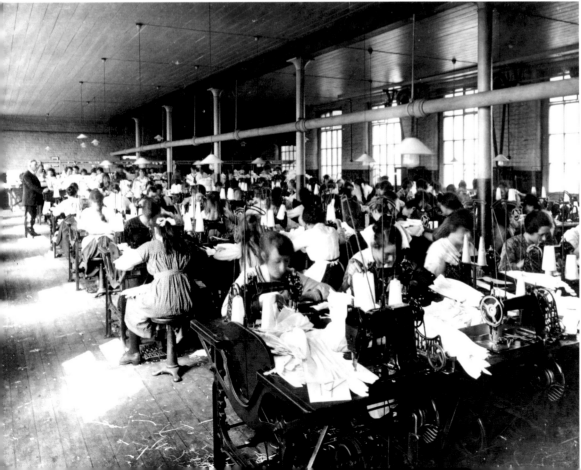

Female stitchers at rows of American-made Singer treadle sewing machines in the McIntyre and Hogg shirt factory. *Courtesy of Public Records Office, Northern Ireland, Londonderry Shirt Industry (T3231/AE/3).*

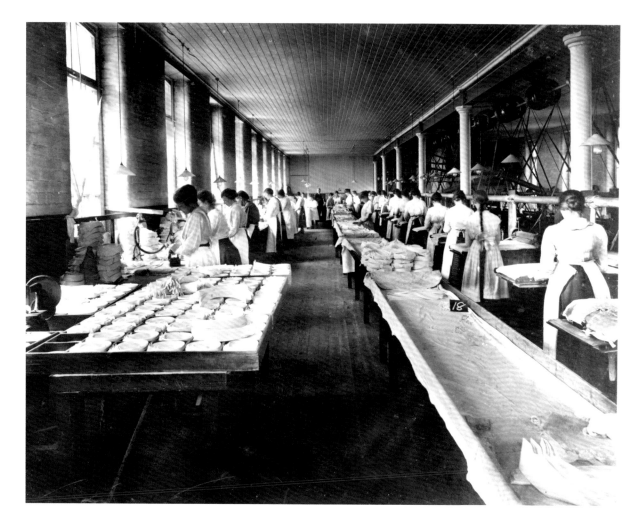

International Sales

City Factory was opened in 1863, and by the 1870s, the firm was employing six hundred workers in the factory and more than two thousand outworkers and homeworkers in Derry and the surrounding area. Shirt sales in the 1870s and 1880s skyrocketed, reinforced by export markets in Australia, South Africa, and the East and West Indies. Listed on the back cover of the illustrated sales brochure for shirts, published in 1891 under the name McIntyre Hogg and Company, were locations where the firm was doing business: factories in Londonderry (Ireland) and in Cheddar and Taunton, Somersetshire (England); the Midland Factory in Manchester; the Commercial Factory in London; bleachworks in Chapelfield, near Glasgow (Scotland); and warehouses in London and Manchester. In 1901, the City Factory building was doubled in size with an addition that filled the entire city block and employed over eight hundred workers.[26]

In 1860, there were nearly as many shirt makers in the American city of Philadelphia as in Derry, and shirts needed for Civil War soldiers increased the demand. The United States instituted high tariff barriers

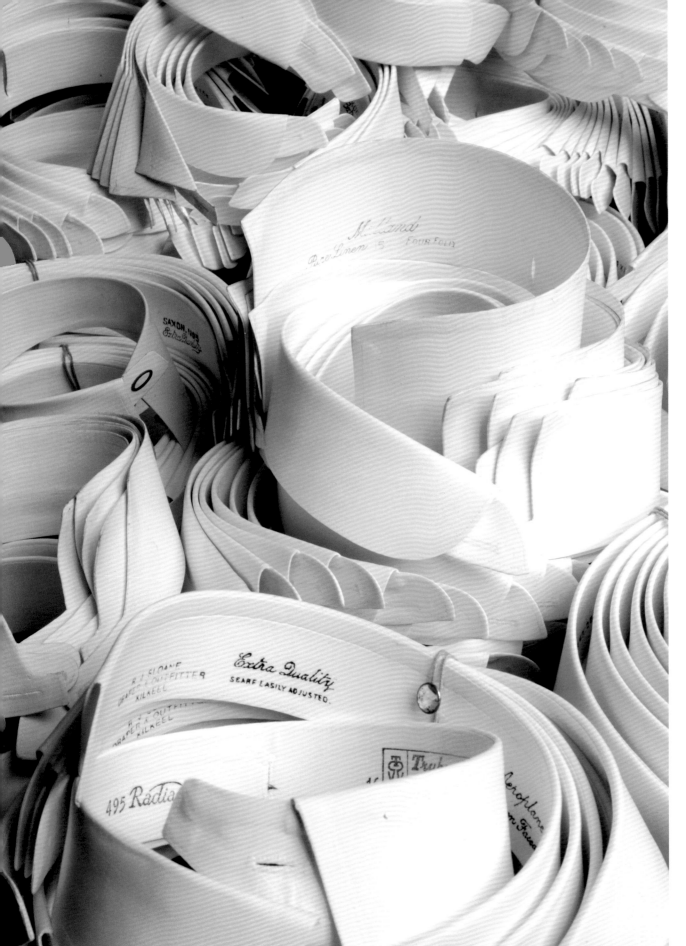

Detachable linen shirt collars from draper and outfitter R. J. Sloane of Kilkeel, county Down, c. 1910–20. © *National Museums Northern Ireland 2011. Collection Ulster Folk & Transport Museum.*

to prevent competition from abroad, a move that hurt sales for Derry shirt makers. During the 1870s, Derry suffered increased competition from London and other large cities located closer to wholesalers and with access to a large, urban female workforce. In response, Derry shirt makers focused on a sector of the market in which their factory methods already had an edge, developing one specific high-quality product—the white shirt with a heavily starched front, cuffs, and collar. The well-known white shirt gained great appeal and became the most demanded clothing item worldwide for middle-class men.

Fashion for the Socially Conscious Man

In the late nineteenth century, upper- and middle-class men were as controlled by fashion etiquette as were women. Both genders had to change clothes to suit various types of social and commercial activity, but men did not have to change their whole shirts, just the collar and cuffs, and there was an extraordinary number of choices available. Shirts came in separate parts that were coordinated and assembled at home by the wearer. The body of the shirt was cotton muslin and simply made; the front panel insert came in a variety of shapes and styles depending on the social event where it would be worn. Each front insertion was identified by a specific name, such as the Donovan, Derby, Victory, Midland, or Great Northern, to name just a few. There were printed versions, and all white inserts were available in various weave patterns. The appropriate collar had to be attached to the front, and McIntyre Hogg Marsh and Company maintained a stock of nearly one hundred different styles listed in the company's 1891 illustrated brochure.[27] Each collar style also had a name—Prince George, Yacht, Aide-de-Camps, Club, Ye Wm. Shakespeare, Tennyson, City of Paris, Oceana, and Chicago (to name only a few)—and each was slightly different in collar height and front closure. Lastly, the company offered thirty-one detachable cuff styles, again, all with individual names.

In general, men wore undershirts, so only collars and cuffs came in direct contact with the skin; as a result, these soiled more readily than the rest of the garment. Detachable collars and cuffs allowed the wearer to wash them individually and more frequently than the whole shirt. Washing was labor intensive and clothing was expensive in the nineteenth century. Very few people could afford the number of garments that the average person owns today. When collars and cuffs frayed from constant wear and washing, a seamstress or family member could unstitch and turn the fabric inside out, then restitch the piece, thereby extending the life of the garment.

Selling a quality product enabled Derry firms to offer workers higher wage rates and better conditions than their counterparts in England, which was unusual for the time. Derry manufacturers did not become the center of shirt making in the world as they hoped, but they did maintain 20 percent of the United Kingdom shirt production from the last quarter of the nineteenth century until the second quarter of the twentieth century. Without matching Hogg's production or Tillie's technical achievement and mammoth factory construction, London usurped Derry's leadership in the manufacture of what was described as "working men's shirts" by parceling out various segments of the operation to small, specialized sweatshops

where low-paid women worked on hand- and treadle-operated sewing machines. Sweatshop labor was prevalent in the clothing industry in textile centers in the northern states in America as well.[28]

Fashion Is Invariably Fickle

William Tillie and colleagues such as Adam Hogg believed that they had found a new manufacturing formula that could conquer markets across the globe. They built imposing industrial monuments that served textile manufacturing for more than a century, but in 1888, they were already talking nostalgically of the days twenty years before, when they earned double their current profits.[29] Additional factories were built in Derry until the tide turned again in 1902; thereafter, Derry began to lose its advantage in design and its previously held determination to keep abreast with modern technology.

By 1930, the advantage that Derry shirt makers had once held as leaders of an industry of innovation and international acumen was gone, because other manufacturers also had electricity, modern equipment, and distribution centers. Moreover, the shirt manufacturers of that period misunderstood the reasons for former greatness: Tillie's vision of technological superiority, not Scott's exploitation of low-cost labor, is what had made Derry's shirt industry great. The shirt trade that had brought worldwide recognition to the city of Derry and had employed nearly half the city's population began to fall behind clothing enterprises based elsewhere in the United Kingdom in terms of efficiency and productivity, and the Derry manufacturers began to lose their market share. The expansive global strategies that Tillie and others had pioneered a century earlier crumbled in the face of sharply increased overseas competition. The onset of The Troubles after 1968, a clash that was particularly violent in Derry, discouraged new investment in Derry's premier industry. Nevertheless, government support encouraged both local and overseas investors to re-equip and redirect the Derry textile industry, resulting in brief but unprecedented growth in response to rapid changes in market demand. Derry shirt manufacturers could not compete with the aggressive marketing of less expensive ready-to-wear shirts with attached collars and cuffs produced by the extremely low cost of labor in Asia and Africa. When the European Union's clothing markets were opened to full, global competition, mass manufacture of clothing products was abandoned in Derry and only a few small-scale, niche producers of shirts and other garments were left.

Linen Shirts: Another Style, Another Country

The starched white shirt so necessary to fashionably dressed European and American men in the nineteenth and twentieth centuries was not the only use for Irish linen in shirt making. In the hot climates of Caribbean and Latin American countries, the lightweight fabric and easy fit of the guayabera shirt made it far more comfortable than the high-necked, tight-collared white shirt worn by Europeans. The origins of the guayabera shirt style are frequently disputed, but the most popular belief is that the shirt was fashioned in central Cuba in the late eighteenth century (although some historians claim that it originated in Spain, Mexico, or the

Philippines). According to common folklore, an affluent farmer discovered a lightweight cotton material on a trip to Havana; he took the material home to his wife and asked her to make a shirt with pockets to hold his belongings. Evidently, the loose-fitting shirt she designed for her husband, with four pockets and side vents for easy fit, appealed to other farmers and workers, who copied the style for their own use. Before long, the shirt was not just a comfortable fashion but a political statement as well, especially during Cuba's fight for independence from Spain in the late 1880s. Initially called *yayabera* after the nearby Yayabo River, the shirt eventually became widely known as the *guayabera* for the *guayaba* (guava) trees that grew locally; today it is also known as the Mexican wedding shirt, Cuban shirt, Havana shirt, barber shirt, and cigar shirt.[30]

Always worn untucked, the open-necked shirt with a flat collar was originally made of cotton or linen with decorative embroidery and narrow vertical pleating on the front and/or back. Ernest Hemingway wore a guayabera in the 1950s while he was living in Cuba, and former U.S. president Jimmy Carter wore a starched, white linen one during his visit to Havana. The fashion was introduced into southern Florida by the many Cuban emigrants who moved there, and over the years, its popularity gained favor with a broader population. The linen material adds a distinct elegance to the styling, and it is a cool fabric to wear against the skin—but the pesky issue of wrinkling remains.[31]

The Casual Shirt and Wrinkle-Free Fabric Take Precedence

In the twenty-first century, the guayabera, or Cuban shirt, has enjoyed a tremendous revival due in part to the more relaxed lifestyle across the United States. Guayaberas are acceptable attire, especially in warm weather, for travel, casual weddings, entertaining, and many work environments. Upscale stores display the shirt in pastel colors, bright exotic prints, and traditional white, all with or without embroidery. Fashion designer Tommy Bahama makes some of the most expensive silk and linen guayaberas, but the shirt is also available in cotton and synthetic blends. In 2009, the 100 percent Irish linen Cuban-style guayabera with long sleeves and elegant French cuffs in white or off-white was still advertised as "our best guayaberas ever" and "perfect for a beach wedding" at an online store (mycubanstore.com) that also sold additional styles of guayaberas in 100 percent cotton and 100 percent Chinese linen.

Today, fabrics of pure linen and linen blends are made into stylish shirts for men and blouses for women, and these are principally popular in the summer months. But the days when a stiff-collared white shirt was a symbol of high social standing for middle-class men are long past. In each decade, there are new objects of desire that indicate wealth and power; it might be an expensive sports car, a designer handbag, or an accessory such as a specific brand of watch. Entrepreneurs in every country in the world are constantly looking for that one special item that customers will aspire to own. The city of Derry, located in the northwest corner of the small island of Ireland, managed to produce a shirt that was such a symbol: made of the most-desired white linen (with a cotton body), these high-quality shirts were coveted by discriminating buyers around the world for decade after decade after decade, a feat not easily attained.

Marketing Irish Linen Worldwide

O N A S T A N D A R D map of the world, the Greenwich Meridian divides the earth into the eastern and western hemisphere, giving the impression that Ireland is at the center of the world. It may not be at the center of the world in any conventional sense of the word, but from 1870 to 1914, Ireland was the undeniable center of linen production worldwide. This position was largely unchallenged not only in terms of sheer scale and output but also in terms of prestige and the quality of the cloth woven and fiber spun. When York Street Flax Spinning Company was the largest linen manufacturing concern in the world, it produced 125,000 miles of linen yarn per day. What makes this all the more remarkable is the fact that when we speak of Ireland, a relatively small country, linen cloth manufacturing was largely concentrated in what has been termed the *Linen Triangle* or *Linen Corridor*, an area roughly located between Belfast, Armagh, and Dungannon.[1]

Through the centuries, sales techniques, marketing strategies, and promotional initiatives were vital to the survival and expansion of Irish linen. Competition from cotton was always a threat, and firms realized that to sell Irish linen, it had to be desired for its exclusivity and fine quality. As the making of linen developed from handwork to industrial labor, the opportunity to honor the past and embrace new technology was a successful approach to selling the product. From color printing technology in the nineteenth century to colorful microfibers in the twentieth century, fabrics and clothing have been sold through creative advertising, name branding, and memorable logos—all ways to make Irish linen desirable to a discriminating clientele.

Facing page: Gold medallion awarded to William Barbour and Sons, International Exhibition, Paris, 1878. *Courtesy of Irish Linen Centre and Lisburn Museum. Photography by David Pauley, Belfast.*

Product branding (with advertising and logos) that identifies a maker, a place, or the merchandise itself is an ongoing challenge in the twenty-first century, just as it was three hundred years ago. Regardless of the quality of any product, whether handmade or mass-produced, branding must somehow connect a maker to a buyer to consummate the transaction. Over the centuries, finding buyers for Irish linen yarn, cloth, thread, and clothing progressed from weavers calling out their wares at a local open-air market to sophisticated sales techniques employed by traveling salesmen, representatives in international offices, telephone communications, and written correspondence.

Spanish billboard advertising Irish linen, c. 1953.

Weave a Logo

Old Bleach was one of the first textile companies to register a trademark after the Trade Mark Act passed in 1875. The company used the image of a sun rising over a field of linen cloth laid in strips on a bleach green and wove the *OB* symbol into the corner of the company's cloth. The firm of John Shaw Brown registered the shamrock as a trademark, Webb's of Newtownards produced a label in the shape of the island of Ireland, and J. N. Richardson Sons and Owden designed an ornate Celtic motif complete with round towers, Celtic crosses, and an Irish wolfhound. When linen firms designed trademark logos to identify their particular product so that customers would be assured of quality, they specifically chose a symbol representative of Ireland, not Britain or the United Kingdom. For the great majority of the world's population, the name Ireland encompasses the entire island, but most linen factories and mills in the nineteenth and twentieth centuries were located in the island's northern counties of Ulster province and were therefore part of the United Kingdom. As such, English laws governed Irish linen import and export tariffs, which either restricted or encouraged production. These laws were constantly revised to suit the ruling political party in Parliament, and these changes affected the lives of Irish citizens. For three centuries, despite changing laws and political shifts, Irish linen continued to be an export product and a way of life for many thousands of people living on the small island off the coast of England. Manufacturers believed that marketing a sense of Irishness by using the country's famous green hills, shamrocks, Celtic crosses, and Irish wolfhounds created a symbolism that associated the whole of the island, rather than just the industrial north, with linen cloth.

After Partition in 1921, when Ireland was divided into the Republic of Ireland and Northern Ireland,[2] some linen firms such as William Ewart and Sons labeled their products according to the political leanings of the majority of their customers in North America; cloth exported to the United States was labeled *Irish*

Linen, Product of Ireland because of the great number of Irish Catholics sympathetic to the Republic of Ireland, but cloth shipped to Canada and Australia (dominions of the British Commonwealth) was labeled *Ulster Linen, Product of Northern Ireland.* This deviation from the well-known brand, *Irish linen*, however, never gained widespread use, and most linen firms continued to use the word *Irish* in labeling their goods. *Irish linen* is the country-of-origin label that has lasted through time; marketing a natural plant product that came from the whole island known for its green hills, rainbows, and leprechauns was a more alluring and memorable image for consumers to remember.[3]

Fit for Royalty

For centuries, wealthy and prominent men and women desired finely woven linen, especially that which was decorated with lace or embroidery. Emperor Charlemagne, for example, wore only linen underwear when his contemporaries favored silk, and Mary Queen of Scots is reputed to have been an avid collector of Irish and French linen handkerchiefs. Irish linen met the high standards demanded by its patrons, but there was always competition from other textile manufacturers marketing to the same population. Cotton was plentiful and cheaper to produce, silk was more elegant, and wool was warmer, but Irish linen could be both elegant and durable.

Industrial Uses

Today, linen is best known as a fabric for clothing apparel and kitchen towels, but for much of its history, linen (including Irish linen) was primarily an industrial fabric. Modern readers are likely to underestimate the diversity of linen products on the market at the dawning of the twentieth century, let alone the purposes to which linen yarn and cloth were put in earlier centuries. Farmers relied on durability and the water-repellent properties of linen for feed and seed bags. Ships were rigged with linen sails and carried letters in mailbags sewn with linen thread. Cartographers drew maps on linen fabric, and flag makers used linen cloth. Book publishers used linen paper, linen cloth for the covers and lining, unwaxed three-ply linen thread for binding, and linen cord, tapes, and twine for hinges. During World War I and World War II, Irish linen was used for hammocks, tents, and hospital bedding and supplies, as well as military clothing. Printed Irish linen has been used for theater stage curtains from Cairo to Stockholm.[4] Architects used coated linen paper for ink drawings and watercolor renderings for clients. Architect Franklin Ellerbe used linen paper for his working drawings of the Mayo Clinic in 1914.

Irish linens used for household goods range from tablecloths, napkins, dishtowels, tea towels, bedding, and tote bags to wall coverings, upholstery, and window treatments. Many of these items lasted for generations, so colors, patterns, and styles were constantly updated and creatively marketed to entice loyal consumers to

Although the word *web* has many contemporary uses, it originally came from the Old English word *wefan*, meaning "to weave." Weavers continue to refer to lengths of fabric on the loom or in the course of being removed from a loom as *webs*. Our language is interwoven or interspersed with many uses for *web* as an adjective, verb, or noun, such as *he was caught in a web of deceit*. The term *web* can be used to describe connective strands of something as tactile as a group of streams or as tenuous as family relationships. The World Wide Web, or as it is more commonly known, the Web, is probably the newest and most widely used adaptation of the word; it describes an application built on top of the Internet containing documents that are often connected by hyperlinks. In other words, this Web is a worldwide connection of many strands of data, instead of yarn.

In the twenty-first century, trains and planes that travel back and forth regularly between two locations are referred to as *shuttles*. A specific type of spacecraft is also known as a *shuttle*, because the craft returns to the starting point after each mission. Long before trains or planes were modes of transportation, a shuttle was a weaving tool that carried yarn back and forth across the warp threads through a narrow opening called a shed. The constant, repetitive motion of the weaver's shuttle has developed a contemporary meaning that echoes its earlier use in weaving. *Shuttle* is also used to describe ideas or strategies traded back and forth among people, such as *shuttle diplomacy*.

The word *thread* is probably the most common weaving term used in everyday speech, regardless of the kind of fiber spun. As a textile word, it comes from Old English and refers to a slender length formed by spinning and twisting textile fibers in a continuous strand. Thread is mainly used for weaving, knitting, sewing, and lace making. In reference to other manufacturing uses, the word *thread* occurs as a noun to describe projecting spiral ribs on a screw or bolt and as a verb to identify parts that are threaded so they can be screwed together. The image of a long, slender length of thread readily expresses contemporary experiences and thoughts. *Thread* can also express an unbroken line of reasoning rather than a specific action; saying that a person is *hanging on by a thread* is quite common. The word even describes aspects of food and its preparation—bean threads are long, skinny cellophane noodles, and pole beans need the fibrous thread or string removed before cooking.

regularly purchase new products. The fabric was also sold in different weights and weaves as the background fabric for crafts such as cross-stitching, quilting, and embroidery. A large, high-quality Irish linen cloth called a *stable rubber* was favored for rubbing the perspiration off a horse after a hard gallop.[5] Linen absorbs the sweat from hands as well as horses, so it is the preferred fabric for pool/billiard cue handles. At one time, Irish linen thread was used for hand sewing the uppers on the hugely popular loafers worn by men and women, which are now stitched with synthetics.

In 2007, unlined linen fire hose tubing was still approved for fire fighting in New York City because linen threads swell shortly after getting wet and close the minuscule spaces in the weave to make the hose

Fabric book of linen samples woven in various designs and colors next to design drawing on paper, c. 1900. © *National Museums Northern Ireland 2011. Collection Ulster Folk & Transport Museum.*

Colored, unbleached linen damask tea towels, c. 1910. © *National Museums Northern Ireland 2011. Collection Ulster Folk & Transport Museum.*

watertight.[6] The United States and many other countries mix strong, crisp linen with cotton to make paper money, and the webbing for the parachute that brought astronaut Neil Armstrong's capsule back to earth from his 1969 walk on the moon was made of Irish linen.[7]

Historically, linen has been the preferred canvas material for most artists, and for some Irish artists, the painting itself has reflected the changing culture of the linen industry through small incidents of everyday life. For one artist, a painted festival banner told of an ancient time when women were at home spinning flax into yarn with a drop spindle. William Conor (1881–1968) painted barefoot children and young adults working in the linen industry in some of his best-known works. His art challenges the viewer to accept the reality of hardship for nineteenth- and twentieth-century mill workers.

In 1927, Darius Joseph MacEagan (1856–1939) combined various symbols to tell a story of Irish linen on his painted canvas. The scene, possibly the artist's portrayal of an exhibition of women scutching flax, takes place in the village of Ballsbridge (county Louth), where there was a long history of flax growing and scutching during the eighteenth and nineteenth centuries. In 1796, the Irish Linen Board listed more than twenty-five hundred names of flax growers in Louth, the smallest county in Ireland, with only 317 square miles. The Royal Dublin Society (RDS), founded in 1731, moved to Ballsbridge in 1879 and held exhibitions of the type MacEagan painted.[8] The Celtic cross in the background of the painting is probably Muiredach's Cross, located at Monasterboice (county Louth), and considered the best-known symbol of early Christianity on the island. It was an important symbol for Catholics in 1927, only six years after partition, when the country was divided into the Irish Free State (with a predominantly Catholic population) and Northern Ireland (mostly Protestant); the fifteen-foot-high cross would have been directed at the Catholic segment of the population working in the linen industry. The clothing is not exact for the period, appearing to be almost habit-like, but MacEagan may have been more concerned with drawing attention to flax scutching than with fashion accuracy.

Irish Village, Ballsbridge (Dublin), 1927. Oil painting by John MacEagan (1856–1939) illustrating an exhibition of women scutching flax. *Courtesy of Brian P. Burns Art Collection.*

How to Sell All Those Linen Products

In the twenty-first century, selling a product often occurs in a faceless, electronic blink of an eye. With Internet, phone, and fax available to nearly every wholesale and retail consumer in the world, marketing strategies are innovative and constantly changing, using techniques that would have been unimaginable to manufacturers only a few years ago. Airplanes transfer salesmen quickly between cities or countries—there is no time to build a personal relationship with a potential client or promote a product to anyone other than the person in the adjoining seat. Irish linen became a worldwide brand name long before the high-tech age, however, a time in history when real people promoted the image of an island culture and its people while peddling a national product on an international scale.

Regardless of its ultimate purpose, each item made from Irish linen required a seller to promote its benefits and a buyer who needed or wanted it. As the industry expanded in the eighteenth and nineteenth centuries, extensive global efforts were required to consume the vast quantities of yarn and cloth manufactured for a wide range of uses. Consequently, the Irish linen industry was heavily reliant on international exports, and sales and marketing initiatives were of major importance. Irish linen houses were represented throughout the world by a network of agents, representatives, and traveling salesmen. Today, there is no need for companies to employ the same number of road salesmen to deal with customers' complaints, take orders, and establish new accounts, but in 1900, salesmen were traveling the globe. As late as 1950, William Ewart and Sons had sales representatives in more than sixty-five countries worldwide.

Leather suitcase with Cunard Line tourist-class stickers attached, early twentieth century. *Courtesy of Monaghan County Museum, Republic of Ireland. Photography by David Pauley, Belfast.*

Salesmen were constantly traveling to cities large and small on every continent while extolling the virtues of linen products to wholesale clients. Transatlantic ships moved slowly, giving salesmen time to establish new business acquaintances within multiple social circles and to discuss style and fashion changes that might affect future sales. As official company representatives, many salesmen traveled first class and stayed in luxury hotels, rubbing shoulders with the rich and famous. One particular salesman, representing a moderate-sized manufacturer, encountered Phil Silvers, Field Marshal Montgomery, and Liberace during a single voyage to New York.

The Customer Base

The island of Ireland was in a particularly advantageous position, both geographically and politically, to benefit from international trade. As part of the United Kingdom (until 1921; see chapter 1), the island of Ireland profited greatly from the captive markets within the British Empire and the demands of its citizens such as viceroys, ambassadors, and their families who served the monarchy from the farthest corners of the world. The large number of British citizens residing abroad continued to live as if they were in England, filling their homes with English-style furniture, wearing English-style clothing, and decorating with fabrics manufactured in the United Kingdom. Furthermore, the Irish diaspora in the growing economies of the United States, Canada, Australia, and New Zealand created a specific demand for Irish linen. Ireland, therefore, remained in an enviable position in terms of physical proximity and political affinity as the balance of economic power began to shift discernibly from Europe to North America.

Although Irish linen was a truly global commodity, the influence of the British Empire and the Irish abroad created particularly favorable marketing conditions. The linen firm of William Ewart and Sons had offices in Belfast, New York, and London. The Belfast-based sales operation was split into specific departments: home, empire, American, and foreign, reflecting the relative importance of the colonial and North American trade. If the rest of the world knew Ireland because of linen, then traveling linen salesmen helped familiarize Ireland with the rest of the world.

Some marketing strategies rely on convincing buyers to envision a more tranquil past of their rural ancestors—a simpler lifestyle with less worry and stress. This is particularly true for companies advertising products to city dwellers. These strategies encourage the current middle-aged population to regard its own youth as superior, a better life experience than the contemporary

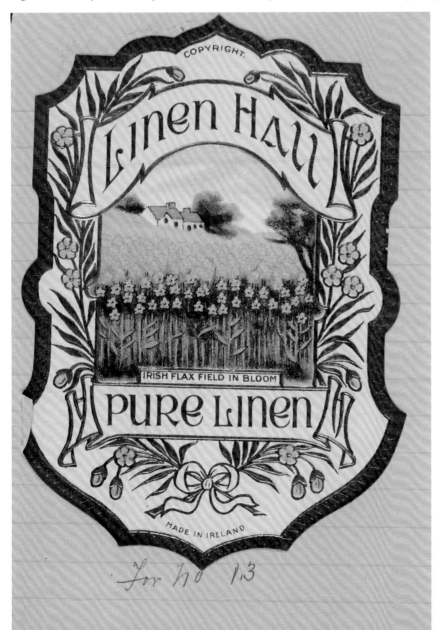

Above: Red-haired woman holding flowers on a light green background. Manufacturer's branding label affixed to packaged bed linens, table linens, and handkerchiefs, c. 1900. © *National Museums Northern Ireland 2011. Collection Ulster Folk & Transport Museum.*

Left: Field of flax in bloom surrounded by stylized flax flowers and the words "Linen Hall" above "Pure Linen." Manufacturer's branding label affixed to packaged bed linens, table linens, and handkerchiefs, c. 1900. © *National Museums Northern Ireland 2011. Collection Ulster Folk & Transport Museum.*

WARRANTED
ALL LINEN

MADE IN IRELAND

Woman spinning at low flax wheel surrounded by oval border of stylized flax. Manufacturer's branding label affixed to packaged bed linens, table linens, and handkerchiefs, c. 1900. © *National Museums Northern Ireland 2011. Collection Ulster Folk & Transport Museum.*

lifestyle of its children. For the huge Irish diaspora in the first quarter of the twentieth century, the pull of the home country was strongly felt and reinforced by family stories, letters, and marketing agendas that romanticized the Ireland of quiet rural life and close-knit communities. Most emigrants during the famine years left out of necessity, not desire, and they still longed for the land of their birth. To promote linen, manufacturers seized upon these nostalgic, and sometimes romantic, connections in their labeling. Packages were labeled with images of women contentedly spinning flax, red-haired Irish beauties dressed in Victorian fashions, and fields of blue flax flowers gently swaying in the unseen breeze. Some labels were romantic while others were more direct, but phrases such as *pure Irish linen* were intended to give the product a sense of goodness and cleanness that placed the fabric in a category above the increasing competition from other fibers in the textile industry.

Commission Merchants Abroad

New Orleans always held an appeal to the Irish because of its Catholic traditions and anti-British sentiments. At the end of the 1700s, an early wave of Irish immigrants landed in New Orleans and integrated into the economy and social life of the city. The first St. Patrick's Day celebration was held in 1809, Irish social and benevolent organizations were formed, and Irish theater thrived. From the city's earliest days, New Orleans had close ties to money centers in New York, Boston, Philadelphia, London, and Paris, and English bankers began living full time in New Orleans in the early 1800s. Before the Civil War, on a per capita basis, New Orleans was the wealthiest city in America. Hibernia, an old term for Ireland, was even the name of a prominent bank (founded in 1870), which prospered from its Irish clientele.

Irish immigrants started arriving in New Orleans in significant numbers during the early famine years of the 1820s and peaked by the end of the Great Famine in the 1840s. When ships carrying bales of Louisiana cotton unloaded their cargo in Liverpool, captains settled for human ballast on the return trip to New York or Philadelphia. By the 1850s, the price of slaves had skyrocketed, and plantation owners could hire cheap Irish labor for menial work at a reduced cost. Irish immigrants found cheap passage for the long journey down the Mississippi River to New Orleans, where new arrivals discovered a welcoming community and employment. Transatlantic ships carried a constant stream of mail between Ireland and North America; those who could not read found someone who could, and those who could not write dictated a

message to a neighbor. So many people were leaving Ireland in the second half of the nineteenth century that ripples of correspondence crossing the Atlantic maintained a steady connection of family, friends, and new acquaintances.[9]

In the antebellum South, most cotton planters relied on commission merchants (factors) to sell their crop. Many commission merchants were located in commercial districts of port cities such as New Orleans, Savannah, and Charleston; they were paid a commission for buying and selling necessary supplies and luxuries desired by clients. In an agrarian society, it was imperative that commission merchants act as middlemen for exporting and importing goods, negotiating the best price for all parties, from planter to shipper to buyer.

In the 1920s, New Orleans remained the wealthiest city in the South; its Cotton Exchange was one of the most important in the world at the time, and most of the cargo exported from New Orleans was in bales of raw cotton. But linen was a more exclusive fabric, fashionable, and cool to wear in the hot southern climate, and wealthy plantation wives and urban socialites wished to purchase Irish linen for bedding, tablecloths, napkins, and household toweling. Southern women also desired fine linen handkerchiefs and lace to embellish fashionable clothing, children's undergarments, and christening gowns.

W. J. Bryan and Company was a commission merchant in New Orleans in 1934 with a warehouse located at 52 New Levee Road. For orders of Irish linen requisitioned in the late nineteenth and early twentieth centuries, the cloth was probably shipped to New York or Baltimore, sent west by railway to the Mississippi, and transferred again for the journey downriver to New Orleans. To help ensure that the order arrived expediently and without mishap, the wholesale company's name, "W. J. Bryan and Co.," and city were stamped on the goods. Many linen seals (stamps) indicate the name of the Irish spinner, bleacher, or manufacturer of the cloth, but Bryan's name stamped on the shipment that designated the final destination is an indication of how desirable linen (specifically, Irish linen) was to consumers in southern American states well into the twentieth century.[10]

In 1880, John Sloan Larmor established the Ulster Weaving Co. Ltd. in Holywood (county Down). By the 1920s, Larmor's son William had moved to the United States as the company's main sales contact abroad. About 1985, the Ulster Weaving Company was divided into two separate and distinct companies owned and operated by Larmor's descendants on different continents. Today, Ulster Linen Co. Inc. of New York imports fine European linens, and Ulster Weavers Home Fashions designs and provides a wide variety of household table linens woven out of cotton and linen to wholesalers around the world, but the firms no longer operate factories in Northern Ireland.

Seal for stamping fabric or containers to ensure that shipments from Ireland reached the warehouse of S. and W. J. Bryan, New Orleans, c. 1920s. Stamp image shown in reverse for ease in reading. *Courtesy of Coleraine Museum, Causeway Museum Services, Northern Ireland.*

Many Irish linen manufacturers were commended for their wares at the Great Exhibition of 1851, held in Hyde Park, London as the first in a series of World's Fair exhibitions of culture and industry that became popular in the nineteenth century. Among those mentioned were Michael Andrews, "for excellence"; James Coulson and Company, "for an extensive and admirable exhibition"; and Thomas McCay, "for an exceedingly fine piece of fronting linen." The exhibitions were not solely interested in finely woven or prohibitively expensive linens; recognition was also given for value. Judges singled out William Kirk and Sons of Armagh, remarking favorably on the firm's "brown linens of low descriptions and prices." Similar accolades were bestowed on Irish manufacturers at the London exhibition of 1862, where local manufacturers were highly praised for great excellence, general excellence, and a good variety. Irish manufacturers were also represented at the Paris exhibition of 1855, in Dublin in 1865, in Paris in 1867, in Vienna in 1873, and in Philadelphia in 1876. Three Irish manufacturers—J and W Charley, Fenton Son and Company, and John Shaw Brown—won prestigious gold medals at the Paris exhibition of 1867. In addition, a combined linen display of approximately thirty Belfast-based producers also won a gold medal, and the firm of Henry Matier was awarded a silver medal. The prestigious number of gold medals in class 28, "Flaxen Thread and Fabrics," was the greatest number won by any individual region or country.[11]

Textile manufacturers throughout the world attended exhibitions to present their products for international recognition and observe the competition's wares. Panels of independent judges awarded medals at most exhibitions, and Irish linen consistently maintained a reputation for fine quality. Belfast hosted an exhibition in 1845, and two prize-winning exhibitors, the Royal Damask Manufactory in Ardoyne and John Henning of Waringstown, were asked to display linen for Queen Victoria's visit to Belfast in August 1849. By the time Queen Victoria returned to Belfast in 1885, the city had erected a huge arch over the entrance to Donegall Square. The lavishly decorated arch was a tribute to international commerce in the city known as Linenopolis; it served as a demonstration of the power and prestige of Irish linen, with a great spinning wheel and a smaller flax-spinning wheel prominently displayed on the center platform at the highest point above the center of the arch. On either side of the arch was a large exhibition replicating a storefront; both were festooned with linen draperies and filled with household accessories, tableware, and a wide variety of goods made of Irish linen. Overall, the objects displayed on the arch platforms signified the power of Ireland's industrial city. Its slogan—*Trade is the golden girdle of the globe*—across the arch facing outward further evidenced the city's strength in the global marketplace.

Magazines, newspapers, and trade cards kept a company's name and product visible to consumers long before television was invented. Trade cards were popular during the last quarter of the nineteenth century; the small, colorfully illustrated cards were collected and often pasted into scrapbooks. Thousands of trade cards were distributed at fairs and international exhibitions, promoting everything from food and clothing to sewing machines and farm equipment. Linen fabric and thread companies on both sides of the Atlantic used this style of advertising.

Arch across Donegall Square, Belfast, erected as a tribute to international trade and commerce. The massive arch celebrated Queen Victoria's return trip to Belfast in 1885 at the invitation of Lord Dufferin, the Marquis of Cladeboye and Ava, a high-ranking diplomat in the United Kingdom from county Down. Queen Victoria and Prince Albert had previously visited Belfast in 1840 when Belfast was a town with only the promise of becoming a great industrial city.

Threading with Linen

In 1880, three major groups of British firms spinning linen thread had mills on both sides of the Atlantic. The Barbours, founded by a Scotsman who migrated to Ireland, were located near Lisburn (county Down) and in Paterson, New Jersey; the Knoxes were located in Kilbirnie near Paisley (Scotland) and in Baltimore, Maryland; and the Finlaysons in Johnstone were near Paisley and in North Grafton, Massachusetts. Each family firm had established a mill in the United States in response to tariffs imposed on textile imports.

Wm. Barbour and Sons, established in 1785, manufactured twisted and braided linen thread to use in the production of footwear and opened a mill in Paterson, New Jersey, in 1865 in response to import trade restrictions; the firm was managed by three Barbour brothers, who marketed the thread through a nationwide sales organization. By 1898, competition in the thread industry had become intense, and the founder, Colonel William Barbour, proposed that three American firms (Barbour's, Marshall Thread Company, and Finlayson) join forces with Britain's Knox and Barbour family-owned mills to form the Linen Thread

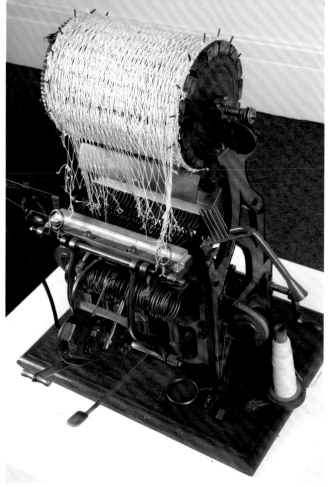

Netting sample loom. This model of a netting machine dates from about 1900. At the end of the nineteenth century and into the early twentieth century, Barbour's and the Linen Thread Company supplied a huge quantity of netting to the fishing industry worldwide. Until the invention of netting machinery, women handworkers knotted the twine. The first semiautomatic single-knot netting machines were developed in the 1870s, followed by double-knot machines about 1900. Both types of machines were operated by foot treadle, as seen in the model. *Courtesy of Irish Linen Centre and Lisburn Museum. Photography by David Pauley, Belfast.*

Company Ltd. In the early twentieth century, three British enterprises (J. and P. Coats Ltd., English Sewing Cotton Company Ltd., and the Linen Thread Company Ltd.) dominated the cotton and linen thread industries in America. At the onset, the Linen Thread Company was the largest manufacturer of flax thread in the United States, and probably the world, primarily supplying the shoe and boot industry and carpet trade. By the twentieth century, the company had established offices and agents in seventy-eight countries or territories throughout the world. From Pakistan and Panama to Denmark and the Faroe Islands, the Linen Thread Company was positioned to respond to any and every need for its thread.[12] During the century, the mill also manufactured

Right: Fisherman loading strong linen nets onto boat to the dismay of the two fish in the foreground. Postcard advertisement for Barbour's linen fish netting, c. 1925. *Courtesy of Irish Linen Centre and Lisburn Museum.*

Below: Fisherman pulling in linen nets full of fish. Postcard advertisement for Barbour's linen fish netting, c. 1925. *Courtesy of Irish Linen Centre and Lisburn Museum.*

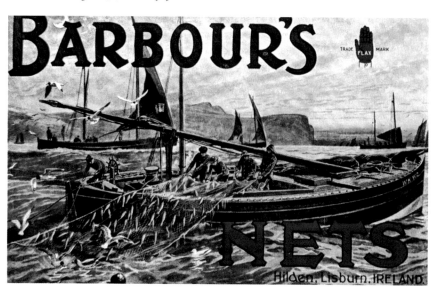

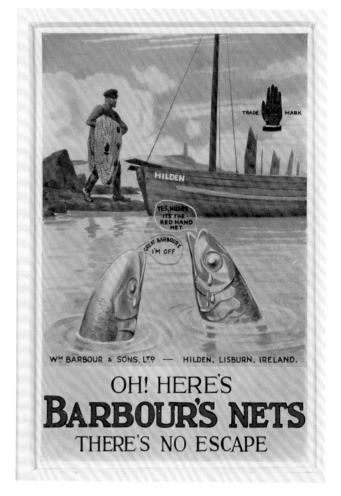

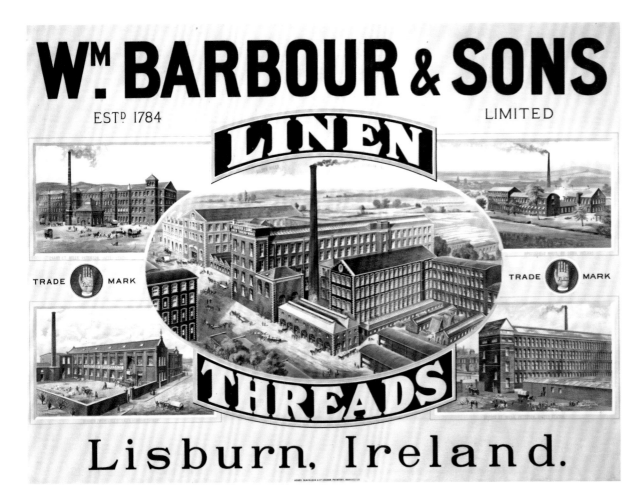

specialty threads for automobiles, upholstery, and the bedding industry, as well as netting used for snares and fishnets. The high profile of the company and huge output of linen thread gave Barbour's in Lisburn a well-deserved international reputation, and by 1914, approximately two thousand people from Lisburn and the surrounding area were working for the company. Next to the location of the mill site at Hilden (outside Lisburn), the company built a model village for its workers, consisting of 350 houses, two schools, a community hall, a children's playground, and a village sports ground.[13]

In 1918, an article in the *Journal of the American Medical Association* proclaimed that linen thread spun at Barbour's (county Down) was a stronger, smoother, and much better product than the German-spun Pagenstecher's, and it could be purchased by the skein in any size at a quarter of the price.[14] Pagenstecher thread was linen thread dipped in a solution of celluloid, and until World War I, it was more popular than silk with surgeons who performed internal suturing.[15]

Over the decades, most international thread manufacturers closed down, merged with other firms in the industry, and struggled to adapt their products to reflect current fashion, advancements in machine technology,

and the discovery of synthetic fibers. In 1999, the firm Coats Viyella acquired Hicking Pentecost and its Barbour Thread division. Barbour's operations were integrated with Coats's North American businesses; the new company used the Coats name with Barbour's. At this time, Barbour's was best known for its filament threads and bonding technology, while Coats's strength was in core threads for apparel businesses; together, these products represented the most complete portfolio of threads available to industrial users. Due to global shifts in the marketplace, Barbour's in Lisburn closed in May 2006 after over two centuries of production.

Lavishly Appointed Linen Warehouses

In the late nineteenth century and the first half of the twentieth century, linen firms known as Irish linen houses relied on an extensive network of employees to sell the enormous quantity of linen produced. Outside company showrooms, sales were primarily made by men, but women worked diligently in the home office planning routes, booking accommodations, arranging passage, processing orders, keeping records, typing inventories, and preparing export documents. Both salesmen and office workers needed to be fluent in several European languages and various currency conversion rates to handle correspondence and negotiate contracts with distributors and wholesalers. Although linen firms actively promoted their products and crisscrossed the globe with a network of salesmen, representatives, and agents, there was also a constant stream of buyers arriving in Belfast to visit factories and warehouses. *The Textile Journal,* published in Belfast, carried a regular feature on buyers and their movements.

The architectural legacy of the linen industry serves as a permanent reminder of a trade that contributed to the creation of civic wealth and prosperity across Ireland. Linen warehouses were built to glorify the natural flax plant and demonstrate the wealth and prosperity of textile manufacturers, especially in the north, where the industry was strongest in the twentieth century. Warehouses were administrative headquarters of the business: a place for buyers from around the world to negotiate contracts, meet executives, and observe new designs and styles being planned for the next season. The warehouse was a place where cloth was cut, stitched, hemmed, individually boxed, and readied for sale. Belfast became the heart of Irish linen, and linen firms based in Linenopolis exuded an image of grandeur, prosperity, and success. The warehouses of Robinson and Cleaver and Richardson Sons and Owden were imposing structures on Belfast's Donegall Square North, each designed to create an opulent impression. The Richardson Sons and Owden warehouse, built in 1869, was described by Oscar Wilde as the finest building in Belfast. An observer can still pick out the inscription, "J N R S & O" (James Nicholson Richardson Sons and Owden), on either side of the main entrance to the building. Rampant lions, the firm's trademark, derived from the Richardson family crest, flank the lettering.

The English architect Charles Lanyon (1813–1889) was commissioned to design the Robinson and Cleaver warehouse that opened in 1888, as the Royal Irish Linen Warehouse. The firm was entitled to use the

J. N. Richardson Sons and Owden linen warehouse, Belfast, nineteenth century. *Courtesy of Richard and Co., Public Records Office, Northern Ireland (D/2826/64/7).*

designation *Royal* after Queen Victoria granted it a warrant in 1878 to supply Irish linens to the royal household.[16] Intricate carvings on the building's façade include depictions of the flax plant and linen cloth alongside busts of Queen Victoria, George Washington, and the emperor and empress of Germany. Each carving represents different aspects of the firm's business, its principal markets, and its patrons. The description of the Robinson and Cleaver building, along with its fixtures and fittings, used for insurance valuation in 1921 gives an idea of the interior layout. Packing and shipping departments and the linen stock room occupied most of the basement; the sixth and seventh floors contained the cutting room, a laundry, and the ornamentations department; and the lower and middle floors were used largely for retail sales. Despite imposing façades and internal splendor, warehouses remained functional buildings.

In 1901, Robinson and Cleaver boasted an impressive list of patrons, including sixty-nine imperial or crowned heads or members of royal families and over five hundred titled personages. Robinson and Cleaver's overseas order book testifies to the global nature of Irish linen; in 1955 alone, the firm's goods were

shipped to customers residing in Australia, the British West Indies, Canada, England, Ethiopia, Finland, France, Germany, Gibraltar, the Gold Coast, Holland, Hong Kong, India, Kenya, New Zealand, Nigeria, Norway, the Philippines, Rhodesia, Scotland, the Seychelles, South Africa, Switzerland, Turkey, and the United States.

Linen warehouses also contained elaborate showrooms richly decorated to impress wholesale buyers who came to place an order. As well as having comfortable furnishings, the showrooms typically displayed the latest fabrics in finely carved wooden cases lined with mirrors and backlit for maximum effect. Like all fine fabrics, linen is a tactile product, and touching the fabric is vitally important for determining quality. Although packaging and presentation were important to the ultimate consumer of linen cloth, a wholesale buyer who visited a lavishly appointed warehouse was encouraged to appreciate the feel, or *hand,* of the cloth. Formally dressed salesmen presented each buyer with the linen samples, hoping that the touch of the cloth itself would result in an order being placed. Linen houses carefully cultivated an image of affluence and grandeur, an image calculated to reflect the product they were selling.

For linen, sales to the gift trade peaked at Christmas, when damask cloths and napkins graced holiday tables, and sold in the piece-goods market for summer clothing when cool linen was most desirable and fashionable. Every season, firms offered new styles of ornately embellished linen handkerchiefs as gifts for mothers, daughters, friends, and neighbors. Salesmen traveled the world to meet wholesale buyers, taking large orders for yard goods, table and bedding linens, decorative kitchen tea towels, and accessories. Orders were processed by the linen manufacturer and shipped in time to arrive at the height of each buying season. Several larger firms had overseas offices and warehouses for international distribution.

In the late 1880s, York Street Flax Spinning and Weaving Company had offices in London, New York, Paris, Berlin, Melbourne, and Sydney.[17] In addition, the company had smaller sales agencies in wealthy and fashionable cities such as Copenhagen, St. Petersburg, Moscow, Milan, Naples, Madrid, and Barcelona; local employees in these agencies were available to deal with wholesale buyers on a personal basis.[18] Company salesmen built personal relationships with wholesale buyers, and they regularly conveyed information to the home office if there was a shift in fashion or a change in the local economy. By living in the same city as the stores that sold their products, linen salesmen were intimately aware of how each item was presented to the ultimate consumer and could advise managers on the most successful ways to display the linen goods in the store setting. Linen companies competed with each other to sell to the best stores in the most fashionable cities around the world. For example, between 1906 and 1914, an order book for Broadway Damask Company listed goods regularly shipped to the fashion and design capitals of New York, Constantinople, London, Paris, Berlin, Rome, Madrid, and Milan.[19] Additionally, having a local office in a city across the ocean gave the company an advantage; if an order was delayed, lost, or damaged in shipping, the local employee could respond quickly to satisfy the client.

For most Americans today, a white sale advertisement means the chance to buy a variety of brightly colored household items, including major appliances, at a reduced price. The marketing strategy called *white*

Facing page: Rolled linen damask proof cloths in various pastel colors woven by the firm John Shaw Brown of Edenderry, c. 1930–35. © National Museums Northern Ireland 2011. Collection Ulster Folk & Transport Museum.

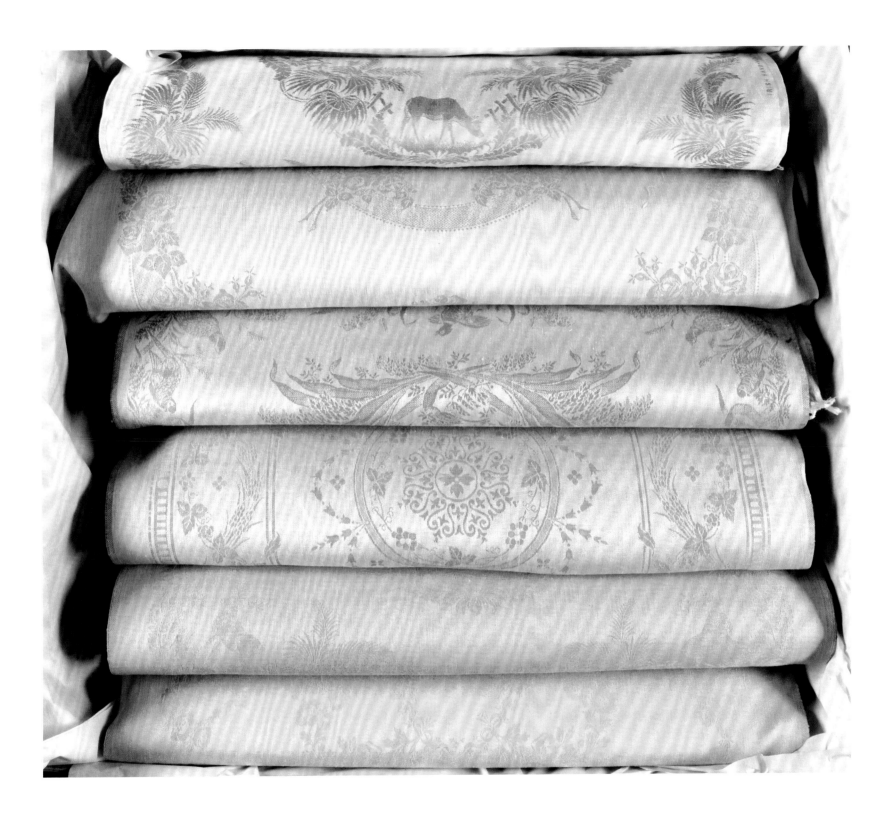

sale, now so commonplace, was the idea of John Wanamaker, founder of Wanamaker's Department Store in Philadelphia, Pennsylvania. In 1878, Wanamaker reduced the price of the store's stock of linen bedding (available only in white at that time) in an effort to promote sales during the slowest time of the year for linen manufacturers.[20]

Weaving in a Logo

For more than a century, the Banff Springs Hotel at the convergence of Canada's Bow and Spray Rivers has provided a unique blend of luxurious comfort, individualized service, and timeless beauty for the most discerning travelers. Rocky Mountain Park had just been established when famed New York architect Bruce Price designed the impressive hotel after a Scottish baronial castle in 1888. Canadian Pacific Railway's general manager, William Cornelius Van Horne, envisioned a succession of lavish resort hotels along the Rocky and Selkirk Mountains to enhance traffic on the railway line; the Banff Springs Hotel was the railway's fourth hotel and the most spectacular.

By the start of the twentieth century, the Banff Springs Hotel had developed into one of the top three mountain getaways in North America, and Van Horne's vision had been realized: the scenery was undeniably magnificent, fishing was abundant, and the dining room was an elegant experience both visually and gastronomically. Marketing the hotel was important to its success. One method of branding the hotel for its guests was to weave a likeness of the castle, surrounded by mountains and visitor activities, into damask tablecloths of Irish linen. This style of artistically designed personalized logos for public facilities was repeated on bedding, toweling, and all table linens. Using fine Irish linen for the sophisticated branding of Canada's premier Banff Springs Hotel signified *class* to guests who expected the optimum in every detail for their visit.[21] Irish linen always fulfilled that promise. This damask pattern was commissioned in 1928 to coincide with the final remodeling, which lasted nearly thirty years.[22]

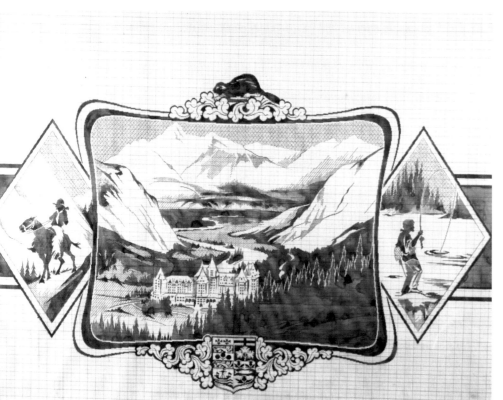

Banff Springs Hotel in Alberta, Canada, painted on point paper for a linen tablecloth woven by McCrum, Watson and Mercier, Milford, county Armagh, 1928. The pattern was designed by William H. Fry (1883–1962). *Courtesy of Irish Linen Centre and Lisburn Museum.*

An example of a linen firm that excelled at devising creative ways to promote and sell products to retail and wholesale consumers within the United Kingdom and abroad was Old Bleach of Randalstown: the company continually looked for new ways to advertise to individual dressmakers, casual vacation shoppers, and society matrons. After Old Bleach was founded in 1864 by Charles James Webb (a member of a Dublin Quaker family, who set up a small weaving business in an abandoned cotton factory), the firm grew rapidly and quickly established a reputation for quality products and excellent design. It was one of the first textile companies to engage in a recognizable advertising campaign. The company's sales director, Hubert Webb, understood the power of advertising and aggressively promoted the company and its products. Individuals from around the world who wanted to purchase the finest-quality linen contacted world-renowned Harrods Department store in London to place their orders, requesting linen from only two sources: Old Bleach and John S. Brown. The large Canadian chain of department stores, T. Eaton Company, and the White House, a coastal specialty store in Portrush (county Antrim), represent two different types of merchandisers that stocked large quantities of Old Bleach linen and its hand-painted damask to sell to their patrons.

All linen houses packaged kitchen ensembles that included a tea cozy, tea towels, and potholders as a boxed set. Embroidered bridge cloths with matching napkins were also fashionable gift sets favored by a broad international audience. In a competitive retail environment, it was crucial to create a product that not only was visually appealing but also presented a sense of quality, luxury, and tradition—the very essence of linen. Most linen products were wrapped in cellophane, tied with ribbons, and placed in boxes beautifully embossed with the words *Irish Linen* or *Pure Irish Linen* prominently displayed with the company name. Linen manufacturers clearly understood that the country-of-origin label was a strong selling point, and they prominently displayed it at every opportunity.

Brown's damask was considered the finest available. Recognizing the importance of brand marketing, the firm went far beyond merely labeling its packaging with a trademark shamrock. To ensure that customers were buying authentic John Shaw Brown and Sons damask, a shamrock was woven into the corner of every piece of cloth produced in the factory in county Down. Although considered subtle by contemporary standards, this was a bold marketing step in the early part of the twentieth century. An Irish linen manufacturer's only true rival was often another Irish linen manufacturer, so company branding and distinctive labels were essential selling tools.

The Irish Linen Guild

It would be incorrect to present an image of an industry consisting of independent and individualistic firms competing with one another. There certainly was competition, as there is in any industry, but the Irish Linen Guild was formed in 1928 as a voluntary promotional organization with members from all sectors of the

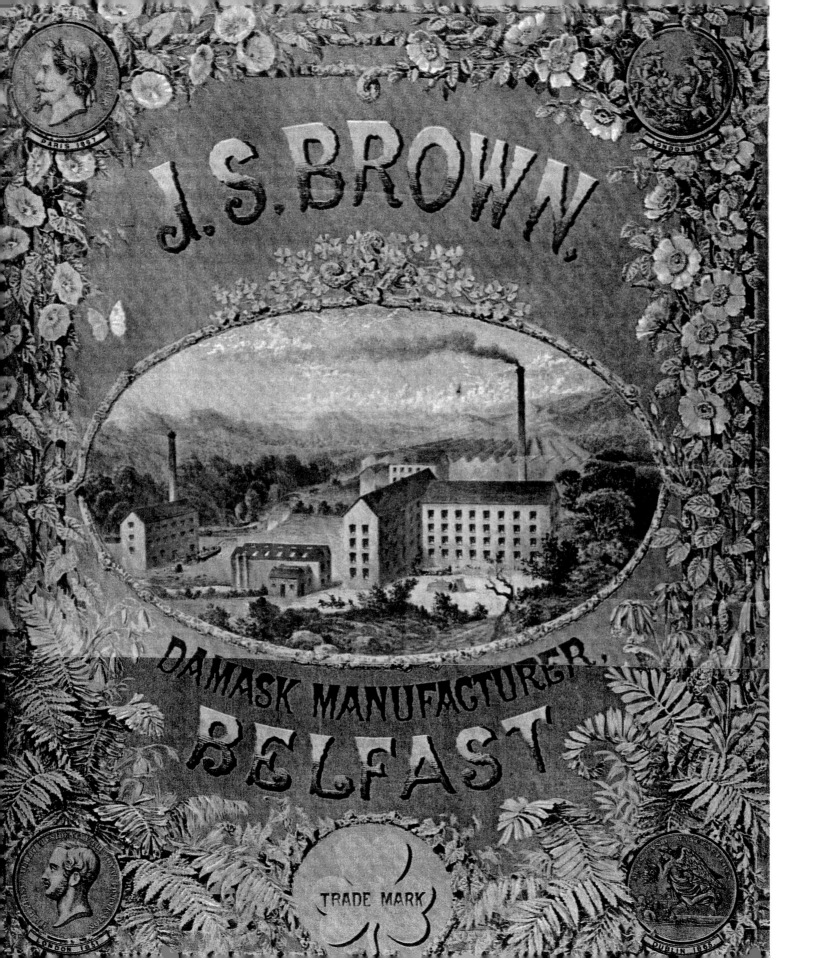

Irish linen industry coming together for a united purpose—marketing *Irish linen* as a single entity. The guild promoted Irish linen as a superior product and coordinated activities to the mutual benefit of all its members for over sixty years. Before disbanding its offices in Hillsborough, Northern Ireland, in 2001, the guild consisted of twenty-six companies ranging from spinners, weavers, and finishers to designers and merchants. In 2010, the guild consists of only six members connected to their customers through an Internet website. The organization continues to promote the high standards of excellence that linen has always enjoyed on a national and international level.[23]

The Irish Linen Guild logo was of prime importance. It remains a registered trademark and can be used only to mark Irish linen products manufactured by its members. The logo continues to be recognized worldwide as a symbol of quality. The guild's promotional activities capitalized on the characteristics of Irish linen, with the intention of expanding knowledge and awareness of linen's natural properties. The guild promoted products of its members at international textile fairs such as Heimtextil in Frankfurt and Première Vision in Paris. The guild regularly organized press trips for journalists to visit Irish linen industry facilities firsthand. In-store promotions and joint ventures with top designers also helped raise the profile of Irish linen. Throughout its history, the Irish Linen Guild supported product development and new technology and maintained its commitment to marrying modern innovation with traditional values. The guild sought to improve competitiveness in an increasingly difficult world market while preserving the special qualities of linen that have been highly regarded for hundreds of years. At the turn of the twenty-first century, exports of Irish linen were valued at an estimated £85 million.[24]

Do It Yourself with a Singer, a Pattern, and Irish Linen

Machinery invented during the Industrial Revolution had a profound impact on textile manufacturing and the daily life of factory workers; it also affected the way of life and social culture of the American homemaker. Sewing machines increased the demand for fabric sold by the yard, colored thread, and fashionable dress patterns. The development of the Singer sewing machine for use at home was invented in the mid-nineteenth century, and Singer Sewing Machine Company soon became an international giant; by 1899, Singer was selling one million sewing machines a year worldwide because of the company's innovative and

Facing page: The linen firm John Shaw Brown and Sons produced this color polychromatic lithograph for the cover of a very large (37" H × 27" W) folio, of which approximately one hundred were printed as presentational gifts. The unbound folios contained sixty-eight damask designs with an index of pattern names, each plate consisting of a single color lithograph. Firms such as Brown's spent a great deal of money advertising their success in the industry. Brown's reproduced prestigious gold medallions received by the firm to enhance each corner of the folio cover: (*top left*) the 1867 Paris Exposition (bearing the head of Emperor Napoleon III); (*top right*) the 1862 London Great Exhibition of Arts and Manufactures; (*bottom left*) the 1851 Exposition at London's Crystal Palace (bearing the head of Prince Albert, president of the Royal Commission on Arts and Manufactures); (*bottom right*) and the 1865 Dublin Exposition. The highly acclaimed firm of Armitage and Ibbetson in Yorkshire, England, printed the folios, c. 1868. *Private collection.*

dynamic advertising. Sewing machines were marketed to individuals, as well as textile manufacturers. Treadle machines were demonstrated to prospective buyers at circuses, outdoor events, and grand balls in New York, where wealthy young women could observe the invention in an affluent setting. Society matrons ordered sewing machines while sitting in beautifully appointed showrooms, pampered in their elegant surroundings.

In 1921, the company introduced a portable electric machine. The invention and marketing of modern home sewing machines enabled American women outside large urban cities to transcend their economic and geographic locations by making fashionable clothing at home. Singer introduced the installment plan for purchasing machines, making them affordable for the poor or working-class woman, while agents carried a machine or two on a wagon and drove through the countryside visiting every small town to demonstrate and sell Singer sewing machines to isolated housewives. Meanwhile, the price of the machine decreased. It seemed as if Singer's motto, *A machine in every home,* might be realized, but a machine is no use without patterns, fabric, and thread. Linen manufacturers were ready to supply the new demand.[25]

By the 1920s, perforated patterns were being printed on thick, stiff, parchment-like paper with holes pricked along the pattern outlines. To transfer the designs to fabric, a chalk-like powder was rubbed over the holes with a piece of felt, a process known as pouncing.[26] Customers could also buy fabric with prestamped patterns already on linen and cotton cloth, and many companies offered their designs on preprinted cloth or as paper patterns. Some paper patterns for current fashions were available from five-and-ten-cent stores or through mail-order catalogs. In small towns, women had limited choices for stylish ready-to-wear to buy in local clothing stores. The sewing machine opened up a whole new market for women who wanted to sew creations to define their own personal style. Practical or fashionable, the American woman could home sew at least a portion of her family's clothing, needing only suitable fabric and thread to complete each project.

Suitable Fabric for New Customers

Old Bleach's New York office at 21 East 26th Street handled the company's sales of household linens, linen accessories, and linen clothing to large department stores across the United States. The company was aware of the changes in the marketplace, and although the firm continued to promote its linen fabrics for women's ready-to-wear, the principals also understood a woman's desire to sew flattering fashions in stylish colors made from patterns designed to fit individual body types. Noting a lack of opportunities for women to purchase pure Irish linen if they did not live in a large urban center, Old Bleach went in search of a new kind of salesman—the saleswoman.

To tap into the market of potential customers who wanted to sew at home, Old Bleach recruited a network of female representatives in small-town America to sell a full range of linen products (circa 1920). Old Bleach's agent George Kiernan, working out of an office at 23 Haddington Gardens in Belfast, managed the marketing initiative. By 1925, at least nine female representatives in the United States were selling Old Bleach's Irish linen to their society friends, club members, and neighbors. Each woman paid $29.75 for a

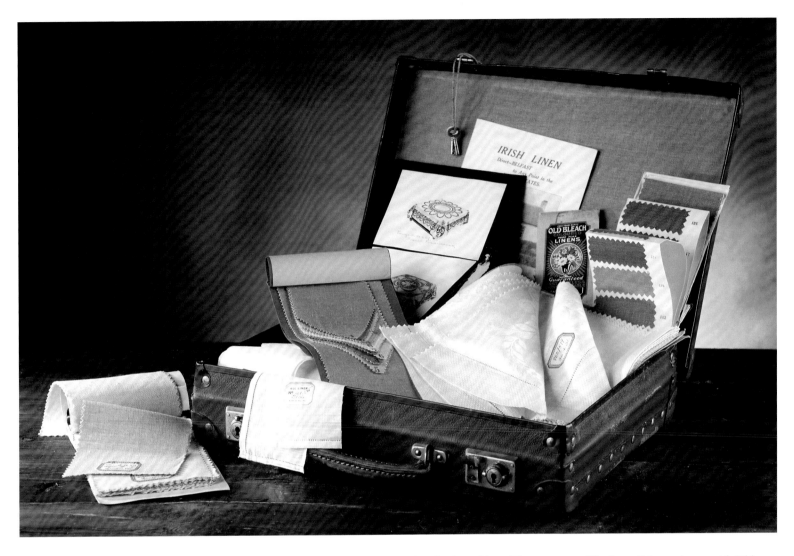

standard-size attaché case, lined with unbleached linen and secured with a lock and key. The case was filled with a complete set of linen samples for each product manufactured, pricing lists, a booklet with photographs of the damask patterns available, and mimeographed sheets with instructions for how to market plain, fancy, and damask linen to potential customers. Miss Alice V. Crawford, Zanesville, Ohio; Mrs. R. C. McGoun, Newcastle, Pennsylvania; Miss Sara A. Moore, Wheeling, West Virginia; Mrs. Ida F. McCollum, Burlington, Iowa; Mrs. J. B. Morris, Charleston, South Carolina; Miss Elva F. Bell, Portland, Maine; Miss L. E. Clark, Tampa, Florida; Mrs. Anna E. Morrison, Wooster, Ohio; and Mrs. Caroline Cox, Sacramento, California, wrote testimonials to Kiernan for publication in a *Special Export Service*, a promotional booklet used to recruit new company representatives in the United States.[27]

The ten-page black-and-white-printed booklet specified the salient points for selling genuine Irish linen with descriptions of the unique qualities of the fabric, the company's commitment to fine service, and

Salesman's case with Old Bleach of Randalstown linen fabric samples and promotional materials, c. 1920s. *Private collection of the author.*

quotations from current saleswomen. Featured on the front page was a picture of two women, hand embroidering as they sat in front of the typical nineteenth-century thatched-roof, whitewashed cottage in county Down, complete with a hedge-entwined fence. Old Bleach undoubtedly hoped that American women would imagine the smell of a peat fire wafting out of the chimney in the tranquil setting and judge the firm's linen based on a perception of old-fashioned, quality handwork by individual women spinning and weaving at home before the Industrial Revolution began mass-producing textiles.[28]

Representative Sara Moore wrote, "The Hand Embroidered Handkerchiefs, the most beautiful work I ever saw. The ones you sent me only lasted a few hours after I received them. I could have sold three times as many as you sent me." She had just sent in an order for $506.00 worth of linens. Miss Bell expresses her success with the words, "The other afternoon, between two and five o'clock, I sold nearly two hundred and fifty dollars worth, making only three calls. The lady I called on first ordered over one hundred and forty-four dollars' worth. The second would have bought more if she had not been going to Europe right away and preferred to wait till her return before buying a great deal." Bell expected that she could make more money if she lived "in the wealthiest city in America"; she observed, "I'd like to be transported thither, with all your Linens piled up round me on a magic carpet. I crave wealth—but not for myself." Bell did not mention for whom or what she craved the wealth, if not herself. Mrs. McCollum traveled from Burlington, Iowa to neighboring towns to present her linens to different clubs, and Miss Clark expected light blue, yellow, and rose to be her best sellers in Tampa, Florida. Mrs. Cox was exuberant about the potential for selling Old Bleach: "I feel sure that the possibility of securing dress and Embroidery Linens in short length is going to greatly add to the business. The Sample Case is a beauty and nicely packed. The Handkerchiefs are exquisite."[29]

The promotional material in the attaché case explicitly stated how sales representatives were to sell linen to potential customers. "Inform your customers of the fact that your line of Irish Embroidery Linens is at least three times greater than may be found in any New York store. This statement is true. Make the statement constantly until it is fixed in the mind of each of your customers." Moreover, sales representatives were to assert, "No such line of Embroidery Linens, of Irish Manufacture, will be found in the largest store in New York, Philadelphia, or Chicago."[30]

Marketing to the Urban Customer

Old Bleach constantly sought new ideas for marketing Irish linen in major metropolitan cities as well as rural communities. The firm was especially known for its range of vibrantly colored, hand-painted, linen damask tablecloths; the technique was taught to several female employees by Mr. McColl, a Scottish artist.[31] When the first examples appeared in shop windows on New York City's Fifth Avenue in the 1920s, they caused quite a sensation for wholesale and retail buyers enchanted with the new creation. Old Bleach regularly staged practical demonstrations of the hand-painting technique at Harrods Department Store in Lon-

don. One or two women painters would travel unaccompanied to London for nearly a week during the peak selling season; a company representative would meet them to handle hotel and transportation arrangements. The women were expected to demonstrate hand painting while conversing with prospective buyers, answering general questions about linen fabric, and providing detailed responses to technical inquiries about the painting method. When they returned to Randalstown, the women filed a report and were debriefed by senior management to determine the ever-changing taste of the buying public.[32]

Right: Women painting pastel designs on linen damask tablecloths woven by Old Bleach of Randalstown, county Antrim, c. 1960.

Below: Close-up of circle of brightly colored flowers painted as the center motif on a large white linen damask tablecloth. Hand-painted linen damask tablecloth woven by Old Bleach of Randalstown, c. 1920s. *Courtesy of Carson family, London House, Randalstown, county Antrim. Private collection.*

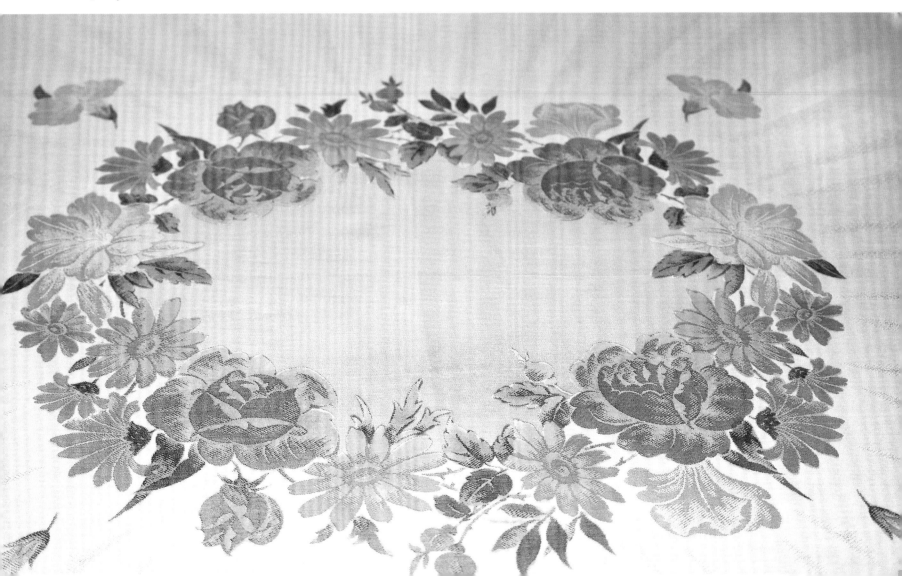

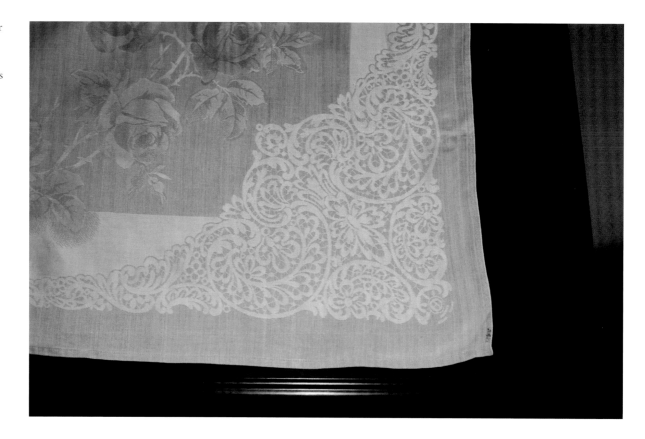

Intricate hand-painted border in white on straight-weave tablecloth. Sprays of hand-painted pastel-colored flowers complete the design. Hand-painted linen tablecloth woven by Old Bleach of Randalstown, c. 1920s. *Courtesy of Carson family, London House, Randalstown, county Antrim. Private collection.*

Old Bleach's product range was quite diverse, extending from dress fabrics and table linens to upholstery fabrics and carpets. Dress linen was available in fifty-nine different color hues, from blues and lavenders to greens, reds, yellows, black, and white. All fabrics, including both vibrant shades and subtle pastels, were guaranteed to be colorfast. In early 1952, Old Bleach acquired the rights to the designs of William Morris (1834–96). An English architect, furniture and textile designer, artist, and writer, Morris was known for his repeating patterns based on nature and his contribution to the resurgence of traditional textile arts and methods of production. Through a traditional block-printing process and the use of modern dyes, Old Bleach faithfully recreated some of Morris's finest designs of the English Arts and Crafts movement for the modern customer.

Selling by the Seaside

The success of the White House, a luxury store located in the fashionable seaside resort town of Portrush, along the Antrim coast, symbolizes rural retail establishments, large and small, that triumphantly marketed and sold great quantities of Irish linen to thousands of loyal customers. Many came to Portrush and to the

store for a daytime excursion; others traveled to the town and stayed in its big hotels for their seaside holiday. During its heyday at the beginning of the twentieth century, the White House catered to an affluent clientele in Ireland and abroad.

Irish linen was marketed aggressively beyond its shores and sold in the finest boutiques and in department stores in all the major capitals of the world, but it sold locally as well as globally, and that was an important market for linen firms to cultivate. While one segment of the population that worked in the linen industry could ill afford the fine linen handkerchiefs and bedding, the middle and upper classes certainly chose Irish linen to use and wear. Throughout the island, there was a national pride of ownership for the quality of the Irish linen products.

For many years, seaside resorts in both the north and the south of Ireland attracted vacationers and weekend tourists throughout the summer season. Before travel was as convenient as it is in the twenty-first century, people went to the coast for a two-week vacation. With its beautiful, sandy beaches, amusements, and cafés, Portrush was an example of one such place;[33] it served as a haven for thousands of people who wanted to escape the crowded, soot-filled industrial city of Belfast. Strategically located on Main Street in Portrush was the White House department store.

Henry Hamilton, who came from a small village near Ballymena (county Antrim), founded the store in 1891. Prior to this venture, Hamilton had apparently been involved in a failed business. Unable to pay his creditors, he faked his suicide by leaving a pile of clothes next to the banks of the River Bann, before fleeing the country for America. When he arrived in the United States, Henry Hamilton worked in New York and later in Santa Cruz, California, where he picked up the entrepreneurial skills needed for future success. After sixteen years, Hamilton went back home to marry his sweetheart, intending to bring his wife back to the States. Instead, Hamilton opened a new drapery business in Portrush called Hamilton and Company. The shop was soon renamed the White House in honor of Hamilton's American connections. His timing was perfect for the new business; the town was expanding, bathing in the sea had become popular, railways were being utilized by more people, and a golf club had opened a couple of years earlier. More and more people were visiting Portrush, and shopping for linens at the elegant White House while on holiday became part of every trip to the quaint village.

Hamilton initially sold a few handcrafts made in county Donegal in addition to his drapery goods, but he soon recognized the potential for selling Irish-made textiles to European and American vacationers. He filled the store with linen household goods, homespun yarns made into knitted clothing, and exquisite linen lingerie. Before long, the White House began to attract a much wider customer base, not just visitors to Portrush. Hamilton advertised in magazines and newspapers, and his mail-order business soared. Queen Victoria placed an order in the late 1890s, and the Prince of Wales carried on the tradition in 1903. In the early part of the century, the White House filled its largest order—twenty-six suits for His Highness the Raja of Pudukkottai in South India.

The shop expanded over the years to stay fashionably elegant. There was a terrazzo floor arcade at the front of the shop, and inside the store a wood-paneled electric passenger elevator connected the first and

Edwardian linen parasol carried by the bride, Portaferry, county Down, August 1909. On each of the eight panels, raised embroidery stitches on white linen form swags of grapes with vine leaves that surround an area of pulled-thread work embroidery. The upper area of each panel is decorated with cutwork shamrocks, the leaves cut out to form tiny holes. The edge of the fabric is scalloped and finished off with buttonhole stitch. The wood handle is labeled "Paragon S. Fox and Co. Ltd." *Courtesy of Irish Linen Centre and Lisburn Museum. Photography by David Pauley, Belfast.*

second floors—very sophisticated for the time and place. The store was stocked with a wide array of exquisite linen handkerchiefs embroidered and trimmed in lace, starched white sheets and pillowcases embellished with drawn-thread work and embroidery, and fashionable linen dresses in a full range of summer pastel colors.

The White House launched a boutique to attract younger, fashion-conscious shoppers in 1971, but shopping for elegant linen lingerie and fashionable evening gowns was by then available in every city across the world, and mail-order catalogs filled homeowners' mailboxes daily. By the 1980s, with travel being cheaper and packaged holidays to seaside resorts in Spain, Portugal, France, and Greece becoming popular, two weeks in Portrush had lost its appeal.[34]

Overcoming Gender Discrimination

With only one or two notable exceptions, men, not women, carried out the selling and marketing of Irish linen. Within the linen industry, it was not unusual for a firm to remain in the hands of a single family and for sons to succeed fathers

and grandfathers over several generations. The family-owned business remained a characteristic feature of the Irish linen industry well into the twentieth century. Men dominated sales, marketing, and managerial positions; apart from counter-based sales, women were relegated to the back office and noticeably absent from public view. A notable exception to this precedent occurred in the family-owned business of Seawright Douglas when Linda Seawright, a single woman, succeeded her father, Walter, as managing director of the family firm in the early 1970s.[35]

Seawright Douglas, located in Lurgan (county Armagh), was formed in 1896 when James Seawright and Henry Douglas entered into partnership. James Seawright's brother William John (1867–1954) inherited the business after James's death in 1909, and William bought out the Douglas family in the early 1920s. Of William's two children, his son was his natural successor, but Walter (1913–88) decided not to continue working in the family business. Linda Seawright joined the firm, supposedly on a temporary basis while she decided on a career "more suitable" for a woman. With her brother out of the picture, Linda Seawright became her father's logical, if unorthodox, successor. She was the first female member of the Belfast Chamber of Commerce and the first female member of the Trade Hemstitchers Association. Seawright was appointed the Trade Hemstitcher's Association's first and only female chairperson in 1989, a year after her father's death.[36]

Seawright Douglas was a medium-sized handkerchief and fancy linen manufacturer. Specializing in the manufacture of cotton and linen handkerchiefs, Seawright Douglas also produced considerable quantities of table runners and pillowcases. The firm had no weaving capacity of its own, buying (or more often commissioning) bolts of cloth from local linen manufacturers such as Spence Bryson and W. F. B. Baird. Most cloth was bought directly off the loom and bleached at Milltown Bleachworks to Seawright Douglas's specific requirements. One of Seawright Douglas's subsidiaries was John Jacoby, a London-based firm that supplied high-end retail stores such as Harrods and stores on London's Burlington Arcade. Jacoby's was also a major supplier for tourist outlets in the Republic of Ireland, giving Seawright Douglas an important foothold in that growing segment of the linen trade. The United Kingdom was Seawright Douglas's primary market. Although the firm had a considerable export trade, the market was largely confined to England, the Republic of Ireland, Northern Ireland, Scotland, and Wales. Until the 1930s, Hungary was also a major market for Seawright Douglas, but orders ceased abruptly with the shifting political environment during the occupation by the Soviet Union. International affairs had a major impact on the Irish linen industry throughout the centuries. The loss of the Cuban market when Fidel Castro took power was a huge blow, and the imposition of prohibitive trade barriers across most of South America in the early 1960s quickly eliminated one of the world's largest and most lucrative markets for Irish linen.[37]

Linda Seawright's name, not her leadership abilities, is what ensured her the title of managing director and acceptance within the industry; for a woman to attain this position on merit alone would not have been possible. In the 1970s, Northern Ireland was a far more conservative society than most other Western societies, a situation accentuated within the textile trade. Seawright undoubtedly benefited from family connec-

tions, and she had the advantage of knowing her major suppliers and customers personally. Her father had entertained his business acquaintances at home, and she continued the practice throughout her career. In the beginning, it was expected that she would leave the firm when she married. Although many women returned to work within the linen industry after marriage and motherhood, women from Linda Seawright's more privileged background did not.[38]

The businessmen with whom Seawright worked were decidedly uncomfortable in the presence of a woman, and she enjoyed the liberating experience of working with North American buyers, among whom traditional gender discrimination was less acute. During a sales trip to North America to expand the customer base, Seawright visited Boston, New York, and Toronto, where being a Seawright of Seawright Douglas effectively guaranteed an appointment with senior buyers at stores such as Bloomingdales and Saks. Although Seawright had no trouble securing appointments, and her samples were very well received, orders proved difficult to secure. Seawright Douglas did not have North American–based warehouses and distribution networks to enable buyers to order small quantities and have a guaranteed quick delivery.[39]

The handkerchief trade was extensive and supported many firms almost exclusively, not the least because handkerchiefs were considered an essential part of formal male attire and were a popular gift item in the twentieth century. Walter Seawright identified two categories of handkerchiefs to market: the *show*-er and the *blow*-er. The show-er (or handkerchief for show) was a fine embroidered linen handkerchief that adorned the breast pocket. The blow-er, a cotton utilitarian item, was kept out of sight in the trouser pocket.

The degree of Seawright's reliance on a single product and, in many cases, on a limited number of expensive High Street (London) retail stores rendered the handkerchief manufacturer extremely vulnerable to market changes. After he was introduced to paper tissues in the United States in the 1950s, Walter Seawright correctly predicted a rapid decline in the use of fabric handkerchiefs. The convenience and economy of paper tissues, coupled with the increasing informality of dress, affected the handkerchief trade severely. Although Seawright Douglas did move with the times and sought to respond to the market by producing innovative and eye-catching products, the underlying trend in the market was one of undeniable and inexorable decline.

This trend threatened to put independent producers such as Seawright Douglas out of business. The reason Seawright Douglas survived as long as it did is because it became primarily a trade hemstitcher, supplying wholesalers and carrying out commission-based work for larger firms with warehouses and agents in the world's major markets. As the quality of linen in Eastern Europe and other countries increased, local manufacturers were afforded a measure of protection by the cachet attached to *pure Irish linen.* In certain markets, and for certain customers, Irish linen and only Irish linen would do, but ultimately, the convenience of inexpensive paper tissues gained the upper hand with customers who dressed less formally and were disinclined to spend time washing and ironing fine linen handkerchiefs. Although Seawright Douglas survived longer than most, the firm finally ceased production in 2000, ending a tradition of production that spanned 104 years and three generations.[40]

Sales and marketing of all kinds of products shifted after World War I, especially in the United States. By the 1920s, more products were being manufactured, so there was more competition to win loyal customers. Hard and fast rules for social etiquette, once so rigid, were softening, and the mood of the country turned toward consumerism, with manufacturers deciding how to best sell their products to the widest audience. Chain stores for customers at all levels of income appeared with the popularity and affordability of the automobile. More shoppers went to stores instead of making their purchases from only those products that were available in mail-order catalogs. Having access to an automobile revolutionized shopping for many families; this was especially true in rural areas with no public transportation, and it is still true today.

Sears, Roebuck and Company was exceptionally successful in taking advantage of new market circumstances. In 1895, Sears was a mail-order company catering largely to the demand from rural customers for basic goods, but in 1925 it began direct retailing, and by 1929 Sears was operating over three hundred stores nationwide. F. W. Woolworth's, whose five-and-ten-cent variety stores gained popularity across the country, catered to lower-income consumers and offered a wide range of household items and supplies for at-home sewing projects.

Growth in retailing and merchandising during the 1920s was spectacular, especially in the United States. Ready-to-wear clothing became increasingly available across the country as America moved ahead of other countries for mass-producing contemporary-style clothing. More women were employed outside the home, and they did not want to spend time and money on seamstress fittings; as inexpensive fashions became available, the status symbol of custom-made garments lost some of its cachet.

Department stores in major cities sought to attract middle- and upper-income customers by presenting the latest fashions in artistic surroundings and promoted a store's wide selection of goods through magazine and newspaper advertising and extravagant window displays. Department store buildings were multistoried, architectural extravaganzas with magnificent interiors that exuded style, comfort, and convenience. Salespersons were fashionably dressed, knowledgeable about the products in their department, and determined to please each customer with impeccable service. Women's fine Irish linen handkerchiefs, collars and cuffs, and other accessories were carefully removed from the counters and displayed on suede or velvet cloth to show them at the best advantage to the customer.

The *Dry Goods Economist,* a trade journal published in New York from 1852 until 1930 for the textile industry, provided instruction in merchandising methods. The *Dry Goods Economist* was a weekly publication with individual sections devoted to a particular category of goods including furniture, decorative furnishings, and traditional notions (accessories). The journal described to industry staff and managers the best ways to display and sell textile merchandise most effectively to attract customers and make a profit. In 1926, the *Economist* sponsored the publication of *Linen: The Emblem of Elegance* by W. D. Darby. It included chapters

Walpole Brothers Ltd. handkerchief box covered with linen fabric, c. 1920. The company was one of many linen manufacturers based in and around Waringstown, county Armagh, at that time. © *National Museums Northern Ireland 2011. Collection Ulster Folk & Transport Museum.*

on how a department store should educate its staff, present merchandise on the sales floor, arrange window displays, and advertise Irish linens in daily and weekly newspapers. Darby uses the word *linens* to include cotton household goods, but he was quick to point out the psychology of merchandising with specific words: *genuine* linen, *real* linen, and *pure* linen brought to the client's mind a recognition of exclusivity and superior qualities in the product—a fabric desired and purchased by the upper-class patron or women who wanted to emulate the upper class.[41]

At one time, shopping for handkerchiefs was a very personal experience. Customers selected handkerchiefs with great care and stored them in elegant boxes provided by the manufacturer. Ladies in particular were treated in almost ceremonial fashion. In one store, the customer was seated on a gilt chair at the side of the handkerchief display counter. A black velvet cushion was then brought out and placed on top of the counter. Individual handkerchiefs were placed on the cushion, where they could be examined and the quality of the embroidery determined. At no stage was the handkerchief passed directly from the assistant to the customer. Department stores often employed specialty handkerchief buyers. As the trade declined, however, the handkerchief buyer disappeared, and handkerchiefs were increasingly linked with other accessories such as costume jewelry, scarves, and umbrellas.

Advertising with Collectibles

In the late nineteenth century, cigarette packs were thin and fragile, so a stiffening card was inserted to prevent crushing.[42] This presented tobacco companies with an opportunity to advertise artwork depicting subjects that appealed to smokers: glamorous actresses, sport, architecture, travel, and industry. At a time when the average person could not afford books, newspapers contained no photographs, and television was still in the future, attractive and informative cigarette cards became very popular. The linen industry was featured with drawings depicting images such as *Linen Bleaching Green, Belfast; Linen Warping, Belfast;* and *Linen*

Crisply starched and folded Irish linen napkins grace the tables for a presidential state dinner at the White House, c. 1995. President William Clinton's place card, reading "The President," is visible in the foreground. *Courtesy of the Clinton Presidential Library.*

Damask Weaving, Belfast.[43] At the beginning of the twentieth century, more cards were issued with cigarette brands than for any other product. The cigarette card era came to a sudden end at the beginning of World War II, because of severe paper rationing. In recent years, there has been a revival of cigarette card collecting; beautifully illustrated ones are highly desirable, and rare cigarette cards are very expensive. When production was at the zenith during the early twentieth century, tourists from around the world bought cigarettes, travel posters, postcards, packaged gift sets, and handkerchiefs all labeled to promote the attributes of Irish linen as *pure Irish linen,* the *product of Ireland.*

Sometimes a catchy phrase was used to remind the public of the linen industry's prowess. When Short Bros. and Harland went to a Belfast linen concern to develop a foam-backed seat covered with durable linen for use on the company's commercial airlines, it was widely advertised with the claim that most European air travelers were riding on Irish linen. Gifts to state governments at official functions were also excellent publicity opportunities for the whole Irish linen industry. One such event happened on St. Patrick's Day in 1964 when the prime minister of Northern Ireland, Captain Terrence O'Neill, presented two Irish linen tablecloths to President Lyndon Johnson at the White House.[44] The banquet-size tablecloths, each woven with the presidential seal and the coat of arms of Northern Ireland, were specially made for the president by John S. Brown and Sons Ltd.[45]

Highly publicized events and famous individuals helped promote Irish linen, keeping the public aware of the brand name from decade to decade. When the Beatles came from obscurity to gain worldwide fame for their music, millions of fans wanted to copy their style; from long hair to footwear, *Beatlemania* was a global phenomenon. The famous pointy-toed black leather boots with a Cuban heel and center seam stitched from ankle to toe became a style icon of the 1960s. It also meant financial rewards for Barbour's in Lisburn, who manufactured the linen thread used for stitching; the demand for the firm's thread increased dramatically when boot sales skyrocketed.[46]

Ulster Weaving Company, recognizing the marketing potential for anything to do with the Beatles, contracted with the band to weave an exclusive linen picture cloth featuring the faces of the famous group. This linen cloth, essentially a tea towel, was initially sold at Robinson and Cleavers department store in London and was then marketed internationally.[47]

Posting a Remembrance

Because the mail was, and still is, used to send messages from one person to another, the stamp has long been an opportunity to present an image of visual importance or historic significance. Between 1963 and 1972, Northern Ireland issued a series of stamps reflecting the importance of the Irish linen industry. Each stamp had a picture of Queen Elizabeth framed by a drawing of the flax plant. Born in Yorkshire, England, Leonard Pilton went to the Belfast School of Art as a lecturer in textile design in 1949 and became highly regarded as a teacher and designer. His design, one of five chosen to represent Northern Ireland, was submitted to Queen Elizabeth in 1957; the image of a shuttle was removed in the final selection approved by the queen. British stamps are identified only by the head of the reigning monarch, not by the written name of the country. Britain is the only nation accorded this privilege. In 2001, another stamp was issued featuring the enlarged detail of an Irish linen drawn-needlework slipcase (see chapter 6 for illustration).

Postage stamps are not merely beautiful and commemorative in their own right but are attached to postcards, letters, or packages to pay the cost of mailing. While the back of a postcard carries the sender's message, the front is often used for promotional purposes, and the Irish linen industry was quick to embrace

Postcard advertisement for Old Bleach of Randalstown, twentieth century. *Private collection of the author.*

Definitive (not commemorative) stamp designed by Leonard Pilton. The one shilling three pence stamp features a symbolic image of Queen Elizabeth in the center above a weaving shuttle and surrounded by stylized flax stalks. ER stands for Elizabeth Regina. The Red Hand of Ulster with the star was the sign of the old Protestant Ascendancy, post-1922. *Courtesy of the Family of Leonard Pilton and with the gracious permission of Her Majesty The Queen.*

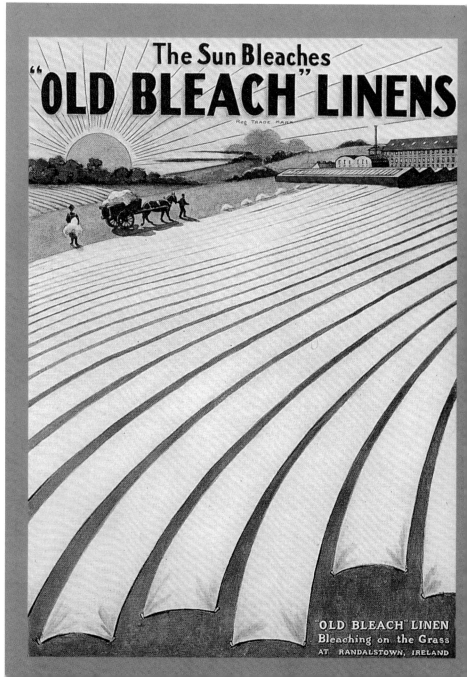

this marketing opportunity in the nineteenth and twentieth centuries. Impossibly long strips of Irish linen bleaching on the grass under natural sunlight makes a charming old-world image of a time when bleaching was a cottage industry. Instead of showing a large industrial factory, this image kept the company name Old Bleach in front of its twentieth-century customers while evoking the perceived romance of an earlier era in history. Postcards of mills, factories, and scenes depicting the uses of linen thread still circulate among twenty-first-century collectors of memorabilia.

What Now?

Spinning flax and weaving linen is no longer a viable industry on the island of Ireland. The world textile market has shifted to other countries that will be the giants of the twenty-first century. Those countries will struggle with ongoing challenges of worker safety, child labor laws, and low wages. Irish linen may no longer be a product of Ireland, but the phrase *Irish linen* will not soon be forgotten.

Today, we live in a hybrid world, an amalgamation of diverse cultures and traditions with a great many choices for what to buy in the ever-widening marketplace. Long before one-word brand names such as Nike, Coke, and Madonna became commonplace, manufacturers of linen succeeded in establishing *Irish linen* in the global psyche; the phrase is now so deeply embedded in the public consciousness that it may be one of the longest-lasting logos in history. Egyptian cotton has gained renewed name recognition in recent years for its high thread count in bedding products, and Chinese silk has always symbolized elegance. But *Irish linen* conveys a deeper, more profound meaning: the two-word phrase signifies a land with a history of adversity as textured as a rough piece of unbleached linen and a people of perseverance and creative marketing.

Pure Irish linen has left an impressive legacy, one that will resonate around the world for many decades in the future. The people and place that produced such a fine fabric for centuries will continue to be honored for their contribution to ingenuity, endurance, technology, and beauty.

Chapter 11

An Enduring Legacy

The Linen Industry

by Michael Longley

Pulling up flax after the blue flowers have fallen
And laying our handfuls in the peaty water
To rot those grasses to the bone, or building stooks
That recall the skirts of an invisible dancer,

We become a part of the linen industry
And follow its processes to the grubby town
Where fields are compacted into window-boxes
And there is little room among the big machines.

But even in our attic under the skylight
We make love on a bleach green, the whole meadow
Draped with material turning white in the sun
As though snow reluctant to melt were our attire.

What's passion but a battering of stubborn stalks,
Than a gentle combing out of fibres like hair

Facing page: Printed and pleated linen fabrics, Belfast, 2008. *Courtesy of John England Textiles, Ltd.*

And a weaving of these into christening robes,
Into garments for a marriage or funeral?

Since it's like a bereavement once the labour's done
To find ourselves last workers in a dying trade,
Let flax be our matchmaker, our undertaker,
The provider of sheets for whatever the bed—

And be shy of your breasts in the presence of death,
Say that you look more beautiful in Linen
Wearing white petticoats, the bow on your bodice
A butterfly attending the embroidered flowers.[1]

L ongley's poem is one of sadness, the loss of meaningful work and the culture of linen making that sustained Irish people for many generations. He understands the feelings of bereavement for a dying trade, a funeral shroud to illustrate the end of life. For many people, the end of their employment in the textile industry was a bitter experience, personally devastating, not someone else's history, as it is for academic scholars who write about shifts in national and world economies. At the same time, Longley captures the essence of pure white linen with compelling words that conjure visions of a time long ago when great effort was required to make this extraordinary cloth—glorious Irish linen.

With the passing of each century on the island of Ireland, there is an inheritance that remains embedded in the land and within the soul of the Irish people. It is a legacy, a gift for consecutive generations to celebrate as part of life's continuum. Some people consider their country's past glory as a birthright, a heritage to inspire ideas for a new and vibrant future, or motivation to create artistic symbols that honor the past. This chapter is a tribute to those inspirations, each separate but with one commonality—Irish linen's legacy.

As of 2008, the linen industry no longer exists in Northern Ireland or in the Republic of Ireland. Flax is not spun into linen thread, nor is the yarn woven into cloth on a significant commercial basis. The Irish Linen Guild closed its offices after eighty years of promoting Irish linen to consumers around the world, with only a website to promote a variety of textile products under the same recognizable logo. Fields once covered with flax for producing linen are now planted with rapeseed for canola oil—trading acres of delicate blue flowering plants for vibrant yellow blossoms. Driving through the countryside in springtime when fields are newly plowed, motorists can only imagine a time when acres of bleaching greens were covered with hundreds of yards of linen cloth; now fields are filled with strips of white plastic stretched out along the furrowed rows to prevent weeds in the current crop.

Bright yellow flowering rapeseed covers hillsides where flax flowers once bloomed, 2008. A member of the mustard family, rapeseed (also known as canola) is grown primarily for its seed, which yields about 40 percent oil and provides a high-protein animal feed. It is low in cholesterol and as such has become a popular cooking oil. *Private collection of the author.*

During the American Civil War, the cotton harvest and yarn production in the United States was so severely reduced that there was not enough cotton shipped to Ireland to meet the previous demand. This situation put the Irish cotton industry into a devastating decline, so many manufacturers seized the opportunity to expand linen cloth and yarn production (see chapter 3). But world economies have shifted yet again—China is today's leader in linen production. Is that unfair? Who is to say? At one time, the earlier shift in world economics gave Irish people decades of textile prowess. Perhaps it is China's turn to deal with issues common to all textile workers—employee housing, fiber-related illnesses, global marketing, and export duties.

People today are accustomed to the ease of no-iron fabrics that are inexpensive and readily replaced, informal dining is the norm, and grandmother's damask table linens remain packed away; the tablecloths have too much history to discard but need too much maintenance to use. The dawning of the twenty-first century marked the end of four centuries of Irish linen production. During that time, millions of Irish men, women, and children left their homeland for economic survival or to seek religious freedom or financial opportunity; many of those who stayed behind worked in the textile industry to produce the millions of yards of linen cloth and spun yarn that were transported across the same oceans. The linen industry had great peaks of productivity and sales along with times of depression through the centuries, but in total Irish linen is a great legacy that will remain in one form or another as the most significant cultural heritage of the island of Ireland.

Tourism is the buzzword for the twenty-first century across the island. Dublin is known for traffic gridlock, high-tech industry, new immigrants, its role as a member of the European Union, and a return migration of young professionals who long to live and work in their native land. Local and international tourists visit National Trust houses and gardens, Belfast's painted murals that depict current political opinion, the *Book of Kells* (housed in the Trinity College library in Dublin), and many other historic and fascinating sights in the Republic of Ireland and Northern Ireland. Young and old alike are awestruck by the magnificent scenery along the island's northern Antrim coast and the southern Ring of Kerry.

For many citizens across the island, the culture of textiles, which once permeated every aspect of life, especially in Ulster province, has not been forgotten in the passing of time. Stories of life in the mills and factories are kept alive as children hear about the "old days" from their parents and grandparents. Each generation of schoolchildren visit living history museums and cultural institutions to learn about the glory days of Irish linen, an education that narrows the distance between the linen industry and contemporary life in their minds. The average person may notice place-names once associated with linen production that now describe leisure activities, such as the Mill Yard Equestrian Centre and Mill Race Hiking Trail. The Bleach Green Railway Line transported passengers between Belfast and the Antrim coast until 1978 and reopened in 2009 with the same name, which recalls its earlier mission for all who ride along the route. The social and economic culture that produced the flax plant, linen yarn, and linen cloth continues to inspire artists, playwrights, authors, poets, folk musicians, and students.

In the twenty-first century, enormous mill and factory buildings loom huge against the rural landscape and delineate city streets across the island of Ireland, daily reminders of a time when linen thread and fabric were coveted by men and women around the world. The stone and brick edifices are carved with symbols of spinning wheels, looms, or insignia from distant lands where linen was exported. Small buildings and store-fronts in nearly every city and town have columns, pediments, or façades that contain a weaving motif visible to the discerning observer. The buildings now serve the public as apartments, condominiums, and office spaces, vastly different from the living and working places they were built as.

Names given to hotels, libraries, buildings, restaurants, roads, and country lanes recall a time of power and glory for the Irish textile industry, especially in Belfast, where so much linen business was transacted. The White Linen Hall was formally opened in 1785, and by 1801, the Society for the Promotion of Knowledge was using part of the building for its library. When the elegant Georgian building was demolished in 1898 to build a massive city hall, the library moved to a linen warehouse in Donegall Square designed by Charles Lanyon; it became popularly known as the Linen Hall Library.[2]

Belfast's Malmaison Hotel, formerly McCausland Hotel, was originally a flaxseed warehouse for two rival firms, McCausland and Lyte. Along the front of the popular hotel (located on Victoria Street) are large, carved stone figures on the main columns, surrounded by flora and fauna; each image represents one of the world's five major landmasses: Europe, the Americas, Asia, Africa, and Australia. The carvings are re-minders of the time when linen warehouses were a prestigious tribute to the plant that was an all-important commodity to importers and exporters across the globe.

Another former linen warehouse, Ten Square Boutique Hotel (circa 1863), is still admired for the stone heads of famous people that appear to be popping out of portholes all along the front of the building. The Marks and Spencer department store occupies the former J. N. Richardson Sons and Owden linen warehouse (built in 1868). The great Irish linen warehouse and showroom building of Robinson and Cleaver's has been remodeled to accommodate several businesses, including a small retail department store. Many people regu-larly walk by these markers of the past without realizing what they represent, but most people, especially in and around Belfast, remain keenly aware of their textile heritage—they are surrounded by it daily.

Across the island, the rural countryside is full of wood, stone, and brick ruins, the remains of family mills that were once vibrant places for the various processes needed to turn flax plants into linen yarn. Built in 1863 and expanded over decades, the impressive buildings of the Andrews and Company Flax Spinning Mill, in Comber (county Down), have been completely renovated into a new-style mill village with multi-storied luxury condominiums, a private swimming pool and spa, a complete fitness center, and courtyards and green space for relaxation. The mill that once employed a thousand local workers was divided into plush units with a state-of-the-art heating and cooling system, a central vacuum system, and top-of-the-line contemporary

kitchen appliances and bath fixtures. The wide expanse of glass used prodigiously throughout the renovation gives the village a contemporary elegance, juxtaposed against the strong permanence of yellow brick and century-old Scrabo stone from a nearby quarry.[3] The new residential mill village communicates a sense of continuity between the old and the new.

Transforming and Personal

Contemporary textile artists find inspiration, insight, and vision by living close to a place powerfully connected to its Irish linen tradition. Many talented fiber artists are women, just as their foremothers who worked in the factories and mills were women. Some artists choose to create textile works that incorporate pieces of lace or linen in the art, for they believe that using linen fragments is a way of preserving the centuries-old cultural heritage of the island of Ireland and serves as a celebration of the past.

Whether artists consider themselves to be creating art or craft, environmental and cultural factors influence the ultimate result of an inspiration. Textile designer Trish Belford at the University of Ulster and Ruth Morrow, professor of architecture at Queens University, exemplify the efforts of a collaboration that combines historic textiles and contemporary technology. Admiring each other's diverse artistic backgrounds and with a strong determination to influence changing attitudes about the built environment, Morrow and Belford returned to Northern Ireland after establishing separate careers in England, Ireland, and Germany. Initially supported by the University of Ulster's Office of Innovation, they developed *Girli Concrete*, an innovative and patented process that transforms concrete into an exciting and tactile material by embedding on its surface linen and lace material and flocking and foiling textile techniques. The process also allows a unique stitched surface to be developed that echoes the imagery of traditional lace production. By combining style and design, then challenging preconceived notions of decoration and aesthetics, the two women bring together two indigenous industries—construction and textiles—to create innovative interior products that coalesce masculine characteristics of construction and feminine characteristics of textiles.

For Morrow, integrating textile technologies into concrete manufacture adds an additional level of aesthetics and transforms low-tech, low-cost materials into high-value products. The work comes out of an inclusive feminist agenda that is about not only the product but also the process of developing it. This transformation involves drawing on local textile traditions of lace making, linen manufacture, and Aran knitwear, alongside other, more modern textile technologies such as flocking, and fusing essentially soft materials and qualities with the structure and depth of concrete.

Morrow and Belford experimented with a variety of fabrics embedded in the concrete to make a frieze and found that linen has the strength and durability to withstand the alkaline properties of wet concrete as it hardens. A frieze is the horizontal band forming part of the entablature of classical buildings, situated between the architrave and the cornice. Often decorated with sculpted ornaments or figures, a frieze normally follows a straight path, but for their first major installation at the refurbished Playhouse in Derry

(county Londonderry), Belford and Morrow transformed the classical concept into a rolling, curving piece of artistry infused with brightly colored yarn.

Morrow and Belford are developing a range of *structural clothing* formed out of their new product, including *wall coats, floor mattresses,* and *column socks,* which might be seen as a kind of emerging feminist counterculture of materials in relation to mainstream traditions of built form and space. They hope to expand their field of experimentation across other materials and techniques, such as stitching and embroidery. In the future, Morrow and Belford plan to be firmly positioned at the cutting edge of female-led research and development for new materials in the built environment. Toward that goal, in 2009 these highly motivated women established an independent organization, Tactility Factory Ltd., located in Belfast's Linfield Industrial Estate, which once housed a linen warehouse. With larger working space and access to expertise and resources at both of Northern Ireland's major universities, Morrow and Belford face new opportunities in their exciting future.

Both women were greatly influenced by the environment of their early childhood. Morrow's father managed a limestone quarry that produced concrete elements, and she was enthralled with the strength and versatility of concrete, which has been used for centuries. But it was not until the Industrial Revolution, when the addition of reinforcing steel elements enabled concrete construction to withstand greater compression and tension, that concrete was used to build huge factories and buildings. Belford's father was an architect and has encouraged her artistic career path. Each woman thus brings special talents and insight to their shared vision, and as a team, they are developing cutting-edge processes to fabricate a hybrid material that honors the past and embraces the future.[4]

Small sections of a single Girli Concrete panel were used as art for the front and back covers of this book; they are magnificent examples of the creative mind and spirit. Designers such as Morrow and Belford continue to challenge traditional concepts of art as technology, fashion, education, social culture, industry, and aesthetics.

Concrete Alchemy. Concrete panel embedded with linen and gold foil by Trish Belford and Ruth Morrow, 2008. *Courtesy of Tactility Factory Ltd. Photography by David Pauley, Belfast.*

Social Culture Reflected in Art

Releasing Eve, by Jill Phillips, 2008. This artwork consists of white Irish linen printed with an old photograph of an Irish lace-trimmed pillowcase, then laser cut to create a further design on top (for the cutout). Look closely to see the repeated image of soldiers with guns. *Photography by David Pauley, Belfast.*

Textile artist Jill Phillips grew up in Armagh (county Armagh) during The Troubles, and her art ingeniously portrays the unrest that she and her contemporaries faced throughout their childhoods. Since the Good Friday Peace Agreement of 1998, an adult Phillips is able to examine her early life and ways in which the Roman Catholic and Protestant communities were similar yet divided—often by outside pressures that caused emotional turmoil and physical destruction. Despite the violence, she has never wanted to leave Northern Ireland, and her work is an opportunity to acknowledge the past and anticipate a brighter future.

Artistic imagery that is politically edgy is something that many people who lived through The Troubles wish to turn away from in an attempt to ignore the past. Phillips's art, in contrast, takes a disquieting image and turns it into a design of beauty. Her textile is pleasing to the eye but lets the viewer subtly discover an evocative underlying image. Phillips does not use art for political commentary, but she does hope that her artwork will transform the dark, heavy energy of the past into a lighter and more positive future.

Phillips's artworks selected as illustrations in this book are an expression of her youth, when she was living with the political tension that she tried to ignore, not be a part of, though it surrounded her and powerfully affected her life and future creative inspirations. Using delicate yet strong linen bedding on which to print and laser engrave a design, Jill juxtaposed antique linen cloth, the labor of Irish working women, against the bold imagery of huge wall mural paintings seen in twenty-first-century Belfast.

Phillips is creative and very diverse in her work, using wood, glass, and fabric for furniture and textile pieces. She graduated with a degree in industrial design from the Scottish College of Textiles in Galashiels, Scotland. Her work made the final selection at the prestigious Royal Dublin Society National Crafts Competition, and she has exhibited her work in the United Kingdom and internationally.

Phillips's own words best describe her inspiration to create works of art: "All my life I've been attracted by the contrast of old and new, past and present, experience and innocence, antique and modern. I desire to explore the traditional and the past, and to imagine how this can inform the future. Nothing is as it seems. Subtlety is key—elegantly deviant in all forms is my slogan."[5]

Lace Maker Extraordinaire

In the nineteenth century, making Irish lace was a major source of revenue for many women across Ireland, especially during the famine years. In the twentieth and twenty-first centuries, the majority of women have been able to contribute to the family income by working outside the home in factories, schools, medical facilities, and the service industry. Educational opportunities in colleges and universities now provide women in Northern Ireland and the Republic of Ireland with the skills necessary to pursue careers in the same professions as men if they choose that option. For the many women who learned to appreciate handcraft skills from their mothers and grandmothers, the great Irish heritage of lace making is not a long-forgotten industry but a contemporary avocation.

One extremely gifted lace maker is Mary Shields, a quiet-spoken, vibrant woman who has preserved the art of making Irish laces by creating magnificent lace pieces out of linen and cotton for most of her life. Shields grew up in county Louth, an area renowned for the most famous Irish laces and lace-making schools across the island of Ireland (see chapter 6). Mary was captivated by the craft at a young age, and Mary's mother (an accomplished needlewoman) introduced her daughter to needlework and lace making, encouraging her to learn how to construct the delicate and intricate designs and styles. Along the residential streets in town, Shields watched makers from the local lace school as they sat in their doorways working on lace in the perfect morning light. In the nineteenth century, linen thread was spun finely enough and smoothly enough to be used by makers of Inishmacsaint needlepoint lace, but by the twentieth century, cotton thread had become the preferred material for most lace makers, including Shields. Cotton was pliable, smooth, and easier for lace makers to work with, and it did not contain the slubs that became prevalent in linen thread.[6]

Clones lace (crochet) wedding purse and baby booties by Máire Treanor, 2008. *Courtesy of Ulster Canal Stores Ltd., Clones, county Monaghan. Photography by David Pauley, Belfast.*

As an adult, Shields became a primary school teacher, but lace making was her passion, and she studied under the guidance of elderly lace makers in the district, collecting oral history and techniques from them. With her strong artistic background, Shields combined her professional life and artistic enthusiasm by teaching lace making to children and tutoring adults in the craft. As she became more knowledgeable, she increasingly understood the need to preserve Ireland's lace-making heritage.

Eventually, Shields widened her expertise by taking courses in lace making and design under world-renowned teachers in Ireland, England, Belgium, Holland, the Czech Republic, the United States, and Russia. Shields continues to accept new challenges and learn new skills in foreign lands while also undertaking the study of historical lace and reviving lace-making techniques no longer used in Ireland. While proficient in many lace disciplines, Shields specializes in the Irish technique of Carrickmacross lace: lace made with a needle and thread using lightweight, translucent organdy fabric and a ground of machine-made tulle (net).

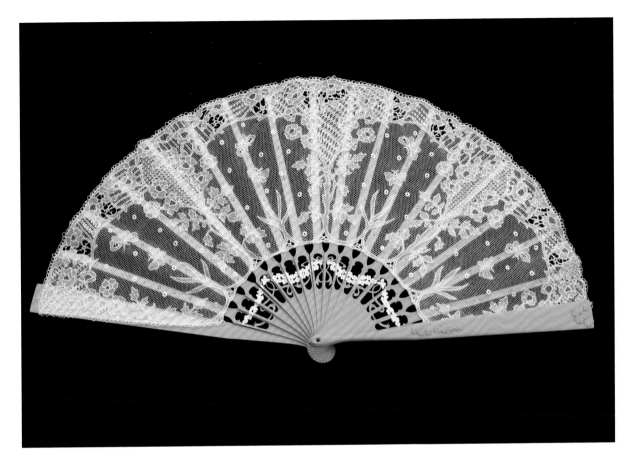

This lace can be very dramatic and lends itself to many design possibilities. Shields enjoys making Carrickmacross lace fans, but she makes a design only once before looking for a new design to tackle. Even though she prefers traditional-style Carrickmacross lace, she also enjoys experimenting with contemporary design and color. Her technical excellence and attention to the tiniest detail make Mary Shields a first-place prize winner in the most prestigious competitions year after year.[7]

Catwalk Spectacular

Over the centuries, Irish linen has served the world of fashion as undergarments, outerwear, high fashion, and accessories. The fabric lends itself to being pleated, quilted, embroidered, stretched taut, and manipulated in countless configurations to impress the wearer and please the artistry of fashion designers. Flax fibers have been blended with other natural and man-made fibers to make combinations of fabrics that are stretchable, maintain linen's characteristic breathability, and reduce the wrinkle factor of pure linen cloth.

Designers of haute couture create unique and costly costumes for their private clientele and flamboyant designs to impress judges of a catwalk show. Geraldine Connon is an award-winning designer, based in Larne (county Antrim), with a big following but not an internationally recognizable name—at least not yet. Connon strives to dress the female form in luxurious cuts of elegant cloth, and over the years, she has used Irish linen frequently.

When the Irish Linen plus Lycra blended fabric was developed in Northern Ireland (see chapter 8), Connon was one of the designers asked to design clothing to test its uses and wearability. In 2002, her designs were showcased at the private residence of the British ambassador in Paris and exhibited at Premiere Vision, the world's largest exhibition for weavers of apparel and furnishing fabrics. In a changing economy in which fashion trends are as fickle as Ireland's weather, Irish Linen plus Lycra found only a niche market in the fashion industry, but Connon continues to choose pure linen and linen blends for her designs whenever the material's properties meet the demands of her creations. John England Textiles Ltd. supplies most of the linen fabrics that Connon uses.

Connon does not have the fame of Paul Costelloe or the notoriety of Phillip Treacy. What she does have is an incredible work ethic, an eye for beauty, and a need to challenge herself, both visually and artistically, with every new design. For the past twenty-five years, Connon has stayed close to her roots in Larne, where she has dressed hundreds of bridal parties and private clients. Pleasing her clients and pushing them to wear more adventurous designs is her goal; it has kept her working around the clock, oblivious to the passing of time. Years ago, her studio, fitting rooms, and work space took over the ground floor of Connon's home, remodeled in ivory and black to resemble a Parisian fashion house. The stone house with a black wrought iron gate is situated on a quiet residential street of terraced

Linen, silk, and tulle (net) wedding ensemble designed by Geraldine Connon. This dress (photographed on the runway) was first shown at the 2009 Hair and Beauty Benevolent Ball in London. The theme for the Black and White Ball was sensuality. Since 1853, the official industry charity has raised money to provide financial support to hair and beauty professionals and their families facing illness, bereavement, or financial difficulties. *Courtesy of ACA Models and photographer Alan Glover.*

houses that date back to the 1880s, not far from where she was born. The energy and vitality of this petite, attractive woman is palpable when a client enters the front room, even before Connon appears in the doorway of her workroom. Descending from generations of tailors and seamstresses, Connon chose not to move to a big city to establish her career, for she was convinced that she could have a successful design business and also stay close to family.

Art in fashion is the core of Connon's inspiration. No matter how extreme a style may seem on the runway, her inherent sense of design is classical, enabling her to switch from pleasing a matronly mother of the bride to dressing a statuesque model in a dramatic costume of gauzy material, feathers, and beads. Her clients still find her in the same place, off the beaten path, but her designs, which constantly evolve through inspiration and an innate sense of style, resound far beyond her hometown.[8]

Elegant, Intriguing, and Costly

John England, a descendent of the Mulholland family that built the first flax-spinning mill in Belfast, established John England Textiles Ltd. in 1964 to supply 100 percent Irish linen and linen blends to leading fashion and interior designers throughout the world. In the twenty-first century, Irish linen is no longer available, but that has not slowed down England, now in his late seventies and still running the business. The company purchases its linen outside Northern Ireland, and finishing, dyeing, pleating, printing, and polishing are outsourced to firms within the United Kingdom. Famous for the innovative textures offered in the company's collections, some John England fabrics have a glossy lace effect or an iridescent printed pattern on sheer pleated linen blends, while others have metallic and pearlized coatings that raise linen to a whole new level of elegance and sophistication.

With the creative design contribution, organizational skills, and marketing savvy of Jackie Best, who has been with the firm for twenty-seven years, John England Textiles has earned a reputation for producing remarkable styles and patterns, taking advantage of technology that continually changes the look and feel of pure linen or linen blended with other natural and synthetic fibers. All patterns are designed in-house with Best in charge of each collection, from creative development to production at firms across the United Kingdom to sales to vendors around the globe. Fashion gurus Ralph Lauren and Betty Jackson use England's unique linen textures and prints for many of their high-end creations. For interior furnishings, England blends a little nylon with linen fibers to give it added strength and durability for home and commercial applications.

Ultimately, distinctive styles of well-known designers are exhibited in museums and galleries as a retrospective view of their career. Over the centuries, Irish linen has been used in various ways, depending on the creative vision of each designer. However, designers can only use materials that are produced by suppliers, and for more than forty years, fabric collections of John England Textiles have given great designers exceptional fabrics to work with. John England's linen is a constant reminder of how an organic fabric such

as Irish linen can be used to enhance high-end clothing for affluent men and women and add style and grace to the interior spaces where they live and work.[9] The photograph used at the head of this chapter is a small example of sheer linen fabric printed and pleated by John England Textiles Ltd. and used by women's fashion designers worldwide.

Students, Linen, and History

Family stories and personal anecdotes about the Irish linen industry are an important part of the valuable legacy that continues to intrigue and inspire students, the general public, and textile historians alike. Gathering together at conferences and symposiums, students and professionals listen to lectures on the history of Irish linen making—who made it, who bought it, and who wore it are subjects of interest to textile and costume fashion enthusiasts worldwide.

In 2000, the symposium title of the Costume Society of the United Kingdom was Coming and Going: Immigrant and Emigrant Dress, 1600–2000, and various interesting papers were presented on the topic. The symposium was held in the Republic of Ireland and Northern Ireland, with museum curators in both countries helping to organize each event. Because of the strong textile design and costume program at the University of Ulster, the Costume Society challenged university students in the program to research a land and design an outfit of Irish linen that would be suitable for traveling, incorporating influences, cultures, and crafts of the chosen country. The award winner was student Jane McGonagle, who used the Ulster-Scots migration to America's Appalachian Mountains for her costume design. For the skirt, she used unbleached linen cut in a full circle and burned into the cloth a series of wagon wheels to represent the long journey west. She painted rich burnt-orange trim on the skirt and linen vest to symbolize the earth, and she anticipated a bright blue sky welcoming the new immigrants, so she chose that color for the costume accessories. At the award ceremony, she explained that some of her ancestors had immigrated to Appalachia and this was her way of remembering their journey to a new land and celebrating the linen history of Ireland.

Words Recall the Past

Longley's poem invites the reader to understand the effort of processing flax, even as his words inspire thoughts of lovely, white linen enveloping a woman's body. Poet Seamus Heaney, winner of the Nobel Prize for literature in 1995, grew up on a cattle farm in county Londonderry, so he understood the life of a farmer, but his mother came from a different lifestyle; her relatives worked in the linen mills. Heaney's poem "Death of a Naturalist" is earthy with images of insects and the land itself suggesting powerful memories of a past culture of linen making—his words a timeless legacy.

Traveling costume designed in 2000 by University of Ulster student Jane McGonagle to illustrate the Ulster-Scots migration to Appalachia. Irish linen was polished, painted, and laser burned for the vest and skirt. *Private collection of the author.*

All the year the flax-dam festered in the heart
Of the townland; green and heavy headed
Flax had rotted there, weighted down by huge sods.
Daily it sweltered in the punishing sun.
Bubbles gargled delicately, bluebottles
Wove a strong gauze of sound around the smell.
There were dragon-flies, spotted butterflies.[10]

The luxurious beauty of snowy white Irish linen cloth is easily admired aesthetically, but it is challenging for the average person to appreciate the effort it took to transform the fibrous flax plant into desirable cloth. For people who worked in the industry through the decades, it was a time of hardship, sharing, and community—a lifestyle far different from what their children and grandchildren expect in the twenty-first century. For consumers who dined on white linen damask tablecloths, carried a linen lace hankie, or dressed in starched white linen clothing, it was a period of elegance and graciousness, a world apart from today's casual lifestyle of blue jeans, sweat suits, and tennis shoes. As each new generation embraces the future, we should remember and pay tribute to the past and our ancestors who defined it. The artists in this chapter have done just that, but they are only a fraction of the many creative people who work in all genres portraying their country's powerful and enduring legacy to enrich all our lives.

Chapter 12

No End in Sight

A hundred times every day I remind myself that my inner and outer life depend on the labours of other men, living and dead, and that I must exert myself in order to give in the same measure as I have received and am still receiving.

Albert Einstein, *The World as I See It*

Facing page: Corner detail of linen damask napkin handwoven for the Earl of Shrewsbury, c. 1820. "Coulsons, Lisburn, Ireland, manufrs to the King" is woven into the border of coiled stems, passion flowers, acanthus leaves, and scrolling vines. There is a cornucopia surmounted by an earl's coronet. In each corner are fruit and flowers with a ribbon tied to a bow around the stems. A narrow border of arches surrounds the main border, and the ground consists of shamrocks. *Courtesy of Irish Linen Centre and Lisburn Museum. Photography by David Pauley, Belfast.*

THERE IS NO definitive end to the story of Irish linen, as there was no fixed beginning date. It would be impossible to know who planted the first flax in Ireland, who grew the last crop, or who spun the final length of commercial linen yarn for an industry that is no longer part of the island's economy. One special company remains where once there were thousands: in the factory of Thomas Ferguson Irish Linen, the tradition for weaving fine linen continues. The company has offered exquisitely woven Irish linen to customers since 1854 and is widely acknowledged for producing quality bed linen, table linen, and tea towels. Women's handkerchiefs are lace-trimmed and men's hankies are finished with traditional hand-rolled hems. For many decades, Fergusons located in Banbridge (county Down) was one of the world's finest weavers of damask linen tablecloths and napkins, and during most of the twentieth century, it was the only firm weaving the thick and luxurious double damask. At the end of 2009, Fergusons was the last firm in Ireland still weaving linen cloth, but the yarn used by the company is spun in Belgium and France.[1] In a real sense, the Irish linen industry has become a subject for historians to analyze, research, and write about; yet the phrase *Irish linen* remains as an iconic symbol of elegance, affluence, and class.

Irish linen once permeated societies across the globe with enough force for the word *linen* to reside in human consciousness long after spindles were quieted and looms fell silent. Because the island of Ireland is a small landmass, the population's ability to produce a single product with a name that will resonate far into the future is quite extraordinary, a curious legacy that remains, at once related and unrelated to the textile industry. *Irish linen* and the descriptive adjectives associated with the fabric—*fresh, clean, white,* and *crisp*—have become a part of our vernacular and are now powerful tools used to brand a broad range of products with an image of elegance and exclusivity. These words have little to do specifically with fine-quality linen cloth, but they have been used for so long as compelling adjectives to market linen to the public that manufacturers can use the same few words to entice customers to buy an entirely different product that has nothing to do with spinning or weaving cloth.

The language we speak not only reflects or expresses our thoughts but also shapes the thoughts we wish to express, and contemporary manufacturers have determined that branding products with a combination of the words *fresh, crisp, white,* and *linen* will promote sales to a public that continues to believe that linen cloth is exclusive and superior: therefore, anything associated with the word *linen* must also be desirable. Actually, the great majority of the buying public has no understanding of how linen is made, what plant material it is made out of, or what the finished cloth should feel or smell like.

The Linen Scent

Irish Linen scented soap by Bog Standard, 2008. The photograph on the package features seed pods of the flax plant. *Private collection of the author.*

The new generation of scented products is not elitist or elegant, not in any way connected to the luxurious fabric worn by kings and queens. Lysol® Crisp Linen® Disinfectant Air Freshener Spray Crisp Linen Scent, Yankee Candle® Simply Home Crisp Linen Electric Home Fragrancer, Easy-OnÆ Speed Starch—Crisp Linen Scent, and Glade Carpet & Room Odor Eliminator Clean Linen are all products manufactured by companies and sold to millions of housewives worldwide. Lysol has gone so far as to register the trademark name Crisp Linen with the U.S. Patent and Trademark Office to provide the company with the exclusive right to use the logo on the product. None of the aforementioned fragrances have the same smell, so it is only the public's perception of a smell associated with Irish linen's quality and prestige that manufacturers want to emulate.

Bog Standard advertises "basic luxury from Ireland," including a line of scented soaps inspired by "Irish life and landscape." The company's Irish linen soap is described as a crisp, clean white soap scented with fresh lavender, and the

best-selling mini candle is advertised with the same words. However, all of the company's other candles and soaps are scented with flavors that come from obtainable fruits and berries, so why scent the linen products with lavender if there is a distinct linen smell to make use of? Linen cloth does not actually have a smell of its own; it takes an odor from the environment. Before clothes dryers became common appliances in most homes, clothing, bedding, and household textiles (regardless of fabric content) were hung outside on a clothesline to dry if space was available and weather permitted. Optimally, items were hung to dry on a sunny day with a gentle breeze when garments dried quickly; the fabric obtained a "fresh" outdoor smell, which was undoubtedly more prevalent in the country than in cities. Manufacturers of the various types of clotheslines did not mention in their advertising that environmental contaminants such as soil, dust, smoke, pollen, and animal droppings frequently came in contact with drying laundry. In rainy weather, clothes were strung in the attic— if there was one—or hung on drying racks in the kitchen, where cooking odors were more apt to linger on linens than was the smell of fresh air.

A dark, damp closet produces musty-smelling linen, but sunlight itself does not make a garment smell clean. Dirt or perspiration on a garment might make it smell unappealing, but a clean garment is one without a particular odor unless it smells like dry cleaning fluid or fabric softener. For example, two products manufactured by Procter and Gamble under the label Bounce (most commonly in the form of fabric softener sheets or bars for the clothes dryer and as lint rollers) can be purchased in "Fresh Linen Scent." Precisely what scent produced in a factory could be rolled on clothing made of wool, cotton, or synthetics to make it smell like linen is unclear. Is there a linen smell, or are advertisers associating adjectives attributed to one of the world's most well-known and, at one time, most desirable fabrics to evoke a perception of quality among the public and thereby create new consumer demand? Irish linen is made from a plant grown in the soil, but it is not advertised as smelling earthy. The firm Scentennials, a maker of scented products, suggests to its customers that they purchase the company's Linen Splash to spray on bedding to give it a smell. Famed cosmetic company Estée Lauder manufactures a fragrance branded White Linen. The company's advertising suggests that this particular scent will "capture the very essence of a perfect day . . . evokes the crispness of clean sheets . . . a kind of natural elegance that transcends the seasons."

A garment cannot smell crisp or white; instead, it is crisp to the touch or white in color. The Glidden Company manufactures a huge palette of paint colors including Crisp Linen White, and Benjamin Moore sells a paint color advertised as Linen White. On The Table, a firm based in the United Kingdom, sells products used for dining and entertaining. To promote the

Estée Lauder's Pure White Linen perfume, 2010. *Private collection of the author.*

company's popular White Linen dinnerware, it is advertised as "not plain and not white" but rather a very pale cream color.

Perception of Elitism

Some products are linked to a specific country so strongly that the brand name includes the country of origin; Irish linen has such a linkage. Even though most of the textile industry was limited to Northern Ireland by the late nineteenth century, linen cloth produced there was primarily branded, marketed, and promoted as *Irish linen,* and for the international consumer it remains part of the whole island's culture identity.

As a luxurious cloth that represents an upper-class society and lifestyle, Irish linen falls into the same category as English silverware, French Limoges china, Belgian lace, and Venetian glass. Authors use recognizable brand images to describe their characters and their surroundings, to instantly give readers images as diverse as an elegant Italian villa or a New York slum. When describing the lifestyles of the rich and famous, authors frequently choose the phrase *Irish linen* to establish the atmosphere. In the mystery novel *Briarpatch,* for example, author Ross Thomas needs the reader to envision the highest degree of sophistication and wealth as he describes the Southern mansion of oil millionaire Ace Dawson. To accomplish this task, Thomas describes a dining table that seats thirty-six guests as covered with an "Irish linen tablecloth" and set with English silver, Limoges china, and Waterford crystal.[2] There is no need for Thomas to elaborate; the four brand names instantly project elitism. It is unlikely that Irish linen as a country-of-origin brand name will be lost in the future. Few people own or have ever seen Venetian glass or Limoges china, but those names and many others, including Irish linen, will continue to signify Old World elegance and affluence in the written and spoken word with no end in sight.

The word *line* is so commonplace in the English language that users rarely consider where the word came from (it was derived from Old English and Latin words for flax) or how it was used a thousand years ago. In the tenth century, *line* was synonymous with fibers of the flax plant, and after the eighth century, *line* referred to flax spun or woven, linen thread, cloth, a napkin of linen, and, in plural, for linen vestments. In the fourteenth century, *under line* and, occasionally, *in line* described a layer of linen cloth attached to or beneath an outer layer, as well as a term for underwear; today, *lining* is the common word used to describe the layer of clth, rather than its fiber content. The word *line* has so many connotations and permutations that it rolls off the tongue in a multitude of contemporary expressions. Even the European finch, the linnet, was so named because its main diet is flaxseed.

Throughout history, linen has played a role in the social and economic development of humankind. It has served its makers as sail cloth of incredible strength and durability for world exploration; it has functioned as watertight containers for farmers and firemen; it has soothed the brows of royalty and absorbed the sweat of the working class. As outerwear and underwear, linen has covered the bodies of men, women, and children from birth to death—the rich and powerful, poor and pitiful alike. *Linen* is a word with meanings and perceptions that change through the centuries but never disappear from constant use. Above all, the most recognizable and widely appreciated adjective for linen is *Irish;* it is the perfect description for both the people and the island culture that gave the world crisp, white, Irish linen.

Notes

1. Donald Harman Akenson, *The Irish Diaspora: A Primer* (Belfast: Institute of Irish Studies, Queen's University Belfast, 1994; Toronto: P. D. Meany, 1996), 15–16.

2. For further details, see "population" and "Irish diaspora" in Sean J. Connolly, *The Oxford Companion to Irish History* (Oxford: Oxford University Press, 1998); Patrick Fitzgerald and Brian Lambkin, *Migration in Irish History, 1600–2000* (Hampshire, UK: Palgrave Macmillan, 2009).

3. Dudley Baines, *Migration in a Mature Economy: Emigration and Internal Migration in England and Wales, 1861–1900* (Cambridge: Cambridge University Press, 1986), 9; Dudley Baines, *Emigration from Europe, 1815–1930* (Cambridge: Cambridge University Press, 1991), 10.

4. Kerby Miller, *Emigrants and Exiles: Ireland and the Irish Exodus to North America* (New York: Oxford University Press, 1985).

5. Thomas M. Truxes, *Irish-American Trade, 1660–1783* (Cambridge: Cambridge University Press, 1988), 127–46.

6. Piaras Mac Éinrí, introduction to *The Irish Diaspora*, ed. Andy Bielenberg, 1–15 (London: Longman, 2000).

7. Patrick Bishop, *The Irish Empire* (London: Boxtree, 1999), 7. Italics added here and in the other quotations in this section.

8. Akenson, *Irish Diaspora*, 3–4.

9. Members of a secret Irish and Irish-American organization dedicated to the overthrow of British rule in Ireland.

10. *Hansard Parliamentary Debates*, 3rd series, March 1, 1870, vol. 199, cols. 1002–1007; Centre for Migration Studies Irish Emigration Database (hereafter referred to as CMSIED), 9910123.

11. *Vindicator*, May 6, 1846; CMSIED 9409380.

12. *Belfast News Letter*, May 25, 1865; CMSIED 107079.

13. Miller, *Emigrants and Exiles*, 26.

14. Akenson, *Irish Diaspora*, 5.

15. Miller, *Emigrants and Exiles*, 3, 11. The second chapter of Akenson's *Irish Diaspora* is "The Homeland and the Outflow."

16. E. Margaret Crawford, *The Hungry Stream: Essays on Emigration and Famine* (Belfast: Institute of Irish Studies, Queen's University of Belfast, and the Centre for Emigration Studies at the Ulster-American Folk Park, 1997), 1; Tim Pat Coogan, *Wherever Green Is Worn: The Story of the Irish Diaspora* (London: Hutchinson, 2000), x; Patrick O'Sullivan, *Patterns of Migration*, vol. 1, *The Irish World Wide: History, Heritage, Identity* (Leicester: Leicester University Press, 1992), xvii, see also discussion of "stream" and "counterstream."

17. Brenda Collins, *Flax to Fabric: The Story of Irish Linen* (Lisburn, Northern Ireland: Irish Linen Centre and Lisburn Museum, 1994).

Facing page: Image of embroidered lace digitally printed on textured linen and bonded reverse appliqué. Artist: Valerie Wilson, 2007. *Courtesy of the University of Ulster.*

18. *Belfast Evening Telegraph*, April 14, 1906; CMSIED 9412123.

19. Mick Moloney, *Far from the Shamrock Shore: The Story of Irish-American Immigration through Song* (Cork: Collins Press, 2002), 34.

20. Patrick Fitzgerald and Brian Lambkin, "Townland Diasporas," in *The Heart's Townland: Marking Boundaries in Ulster*, ed. Brian S. Turner, 88–92 (Downpatrick, Northern Ireland: Ulster History Trust, 2004).

21. Lynn Usitat [pseud.], *Linen: The Story of an Irish Industry* (Belfast: Carter Publishing, 1957), 36.

22. Irish Linen Guild, *Irish Linen: Queen of Fabrics* (Belfast: Irish Linen Guild, 1937).

23. Wallace Clark, *Linen on the Green: An Irish Mill Village, 1730–1832* (Belfast: Universities Press, 1982), x.

24. Heather Thompson, *Weaving Webs of Wealth: Two Hundred Years of Linen Manufacture in the Linen Area* (Antrim, Northern Ireland: Area Resource Centre, 1983).

25. Letter from John McKee, 113 Columbia Heights, Brooklyn, New York, USA to Mr [Rankin?], Public Record Office of Northern Ireland (hereafter referred to as PRONI) T 2753/3; CMSIED 8910007.

26. Miller, *Emigrants and Exiles*; David Fitzpatrick, *Oceans of Consolation: Personal Accounts of Irish Migration to Australia* (Cork: Cork University Press, 1994); Kerby A. Miller, Arnold Schreir, Bruce D. Boling, and David N. Doyle, eds., *Irish Immigrants in the Land of Canaan: Letters and Memoirs from Colonial and Revolutionary America, 1675–1815* (New York: Oxford University Press, 2003).

27. Fitzpatrick, *Oceans of Consolation*, 5.

28. Letter to James McBride Junr, Derriaghy, Care of Mr Wm Phillips In[n]keeper, Lisburn, County Antrim, Ireland, PRONI T 2613/5; CMSIED 9007099.

29. Letter from Susanna Boyd, Bleary, September 16, 1864, in Fitzpatrick, *Oceans of Consolation*, 387.

30. W. H. Crawford, *The Handloom Weavers and the Ulster Linen Industry* (Belfast: Ulster Historical Foundation, 1972), introduction.

31. See map of Ulster showing ports and their hinterlands, including the locations of agents for emigrant shipping, in R. J. Dickson, *Ulster Emigration to Colonial America, 1718–1775* (Belfast: Ulster Historical Foundation, 1966), 106–7.

32. Adrienne D. Hood, "Flax Seed, Fibre and Cloth: Pennyslvania's Domestic Linen Manufacture and Its Irish Connection, 1700–1830," in *The European Linen Industry in Historical Perspective*, ed. Brenda Collins and Philip Ollerenshaw, 139–58 (London: Oxford University Press, 2003).

33. Silas Weir to James Robinson, 1795, PRONI D 1140.72; CMSIED 9012017. I am grateful to my colleague Patrick Fitzgerald for this reference.

Chapter One. The People and the Place

1. Winston Churchill, speech to Royal College of Physicians, London, March 2, 1944.

2. Paul T. Nicholson and Ian Shaw, *Ancient Egyptian Materials and Technology* (Cambridge: Cambridge University Press, 2009), 467–68.

3. Brenda Collins, *Flax to Fabric: The Story of Irish Linen* (Lisburn, Northern Ireland: Irish Linen Centre and Lisburn Museum, 1994), 7–9.

4. Until Partition in 1921, the entire island of Ireland was part of the United Kingdom, which also included England, Scotland, and Wales, but now the island is divided into two separate countries. After partition, six of the nine northernmost counties in the province of Ulster became Northern Ireland and continue to be part of the United Kingdom. The rest of the island, approximately five-sixths of the landmass, was the Irish Free State until 1949, when it became the Republic of Ireland, a sovereign state not politically or economically connected to the United

Kingdom. A Northern Ireland Assembly with legislative powers granted by the central government in London was established with the signing of the Good Friday Peace Agreement in 1998 to give Northern Ireland some measure of political autonomy. This is a power-sharing executive political body comprising ministers who proportionally represent the major political parties. Northern Ireland remains part of the United Kingdom, with representation in both houses of Parliament.

5. Scutching is the process of removing the woody stem of the flax plant after it is broken. A scutching bat or knife is used to beat the broken stem away from interior fibers.

6. The official name of the city is Londonderry, but in the twenty-first century it is commonly called by the abbreviated name Derry. Many references to the city use the double "Londonderry/Derry," leading to its humorous nickname, "Stroke City."

7. James G. Leyburn, *The Scotch-Irish: A Social History* (Chapel Hill: University of North Carolina Press, 1962), 87–88.

8. The term *laird* refers to a member of the gentry; in Scotland, it is an inheritable title.

9. Untitled poem by Rev. Samuel Burdy (1754–1821), cited in John Stevenson, *Two Centuries of Life in Down, 1600–1800* (Belfast: McCaw, Stevenson and Orr, 1920), 263. The third line of the quotation ends with the word *bohea*, which rhymes with "way" and refers to a type of tea.

10. Leslie Clarkson, "The Linen Industry in Early Modern Europe," in *The Cambridge History of Western Textiles*, ed. David Jenkins, 473–92 (Cambridge: Cambridge University Press, 2003), 484.

11. Brenda Collins, research officer at the Lisburn Linen Centre and Lisburn Museum, graciously shared some esoteric facts and stories about makers and users of Irish linen in this chapter during personal communications with the author (2003–4). Much of her research is published but the author is grateful for her additional information that adds depth to the overall history.

12. Thomas M. Truxes, *Irish-American Trade, 1660–1783* (Cambridge: Cambridge University Press, 1988), 33–36.

13. Gail Fowler Mohanty, *Labor and Laborers of the Loom: Mechanization and Handloom Weavers, 1780–1840* (New York: Routledge, 2006).

14. Truxes, *Irish-American Trade*, 4.

15. Ibid.

16. Nini Rodgers, *Ireland, Slavery and Anti-Slavery: 1612–1865* (New York: Palgrave Macmillan, 2007), 95–118.

17. Truxes, *Irish-American Trade*, 66.

18. Ibid., 76.

19. Ibid., 146.

20. Robert Gavin, William Kelly, and Dolores O'Reilly, *Atlantic Gateway: The Port and City of Derry since 1700* (Dublin: Four Courts Press, 2009), 4.

21. Martha Coons, *All Sorts of Good Sufficient Cloth: Linen-Making in New England, 1640–1860* (North Andover, MA: Merrimack Valley Textile Museum, 1980), 12.

22. Quoted in Gavin, Kelly, and O'Reilly, *Atlantic Gateway*, 4.

Chapter Two. A Long Way from Field to Finish by Hand

1. Adrienne D. Hood, *The Weaver's Craft: Cloth, Commerce, and Industry in Early Pennsylvania* (Philadelphia: University of Pennsylvania Press, 2003), 16.

2. W. H. Crawford, *The Domestic Linen Industry in Ulster* (Belfast: Ulster Historical Foundation, 2005), 44.

3. Caroline Carr, unpublished research, Donegal County Museum Collection, Letterkenny, Republic of Ireland. This chapter is based in part on the unpublished research of Caroline Carr, Donegal County Museum, Letterkenny, Republic of Ireland. Her work in the museum collections gives her access to many interesting facts pertaining to the local linen culture in county Donegal. Through written and person communications (2003), Caroline graciously provided the author with additional information on processing flax into yarn.

4. Ibid.

5. Patricia Baines, *Linen Hand Spinning and Weaving* (London: B. T. Batsford, 1989), 196. Shoos were also known as *boon, shous,* or *shoves.*

6. Carr, unpublished research, Donegal County Museum Collection, Letterkenny, Republic of Ireland. Written and personal communication, 2003.

7. Ibid.

8. Baines, *Linen Hand Spinning,* 31.

9. *Report of the Commissioners Appointed to Inquire into the Date of Markets and Fairs in Ireland,* House of Commons, 1852–53, vol. 41. The parliamentary report reveals that patents were granted to numerous landlords in county Cavan as part of the Ulster Plantation. Cavan town received its patent in 1610.

10. The Williamite War in Ireland, also known as the Jacobite War in Ireland, was the opening conflict following the deposition of King James II in 1688, when he attempted to regain the throne of his Three Kingdoms from his daughter Mary II, who replaced him jointly with her husband, William of Orange. It influenced the Jacobite Rising in Scotland (which started at about the same time), led by Viscount Dundee. Although William successfully defeated Jacobitism in Ireland and subsequent Jacobite Risings were confined to Scotland and England, the war had a lasting effect on Ireland, confirming British and Protestant rule over the country for more than a century. The iconic Williamite victories of the siege of Derry and the battle of the Boyne continue to be celebrated by the Unionist community in Northern Ireland.

11. Much of the information about the Coote family and linen making in county Cavan came from the unpublished thesis of Patrick A. Cassidy (1998), graciously given to the author in 2003. During numerous personal conversations between the author and Patrick, lecturer at Cavan College of Further Studies in Cavan, the author gained additional insight into the people and culture of this particular county (2003–8).

12. Rev A. de Vlieger, *Historical and Genealogical Record of the Coote Family* (Lausanne, Switzerland: Bridel, 1900).

13. Ibid., 43.

14. *Faulkner's Dublin Journal,* September 1760.

15. Public Records Office, Belfast, Northern Ireland, D 562/1267.

16. W. H. Crawford, *Domestic Industry in Ireland—The Experience of the Linen Industry* (Dublin: Macmillan, 1972).

17. Arthur Young, *A Tour in Ireland, with General Observations on the Present State of That Kingdom . . . [1776–1779],* 2 vols. (London: T. Cadell, 1780; repr., Charleston, SC: Bibliobazaar, 2007), 1:112.

18. [Unknown author], *Linen—The Development of Machine Spinning and Power Loom Weaving,* Monaghan Museum reference book, 241.

19. Conrad Gill, *The Rise of the Irish Linen Industry* (London: Oxford University Press, 1964), 50.

20. Ibid., 315.

21. James H. Murnane and Peadar Murnane, *At the Ford of the Birches: The History of Ballybay, Its People and Vicinity* (n.p.: Murnane Brothers, 1999), 256.

22. *Proceedings of the Trustees of the Linen and Hempen Manufactures of Ireland, Year Ending 5th of January 1821* (Dublin: William Folds and Sons), 127–28.

23. Rev. Dean Richardson, Richardson Account 1740, Lodge Manuscript Collection, Armagh Public Library, Armagh, Northern Ireland.

24. W. H. Crawford, *The Irish Linen Industry* (Cultra, Northern Ireland: Ulster Folk and Transport Museum in conjunction with the Irish Linen Guild: 1987), 14.

25. H. D. Gribbon, *The History of Water Power in Ulster* (Newton Abbot, UK: David and Charles, 1969), 87.

26. Like the smaller, local bleach works, brown linen markets such as Cootehill's began to decline toward the middle of the nineteenth century, when the Industrial Revolution led to the creation of large linen factories in the Lagan Valley and linen production became more concentrated in counties Antrim and Armagh.

27. Martha Coons, *All Sorts of Good Sufficient Cloth: Linen-Making in New England, 1640–1860* (North Andover, MA: Merrimack Valley Textile Museum, 1980), 18.

28. Samuel Gregg, "Autobiography of Major Samuel Gregg, 1806," Collection of the American Textile History Museum, Lowell, Massachusetts, pp. 3–11. Copy of manuscript found among the Papers of Washington P. Gregg, of Boston Mass., by Miss Lucinda J. Gregg.

29. James Webb, *Born Fighting: How the Scots-Irish Shaped America* (New York: Broadway Books, 2004), 186–87.

30. James Irvine, ed., *Mary Cumming's Letters Home to Lisburn* (Cultra, Northern Ireland: Ulster Folk and Transport Museum, 1982), letter no. 6, dated December 6, 1811.

31. Ibid., letter no. 5, November 25, 1811.

32. Ibid., letter no. 9, February 24, 1812.

33. Ibid., letter no. 22, January 2, 1814. A pelisse is an ankle-length, figure-fitting overcoat-dress worn over a lighter dress, and usually open in the front, for house or street wear, circa 1800–70.

34. Ibid. Birth-night balls were held annually to commemorate the birth of George Washington.

35. Ibid., letter no. 19, November 14, 1813.

36. Ibid., letter no. 22, May 2, 1812.

37. David Crockett, *Narrative of the Life of David Crockett of the State of Tennessee* (Baltimore: Cary, Hart and Company, 1834).

Chapter Three. Domestic Life and Factory Work Grow Side by Side

1. Philip Ollerenshaw, "The European Linen Industry since the Middle Ages," in *The European Linen Industry in Historical Perspective*, ed. Brenda Collins and Philip Ollerenshaw, 1–41 (London: Oxford University Press, 2003).

2. Linde Lunney, "The Original Spinsters: The Role of Women in the Ulster Domestic Linen Industry," *Familia: Ulster Genealogical Review* no. 23 (2007): 39–40.

3. The bandle loom, only two feet wide, is a handloom particularly associated with Ireland and used primarily for coarse homespun linen.

4. Lunney, "Original Spinsters," 40–41.

5. John Dickey of Rockfield, county Antrim (1818), list of subscribers' names, in *Rhyming Weavers, and Other Country Poets of Antrim and Down*, ed. John Hewitt (Belfast: Blackstaff Press, 1974), 11, as cited in Lunney, "Original Spinsters," 43.

6. Olivia Elder, "To Mrs D.C.H., an account of the author's manner of spending her time," as cited in Lunney, "Original Spinsters," 43.

7. Ibid., 43–44.

8. Joseph Carson of Kilpike, county Down (1831), untitled quotation in Hewitt, *Rhyming Weavers*, 22, as cited in Lunney, "Original Spinsters," 46.

9. "Evidence before the Parliamentary Commission on Hand-Loom Weavers in the West Riding and Ireland in 1840," by a man from near Lurgan, county Armagh, quoted in Marilyn Cohen, *Linen, Family and Community in Tullylish, Co. Down, 1690–1914* (Dublin: Four Courts Press, 1992), 85, as cited in Lunney, "Original Spinsters," 46.

10. Sarah Leech, *Poems on Various Subjects by Sarah Leech, a Peasant Girl, with a Biographical Memoir* (Dublin: J. Charles, 1828), 13, as cited in Lunney, "Original Spinsters," 44.

11. Leech, "Epistle to Mr Richard Ramsay, on perusing his beautiful address to the author," 55–56, as cited in Lunney, "Original Spinsters," 44–45.

12. Brenda Collins, *Flax to Fabric: The Story of Irish Linen* (Lisburn, Northern Ireland: Irish Linen Centre and Lisburn Museum, 1994). "Slieve Croob" is from the Irish *sliabh crúib*, "mountain of the hoof."

13. In the United Kingdom and Ireland, the word *river* precedes the name.

14. Saint Monday is the tradition of absenteeism from work on a Monday by the working class, common among craftworkers since at least the seventeenth century. Payday was typically Saturday, and therefore workers often had spare money on Monday. The tradition declined during the nineteenth century, in part because of the adoption of half-day working on Saturdays, which legitimized leisure time for workers.

15. Printed cambric linen was used in London by 1595, mainly for bands, ruffs, and cuffs.

16. Brenda Collins, "Proto-industrialisation and Pre-famine Emigration," *Social History* 7, no. 2 (1982): 127–46.

17. W. H. Crawford, "The Origins of the Linen Industry in North Armagh and the Lagan Valley," *Ulster Folklife* no. 17 (1971): 42–51.

18. W. H. Crawford, *The Impact of the Domestic Linen Industry in Ulster* (Belfast: Ulster Historical Foundation, 2005), 21.

19. Collins, *Flax to Fabric*.

20. Kathleen Rankin, *The Linen Houses of the Lagan Valley: The Story of Their Families* (Belfast: Ulster Historical Foundation, 2002), 86–91.

21. Clare Brant and Susan E. Whyman, eds. *Walking the Streets of Eighteenth-Century London: John Gay's Trivia (1716).* (New York: Oxford University Press, 2007), 238n55.

22. Couching stitch is used to attach threads that are too thick or textured to pass through the foundation fabric. The thick thread is laid on top of the cloth and finer thread is wrapped around and around it from back to front, holding the heavy thread in place. Couching gives a raised appearance to the completed project. The term is from the French word *coucher*, which means to lay down.

23. Her writings are in the collection of the Ulster Museum, Belfast. See also Brenda Collins, "Matters Material and Luxurious—Eighteenth and Early Nineteenth Century Irish Linen Consumption," in *Luxury and Austerity*, ed. Jacqueline Hill and Colm Lennon, 106–20 (Dublin: University College Dublin Press, 1999).

24. Collins, *Flax to Fabric*.

25. Edith Johnson-Liik, *History of the Irish Parliament, 1692–1800* (Belfast: Ulster Historical Foundation, 2007).

26. Linen was not rolled but folded back and forth in a stack of yard-wide widths, or "laps," so it was easier for the seal master to measure. The final lap was turned outward so that the fabric quality could be assessed and stamping be done easily and quickly.

27. A web is the length of cloth that comes off the loom uncut. It is a single piece, but no particular number of yards is attached to the word *web*. It is usually the cloth woven from one warp, but a warp can be any length that the warping frame or loom beam can accommodate or the weaver chooses for that project. Today, most weavers refer to this uncut length as a bolt, but eighteenth-century weavers lapped the cloth instead of rolling it onto a cylinder.

28. James H. Murnane and Peadar Murnane, *At the Ford of the Birches: The History of Ballybay, Its People and Vicinity* (n.p.: Murnane Brothers, 1999), 256.

29. Anne McKernan, "Contested Terrain: The Making of a Market Culture in Ulster Linens," in *The Warp of Ulster's Past: Interdisciplinary Perspectives of the Irish Linen Industry, 1700–1920*, ed. Marilyn Cohen, 93–110 (New York: St. Martin's Press, 1997), 104–5.

30. S. M. Stephenson, *On the Linen and Hempen Manufactures in the Province of Ulster*, Selected Papers of the Belfast Literary Society (Belfast: Archer, 1808), 30–31.

31. Register of the flax growers of county Louth, 1796, http://www.failteromhat.com/flax/louth.htm.

32. Collins, *Flax to Fabric.*

33. Angélique Day and Patrick McWilliams, eds., *Ordnance Survey Memoirs of Ireland*, Vol. 4, no. 23. Parishes of Co. Fermanagh 1, 1834–5, Enniskillen and Upper Lough Erne (Belfast: Institute of Irish Studies/RIA, 1990). This is part of a series of county surveys edited by the authors and published between 1990–97. See "Parish of Aghavea."

The ordnance survey memoirs were conducted for parliament by field commissioners, each required to keep a journal of the scientific, economic, and historical facts about the locality he was surveying. The results were to be published accompanied by detailed maps, since it was reasoned that additional information was necessary to clarify place names and other information distinctive to each parish within the counties. In 1833, the scope was enlarged to include all aspects of country life: population, religion, architecture, archeology, politics, and literature. Although the journals had been written for each county in Ulster, an ordnance survey memoir, the term describing the writings, was only published for the parish of Templemore in county Londonderry in 1837. The government refused to support the cost to publish the other parishes surveyed, and the unpublished manuscripts were deposited in the Royal Irish Academy in Dublin. In 1990, the Institute of Irish Studies, Queen's University Belfast, began publishing a small number of the previously unpublished manuscripts. As of 1998, forty volumes of Ulster Province memoirs have been published.

For more information about the ordnance surveys in Ireland, see James R. Reilly, *Richard Griffith and His Valuations of Ireland: With an Inventory of the Books of the General Valuation of Rateable Property in Ireland* (Baltimore, MD: Clearfield Company, 2000), 3–12 and appendix 2.

34. Ibid., 13.

35. Collins, "Proto-industrialisation and Pre-famine Emigration."

36. Brenda Collins, "The Organisation of Sewing Outwork in Nineteenth Century Ulster," in *Markets and Manufacture in Early Industrial Europe*, ed. Maxine Berg, 139–58 (London: Routledge, 1991).

37. Linda May Ballard, unpublished research, National Museums of Northern Ireland. Linda May Ballard and I met in 1994 and thereafter discussed the many facets of Irish linen whenever I was in Belfast (2003–8). Before moving into an administrative position at the National Museums of Northern Ireland, Linda worked as social historian, speaker, and exhibitions curator at the Ulster Folk and Transport Museum, Cultra, Northern Ireland. In that position, she was intimately familiar with all aspects of the impressive textile collection. Linda wrote a short essay (unpublished) about lace and embroidery in nineteenth-century Ireland the author has referred to for background information in this chapter.

38. Collins, "Organisation of Sewing Outwork."

39. *Proceedings of the Trustees of the Linen and Hempen Manufactures of Ireland, for the Year 1810* (Dublin: Williamson and Folds), 171. Duck is a strong, untwilled linen (later cotton) fabric, lighter and finer than canvas; it was used for small sails and men's, especially sailors', outer clothing.

40. *Proceedings of the Trustees of the Linen and Hempen Manufactures of Ireland, for the Year 1816* (Dublin: W. Folds and Sons), 55.

41. *Proceedings of the Trustees of the Linen and Hempen Manufactures of Ireland, for the Year 1813* (Dublin: William Folds), 112.

42. *Proceedings of the Trustees of the Linen and Hempen Manufactures of Ireland, for the Year 1818* (Dublin: William Folds and Sons), 70. See also Philip Ollerenshaw, "The European Linen Industry since the Middle Ages," in *The European Linen Industry in Historical Perspective*, ed. Brenda Collins and Philip Ollerenshaw, 1–41 (London: Oxford University Press, 2003).

43. *Minutes of the Trustees of the Linen and Hempen Manufactures of Ireland, Containing the Reports of Their Secretary, on a Tour of Inspection through the Province of Ulster, in October, November, and December, 1816* (Dublin: W. Folds and Sons), 14.

44. *Proceedings of the Trustees of the Linen and Hempen Manufactures of Ireland, for the Year Ended the 5th of January, 1821* (Dublin: William Folds and Sons), appendix 84.

45. Emily Boyle, "Vertical Integration and Deintegration in the Irish Linen Industry," in *The Warp of Ulster's Past: Interdisciplinary Perspectives on the Irish Linen Industry, 1700–1920*, ed. Marilyn Cohen, 211–27 (New York: St. Martin's Press, 1997).

46. Jonathan Hamill, unpublished research, Ulster Historical Foundation, 2004. Jonathan Hamill was a research officer working on the Living Linen project at the Ulster Historical Foundation, Belfast, until he changed careers in 2006. He was a consummate researcher and wrote two essays (unpublished) to provide much of the background information on marketing and selling Irish linen. During numerous personal interviews (2003–6), Jonathan added to my knowledge of marketing linen with specific details; I rarely posed a question that he didn't have an answer to or know where I could find it.

47. Boyle, "Vertical Integration and Deintegration," 211–27.

48. Various spellings of the name include Eawarte, Yowart, Yearworthe, and Yearwort.

49. Full-page advertisement placed in the *Belfast Newsletter 200th Anniversary Supplement*, 1937, p. 1.

50. Rankin, *Linen Houses*, 76–79.

51. Boyle, "Vertical Integration and Deintegration," 211–27.

Chapter Four. Irish Linen as Cargo and Coverings on Land, Sea, and Air

1. Brenda Collins and Philip Ollerenshaw, eds., *The European Linen Industry in Historical Perspective* (London: Oxford University Press, 2003), 1–41.

2. Textile collection of the Lisburn Museum and Linen Centre, Lisburn, Northern Ireland. Duplicates of these particular textiles were made at the same time as originals and are in the Lisburn Collection.

3. Maxine Berg, *Luxury and Pleasure in Eighteenth-Century Britain* (Oxford: Oxford University Press, 2005), 259.

4. Ibid.

5. General MacArthur briefly used the hotel as his American headquarters; it was heavily bombed during the war.

6. Old Bleach Linen Co., *Old Bleach At Your Service: A Decorative History* (Randalstown, Northern Ireland: Old Bleach Linen Co., c. 1940).

7. David Jenkins, ed., *Cambridge History of Western Textiles* (Cambridge: Cambridge University Press, 2003), 504.

8. Joyce Storey, *The Thames and Hudson Manual of Textile Printing*, rev. ed. (London: Thames and Hudson, 1992), 37–40.

9. Serge Chassagne, "Calico Printing in Europe before 1780," in *Cambridge History of Western Textiles*, ed. David Jenkins, 520 (Cambridge: Cambridge University Press, 2003).

10. http://cprr.org/Museum/Engravings/Harpers_Engravings.html.

11. This fabric is now in the Collection of the Ulster Museum, National Museums of Northern Ireland, Belfast.

12. John Crandall, "Transatlantic Steam: The Great Steamships" (August 20, 2006), Suite 101.com, http://www.suite101.com/content/transatlantic-steam-a4527.

13. Sara Swain Adams, *Linen and How to Set the Table for Every Occasion* (New York: Derryvale Linen Co., 1926).

14. This information on the *Franconia* comes from the Gjenvick-Gjønvik Archives, "The Future of Our Past" (http://www.gjenvick.com/), one of the largest private archives of historical documents from the 1800s through 1954, with steamship and ocean liner documents and photographs, passenger lists, materials covering World Wars I and II, the Works Progress Administration (WPA), and immigration documents from Ellis Island, Castle Garden, and other immigration stations.

15. In 1934, Shaw Savill and Albion SS Co. took over White Star Line's Australian interests but continued on the same service. The *Ceramic* was taken over for troop transport in 1940, and in 1942 (with 656 passengers and crew on board) the *Ceramic* was torpedoed by a German submarine off the Azores. One survivor was taken prisoner and all the rest were lost.

16. Independent historian and collector Paul Louden-Brown (county Fermanagh) graciously provided the author with information for this chapter from his private papers and unpublished manuscript, "Atlantic Star—The History of the White Star Line" and through personal communications and e-mail correspondence (2008–10).

17. Ibid.

18. Author's interview with Ethel Motherwell, Jupiter, Florida, 1975.

19. For information on airplane linen, see the Talas Web site, http://www.talasonline.com/.

20. See http://www.thevintageaviator.co.nz/.

21. See http://militaryhistory.about.com/.

22. Fabrics for the Hindenburg were likely made in Germany.

23. See http://www.thevintageaviator.co.nz/.

24. The anecdote was told to his son Mike by Herbert George Catto, who was based in the western desert of North Africa during World War II. Author's telephone interview with Mike Catto, Belfast, 2010.

25. See http://militaryhistory.about.com/od/worldwariiaircraft/p/hawker-hurricane.htm.

26. This tablecloth is in the textile collection of the City Museum, The Square, Winchester, England.

27. This tablecloth is in the textile collection of the Lisburn Museum and Linen Centre, Lisburn, Northern Ireland.

28. Jonathan Hamill, Ulster Historical Foundation. Unpublished research. See chapter 3, note 46.

29. Old Bleach, *Old Bleach At Your Service.*

30. Louden-Brown, "Atlantic Star."

31. Adams, *Linen.*

Chapter Five. A Social Experiment in Two Mill Villages

1. Liam Kennedy and Philip Ollerenshaw, *An Economic History of Ulster, 1820–1940* (Manchester: Manchester University Press, 1985), 71.

2. Ibid., 124.

3. New Lanark is a restored cultural World Heritage site located between Edinburgh and Glasgow, Scotland.

4. Sion Mills cottages, unlike the typical Irish cottage of the period, were terraced. See J. Williams, *Architecture in Ireland, 1857–1892* (Dublin: Irish Academic Press, 1994), 358.

5. Celia (Herdman) Ferguson, Sion Mills History and Heritage, 2002; see also diary of James Herdman, private collection, and http://www.sionmills.org. Author's personal interviews with Celia, Sion Mills, 2003–8.

6. Ashlar stone is masonry composed of rectangular units, generally larger in size than brick and properly bonded, having sawn, dressed, or squared beds and mortared joints.

7. Author's interviews with retired female mill workers living in Sion Mills, 2004.

8. The name change to "Herdmans Ltd." occurred in the twentieth century.

9. Celia (Herdman) Ferguson, Sion Mills Buildings Preservation Trust, http://www.sionmills.org.

10. Six hundred workers were laid off during the final two years. Herdmans Ltd. planned to maintain a manufacturing facility in South Africa.

11. Richard H Blum, Bessbrook: A Record of Industry in a Northern Ireland Village Community and of a Social Experiment, 1845–1945 (Belfast: Bessbrook Spinning Co. and J. N. Richardson Sons and Owden, 1945), 13.

12. Arthur P. Williamson, "Enterprise: Industrial Development and Social Planning" (Paper presented at the University of Ulster at Magee, Department of Social Administration, Londonderry, 1992).

13. Emily Boyle, "Vertical Integration and Deintegration in the Irish Linen Industry," in The Warp of Ulster's Past: Interdisciplinary Perspectives on the Irish Linen Industry, 1700–1920, ed. Marilyn Cohen, 211–28 (New York: St. Martin's Press, 1997), 224.

14. Williamson, "Enterprise."

15. J. Ewing Ritchie, Bessbrook and Its Linen Mills (London: William Tweedie, 1876), 12–21.

16. Blum, Bessbrook, 61.

17. Ferguson, Sion Mills Buildings Preservation Trust, http://www.sionmills.org.

18. "Irish Potato Famine," http://www.historyplace.com/worldhistory/famine/index.html.

Chapter Six. Famine for the Poor, Lace for the Rich

1. Mairead Dunlevy (1941–2008) provided much of the information in this chapter as an unpublished essay written for the author in 2003. As keeper for the art and industrial division at the National Museum of Ireland at Collins Barracks, Dublin, Mairead was highly regarded nationally and internationally for her vast knowledge of Irish fashion and textiles. Additional facts were provided during personal communications in 2002 and 2005. Due to her many years of research and her intimate knowledge of the museum's textile collection, Mairead was a leading museum professional in Irish decorative arts and her work has left a rich legacy of learned publications. The author is greatly appreciative of Mairead's willingness to share information and specific references on the subject of lace and embroidery.

2. E. R. R. Green, Industrial Archaeology of County Down (Belfast: Her Majesty's Stationery Office, 1963), 9.

3. Pue's Occurrences, January 21–25, 1746, 2.

4. Sean J. Connolly, ed. The Oxford Companion to Irish History (Oxford: Oxford University Press, 1998/2004). In 1968, the society initiated a national craft competition, an exhibition that is held every year in conjunction with the August Horse Show. Within thirty years, there were nearly a thousand entries.

5. Samuel Madden, A Letter to the Dublin Society (Dublin: privately printed, 1739); Arthur Dobbs, An Essay on the Trade and Improvement of Ireland (Dublin: privately printed, 1729); Fintan Cullen, "Samuel Madden, Reflections and Resolution, 1738," in Cullen, ed., Sources in Irish Art: A Reader (Cork: Cork University Press, 2000), 163.

6. Proceedings of the Dublin Society, minutes, March 25, 1742.

7. Miss Eyre of Dawson Street, Dublin, was presented with a silver medal by the Dublin Society for this invention. Miss Sarah Persse also made needlework in imitation of point lace, and Miss Isabella Hamilton worked a cloak in network (Dunlevy, unpublished essay).

8. Bobbinet tulle is constructed of warp and weft yarns in which the weft yarn is looped diagonally around the vertical warp yarn to form a hexagonal mesh that is regular and clearly defined. Bobbinet netting is uniform, durable, flexible, and sheer and has a high strength-to-weight ratio. The net is used for bridal wear, fashion, lingerie, and embroidery.

9. Limerick lace is associated with the city of Limerick, Ireland. It is an embroidered needle lace formed on a mesh (net) using one or both of two techniques: tambour, in which a chain stitch is created using a hook; and neddlerun, in which stitches are darned into the ground net using a needle.

10. Crochet is a form of needlework lace consisting of the interlocking of looped stitches formed with a single thread and a hooked needle called a crochet hook. Tatting is a form of knotted net worked with a small, specialized tatting shuttle.

11. Peter Duffy, *The Killing of Major Denis Mahon* (New York: HarperCollins, 2007).

12. Tom Smallman, F. Davenport, and D. Talbot, *Ireland* (Oakland, CA: Lonely Planet Publications, 2004), 449.

13. Duffy, *Killing of Major Denis Mahon*, 13.

14. In 1847, the population of Mahon's estate is estimated as having been twelve thousand people. Three thousand had already been removed, one thousand had been transported, and two thousand were paid to leave quietly. There were plans to evict another six thousand in the coming months.

15. For a list of flax growers in county Louth, 1796, see http://www.failteromhat.com/flax/louth.htm.

16. Greg Romaneck, *Albert and Jennie: A Civil War Story* (Bloomington, IN: AuthorHouse, 2006).

17. *Irish Industrial Association*, Chicago Exhibition, 1893.

18. Colum Kenny, "Paradox or Pragmatist? Honest Tristram Kennedy (1805–85): Lawyer, Educationalist, Land Agent and Member of Parliament," *Proceedings of the Royal Irish Academy* 92C, no. 1 (1992): 10–15.

19. Miss Papworth is said to have worked the pieces numbered A&I 1895.457 in the National Museum of Ireland. The designs have been attributed to the architect George Papworth (1775–1847) of Raheny, Dublin. John Turpin, "The Dublin Society's School of Architectural Drawing," *Bulletin of the Irish Georgian Society* 28 (1985): 19; *Dublin Evening Post*, September 3, 1853, 3.

20. Guipure is a needlepoint lace made with a heavy buttonhole stitch and with the pattern on a coarse mesh or held together with connecting threads. Cambric is a thin, plain cotton or linen fabric of fine close weave, usually white. The name comes from the French town Cambrai, where it was first woven in the sixteenth century and where high-quality linens were originally developed and produced. "Irish Home Industries—Irish Lace," *Irish Builder*, July 1, 1883, 210.

21. See the catalog *Great Exhibition of the Works of Industry of All Nations* (London, 1851), 2:561.

22. Accession no. 9954, crochet textile pieces, Miss V. Hughes, Divis St., Belfast from T. Hamill, Trench House, Belfast, PRONI T3051/1–4; Zillah Halls, *Machine-Made Lace in Nottingham in the 18th and 19th Centuries* (Nottingham, UK: Nottingham Publishers, 1973), 52.

23. The raised point lace was worked over linen cord or horsehair.

24. Inishmacsaint itself is an island in Lough Erne near Enniskillen, county Fermanagh, Northern Ireland.

25. Linen thread was also used in Limavady (torchon or pillow lace edgings) and occasionally in Ardara (crochet). Barbour's of Lisburn made excellent linen thread.

26. *Great Exhibition*, 2:566.

27. Mary explained tatting in more detail in an earlier paragraph of her letter (see chapter 2). James Irvine, ed., *Mary Cumming's Letters Home to Lisburn* (Cultra, Northern Ireland: Ulster Folk and Transport Museum, 1982), letter no. 22.

28. Mairead Dunlevy and E. Charles Nelson, "Sir William's Irish Lace: Gifts from an Irish Viscountess," *Curtis's Botanical Magazine* 12, pt. 4 (November 1995): 220–36.

29. Author's interview with Paddy Boylan, Ulster Canal Stores, county Monaghan, Ireland, 2002.

30. Susannah Meredith, *The Lacemakers: Sketches of Irish Characters with Sound Accounts of the Effort to Establish Lacemaking in Ireland* (London: Jackson, Walford, and Hodder, 1865).

31. *The Anglo-Celt* (Co. Cavan), September 21, 1854, 2. Weekly newspaper.

32. Magdalene asylums grew out of the rescue movement in Britain and Ireland in the nineteenth century; the original purpose of these facilities was to rehabilitate women who had worked as prostitutes. In Ireland, the institutions were named for St. Mary Magdalene and were run by the Roman Catholic Church. Women were expected to contribute hard labor, usually in laundries, to pay their expenses. In the late twentieth century, the asylums were exposed as institutions where forced detention and systematic mental and physical abuse of young women commonly occurred.

33. In the early years of the twentieth century, the school was renamed the School of Art of the Municipal Institute of Technology, Belfast, promoting the links between creative design and the textile technologies. Two well-known Ulster painters, William Conor and Colin Middleton (the father of the latter was a damask designer), trained at the school.

34. J. H. Bruce, *H. R. Lilley: Artist and Designer, 1886–1970* (Belfast: Cultural Traditions Group of the Northern Ireland Community Relations Council, 1997). An extensive legacy of Lilley textiles and documents is in the collection of the Ulster Folk and Transport Museum, Cultra, Northern Ireland.

35. The two kinds of lace sold directly to merchants in London and Nottingham were Limerick lace after 1829 and Kells lace after 1825.

36. *Irish Society*, August 3, 1889, and September 2 and June 24, 1893.

37. *Broderie anglaise* is a form of whitework embroidery in which round or oval holes are pierced in the material (such as cotton) and the cut edges are then overcast; these holes, or eyelets, are grouped in a pattern that is further delineated by simple embroidery stitches on the surrounding material. The technique originated in sixteenth-century Europe and was not confined to England, as its name would imply. In the nineteenth century, it was much used on nightwear and underclothing, with transfers being used to rough out the design. Present-day *broderie anglaise* is generally done by machine. *Encyclopedia Britannica Online*, http://www.britannica.com/bps/browse/alpha/b/158.

38. Linda May Ballard, "National Museums of Northern Ireland," unpublished essay, 2002.

39. Author's interview with director Paddy Boylan, Ulster Canal Stores, Clones, Ireland, 2002. The Canal Stores is an eighteenth-century stone warehouse exhibiting handcrafts of the Great Famine.

40. John McCormack was one of the greatest, most versatile singers of the last century. Not only did the Irish tenor sing famous folk songs such as "When Irish Eyes Are Smiling," he also was a much-admired opera singer, performing in music halls worldwide. He was granted the title of count by Pope Pious XII; the holder of this title is a temporal sovereign often known as a Roman count but is not part of the United Kingdom hierarchy (there are no counts in the United Kingdom's arcane ranking of nobility). Accordingly, Mrs. McCormack signed her letters "Countess McCormack."

41. Author's interview with Kathleen and Arthur McCabe, nephew of Sarah McCabe, October 2002. Information in this section also came from the author's research and study of the private papers of Sarah McCabe, 2008.

42. Author's interview with Ruth Lynch, daughter of Gertrude Jones, Tazewell, Virginia, 1993.

43. Details are available at the official wedding website, http://www.officialroyalwedding2011.org/blog/2011/April/29/The-Wedding-Dress--Bridesmaids--Dresses-and-Pages--Uniforms.

44. Joanna Bourke, "I Was Always Fond of My Pillow: The Handmade Lace Industry in the United Kingdom, 1870–1914," *Rural History* 5 (1994): 156–59.

Chapter Seven. Linenopolis Leads the Industrialization of Irish Linen

1. Brenda Collins, "The Loom, the Land, and the Marketplace: Women Weavers and the Family Economy in Late Nineteenth- and Early Twentieth-Century Ireland," in *The Warp of Ulster's Past: Interdisciplinary Perspectives on the Irish Linen Industry, 1700–1920*, ed. Marilyn Cohen, 229–52 (New York: St. Martin's Press, 1997), 237; J. H. Bruce, *H. R. Lilley: Artist and Designer, 1886–1970* (Belfast: Cultural Traditions Group of the Northern Ireland Community Relations Council, 1997), 4.

2. The statistics are from a full-page advertisement placed on page 1 of the *Belfast Newsletter*'s 200th Anniversary Supplement in 1937.

3. Angela Bourke, *The Field Day Anthology of Irish Writing*, vol. 5, *Irish Women's Writing and Traditions* (New York: New York University Press, 2002), 464–65.

4. This mill became the York Street Flax Spinning Company.

5. The Linen Board can be traced back to Queen Anne's reign, when a board of trustees was appointed to encourage flax and linen trades in Ireland. The resultant Linen Board was officially ratified in 1707. The annual grant given to the Linen Board by the British government was halved in 1826 and ended altogether in 1828.

6. Jonathan Hamill, Ulster Historical Foundation. Unpublished research, 2003, and personal interviews, 2003–6.

7. Marion Green, *Mill to Millennium* (Belfast: December Publications, Springfield Inter-Community Development Project, 1996), 4.

8. Ibid., 10.

9. Byssinosis is a disease of the lungs caused by breathing in cotton dust or dusts from other vegetable fibers (such as flax, hemp, or sisal) while at work.

10. W. A. McCutcheon, *The Industrial Archaeology of Northern Ireland* (Rutherford, NJ: Fairleigh Dickinson University Press, 1984), 323.

11. Green, *Mill to Millennium*, 16.

12. A roving is a long, narrow bundle of fiber. Rovings are created by carding the fiber, then drawing it into long strips. Carded fibers are not parallel and not uniform in length, so roving is only one of the many steps needed to process fiber into spun yarn.

13. Green, *Mill to Millennium*, 16.

14. Onychia is an inflammation or infection of the nail matrix, resulting in deformity or loss of the nail plate.

15. Betty Messenger, *Picking Up the Linen Threads* (Belfast: Blackstaff Press, 1988), 41–42.

16. *Doffer* is a generic term encompassing a variety of jobs that an individual would be assigned prior to becoming a full-time spinner. The word *doffer* also denotes a specific supervisory position over spinners.

17. Green, *Mill to Millennium*, 14–15.

18. Messenger, *Picking Up the Linen Threads*, 62.

19. Alan Lomax, Archive of American Folk Song, Library of Congress. Lomax went to Ireland in 1951 to record native singers and musicians. Additionally, Peter Kennedy from England, Sean O'Boyle from Belfast, and Seamus Ennis

from Dublin were commissioned by the British Broadcasting Corporation (BBC) to record singers and musicians throughout Ulster in the early 1950s for broadcasting on the radio.

20. Messenger, *Picking Up the Linen Threads*, 62.

21. A. L. Lloyd, *Folk Song in England* (London: Lawrence and Wishart, 1967), 323.

22. Pete Seeger, *Carry It On: A History in Song and Picture of Working Men and Women of America* (London: Blandford Press, 1985), 27–28.

23. Messenger, *Picking Up the Linen Threads*, 49.

24. Ibid., 46.

25. "The Doffing Mistress," in Maurice Leyden, *Belfast: City of Song* (Dingle, Republic of Ireland: Brandon Book Publishers, 1989).

26. Liam Kennedy and Philip Ollerenshaw, *An Economic History of Ulster, 1820–1940* (Manchester: Manchester University Press, 1985), 173.

27. Independent historian and musician Maurice Leyden (Belfast) generously provided the author with an unpublished essay of informative historical background about the song tradition of female mill workers used in this chapter. During personal interviews (2002 and 2008) and e-mail correspondence, he shared additional insights for the author to better understand the mill culture of the time. Maurice has written extensively on the subject and published many of the factory songs on CDs.

28. Author's interview with Baroness May Blood, Belfast, 2003.

29. Emily Boyle, "Linenopolis: The Rise of the Textile Industry in Belfast," in *Belfast: The Making of the City, 1800–1914*, ed. James Camlin Beckett (Belfast: Appletree Press, 1983), 51.

30. Conrad Gill, *The Rise of the Irish Linen Industry* (London: Oxford University Press, 1964), 319.

31. Richard H. Blum, *Bessbrook: A Record of Industry in a Northern Ireland Village Community and of a Social Experiment, 1845–1945* (Belfast: Bessbrook Spinning Co. and J. N. Richardson Sons and Owden, 1945).

32. Author's interview with Mike Catto, historian and broadcaster, Belfast, Northern Ireland, 2006. Personal communication, 2010.

33. Green, *Mill to Millennium*, 16.

34. *Reports from Commissioners, Inspectors, and Others*, vol. 11, *Factories and Workshops, Part 2: Annual Report by the Chief Inspector* (London: Parliament, 1900), 38.

35. "Catherine, age 64," in ibid., 17.

36. Messenger, *Picking Up the Linen Threads*, 57.

37. William Topping, *A Life in Linenopolis* (Belfast: Ulster Historical Foundation, 1992), 20–21.

38. Hamill, unpublished research, 2003, and personal interviews, 2003–6.

39. Messenger, *Picking Up the Linen Thread*, 133.

40. The Ulster vernacular phrase *going to the parliament* is an adaptation of *sitting on the throne*, a term used more widely throughout the United Kingdom. A session in the British parliament is known as a sitting.

41. Green, *Mill to Millennium*, 21.

42. Hamill, personal conversation with Mrs. Grimes, Edenderry, Northern Ireland, 2004.

43. Jim Johnston, *A Well-Spun Thread: Memoirs from Mossley Mill* (Newtownabbey, Northern Ireland: Newtownabbey Borough Council, n.d.), 23.

44. Ibid., 41–43.

45. Ibid., 47.

46. Messenger, *Picking Up the Linen Threads*, 41.

47. Author's interviews with Baroness May Blood, Belfast, 2001–8.

48. Ibid.

49. Messenger, *Picking Up the Linen Threads*, 155.

50. Duck is a strong untwilled linen (later, cotton) fabric, lighter and finer than canvas, used for small sails and men's (especially sailors') outer clothing. Duck is favored by many painters for smaller works of art because it is lighter than the heavy canvas needed to support large paintings. Drill is a durable linen or cotton twill of varying weights, generally used for work clothes.

51. Green, *Mill to Millennium*, 20–25.

52. Author's interview with Baroness May Blood, 2005. The 1980 and 1981 Irish hunger strikes were the culmination of a five-year protest during The Troubles by Irish republican prisoners in Northern Ireland; ten died in the 1981 strike.

53. Green, *Mill to Millennium*, 27–30.

Chapter Eight. Smoothing Out the Wrinkles . . . or Not

1. Elizabeth McCrum, keeper of applied art, Ulster Museum, National Museums of Ireland (retired), was instrumental to my understanding of the many ways in which Ireland has used linen in fashion over the centuries. During many personal interviews (2002–8), she shared her vast knowledge of fashion and the way society in Great Britain and Ireland dressed women through the ages. Elizabeth gave me access to the museum's significant textile collection and directed my attention to the important artifacts to write about and photograph for the book. She also wrote a short essay for me to use as background information.

2. Aileen Ribeiro, *Dress in Eighteenth Century Europe, 1715–1789* (London: Batsford, 1984), 57. Most women built up a trousseau of at least a dozen of each item of underwear, and Ribeiro mentions a French bride who included a hundred dozen shifts in her trousseau.

3. Rogier van der Weyden's female portraits, such as *Portrait of an Unknown Lady*, circa 1460, have ironed creases plainly visible, and the distinctive Irish women's headdresses are often remarked on in the seventeenth century. *The Family of Thomas Bateson, Esq.* (1762), by Strickland Lowry, illustrates the lavish use of white embroidered accessories. Collection of Ulster Museum, Belfast.

4. Ribeiro, *Dress in Eighteenth Century*, 100. Beau Brummell, the Regency-era arbiter of taste, whose neckcloth ties were much admired, recommended "very fine linen, and plenty of it, and country-washing," quoted in Mairead Dunlevy, unpublished essay.

5. Mairead Dunlevy, "The Way We Wore: 250 Years of Irish Clothing and Jewellery," brochure for permanent exhibition (Dublin: National Museum of Ireland, 2000).

6. The French term *lingerie* still describes underwear, whether of linen or not.

7. *Belfast Newsletter* advertisements in the late eighteenth century often cited more than forty types of cloth.

8. In 1786, Marie Antoinette spent approximately £135,000 on a dress.

9. Fashionable dress can be briefly defined as that which originated in the late medieval courts of Western Europe and conferred status not merely by its fineness but most characteristically by the constant change from one style to another. Fashion, reflective of society's values, is one of the most vital of the applied arts.

10. Although primarily featuring anti-Irish propaganda, Derricke woodcuts (c. 1581) give a vivid illustration of the distinctive native Irish dress of the time. James A. Knapp, *Illustrating the Past in Early Modern England: The Representation of History in Printed Books.* (Surrey, UK: Ashgate Publishing, 2003), 210–13.

11. Many of these jackets are documented as having once existed in the Textile and Costume Collection of the Ulster Museum in Belfast, but they were lost in a bombing that destroyed the museum's textile collection in 1976.

12. A dress of this type belonging to Mrs. John Dunlop is in the collection of the Ulster Museum, Belfast.

13. According to fashion commentator Martin Raymond. http://www.textilesandbicycles.wordpress.com/2008/03/15/welcome-to-my-stash-linen-my-love.

14. A surplice is a loose vestment of white linen having wide sleeves and, in its amplest form, reaching to the feet. It was worn (usually over a cassock) by clerics, choristers, and others taking part in church services.

15. Poplin is a strong fabric characterized by fine, closely spaced, crosswise ribs.

16. Mairead Dunlevy, *Dress in Ireland: A History* (London: Batsford, 1989), 160. Tea gowns were informal, loose-fitting gowns worn at home beginning in the late 1870s. Tussore is an oriental moth that produces brownish silk.

17. A fine example belonging to Miss Heather Firbank (T.23&A-1960) is in the collection of the Victoria and Albert Museum, London.

18. An example of an appliquéd petal dress in pale lilac lawn by Madeleine Vionnet, dated 1920, is in the collection of the Victoria and Albert Museum, London.

19. Examples of garments by these designers are in the collection of the Ulster Museum, Belfast.

20. Dress of the Year awards began in 1963, when the Museum of Costume (now named the Fashion Museum) opened in Bath. Each year the Fashion Museum asks a fashion expert to choose his or her top fashion outfit or look of the year for the collection. The Dress of the Year collection now numbers over fifty pieces, along with show-stopping accessories.

21. In 2008, Maggie established a line of yarns that include linen and linen blends sold across the United States, in the United Kingdom, and in Europe. She has written sixteen knitting pattern books and another about Ireland; she continues to win awards for her creative knitwear designs.

22. Lycra and Irish Linen plus Lycra are registered trademarks for the fabric and the blend of fibers.

23. The Drake Room opened in December 21, 1945. It was a success from the start with its unique ceramic tree, great food, and impeccable service. Famous entertainers, bankers, and politicians made the Drake Room one of the most cosmopolitan dining rooms in New York. One of the most famous dishes served was Steak Diane. Swissotel of Zurich owned the hotel when it was demolished in 2009.

Chapter Nine. Bright White and Crisply Starched

1. Robert Gavin, University of Ulster Magee, contributed general background information and many specific details used in this chapter. Between 2003–8, we met personally to discuss the shirt industry and exchanged numerous e-mails over the years. I am grateful for his help and advice.

2. Robert Gavin, William Kelly, and Dolores O'Reilly, *Atlantic Gateway: The Port and City of Londonderry since 1700* (Dublin: Four Courts Press, 2009), 3–4.

3. Ibid., 12–13.

4. Ibid., 19, 23; *Ordnance Survey Memoir: Parish of Templemore* (Dublin, 1837), 15:258, 268–71.

5. *Ordnance Survey Memoir: Parish of Templemore*, 15:104, 25:92–93.

6. Maxine Berg, *The Machinery Question and the Making of Political Economy, 1815–1848* (Cambridge: Cambridge University Press, 1982), 238–39.

7. Gavin, Kelly, and O'Reilly, *Atlantic Gateway*, 35.

8. Ibid., 40–42.

9. *Ordnance Survey Memoir: Parish of Templemore*, 15:288.

10. Gavin, Kelly, and O'Reilly, *Atlantic Gateway*, 33–34.

11. Julie Ann Grew, "The Derry Shirt-Making Industry, 1831–1913" (M.Phil. diss., University of Ulster, 1987); Gavin, Kelly, and O'Reilly, *Atlantic Gateway*, 78, 194.

12. Geraldine McCarter, *Derry's Shirt Tale* (Derry: Guildhall Press, 1991).

13. M. de Garsault, *L'art de la lingère* (1769; reprint, Neuchâtel, 1780), http://www.marquise.de/en/1700/howto/maenner/18hemd.shtml. This document included instructions and patterns for making underwear, caps, and whatever else was made of white linen.

14. *Ready-to-wear* refers to mass-produced clothing. In the United States, *custom-made* describes clothing made to a client's individual size and taste; in Britain, *bespoke* is a word used to refer to anything custom-made for a particular customer.

15. Personal interview with Robert Gavin, Derry, 2005.

16. John Hume, *Derry beyond the Walls: Social and Economic Aspects of the Growth of Derry, 1825–1850* (Belfast: Ulster Historical Foundation, 2002), 111; McCarter, *Derry's Shirt Tale*, 15–17.

17. Hume, *Derry beyond the Walls*, 162–63.

18. Liam Kennedy and Phillip Ollerenshaw, *An Economic History of Ulster, 1820–1940* (Manchester: Manchester University Press, 1985), 85.

19. *Londonderry Guardian*, August 6, 1863, and March 14, 1867; *Hansard's Parliamentary Debates*, 3rd series, vol. 22, cols. 59–60.

20. Patrick Durin, *Tillies* (Derry: Guildhall Press, 2005), 18, 30, 37–40.

21. McCarter, *Derry's Shirt Tale*, 13; Hume, *Derry beyond the Walls*, 111; Brian Mitchell, *The Making of Derry: An Economic History* (Derry: Genealogy Centre, 1992), 103–5.

22. Durin, *Tillies*, 34; Gavin, Kelly, and O'Reilly, *Atlantic Gateway*, 80.

23. Charles Lanyon designed Sion House for Herdmans in 1846 (see chapter 5).

24. A wythe is a continuous vertical section of masonry one unit in thickness. It may be independent of, or interlocked with, the adjoining wythe(s). A single wythe of brick is referred to as a veneer.

25. Gavin, Kelly, and O'Reilly, *Atlantic Gateway*, 157.

26. *Masters of Shirtmaking: The Story of Radiac*, available online at the website "History of Shirtmaking from the 1840s to 1950s and the Involvement of Powell & Henderson," http://www.h-f-h.org.uk/gallery/shirtmaking.html. Radiac was one trade name for shirts produced by McIntyre Hogg Marsh and Co.

27. McIntyre Hogg Marsh and Co. sales brochure, author's collection.

28. Durin, *Tillies*, 18, 44; Gavin, Kelly, and O'Reilly, *Atlantic Gateway*, 157; James A. Schmiechen, *Sweated Industries and Sweated Labor: The London Clothing Trades, 1860–1914* (London: Croom Helm, 1984), 32–82; Martin E. Popkin, *Organization, Management, and Technology in the Manufacture of Men's Clothing* (New York: J. Pitman and Sons, 1939), 18.

29. *Londonderry Sentinel*, December 29, 1888.

30. Alan D. Davis, "The Legend, the Leisure and the Lure of the Guayabera," LocoStyle.com, May 2008.

31. Kevin Gray, "Cuban Shirt Known as Guayabera Enjoys Revival," *Cuba Culture*, May 19, 2003.

Chapter Ten. Marketing Irish Linen Worldwide

1. Jonathan Hamill, Ulster Historical Foundation. Unpublished research, 2004; personal interviews, 2003–6.

2. In 1921, twenty-six counties became the Irish Free State and were granted Dominion status within the British Empire; they did not become the totally independent Republic of Ireland until 1949. The Irish Civil War (1921–23) was fought between those who supported the treaty that gave the state partial independence and those who wanted full and immediate autonomy.

3. Kathleen Curtis Wilson, Gary McCain, and Nina M. Ray, *The Challenge of Creating and Maintaining Respected Country-of-Origin Assets* (Littleton, CO: Clute Institute for Academic Research, 2006).

4. Old Bleach Linen Co., *Old Bleach At Your Service: A Decorative History* (Randalstown, Northern Ireland: Old Bleach Linen Co., c. 1940), 3.

5. Author's interview with Paul Larmor, marketing services manager, Ulster Weavers Home Fashions Ltd., Northern Ireland, 2009.

6. Approval Standard for Unlined Linen Fire Hose, Class Number 2121, September 1970 (2002 FM Approvals LLC).

7. Renata Polt, "Lisburn's Irish Linen Centre: Woven Treasures," *Travelworld* online magazine, http://classic .travelworldmagazine.com/includes/print.php?ArticleID=391.

8. The RDS site covers forty acres; there are ten exhibition halls, meeting rooms, a stadium, and eating facilities. When the Craft Council was founded in 1971, the Royal Dublin Society was a founding member.

9. William W. Freehling, *The Road to Disunion* (New York: Oxford University Press, 2007), 2:148.

10. However, Bryan was undoubtedly purchasing Irish linen well before 1934. The warehouse location is found in New Orleans City Directory, 1934, Louisiana State Museum, New Orleans.

11. Hamill, unpublished research, 2004; personal interviews, 2003–6.

12. Linen Thread Co., *The Faithful Fibre: The Story of the Development of the Linen Thread Company Limited and Its Subsidiaries* (Glasgow: Linen Thread Co., n.d.), 37, 67.

13. Mark Casson, ed., *The Rise of Big Business* (New York: Routledge, 1997), 136–37.

14. Stephen E. Tracy, "Barbour's Linen Flax Thread as a Substitute for Pagenstecher Thread," *Journal of the American Medical Association* 70, no. 23 (1918): 1787.

15. Herman A. Haubold, *Preparatory and After Treatment in Operative Cases* (New York: D. Appleton, 1910), 100–101.

16. The first awards for loyal service to the English sovereign for providing goods and services were granted to trade guilds in the twelfth century. Royal charters were granted to the Weaver's Company in 1155 by Henry II and to Mercers, who traded in luxury fabrics in 1394. By the late eighteenth century, warrant holders were displaying the royal arms to signify their prestigious patronage. Queen Victoria and her family granted more than two thousand royal warrants during her sixty-four-year reign.

17. Emily Boyle, "Vertical Integration and Deintegration in the Irish Linen Industry," in *The Warp of Ulster's Past: Interdisciplinary Perspectives on the Irish Linen Industry, 1700–1920*, ed. Marilyn Cohen, 211–28 (New York: St. Martin's Press, 1997), 223.

18. [Author unknown], *Industries of the North One Hundred Years Ago—Industrial and Commercial Life in the North of Ireland, 1888–1891* (Belfast: Friar's Bush Press, 1986), 26.

19. Hamill, unpublished research, 2004; personal interviews, 2003–6.

20. Andrew Maykuth, "John Wanamaker: A Retailing Innovator," *Philadelphia Inquirer*, June 22, 1995.

21. Http://www.Fairmont.com/BanffSprings. The Canadian Pacific Railway began a program of enhancement and expansion for the Banff Springs Hotel that ran from 1900 to 1928, when the current hotel (now the Fairmont Banff Springs Hotel) was finished. Throughout the 1920s and 1930s, the facility combined day-to-day hotel life with the concept of luxurious living; it was a time of stylish attire, tasteful entertainment, and refined etiquette. The 1930s were also a time of promoting tourism as travel conditions continued to improve, and the hotel hosted many high-society guests, including heads of states and actors visiting the hotel for photo opportunities. Helen Keller, King George VI, and Queen Elizabeth visited the hotel, and Benny Goodman was influential in Banff's obtaining a landing

strip, as he wanted to stay at the hotel but could only do so if there was an area to land his plane. Stanley Thompson, a world-recognized golf course designer, was selected to construct a splendid mountain golf course.

22. Irish Linen Centre and Lisburn Museum.

23. Author's telephone interview and e-mail correspondence with Richard Saunders, chairman of the Irish Linen Guild, 2009.

24. Author's interviews with Linda MacHugh, director of the Northern Ireland Textiles and Apparel Association, and Cathy Martin, of the Irish Linen Guild in Hillsborough, Northern Ireland, 2004.

25. Http://www.singermemories.com.

26. Susan Crabtree and Peter Beudert, *Scenic Art for the Theatre: History, Tools, and Techniques* (Boston, MA: Focal Press, 1998), 148.

27. Old Bleach Linen Co., "Irish Linen . . . Special Export Service through Our Representatives in the U.S.," promotional booklet (Randalstown, Northern Ireland: Old Bleach Linen Co., n.d.), 1–11, author's collection.

28. Ibid.

29. Ibid.

30. Ibid.

31. Author's interview with Joan Smyth, daughter of Kathleen Carson, the eighth daughter of J. M. Carson of Randalstown. Her brother Jack worked for Old Bleach, and Mr. McColl was a friend of the Carson family.

32. Peter Collins, *The Making of Irish Linen: Historic Photographs of an Ulster Industry* (Belfast: Friar's Bush Press, 1994).

33. Portrush is on the Irish Sea in the north. The winding Antrim coast remains a major tourist attraction for its breathtaking beauty and historical sites.

34. Claire Burgoyne, "The White House, Portrush," BBC series *Your Place and Mine*, July 26, 2009.

35. Jonathan Hamill, Ulster Historical Foundation, a personal interview with Linda Seawright as told to author, 2004.

36. Ibid.

37. Ibid.

38. Ibid.

39. Ibid.

40. Ibid.

41. *Prosperity and Thrift: The Coolidge Era and the Consumer Economy, 1921–1929* (Washington, DC: Library of Congress, c. 1999). Electronic Resource.

42. In 1875, picture cards began to be used for Allen and Ginter cigarette brands Richmond Straight Cut No. 1 and Pet to stiffen the pack and protect the cigarettes. The cards (with photos of actresses, baseball players, Indian chiefs, and boxers) were enormously successful; this was considered a modern promotion scheme for a manufactured product.

43. From the collection of 189 cigarette cards, circa 1910–1930, in the collection of the Monaghan County Museum, Monaghan, Republic of Ireland.

44. *Linen Trade Circular and New Fibres Review* (United Kingdom), March 28, 1964.

45. The coat of arms was granted to the government of Northern Ireland in 1924.

46. *Linen Trade Circular and New Fibres Review* (United Kingdom), March 28, 1964.

47. Author's interview with Paul Larmor, Ulster Weavers Home Fashions, Northern Ireland, 2009.

1. Reprinted with the permission of Michael Longley and publisher Jonathan Cape, Random House, London.

2. The Linen Hall Library is the oldest library in Belfast and the last subscribing library in Northern Ireland. It has an extensive General Collection, a Children's Collection, and a Theatre and Performing Arts Archive. The library is best known for its Irish and Local Studies Collection and, notably, the Northern Ireland Political Collection. The library also has a significant Genealogy and Heraldry Collection, and one of the largest collections of works by Robert Burns outside Scotland.

3. An attractive sandstone showing a huge variety of colors, hues, and textures, Scrabo stone has been quarried in county Down for building since at least Anglo-Norman times. The word *scrabo* may be derived from the old Irish word *scrabac*, "scraggy hill." For more information about the stone and its use, refer to http://www.qub.ac.uk/geomaterials/weathering/education/poster_stones.pdf.

4. Author's interviews with Trish Belford and Ruth Morrow, 2008. See also http://www.tactilityfactory.com.

5. Author's interviews with Jill Phillips, 2008. See also http://www.jill-phillips.com/.

6. Linen thread does not work well in Carrickmacross lace, because two layers of fabric are used; the slubs in linen thread do not pull through the thickness easily.

7. Mary Shields is a member of many lace organizations and groups, including the Guild of Irish Lace Makers, the Lace Guild in England, and International Old Lacers in the United States; she served as vice president of the Organisation Internationale de la Dentelle au Fuseau et l'Aiguille in 2009. She has taught Carrickmacross lace workshops for all these organizations at various venues worldwide for more than twenty years. Shields has made commission presentation laces for state and church dignitaries across Ireland. Her lace pieces have received awards and prizes, including the California Gold Medal and the Award of Excellence from the Royal Dublin Society and the Eleanor de la Branchardiére Award for creative lace design in 2005 and 2007. Her publications include articles in various magazines and journals and two workbooks on Carrickmacross lace. Shields and her family live in Cootehill, county Cavan.

8. Author's personal interviews with Geraldine Connon, 2004 and 2008. See also http://www.geraldineconnon.com.

9. Author's interviews with John England and Jackie Best, 2008. See also http://www.johnenglandtextiles.com.

10. Seamus Heaney, "Death of a Naturalist," in *Death of a Naturalist* (Essex: Farber and Farber, 1985). This is only seven lines of the poem. The complete poem can be found in *Death of a Naturalist*, other published works by Seamus Heaney, and online.

Chapter Twelve. No End in Sight

1. Telephone interview with Nigel Spiers, Thomas Fergusons Irish Linen, 2009. See also http://www.fergusonsirishlinen.com/.

2. Ross Thomas, *Briarpatch* (New York: St. Martin's Griffin, 2003), chapter 11.

Sidebars

The *Oxford English Dictionary* is the source for etymological and historical information on the terms discussed in the sidebars.

Selected Bibliography

The following is a selection from the writings used as reference material for the book. Making and using cloth of any kind through the centuries encompasses every subject from global migration to the industrial revolution—from laying out a body for burial to fashionable dress for royalty. This list contains the substance and range of my reading on a variety of subjects and may serve to direct readers who wish to pursue the study of one or more aspects of Irish linen—who made it, who wore it, and what purpose it served for humankind.

Adams, Sara Swain. *Linen and How to Set the Table for Every Occasion.* New York: Derryvale Linen, 1926.

Arthur, Ian. "Shipboard Refrigeration and the Beginnings of the Frozen Meat Trade." *Journal of the Royal Australian Historical Society* 92 (June 2006).

Baines, Patricia. *Linen Hand Spinning and Weaving.* London: B. T. Batsford, 1989.

Ballard, Linda. *H. R. Lilley: Artist and Designer, 1886–1970.* Undated exhibition catalogue. Ulster Folk and Transport Museum, National Museums of Cultra, Northern Ireland.

Barber, Elizabeth Wayland. *Women's Work: The First 20,000 Years.* New York: W. W. Norton, 1994.

Barbour, Hugh, and J. William Frost. *The Quakers: Denominations in America.* Westport, CT: Greenwood Publishing, 1988.

Berg, Maxine. *Luxury and Pleasure in Eighteenth-Century Britain.* Oxford: Oxford University Press, 2005.

Blethen, Tyler, and Curtis Wood Jr. *From Ulster to Carolina: The Migration of the Scotch-Irish to Southwestern North Carolina.* Cullowhee, NC: Western Carolina University, 1986.

Blum, Richard H. *Bessbrook: A Record of Industry in a Northern Ireland Village Community and of a Social Experiment, 1845–1945.* Belfast: Bessbrook Spinning Co. and J. N. Richardson Sons and Owden, 1945.

Bronson, J., and R. Bronson. *Early American Weaving and Dyeing: The Domestic Manufacturer's Assistant and Family Directory in the Arts of Weaving and Dyeing.* New York: Dover, 1977.

Carroll, Francis M. *The American Presence in Ulster: A Diplomatic History, 1796–1996.* Washington, DC: Catholic University of America Press, 2005.

Casson, Mark, ed. *The Rise of Big Business.* New York: Routledge, 1997.

Charley, William. *Flax and Its Products in Ireland.* London: Bell and Daldy, 1862.

Clark, John G. *New Orleans, 1718–1812: An Economic History.* Baton Rouge: Louisiana State University Press, 1970.

Clarkson, L. A., and E. Margaret Crawford. *Feast and Famine: Food and Nutrition in Ireland, 1500–1920.* Oxford: Oxford University Press, 2001.

Cohen, Marilyn, ed. *The Warp of Ulster's Past: Interdisciplinary Perspectives on the Irish Linen Industry, 1700–1920.* New York: St. Martin's Press, 1997.

Cole, Alan S. *A Renascence in the Art of Irish Lace-Making.* London: Chapman and Hall, 1888.

Collins, Brenda. *Flax to Fabric: The Story of Irish Linen.* Lisburn, Northern Ireland: Irish Linen Centre and Lisburn Museum, 1994.

Collins, Brenda, and Philip Ollerenshaw, eds. *The European Linen Industry in Historical Perspective.* London: Oxford University Press, 2003.

Collins, Brenda, Philip Ollerenshaw, and Trevor Parkhill, eds. *Industry, Trade and People in Ireland, 1650–1950.* Belfast: Ulster Historical Foundation, 2005.

Collins, Peter. *The Making of Irish Linen: Historic Photographs of an Ulster Industry.* Belfast: Friar's Bush Press, 1994.

Connolly, Sybil. *Irish Hands: The Tradition of Beautiful Crafts.* New York: Hearst Books, 1994.

Coons, Martha. *All Sorts of Good Sufficient Cloth: Linen-Making in New England, 1640–1860.* North Andover, MA: Merrimack Valley Textile Museum, 1980.

Crawford, W. H. *Domestic Industry in Ireland—The Experience of the Linen Industry.* Dublin: Macmillan, 1972.

Crawford, W. H. *The Domestic Linen Industry in Ulster.* Belfast: Ulster Historical Foundation, 2005.

Crawford, W. H. *The Handloom Weavers and the Ulster Linen Industry.* Belfast: Ulster Historical Foundation, 1972.

De Kerbrech, Richard. *Ships of the White Star Line.* Surrey, UK: Ian Allan Publishing, 2006.

Duffy, Peter. *The Killing of Major Denis Mahon.* New York: HarperCollins, 2007.

Dunlevy, Mairead. *Dress in Ireland: A History.* London: Batsford, 1989.

Durin, Patrick. *Tillies.* Derry, Northern Ireland: Guildhall Press, 2005.

Evans, E. Estyn. *Irish Folk Ways.* Belfast: Queen's University, 1957.

Freehling, William W. *The Road to Disunion.* 2 vols. New York: Oxford University Press, 2007.

Freese, Barbara. *Coal: A Human History.* Cambridge, MA: Perseus Publishing, 2003.

Gauldie, Enid. *Spinning and Weaving.* Edinburgh: National Museums of Scotland, 1995.

Gavin, Robert, William Kelly, and Dolores O'Reilly. *Atlantic Gateway: The Port and City of Derry since 1700.* Dublin: Four Courts Press, 2009.

Gill, Conrad. *The Rise of the Irish Linen Industry.* London: Oxford University Press, 1964.

Gleeson, David T. *The Irish in the South, 1815–1877.* Chapel Hill: University of North Carolina Press, 2001.

Green, Marion. *Mill to Millennium.* Belfast: December Publications, Springfield Inter-Community Development Project, 1996.

Griffin, Patrick. *The People with No Name: Ireland's Ulster Scots, America's Scots Irish, and the Creation of a British Atlantic World, 1689–1764.* Princeton, NJ: Princeton University Press, 2001.

Hewitt, John. *Rhyming Weavers, and Other Country Poets of Antrim and Down.* 1974. Reprint, Belfast: Blackstaff Press, 2004.

Hill, Myrtle, and Vivienne Pollock. *Women of Ireland: Image and Experience, c. 1880–1920.* Belfast: Blackstaff Press, 1993.

Hood, Adrienne D. *The Weaver's Craft: Cloth, Commerce, and Industry in Early Pennsylvania.* Philadelphia: University of Pennsylvania Press, 2003.

Hume, John. *Derry beyond the Walls: Social and Economic Aspects of the Growth of Derry, 1825–1850.* Belfast: Ulster Historical Foundation, 2002.

Irvine, James, ed. *Mary Cumming's Letters Home to Lisburn.* Cultra, Northern Ireland: Ulster Folk and Transport Museum, 1982.

Jenkins, David, ed. *Cambridge History of Western Textiles.* Cambridge: Cambridge University Press, 2003.

Johnston, Jim. *A Well-Spun Thread: Memoirs from Mossley Mill.* Newtownabbey, Northern Ireland: Newtownabbey Borough Council, n.d.

Kennedy, Liam, and Philip Ollerenshaw. *An Economic History of Ulster, 1820–1940.* Manchester: Manchester University Press, 1985.

Keough, Willeen. *The Slender Thread: Irish Women on the Southern Avalon, 1750–1860.* New York: Columbia University Press, 2008.

Laird, Mark, and Alicia Weisberg-Roberts. *Mrs. Delany and Her Circle.* New Haven, CT: Yale University Press, 2009.

Leyburn, James G. *The Scotch-Irish: A Social History.* Chapel Hill: University of North Carolina Press, 1962.

Selected Bibliography

Leyden, Maurice. *Belfast: City of Song.* Dingle, Republic of Ireland: Brandon Book Publishers, 1989.

Leyden, Maurice. *Boys and Girls Come Out to Play.* Belfast: Appletree Press, 2008.

Linen Thread Co. *Faithful Fibre: The Story of the Development of the Linen Thread Company Limited and Its Subsidiaries.* Glasgow: Linen Thread Co., n.d.

Lunney, Linde. "The Original Spinsters: The Role of Women in the Ulster Domestic Linen Industry." *Familia: Ulster Genealogical Review* no. 23 (2007): 39–53.

McCarter, Geraldine. *Derry's Shirt Tale.* Derry: Guildhall Press, 1991.

McCrum, Elizabeth. *Fabric and Form: Irish Fashion since 1950.* Gloucestershire, UK: Sutton, 1997.

McCutcheon, W. A. *The Industrial Archaeology of Northern Ireland.* Rutherford, NJ: Fairleigh Dickinson University Press, 1984.

Messenger, Betty. *Picking Up the Linen Threads.* Belfast: Blackstaff Press, 1988.

Miller, William H. *The Great Luxury Liners, 1927–1954: A Photographic Record.* New York: Dover, 1981.

Mohanty, Gail Fowler. *Labor and Laborers of the Loom: Mechanization and Handloom Weavers, 1780–1840.* New York: Routledge, 2006.

Murnane, James H., and Peadar Murnane. *At the Ford of the Birches: The History of Ballybay, Its People and Vicinity.* N.p.: Murnane Brothers, 1999.

Nicholson, Paul T., and Ian Shaw. *Ancient Egyptian Materials and Technology.* Cambridge: Cambridge University Press, 2009.

Old Bleach Linen Co. *Old Bleach At Your Service: A Decorative History.* Randalstown, Northern Ireland: Old Bleach Linen Co., c. 1940.

Rankin, Kathleen. *The Linen Houses of the Lagan Valley: The Story of Their Families.* Belfast: Ulster Historical Foundation, 2002.

Riordan, E. J. *Modern Irish Trade and Industry.* London: Methuen, 1920.

Ritchie, J. Ewing. *Bessbrook and Its Linen Mills.* London: William Tweedie, 1876.

Stewart, A. T. Q. *The Narrow Ground.* Belfast: Blackstaff Press, 1977.

Treanor, Máire. *Clones Lace: The Story and Patterns of an Irish Crochet.* Dublin: Mercier Press, 2002.

Truxes, Thomas M. *Irish-American Trade, 1660–1783.* Cambridge: Cambridge University Press, 1988.

Tye, Larry. *The Father of Spin.* New York: Henry Holt, 1998.

Uschapovsky, Igor. "The Russian Flax Sector: Bottlenecks and Solutions." *Journal of Natural Fibers* 6 (2009): 108–13.

Walton, Perry. *The Story of Textiles: A Bird's Eye View of the History of the Beginning and the Growth of the Industry by Which Mankind Is Clothed.* Boston: Walton Advertising and Printing, 1925.

Wilkins, Mira. *The History of Foreign Investment in the United States to 1914.* Cambridge, MA: Harvard University Press, 1989.

Willett, C., and Phillis Cunnington. *The History of Underclothes.* New York: Dover, 1992.

Williams, J. *Architecture in Ireland, 1857–1892.* Dublin: Irish Academic Press, 1994.

Wilson, Catharine Anne. *A New Lease on Life: Landlords, Tenants, and Immigrants in Ireland and Canada.* Montreal and Kingston, Canada: McGill-Queen's University Press, 1994.

Wilson, Kax. *A History of Textiles.* Boulder, CO: Westview Press, 1979.

Young, Arthur. *A Tour in Ireland, with General Observations on the Present State of That Kingdom . . . [1776–1779].* 2 vols. London: T. Cadell, 1780. Reprint, Charleston, SC: Bibliobazaar, 2007.

Index

men, 46, 160; metaphors of, 24; shuttle, *18*; by women, 160. *See also* looms; *specific types of linen*
Weaving Webs of Wealth (Thompson), 5
"web," use of term, 216
Webb, Charles James, 233
Webb, Hubert, 233
Webb's of Newtownards, 214
Weir, Silas, 7
Wellbrook Beetling Mill, *36*
wet spinning. *See under* spinning
"white-collar crime," use of phrase, 198
White House (store), 233, 240–43
White Linen Halls, 34, *35*, 59, 60, *60*, 257
white sales, 230–32

White Star Line Company, 84–91, *85*, *87–91*
wigs, 53
William, Prince, 144
William III, King of England, 52
William Barbour and Sons, *212*, 225, 227
William Coulson's Damask Linen Manufactory, 96–97
William Ewart and Son, 68, 86, 166–67, *220, 221*
Williamite War (1689-91), 31
William Liddell and Company, 89, 99
William Walkers of Banbridge (company), 147–49
Winchester Cathedral, 10

winnowing, defined, 15
W. J. Bryan and Company, 223
Wm. Barbour and Sons. *See* William Barbour and Sons
Wm. Liddell and Company. *See* William Liddell and Company
woodblock printing, 78–81, *79–80*, 82
World's Fair exhibitions, 224
Worth, Charles Frederick, 183

"yarn," use of term, 114
York Street Flax Spinning Company, 68, 151, 213, 230
Young, Arthur, 17, 33–34
Young, Robert, 203